# A PEOPLE'S
# ART HISTORY
# OF THE UNITED STATES

## 250 YEARS OF ACTIVIST ART AND ARTISTS WORKING IN SOCIAL JUSTICE MOVEMENTS

### Nicolas Lampert

THE NEW PRESS

NEW YORK
LONDON

A longer version of chapter 8 ("Haymarket: An Embattled History of Static Monuments and Public Interventions") was published in *Realizing the Impossible: Art Against Authority*, Josh MacPhee and Eril Reuland, editors (Oakland: AK Press, 2007). Permission to reprint this new version of the essay was granted by AK Press.

Requests for permission to reproduce selections from this book should be mailed to: Permissions Department, The New Press, 38 Greene Street, New York, NY 10013.

Published in the United States by The New Press, New York, 2013
Distributed by Perseus Distribution

LIBRARY OF CONGRESS CATALOGING-IN-PUBLICATION DATA
Lampert, Nicolas, 1969—
    A people's art history of the United States : 250 years of activist art and artists working in social justice movements / Nicolas Lampert.
        pages cm — (New press people's history)
    Includes bibliographical references and index.
    ISBN 978-1-59558-324-6 (hardback) — ISBN 978-1-59558-931-6 (e-book)    1.  Art—Political aspects—United States.    2.  History in art.    3.  Art, American—Themes, motives.    I.  Title.
    N72.P6L37 2013
    701'.030973—dc23
                                                                                    2013014977

The New Press publishes books that promote and enrich public discussion and understanding of the issues vital to our democracy and to a more equitable world. These books are made possible by the enthusiasm of our readers; the support of a committed group of donors, large and small; the collaboration of our many partners in the independent media and the not-for-profit sector; booksellers, who often hand-sell New Press books; librarians; and above all by our authors.

www.thenewpress.com

Book design by Josh MacPhee/Antumbradesign.org
Composition by Westchester Book Composition
This book was set in Chaparral Pro and DIN Schrift

Printed in the United States of America

10 9 8 7 6 5 4 3 2 1

To the activist-artists and the artist-activists

# Contents

# Series Preface

TURNING HISTORY ON ITS HEAD opens up whole new worlds of possibility. Once, historians looked only at society's upper crust: the leaders and others who made the headlines and whose words and deeds survived as historical truth. In our lifetimes, this has begun to change. Shifting history's lens from the upper rungs to the lower, we are learning more than ever about the masses of people who did the work that made society tick.

Not surprisingly, as the lens shifts the basic narratives change as well. The history of men and women of all classes, colors, and cultures reveals an astonishing degree of struggle and independent political action. Everyday people played complicated historical roles, and they developed highly sophisticated and often very different political ideas from the people who ruled them. Sometimes their accomplishments left tangible traces; other times, the traces are invisible but no less real. They left their mark on our institutions, our folkways and language, on our political habits and vocabulary. We are only now beginning to excavate this multifaceted history.

The New Press People's History Series roams far and wide through human history, revisiting old stories in new ways, and introducing altogether new accounts of the struggles of common people to make their own history. Taking the lives and viewpoints of common people as its point of departure, the series reexamines subjects as different as the American Revolution, the history of sports, the history of American art, the Mexican Revolution, and the rise of the Third World.

A people's history does more than add to the catalogue of what we already know. These books will shake up readers' understanding of the past—just as common people throughout history have shaken up their always changeable worlds.

Howard Zinn
Boston, 2000

# Preface

A FEW YEARS BACK, a friend caught me off guard when he asked, "Why aren't the artists of today responding in force to the political crisis of the moment?" He mentioned some of the visual artists who were radicalized by the Vietnam War—Mark di Suvero, Leon Golub, Nancy Spero, Ad Reinhardt, Hans Haacke, Carl Andre, and so on, and said that nothing approaching that level of engagement has taken place in the decades that have followed. My answer to him was simple. I told him that artists *were* responding, and more important, he was looking in the wrong places.

My colleague was drawing names from the art world (primarily the New York art world of galleries and museums), while I was looking elsewhere. I suggested that he look to the artists, designers, photographers, and creative agitators who took part in the civil rights movement, the black power movement, the Chicano/Chicana movement, and the red power movement. That he look to the artists in the antinuclear movements, the AIDS movements, the antiwar movements, the environmental movements, the antiglobalization movements, the prison-justice movements, and the feminist movements that did not end in the 1970s. If he wanted to go further back, he could look at the artists in the 1930s' federal art projects and labor unions, those in the suffrage movements, the Industrial Workers of the World (IWW), and so on.

However, his point was clear. Many people look to the world of museums and galleries when they think of visual art, including political art. My argument was that these places are not the primary site for *activist art*. Politically engaged art can and does exist in museums and galleries, but activist art is altogether different and is firmly located in movements and in the streets and communities that produce these movements.[1] My deeper point was that there is another art history that is overlooked—a history of activist art.

This study addresses this parallel history. Some examples draw upon *movement culture*—the art, objects, ephemera, photographs, and visual culture that emerges directly out of movements by the participants themselves. This work is done by individuals who may or may not self-identify as an "artist" or a producer of media. These individuals more likely consider themselves activists first—people who organize and at times employ visual tactics to help their causes succeed.

In contrast, other examples in this study focus upon individuals who identify first and foremost as an "artist"—individuals who were often trained in art academies and art schools. These

individuals (or art collectives) chose to locate their art within a movement—rather than a gallery or a museum—because they were inspired by the cause and decided to join the movement in solidarity as an artist.

Both paths taken—movement culture and the work created by "artists" aligned with social-justice movements—are equally significant. And both paths fundamentally change the role of art in society. Likewise, when the definition of an artist becomes more flexible (for example: an artist is anyone who creates visual culture), it breaks down the elitism in the visual arts and challenges the notion that only a select few people with special talents can participate in the visual-art field. In short, it makes art accessible to all.

Curiously, or perhaps not, the term "visual artist" is often the biggest impediment to artists themselves in the modern era. "Visual artist" comes with its own set of cultural biases, internalized dilemmas, fixed paths, and stereotypes—*isolated, aloof, fringe, eccentric,* and so forth—labels that define the artist from the outside. These labels and misnomers are detrimental: they present artists as fundamentally different, when in fact *most* artists are much like everyone else—working-class people with working-class concerns.

Additionally even the term "art" is suspect when one looks at material items from the past four centuries. Different cultures see the world from different perspectives, and the central thesis of this book—artists working in movements—is less applicable in describing traditional Native art in the seventeenth and eighteenth centuries. Mary Lou Fox Radulovich, the late director of the Ojibwe Cultural Foundation, stated that "Indian people have no word for art. Art is part of life, like hunting, fishing, growing food, marrying, and having children. This is an art in the broadest sense . . . an object of daily usefulness, to be admired, respected, appreciated, and used, the expression thereby nurturing the needs of body and soul, thereby giving meaning to everything."[2]

Contemporary artistic practice also blurs our understanding of art. Arguably, some of the most profound examples of activist art, especially during the past four decades, is work that negates traditional ideas about art—projects where the art is difficult to define. This type of work shares commonality with the tactics of social-justice movements—art as a form of civil disobedience and art that intervenes in public space and the mass media, becoming a form of tactical media itself.

Yet if anything connects the multitude of examples that are presented in this study, it is the recycling of tactics that are redeployed with minor variations—a practice that is wholly welcomed. Tactics that succeed do so for a reason, and if activist artists can draw inspiration from the past and adapt them to the present, then all the power to them.

Significantly, this study is not an all-encompassing survey of activist art throughout U.S. history. If so, I would have included essays on Thomas Nast, Lewis Hine, Dorothea Lange, Black Mask, Bread and Puppet, and others, along with key struggles like the ones led by the Young Lords and the United Farm Workers, to name just a couple. Rather, my decision-making process was to move through U.S. history chronologically and to focus upon a select number of examples that inform us about various visual art disciplines and tactics used in activist campaigns. Some that worked. Others that fell short. At times, I was particularly drawn to the examples that were complicated, where the decisions made by artists were con-

troversial and confounding. My logic: analyzing histories that are deeply complicated helps us learn. A history of *only* success stories does not.

Collectively, my hope is that this study serves as a call to action for *more* artists to become activists, and conversely for more activists to employ art, for the benefits are vast. When social movements embrace artists, they harness the power of those who excel at expressing new ideas and reaching people in ways that words and other forms of media cannot. They harness the power of visual culture. And when artists join movements, their work—and by extension their lives—takes on a far greater meaning. They become agitators in the best sense of the word and their art becomes less about the individual and more about the common vision and aspirations of many. Their art becomes part of a culture of resistance.

# Acknowledgments

WRITING A BOOK IS a unique opportunity to collaborate, and to be in communication with many brilliant people. I am forever grateful to Marc Favreau, Maury Botton, Azzurra Cox, and all at The New Press for supporting this project from the start. I thank them for their thoughtful suggestions, edits, and patience in allowing me ample time to develop my manuscript. Gratitude is also extended to colleagues and close friends who reviewed the manuscript—most notably to Josh MacPhee. Josh's suggestions for edits were invaluable, as has been his support in other facets of my creative life. He brought twenty-five of us together to form the Justseeds Artists' Cooperative in 2007, a community that has continuously nurtured my hybrid practice of producing art for social-justice movements, writing about activist art, and curating activist art exhibitions.

I also thank Gregory Sholette, Dylan A.T. Miner. Alan W. Moore, Susan Simensky Bietila, Tom Klem, and Sandra de la Loza for reviewing specific chapters, along with James Lampert for his careful edits and for *everything*. Vast appreciation is also extended to John Couture for his insight during the early stages of the project, along with Gregory Sholette and Janet Koenig. Thank you also to Rachelle Mandik for her copyedits of the final manuscript.

In Milwaukee, I thank all my colleagues in the Department of Art and Design at the University of Wisconsin–Milwaukee who have allowed me the opportunity to teach my practice—art and social justice—from day one. Special thank-you to Kim Cosier, Lee Ann Garrison, Yevgeniya Kaganovich, Denis Sargent, Josie Osborne, Raoul Deal, Nathaniel Stern, Jessica Meuninck-Ganger, Shelleen Greene, and Laura Trafi-Prats, along with other colleagues across the University—Greg Jay, Linda Corbin-Pardee, Lane Hall, and Max Yela for supporting my scholarship, art, and teaching on topics that relate specifically to this study.

Thank you also to the teaching and learning community *outside* of academia—the many collective spaces and independent publications that have allowed me the opportunity to present on activist art and to contribute essays and interviews to the dialogue. In Chicago: Mess Hall, *AREA Chicago*, Daniel Tucker, Jane Addams Hull-House Museum, Lisa Lee, InCUBATE, *Proximity*, Ed Marzewski, and Mairead Case. In Milwaukee: the Public House and "Night School," Paul Kjelland, Woodland Pattern, Michael Carriere and all colleagues at ReciproCity. In Madison: Rainbow Bookstore Cooperative, Dan S. Wang, and Camy Matthay and Sarah Quinn for the opportunity to

present radical art history inside the prison industrial complex. In Detroit: Mike Medow, Jeanette Lee, Josh Breitbart, and all who organize the annual Allied Media Conference. In Bowling Green and elsewhere: Jen Angel, Jason Kucsma, and all involved in the past Allied Media Conferences, and the greatly missed *Clamor* magazine.

I also extend my gratitude to those who have supported my research and have invited me to contribute writings to various books and publications, including Temporary Services (Salem Collo-Julin, Marc Fischer, Brett Bloom), Jennifer A. Sandlin, Brian D. Schultz, Jake Burdick, Peter McLaren, Therese Quinn, John Ploof, Lisa Hochtritt, Josh MacPhee, Erik Reuland, Erica Sagrans, the Compass Collaborators (the Midwest Radical Cultural Corridor), and James Mann. Thank you also to those who have provided me with art and research grants: the Mary L. Nohl Individual Artists Fund in Milwaukee, and the Jean Gimbel Lane Artist-in-Residence at Northwestern University. Special thank-you to Polly Morris and Michael Rakowitz. Thank you also to Nato Thompson, Gretchen L. Wagner, Lori Waxman, and Linda Fleming.

I am also indebted to the many co-collaborators who have allowed me the chance to collaborate as an artist in a movement. Thank you first and foremost to all in Justseeds, and to Dara Greenwald, whom we miss dearly. Thank you to Aaron Hughes and the Chicago chapter of Iraq Veterans Against the War (IVAW); TAMMS Year Ten, Laurie Jo Reynolds, Jesse Graves, and all involved in the mud stencil action; the Chicago chapter of the Rain Forest Action Network (RAN); and all involved in the Warning Signs project.

Much appreciation is also extended to the activist art archives, in particular the Center for the Study of Political Graphics (CSPG) in Los Angeles, the Interference Archive in Brooklyn, the Tamiment Library and Robert F. Wagner Labor Archives and Radicalism Photograph Collection at NYU, the Joseph A. Labadie Collection at the University of Michigan, the LGBT and HIV/AIDS Activist Collections at the New York Public Library, and the Woman's Building Image Archive at Otis College of Art and Design. And thank you to the art historians and the artists who informed this study. The book is a tribute to your work.

Much gratitude is extended to all the artists, art historians, historians, scholars, librarians, and archivists who provided images for this book, provided insight, and directed me to various collections. First and foremost thank you to those who reduced or waived image permission fees. It would not have been possible to compliment the text with so many images without your generosity. Special thank-you to Seiko Buckingham, Suzanne Lacy, Russell Campbell, the Yes Men, Betsy Damon, Aaron Hughes, Sue Maberry at the Woman's Building Image Archive at Otis College of Art and Design, Faith Wilding, Nancy Youdelman, Judy Baca, Pilar Castillo at SPARC, Harry Gamboa Jr., Chon A. Noriega at the UCLA Chicano Studies Research Center (CSRC), Francis V. O'Connor, Penelope Rosemont, Sandra de la Loza, Jon Hendricks, Marc Fischer, the Jump Cut editors, Mike Greenlar, Lincoln Cushing, Michael Shulman at Magnum Photos, Josh MacPhee at the Interference Archive, Carol A. Wells at the Center for the Study of Political Graphics (CSPG), Julie Herrada at the Joseph A. Labadie Collection at the University of Michigan, and Evelyn Hershe at the American Labor Museum/Botto House National Landmark. I am a firm believer that art created for social justice movements should be part of the public commons and our shared collective history and not restricted by copyrights and expensive image permission fees, something that many activist-

artists and activist groups have embraced, often through Creative Common licenses. In closing, thank you to Azzurra Cox and Ben Woodward at The New Press for assisting me with the image permission process.

Lastly, and most importantly, thank you to my family—Laura, Isa, my parents, and my brothers. Special thank-you to Laura for the never-ending support of this project and the time needed to accomplish it. Finally, thank you to Howard Zinn. In 2003, I invited Professor Zinn to Milwaukee to present to my students, and during his visit we talked at length about art and activism. At the end of his stay, he encouraged me to propose a book to The New Press. His enthusiasm for the project and his early feedback helped fuel me through many years of research and revisions. Always the teacher, he reminded me of the need to inspire others, to communicate in clear prose, and to bring more people into the movement.

# A PEOPLE'S ART HISTORY OF THE UNITED STATES

# Plate 4

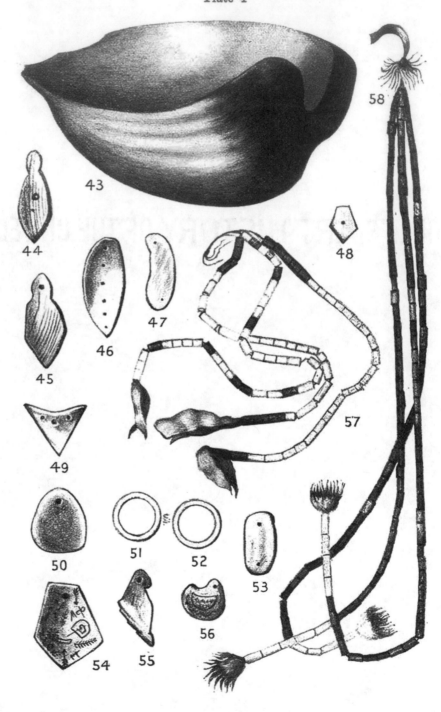

Illustration from *Wampum and Shell Articles Used by the New York Indians* (William M. Beauchamp, New York State Museum Bulletin #41, volume 8, February 1901, plate 4; University of Wisconsin–Milwaukee Libraries collection)

# 1

# Parallel Paths on the Same River

ART IS A SUBJECTIVE MEDIUM. Even the term is suspect. In Native societies, art was not isolated from other aspects of life; it was interwoven with political, social, and religious life. It was expressed on the body, clothing, objects of daily use, warfare, and through gifts to the spiritual world. Art was also affected by events taking place throughout the continent. Thus, it is not surprising that one of the first material objects that showcased the early contact between Native peoples and European colonists was a cross-cultural product—wampum belts.

Wampum derived from shells. Atlantic coastal tribes, and later European settlers, collected whelk and quahog shells from the coastal regions of present-day Cape Cod to Virginia and transformed the central column of the shell into cylindrical beads that were then strung together into ceremonial wampum strings and later elaborate wampum belts. These objects—produced by the aid of European tools and manufacturing techniques—became essential objects that facilitated communication between the living and dead, increased trade, nurtured treaty agreements, and recorded histories.

Metaphorically, wampum belts connected Native tribes with other tribes, Native peoples with European colonists, and North America with the markets of Europe.[1] Present-day Albany, New York, became the epicenter for Dutch colonists, and later the English, to trade wampum to the Iroquois. In return, the Iroquois traded tens of thousands of beaver pelts to the colonists; the pelts served as the material for broad-brimmed felt hats that were immensely popular in Europe. In payment, the Iroquois received wampum beads, brass kettles, iron axes, and other European goods. In essence, nearly two centuries of economic life in the Woodlands—northeastern North America—revolved around four essential goods: beavers, iron, copper, and shells.

## Cross-Cultural Product

The wampum-bead trade had existed long before Europeans began establishing permanent settlements in North America. Woodland Natives circulated shells throughout the continent in an

extensive trade network that included other luminous materials—quartz from the Rocky Mountains and copper from the Great Lakes.

Wampum was revered for many reasons. The shells were used as ornamentation for the body, and to project one's status. It was worn on the ears, applied to wooden objects, and crafted into headbands, necklaces, and cuffs. Wampum was also strung together on a single strand and used during treaty agreements to facilitate the communication process between two tribes. It was also "tossed into waterfalls and rivers as offerings to spirits, and burned in the White Dog ceremony."[2]

Moreover, wampum served as a burial item—gifts that the dead could take with them on their journey to the next world. Adult men and women, to strengthen their voyage to the spirit world, were buried with food and other items, including personal possessions, tools, weapons, and effigies. Children required even more burial items. In one example, archeologists excavated a grave where a young Seneca girl who had died in the 1650s was buried under belts and necklaces containing more than 43,000 wampum and glass beads.[3]

European arrival on the North American continent extended the trade of wampum and other material goods. Europeans were first called *metalworkers*, *ax makers,* and *cloth makers* by Native peoples, and their goods made of iron, copper, and glass were seen as a positive development that made cooking, starting fires, hunting, and fighting wars easier.[4] Tools and materials from Europe also allowed Native crafts to flourish. Beadwork was greatly enhanced by the introduction of glass beads, needles, threads, and various clothes. Iron knives, chisels, and awls all improved carving techniques.[5]

Native tribes often moved closer to, rather then farther away from, those who had arrived on their shores. Some tribes, including the Susquehannock, relocated near the mouth of the Chesapeake Bay around 1580 to be closer to the European fishing vessels.[6] The goal for Native people: gain access to European goods and the "power they might possess."[7]

Natives believed that the next world was not adequately supplied with European goods but that an abundance of traditional crafts already existed in large amounts in the next world. Trade with Europeans could serve the needs of the spirit world, but it could also serve the needs of the living. European copper kettles were cut into smaller pieces and turned into ritual items—jewelry, ornaments, and weapons. Iron ax heads and knives were reappropriated into needles, awls, and arrowheads—objects that were all rooted in Native culture.

European contact also transformed the use of wampum. Wampum strings evolved to wampum belts that developed through the use of European tools. The Dutch introduced drills and grindstones to coastal Algonquians and revolutionized the manufacturing process that allowed Native women to produce a more refined product—small, tubular wampum beads that were more uniform in shape and size. Tools also allowed a small hole to be drilled through the bead at opposite ends, where it was then strung with vegetable fiber. Finally, the rows of strings were arranged in geometric designs that were placed on top of a piece of deerskin that served as the backside of the belt.

The Two Row Belt (Guswenta)—a wampum belt that the Mohawk first gave to the Dutch in 1613, and later versions to the English, French, and Americans—exemplified wampum's physical form, its mode of communication,[8] and its meanings.

The belt consists of two rows of purple wampum beads against a background of white beads and depicts two purple lines (two vessels—one canoe and one European ship) traveling down parallel paths on the same river. The three white stripes on the background signify peace, friendship, and forever. Together, the belt advocates for the ideal scenario—the peaceful relationship between the Iroquois and the European colonial power that they were negotiating with. In a broader sense, the wampum belt advocated for tolerance for other cultures, a separate but equal coexistence, and the "enduring separation of [the] Iroquois from European law and custom."[9] It symbolized two distinct peoples sharing the same continent.

The Iroquois, neighboring tribes in the Northeast Woodlands, and colonial officials produced hundreds, if not thousands, of wampum belts during the seventeenth and eighteenth centuries. Famous belts included the "Hiawatha" belt that symbolized the formation of the Iroquois League (also called the Five Nations, or by the people themselves the Haudenosaunee—the People of the Longhouse) that formed in the late fifteenth century, nearly a century before Europeans began settling on the northeastern seaboard and the St. Lawrence River.[10]

Illustration from *Wampum and Shell Articles Used by the New York Indians* (William M. Beauchamp, New York State Museum Bulletin #41, volume 8, February 1901, plate 16; University of Wisconsin–Milwaukee Libraries collection)

The "Hiawatha" belt pictured the powerful confederacy of five Indian nations—Mohawk, Seneca, Onondaga, Oneida, and Cayuga—that were spread across what is now present-day central New York. Four of the five nations are represented by rectangles. In the center is pictured the Great Tree of Peace, representing Onondaga (Keepers of the Council Fire and Keepers of the Wampum Belts), and outward from it extends lines that connect the Five Nations in a shared alliance.

Wampum belts of this scale required intensive labor to produce. The bulk of the time involved manufacturing the central column of a shell into a bead with hand tools. In the mid-seventeenth century, the average output for a Native person manufacturing shells was forty-two white beads per day, and this excluded the time needed to collect the shells. Purple beads, which derived from a much harder part of the shell, took twice the time to produce: twenty-one beads per day."[11] A wampum belt with three hundred beads took upward of 7.1 days of labor and a belt with five thousand beads took 119 days of labor just to produce the beads alone.[12] One can barely imagine the time and labor needed to produce Pontiac's Great War belt, at six feet long and containing more than nine thousand beads that were arranged in patterns to depict the emblems of forty-seven tribes that were in alliance with him.

As non-Native people began taking over the trade—mainly owing to Native tribes being decimated by European diseases and colonial populations waging war against coastal

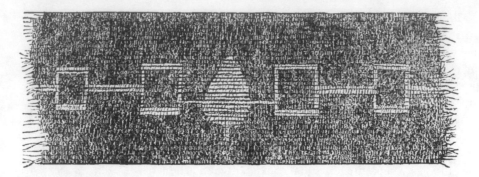

*Hiawatha Belt,* illustration (*Popular Science Monthly,* volume 26, 1885–1886)

Native communities—both the labor dynamics of wampum and its value began to change.[13] By the mid-seventeenth century, colonists in New England, New York, and New Jersey began churning out wampum beads by the tens of thousands, including at a wampum factory that was established by John Campbell in New Jersey.[14] Colonists using lathes and more refined tools were then able to produce upward of 375 beads per day per worker; a 5,000-bead belt would take approximately thirteen days to manufacture.[15]

The colonial production of wampum was also fueled, briefly, by its role as money. The Dutch and the English lacked adequate metal coinage and by the mid-1630s wampum beads were adopted as colonial currency to purchase goods, land, and labor.[16] However, wampum's value quickly depreciated. The value of wampum compared to pelts fell by 60 percent between 1641 and 1658, and by 200 percent during the 1660s.[17] By the end of the decade, colonists had largely abandoned wampum as a form of currency.

During this same era, the use of wampum by the Iroquois accelerated; by the midcentury mark, more than three million individual beads were estimated to be in circulation in the Five Nations alone.[18] The demand was fueled by the spread of European diseases, constant warfare, and competition over scarce resources that heightened the need for alliances, treaties, and burial gifts.[19] Between 1663 and 1730, the Iroquois alone had approximately four hundred diplomatic encounters with the Dutch, English, and French.[20] Wampum strings and belts became an essential part of this process.

## Forest Diplomacy

"You may know our words are of no weight unless accompanied with wampum, and you know we spoke with none and therefore you will not take notice of what was inconsiderately said by two or three of our People."

—Mohawk speaker addressing Sir William Johnson, the Superintendent of Northern Indian Affairs, February 1757[21]

Colonists, newcomers to the continent, quickly came to realize that they had to follow Native customs if they wanted to negotiate over the two things that mattered most to them: obtaining beaver pelts and obtaining land.[22] Additionally, colonial powers had a strategic interest in negotiating with the Iroquois, for they were the strongest confederation in the region. The Iroquois were situated between two imperial powers—the French on the St. Lawrence River and the Dutch (later the English) on the Hudson River. This location allowed the Iroquois to be the trade broker between colonists in New York and Albany and the Native people to the north and the west. To the Dutch, and later the English, the Iroquois were the perfect buffer zone between them and the French in Montreal and Quebec. They could be counted on to fight against Native tribes allied to New France, and they could help offset New France's control of the St. Lawrence River trade route by facilitating the trade of beaver pelts from the Great Lakes toward Albany and New York.

The Iroquois also viewed alliances with colonial powers as beneficial. Direct access to European goods—iron implements and guns in particular—allowed the Iroquois to decimate many of their Native enemies, and their favorable geographic location allowed them to play one colonial power off another. If New York did not accommodate them well, they could make a treaty with the French. And if New France did not make certain alliances with them, they could side exclusively with New York, a scenario that the French sought to avoid. Thus, as long as two colonial powers were in the region, the Iroquois could be assured of relative political stability.

Stability, however, depended upon treaty alliances, and these meetings depended upon passing wampum strings and wampum belts. Likewise, colonial negotiators knew if they were to trade and form strategic alliances with Native tribes, they'd have to learn how to pass wampum strings and belts properly, to reject them if need be, and to follow the etiquette of council treaties.[23]

The process of treaty councils followed four major stages: invitations, the preliminary meetings of delegates, council transactions, and the ratifying of treaties. To the Iroquois, a council oratory followed three metaphors: the *path*, the *fire*, and the *chain*.

The process for calling a council began with an invitation. A runner would be sent out to deliver a wampum string, prepared in advance, that served as the invitation notice. The wampum string, not the messenger, was what mattered most. The role of the messenger was to deliver, in essence, a prerecorded message that conveyed the invitation from the chief. The messenger would then return to the home fire to inform the chiefs of whether the invitation was accepted.

If the wampum string was accepted, the invited visitors, sometimes numbering in the dozens, would set out on the path—a ceremonial process by foot or canoe to the council site, a neutral site at the woods' edge, where the two groups would meet. There they would first rest and ceremonially cleanse their eyes, ears, and throats from the hardships of the journey. After a day of rest the delegates would be seated and a condolence ceremony would begin where tearful eyes would be dried and minds and hearts would be cleansed of thoughts of revenge.

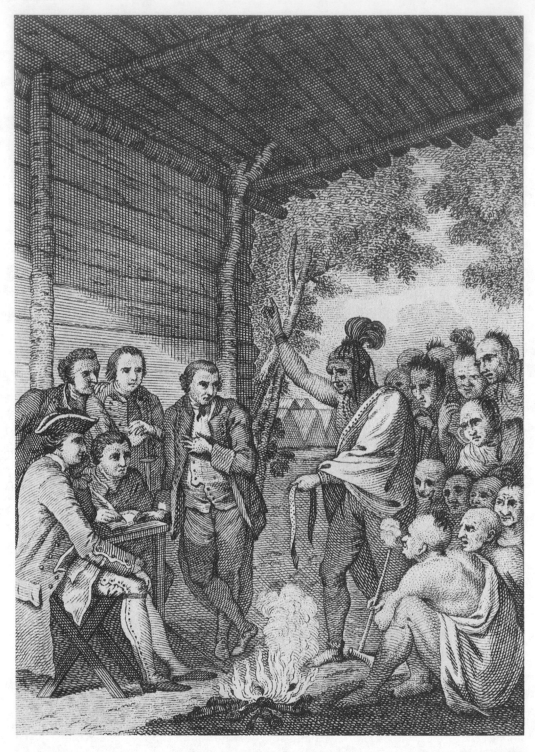

*Native Orator Reading a Wampum Belt*, illustration (William Smith and Charles Guillaume Frédéric Dumas, *Historical Account of Bouquet's Expedition Against the Ohio Indians, in 1764*; Amsterdam: M.M. Rey, 1769, American Geographical Society Library. University of Wisconsin—Milwaukee Libraries collection)

Then the fire would be kindled. This was followed by the retelling of the history of the two groups gathered together and the explanation of the laws that guided council meetings. The next stage involved the offering up of specific propositions. A wampum belt for each specific proposal would then be passed. This process made the proposal visual and helped regulate the council's business and promoted "the orderly succession of speakers from the two sides."[24]

The recipients of the proposal listened to the offer and would not respond until the next day. If wampum was thrown to the ground, it meant that the proposal was not acceptable. This process of accepting or rejecting belts could last for weeks. Every Native voice had to be heard, from sachems to warriors.[25]

Colors and symbols on wampum belts communicated the tone of the proposal. Belts with a white background of beads communicated peace and goodwill. Black backgrounds conveyed a more serious matter—hostility, sorrow, death, and mourning. Belts that had red painted onto the beads changed the meaning into an invitation for war.

Symbols could also convey the same messages. In 1757, the French sent the Iroquois a black war belt with an image of a white ax in the center.[26] Symbols of diamonds or squares represented a nation or a castle. The cross represented Canada and, by extension, the French Jesuit missionaries and Christianity. Sloping lines represented temporary alliances, whereas connecting lines represented a strong alliance.

The final stage was the ratifying of treaties—or the *chain*—a bond that brought two groups of people together in agreement. This was followed by a feast and presentations of gifts from the host—an assortment of food, clothing, weapons, and often liquor. These gifts would then be subsequently redistributed to the village.

## Historical Records, Consensus, and Capitalism

The significance of wampum belts did not end after the treaty process had concluded at the edge of the forest. When leaders returned from councils, important belts were taken to the Onondaga village, as the Onondaga were the Keepers of the Wampum Belts, and stored in the Council House.[27] There they served as a mnemonic device, objects that aided in the memory of alliances and words spoken. In the months and years that followed councils, chiefs would take out the belts and read them to younger members of the village, teaching them the history of their relations with those outside their tribe.

Council negotiators also had another process for belts and strings of lesser importance—they would break them up and redistribute the beads amongst the village.[28] A leader's status was not determined by his material wealth but by how he provided for his people. Daniel K. Richter explains, "Most presents delivered during treaty councils belonged to the lineages of these headsmen, who could then raise their status by distributing coveted items in community."[29] Wampum became a shared community asset, and family and village stores typically held wampum beads as public treasures.[30]

Shared resources reflected upon a shared vision of governance. Politically, the Iroquois League was structured to ensure that one faction could not gain absolute authority.[31] The Five

Nations of the League (and later the Six Nations, when the Tuscarora joined in 1722–1723) could negotiate with colonial powers as individual entities as long as their actions did not harm other League members.[32] This allowed a certain degree of autonomy, but its key purpose was to decentralize leadership. Richter explains, "In a paradoxical way, it was precisely the *lack* of centralized political unity that made the modern Indian politics work: factional leaders independently cultivated ties to particular European colonies, cumulatively maintaining the multiple connections that warded off political dependence on powerful European neighbors."[33]

This process no doubt frustrated colonial negotiators to no end (accustomed as they were to negotiating with a central authority that made finite decisions), but the more anarchistic structure served the Iroquois' purpose well: it allowed for neutrality to occur when needed and it kept the power in check among League nations.

In this manner council negotiators were free to complement or contradict the terms negotiated by other League members. Richter writes:

**Plate 27**

281

Illustration from *Wampum and Shell Articles Used by the New York Indians* (William M. Beauchamp, New York State Museum Bulletin #41, volume 8., February 1901, plate 27; University of Wisconsin–Milwaukee Libraries collection)

In a nonstate society, neither the village majority nor those who held hereditary office had any power to force a leader who spoke for a substantial following to abide by collective decisions. Issues of war and peace therefore became extraordinarily complex, with at least the potential that arrangements painstakingly crafted by one group of village headmen might be undone by another, as each leader sought by his own lights to forge alliances with forces that might bring spiritual and material power to his kin, followers, and community. Each headman and war chief was free, to the extent he could mobilize resources and followers, to pursue his own policies both at home and in dealings with other people.[34]

At stake were two competing value systems between Native and non-Native peoples: one based on consensus and various degrees of shared power, land, and resources, versus one based on hierarchal forms of government and private property.

These fundamentally different views of society came to a head during council treaties. Europeans viewed signed paper documents, not wampum belts, as "concrete evidence that a binding contract had been made."[35] During the councils, colonial clerks recorded only small portions of the speeches made by the Iroquois participants. These individuals, like the majority of colonists, outside of Jesuit missionaries, never learned the Iroquois language. This affected the reading of the wampum belts. Mary A. Druke writes that colonial negotiators "never developed a system for transmitting oral traditions associated with wampum belts, so the specific meanings of belts were lost to them."[36] Conversely, the Iroquois did not care for signed documents, nor did they care for the note-taking process by European clerks during the councils.[37] To the Iroquois, the treaty council process was not a means to an end. It was part of the regular lines of communication, not a concluding statement. The Iroquois believed that alliances were in need of *constant* attention, and the belts were part of a continuous process that regulated the dialogue and face-to-face communication that was needed to bring forth peace as conditions *changed*. Thus, wampum belts, both then and now, embody a large cultural disconnect: their meanings were understood by the Iroquois, but largely lost on the colonial population.

In more recent times, Native nations have brought wampum belts into the courts of law in the United States and Canada to support sovereignty rights, treaty rights, and other agreements that took place in the past, but the meanings of the belts are dependent on Native oral history and have been subsequently downplayed due to a system that prioritizes the methods that the colonial powers institutionalized—signed paper documents.

The Iroquois' oral history of wampum belts presents a different perspective—a Native perspective. It viewed the 1613 Two Row treaty alliance with the Dutch as binding. Onondaga Chief Irving

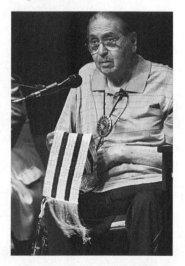

Onondaga Nation Chief Irving Powless Jr. displays the two-row wampum belt at the Onondaga Land Rights forum at Syracuse Stage, July 13, 2010 (photograph by Mike Greenlar, Courtesy Mike Greenlar)

Powless Jr. noted in 1994 that the duration of the agreement, according to his ancestors, meant forever: "As long as the grass is green, as long as the water flows downhill, and as long as the sun rises in the east and sets in the west."[38] However, to non-Native audiences, unable or unwilling to accept Native perspectives, wampum belts became something to dismiss. They signified a past meeting, but not the specific details. In contrast, Rick Hill (Tuscarora) writes, "Wampum represents our interpretation of the agreements that took place. It is our understanding that we have inherited from our ancestors, which is not subject for debate; to be shared with those who are willing to consider our side of the story."[39] From a broader perspective, wampum belts become objects that tell the story of *survival*. Native people—despite the onslaught of European diseases, war, and colonial power competing to rob them of their land and resources—have persisted and retained their self-determination, identity, culture, and their sovereignty.[40]

# 2

## Visualizing a Partial Revolution

HOW A REVOLUTION UNFOLDS and how it is *visualized* are often at odds with each other. Consider the King Street Massacre, better known as the Boston Massacre—a pinnacle moment in history that laid the foundation for the American Revolution.

On March 5, 1770, a multiracial mob confronted a small group of British soldiers and turned a tense situation into a crisis. Massachusetts was the epicenter of the growing revolt against British policy, and the presence of British soldiers in Boston was viewed as an occupying army sent by the Crown and Parliament to enforce its will on the colonial population.

Things began to escalate on March 2, when a group of Boston rope makers insulted a British soldier, knocked him down, and took his sword as a memento. The soldier retreated to his barracks and returned with reinforcements, but again the rope makers prevailed. The following day British soldiers from the 14th and 29th Regiments exacted revenge by beating anyone they could find who was out walking on the streets. Random skirmishes continued the following day.

On March 5, daytime fights turned into a nighttime riot on King Street. A multiracial mob of seventy people or more, armed with sticks and clubs, pelted a group of seven soldiers with snowballs. As tensions grew, the size of the crowd grew. Sailors rushed up from the docks and joined rope makers, journeymen, apprentices, and others to form a sizable crowd of upward of one thousand. The crowd berated the soldiers with insults, attempted to knock their guns out of their hands, and dared them to fire. Soldier Hugh Montgomery was the first to oblige. Montgomery fired as he was struck and falling to the ground. Other soldiers followed suit.

Four people in the crowd were instantly killed. One would later die of his wounds. Those killed were a sailor, a second mate on a ship, a ropewalk worker, an apprentice to a leather-breeches maker, and an apprentice to an ivory turner.[1] The first person to die was Crispus Attucks, a six-foot-two sailor and former slave who was part African American and part Native Indian. Attucks would have the unlucky distinction of becoming the first martyr of the American Revolution. He would also become emblematic of the power dynamics at play as the revolution unfolded: a revolution instigated by working-class people (both urban and rural), and a revolution where power

would ultimately be seized by the colonial elites who fought on two fronts: one against British rule and one against their own working class.

## The Bloody Massacre

Images of the Boston Massacre represented this power play. Silversmith, engraver, and patriot Paul Revere published the most influential Boston Massacre image on March 26, three weeks after the riot. His image *The Bloody Massacre* was riddled with factual errors.

Revere's engraving depicted the British soldiers all firing at once, instead of randomly. Capt. Thomas Preston was depicted as giving the command to fire, instead of simply being present among the soldiers. Revere added a fictitious gun shooting down from the second-floor window of the Custom House that he renamed "Butcher's Hall." He also depicted the crowd as small: two dozen people instead of upward of one thousand. More problematic, Revere depicted the crowd as passive—without sticks and clubs—turning a working-class mob into a respectable assortment of men and women. Worst of all, he depicts Attucks as someone he wasn't: a white man.

Revere's engraving was designed as anti-British propaganda that fell in line with how wealthy colonial elites wished to portray the revolution: a revolt that was led by an educated, white, male leadership that had rallied the colonial population against the unjust policies of the British Parliament and its use of force. This was far from reality, but artistic representations of significant historical events are rarely accurate. Instead they express points of view and political agendas. They are a form of media and part of the fight to win over public opinion.

Revere's unstated objective with his print was to direct colonial anger toward the British and to defuse class tensions among the colonial population. His source image derived from the Boston artist Henry Pelham. Pelham had witnessed the massacre and lent Revere a copy of his engraving for reasons that remain unclear. Revere himself was not a printmaker or "artist," per se. He was an engraver who copied other people's images, primarily images by British artists. This time he copied Pelham's work.[2]

However, Pelham never expected Revere to duplicate his image, much less publish it before he had the chance to do the same. But to Pelham's dismay, Revere copied his image, almost to the last detail, while adding his own text, and then advertised the print for sale on March 26, one week before Pelham released his own print for sale on April 2.

Pelham was furious at Revere for stealing his image. He wrote Revere a scathing letter, stating that Revere had plundered him "on the highway" and he was guilty of "one of the most dishonorable Actions you could well be guilty of." But the real issue in terms of its national impact was not the plagiarism, but the influence that the Revere print's message exerted on the colonial population.[3]

Revere's engraving came to serve as the *primary* image that documented the Boston Massacre. Copies of his prints (he pulled two hundred impressions) traveled up and down the eastern seaboard and across the Atlantic, where they were subsequently copied (without permission) by other artists and republished in broadsides, newspapers, and other forms of print media. Thus, his image served as news—visual information that augmented the text about

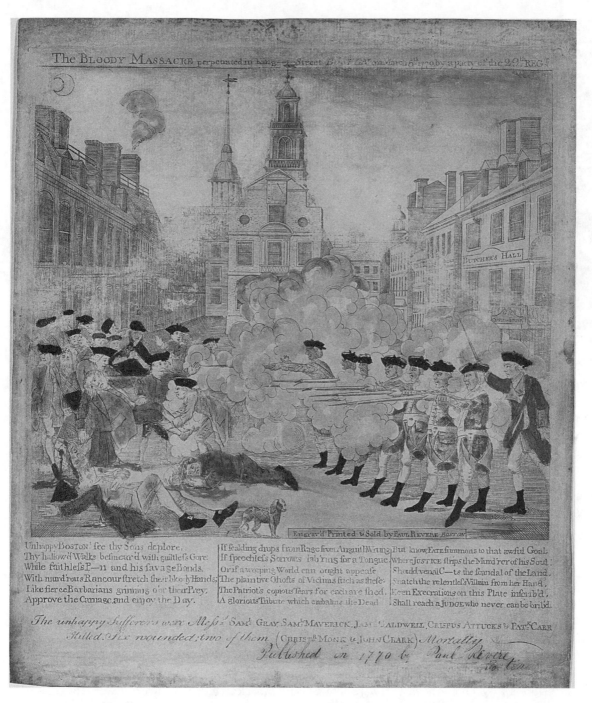

Paul Revere, after Henry Pelham's design, *The Bloody Massacre Perpetrated in King Street Boston on March 5th 1770 by a Party of the 29th Regt.*, 1770 (LC-DIG-ppmsca-01657, Library of Congress)

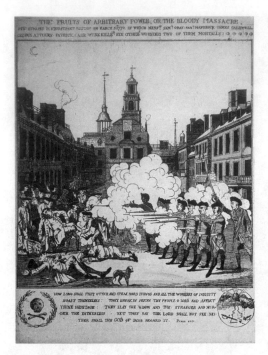

Henry Pelham, *The Fruits of Arbitrary Power, Or the Bloody Massacre*, 1770 (American Antiquarian Society)

the massacre—all of which incited anger against the British Parliament while downplaying the role that the multiracial mob had played in the action.

This newsmaking role is significant, for in the 1770s a mass media did not exist. News traveled slowly and was transported by ship or by horseback down poorly constructed roads. At best, it took three weeks for news to travel by road from Boston to Savannah, Georgia. Often it would take six. Traveling lines of communication to frontier communities took much longer, if at all.[4] When copies of Revere's engraving and subsequent broadsides reached far-flung communities, it was likely the first and *only* image that people would see that visualized the massacre.[5]

This singular version of events was also disseminated overseas. Boston Whigs sent copies to London, hoping that the brutal image and text would find a sympathetic audience among the British public, which would then lead to a public outcry against the policies and actions of the British government toward the colonial population. Once again, the Revere/Pelham image (which was reengraved and circulated around England) obscured the class tensions that existed in colonial America, including the reality that some workers and tenants had sided with the British, placing more trust in the British Parliament than the colonial elite.

Revere's omission of the multiracial mob was intentional. The Pelham image served as his source material, but he inserted additional information as he saw fit, and he hired the artist Christian Remick to hand color his print edition. Revere could have easily instructed Remick to color Attucks and others in the crowd black, but he chose not to. He could have easily added sticks and clubs to the hands of those in the crowd, but instead, he made the crowd white men from the respectable artisan class. Marcus Rediker writes that Revere "apparently did not want the American cause to be represented by a huge, half–Native American, half–African American, stave-wielding, street-fighting sailor . . . Attucks was the wrong color, the wrong ethnicity, and the wrong occupation to be included in the national story."[6]

This omission in Revere's image echoed the dominant narrative of the American Revolution and the formative years of the new nation, a narrative that was written by the colonial elite. The same elite that attached themselves to the popular uprising in colonial America—whose foot soldiers were debt-ridden farmers, sailors, and disenfranchised artisans and laborers—yet once the British were defeated and American independence was won, the colonial elite kept similar oppressive structures in place.

Women remained second-class citizens: unable to vote, unable to hold political office, receive a higher education, unable to work in the majority of occupations. Africans remained

enslaved. Eastern Native people were forced to relocate to the western plains as their land was taken from them. As for the white, male working class, it was welcomed in the new nation, but the vast majority of colonial people remained impoverished. Those without property were disenfranchised. They were not allowed to vote, and neither were they allowed to participate in town meetings. Instead, they found themselves positioned against a new power—the ruling elite, the laws of the courts that favored wealth, and a federal government that had the tools to quickly put down future uprisings should they begin.

## Revere's Ride Away from the Mob

In the mid-eighteenth century, Boston was a mob town in the best sense of the word. Sailors were often the first to lead the tumults. In 1747, sailors rioted against impressment—losing one's freedom when the British would force sailors on the docks against their will to serve in the British Navy. At one point during a Boston riot, sailors lifted a British-owned boat from the harbor, carried it to the Commons, and burned it to the ground. Additionally, four separate grain riots and two market riots had taken place before 1750.[7]

In Boston, the dominant occupation was to be an artisan—an occupation that excluded women. Artisans started out as apprentices, became journeymen, and if fortunate, became mechanics and owned their own shops. In 1790, 1,271 artisans could be found in Boston out of 2,754 adult males.[8] These urban workers, along with the farmers in the surrounding communities, were the backbone of the Revolution, but not the spokespeople of it. Rather, individuals such as Samuel Adams (born into an elite family and educated at Harvard) and John Hancock (one of the wealthiest merchants in New England) were. Ray Raphael writes, "The verbiage was clearly the work of educated Boston Whigs, not their country cousins who were actually driving the Revolution forward."[9] Consequently, these artisans and farmers were excluded from the policymaking. They were not invited to the Continental Congress in 1774 (an illegal body and forerunner of the new independent government), and neither were they invited to Philadelphia to draft the new Constitution.

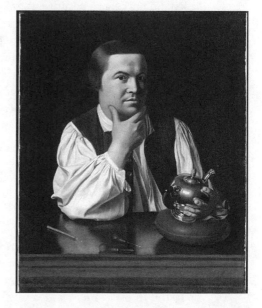

A conundrum existed for Paul Revere. Revere identified himself as an artisan. He was a silversmith and engraver by trade, and admired by Boston's working class. When Revere allowed John Singleton Copley to paint his portrait in 1768, he made certain that he was pictured as an artisan, surrounded by the tools of his trade.

John Singleton Copley, *Paul Revere*, 1768 (Museum of Fine Arts, Boston)

But Revere was also connected to the elite leadership in Boston. He was a mechanic and belonged to the top echelon of the artisan community. Mechanics in colonial America faced competition from English manufacturers, and when Parliament began levying taxes and forcing oppressive regulations on the colonies, many sided against the British.

Revere became active when Parliament passed the Stamp Act in 1765—a tax on stamped paper that transferred the costs of the French and Indian War (the Seven Years' War) onto the colonial population. He also became a member of pro-independence groups—the Loyal Nine, the Sons of Liberty, and the North End Caucus. Both the Loyal Nine and the Sons of Liberty drew from the middle and upper class, with members representing merchants, mechanics, distillers, and ship owners, among others.

Revere was not unlike the colonial elite leaders and merchants who feared that the power of the mob would extend to other facets of colonial and post-colonial life. The merchant Elbridge Gerry had warned Samuel Adams in 1775 that a new government had to be established quickly after British rule, for "the people are fully possessed of their dignity from the frequent delineation of their rights . . . They now feel rather too much of their own importance, and it requires great skill to produce such subordination as is necessary."[10] One place that the mechanisms for subordination existed was in the courts. Boston's elite had urged John Adams and Josiah Quincy to defend the British soldiers responsible for the Boston Massacre, and during the proceedings both Adams and Quincy were highly antagonistic toward the multiracial mob. Adams labeled the crowd a "motley rabble of saucy boys, negroes and molattoes, Irish teagues, and out landish Jack Tarrs" and stated that the appearance of Attucks "would be enough to terrify any person."[11] Certainly the crowd of more than 10,000 colonists (out of a city population of around 15,000) who marched in the funeral procession for Attucks and the four others killed did not feel so negatively toward the mob. Yet the court of public opinion and the court of law were different bodies. Adams and Quincy were able to obtain a favorable decision for their clients. All of the soldiers were acquitted, except Montgomery and Kilroy, who were convicted of manslaughter, yet their punishment consisted of only being branded on the hand.

Ironically, John Adams himself would credit the mob for sparking the revolution. He later described the Boston Massacre as having laid the "foundation of American independence," and when he penned a letter about liberty to Gov. Thomas Hutchinson in 1773, he signed it not with his own name, but with the name "Crispus Attucks."[12] This remarkable double consciousness signified that Adams and others in his class both depended upon and despised the multiracial mob. They needed the rural and urban working-class revolt to spark the revolution and to fill the front lines, yet they feared the power of the mob and did everything they could to contain it and crush it once they obtained positions of leadership and power.

## Sites of Resistance and Class Conflict

Though missing from Revere's famous engraving, examples of working-class resistance can be found in other items of material culture from the Revolutionary era—printed material, engravings, paintings, monuments, and mementos, to name just a few. However, the best example is *a tree*.

The Liberty Tree in Boston, located at the intersection of Essex and Newbury Streets (today Essex and Washington), was an epicenter of anti-British organizing. The Liberty Tree, first known as the Great Elm or the Great Tree, was dedicated on September 11, 1765, and stood as an important site of resistance for a decade until British troops cut it down in 1775.

For ten years the tree served as a location where Bostonians—or at least white men of all classes—could take part in civic life, regardless of whether they owned property.[13] The Liberty Tree was a meeting space for assemblies, orations, street theatre, and mock trials, and often served as the starting point or stopping point for funeral processions for martyrs of the revolution.

The tree itself was also a canvas for creative resistance. Effigies and lantern slides (painted images on thin paper that were pasted over a framework and illuminated with a candle from within) hung from its branches. Events were posted on the trunk of the tree and a liberty pole ran up the center and extended above its tallest branch.

During the first year of the Liberty Tree, working-class artisans directed the bulk of the actions. They were led by the shoemaker Ebenezer Mackintosh, nicknamed the "Captain General of the Liberty Tree," who had upward of three hundred men at his command. His notoriety ranged from leading peaceful parades against the Stamp Act to leading mob actions that completely dismantled Lt. Gov. Thomas Hutchinson's mansion.[14]

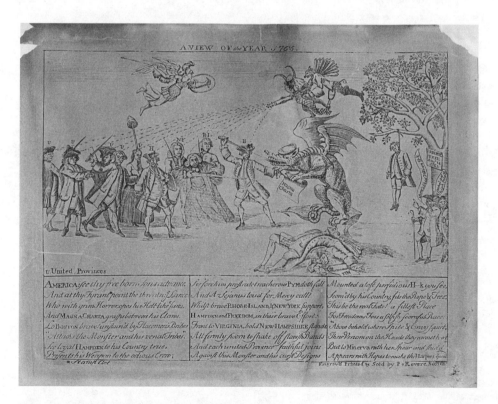

Paul Revere, *A View of the Year 1765*, 1765 (American Antiquarian Society)

Mackintosh caused a dilemma for the elite patriot leadership. The Sons of Liberty leaders could not ignore him, and neither could they reject him outright, due to his popularity. So they embraced him. They followed the strategy of Robert R. Livingston Jr., a wealthy landlord in the Hudson Valley in New York, who in response to a series of urban and rural uprisings warned that the wealthy should learn "the propriety of Swimming with the Stream which it is impossible to stem."[15] That the wealthy "should yield to the torrent if they hoped to direct its course."[16]

The Sons of Liberty followed this path. They embraced Mackintosh, won the respect of the crowd, and then they began to slowly distance themselves from him.[17] Their slogans included "No Mobs—No Confusions—No Tumults" and "No Violence or You Will Hurt the Cause."[18]

This is why it is so perplexing that Paul Revere—a member of the Sons of Liberty—paid homage to the mob actions with his engraving *A View of the Year 1765*, a print that featured a depiction of the Liberty Tree. *A View of the Year 1765* positioned Revere in solidarity with the working class (and the mob), and much like all of his images, it was directly copied from another artist. This time the source material was a British cartoon entitled "View of the Present Crisis" that was published in April of 1763 and critiqued the Excise Bill of 1763. Revere's print had a different political agenda. It was a scathing piece of anti-British propaganda that was aimed at the Stamp Act and depicted colonists raising their swords to slay a dragon that represented the detested law. To make his point clear, Revere added text to the bottom, labeled the dragon and the figures, and erased three figures on the far right, replacing them with a scene from the Liberty Tree.[19]

Revere could have simply depicted the tree, considering that all classes claimed ownership to it, yet he chose to include symbols that celebrated the events of August 14, 1765, when a mob action forced Andrew Oliver, the colony's stamp distributor, to resign from his position.[20] The events of August 14 began when organizers set up next to the Liberty Tree and did a mock stamping of goods as farmers from the countryside passed by en route to the downtown markets. As the afternoon sun began to cast its shadow, thousands gathered in front of the tree. An effigy of Oliver was hung from it. At five o'clock a mock funeral assembled and paraded through town carrying Oliver's effigy. Next, the mob went to Oliver's office and leveled it with a battering ram. Not content, the mob then went to Oliver's house and demanded his resignation. Oliver was nowhere to be found, so the mob dismantled his house, stamping each piece of timber before it was thrown in a bonfire. Not surprisingly, Oliver sent word the next day announcing his resignation.

However, Oliver's nightmare did not end there. The Loyal Nine posted upward of 100 broadsides around Boston in the dead of night that announced that on December 17, Oliver would publicly resign in front of the Liberty Tree.[21]

True to the broadsides' advertisement, Ebenezer Mackintosh and a company of men escorted Oliver to the site, where he was forced to resign in front of a crowd of approximately two thousand people.[22]

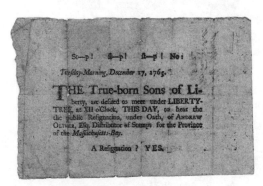

"Stop! Stop! No: Tuesday-Morning, December 17, 1765": Loyal Nine, broadside announcing resignation of the Stamp Act Commissioner Andrew Oliver, December 1765 (Massachusetts Historical Society)

Here, public theatre merged with public humiliation, serving as a warning sign to others that they would meet the same fate if they backed the Stamp Act.[23] These tactics showcased just how radical the movement was in 1765 when its leadership was in the hands of working-class people. More so, it exemplified just how important the Liberty Tree was as a site to gather, organize, and protest. The Liberty Tree allowed those who detested British rule to *occupy space*—a tactic that future movements would embrace, ranging from sit-down strikes in auto plants in the 1930s to campus occupations during the Vietnam War to the occupation of Zuccotti Park during Occupy Wall Street in 2011, among others. This tactic—occupying space—allows movements to recruit more people and forces the opposition to act. In short, it serves to escalate the conflict.

Boston's Liberty Tree was not the only important location for organized resistance and occupying space. Another symbol of colonial revolt included liberty poles. These markers, much like the Liberty Tree, were also key locations for working-class people to congregate and to openly express their dissent toward British rule.

Liberty poles were found throughout the colony. However, the most famous liberty pole was located in New York City in "the fields" and close to the barracks of British soldiers.

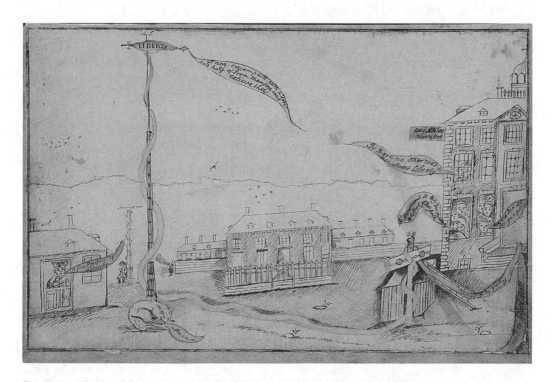

Pierre Eugene du Simitiere, *Raising the Liberty Pole in New York City*, ca. 1770 (Library Company of Philadelphia)

This pole, first erected in 1766, was eighty-six feet tall and further topped by another twenty-two-foot-tall pole.

The pole itself was crowned with the number "45" to link the imprisoned patriot Alexander MacDougall (put in jail for printing an inflammatory broadside) with the imprisoned English reformer John Wilkes, who was sympathetic to the cause of the American revolt. To the British Parliament and Crown, it must have stood as a 108-foot-tall monument against their rule—a provocative middle finger that was designed to escalate tensions. British forces cut down the pole four times before colonists resorted to fortifying it with iron hoops crafted by blacksmiths. In 1770, sailors and laborers fought British soldiers in hand-to-hand combat to defend the pole in a skirmish that led to the Battle of Golden Hill, a shift that historian Alfred F. Young describes as a celebratory space segueing to a "staging place for military action."[24] This materialized in 1776 during the Revolutionary War, when the pole was cut down by the British Army as they occupied the city.

Just like liberty poles and the Liberty Tree, King Street itself also became an important site for organizing and creative resistance. Following the Boston Massacre, the colonial government in Boston voted in 1770 that speeches would be held there annually on March 5, followed by various exhibitions on the street. During these celebrations, lantern slides adorned balconies overlooking the massacre site, while other lantern slides were carried in parades or hung at the Liberty Tree.[25] Historian Philip Davidson writes that "the exhibition depicted the murder, the troops, and the slaughtered victims [and included the slogan] 'The fatal effect of a standing Army, posted in a free City.'"[26]

The March 5 remembrances would not last long. Annual commemorations ended in 1783 when March 5 (the Boston Massacre) was rolled into the July 4th holiday. Erased was a celebratory day to working-class revolt and revolution, and in its place was a holiday that celebrated independence and patriotism. In short, the March 5 remembrance day met the same fate as the Liberty Tree and the poles: it was cut down.

## A Need for More Liberty Poles

Peter Linebaugh and Marcus Rediker describe the Revolutionary War era in three stages: "militant origins, radical momentum, and conservative political conclusion."[27] However, the success of the conservative elites did not defuse class tensions during the War of Independence (1775–1783) or after. If anything, the tensions heightened.

During the war, the wealthy could opt out of the draft by paying for someone to serve in their place, leaving the bulk of the fighting to the poor. To add insult to injury, many soldiers were not given the pay that was promised to them, and pensions for military service were not forthcoming for decades.

All the while, the working class were being shut out of the conversations that established the legal framework for a new nation. The 1787 Philadelphia Convention that drafted the Constitution was a closed meeting dominated by wealthy conservatives. William Manning, a New England farmer, soldier, and author, compared the Constitution to a fiddle: a document that was "made like a Fiddle, with but few Strings, but so the ruling Majority

could play any tune upon it they please."[28] He added that it was "a good one prinsapaly [*sic*], but I have no doubt but that the Convention who made it intended to destroy our free governments by it, or they neaver [*sic*] would have spent 4 Months in making such an inexpliset [*sic*] thing."[29] To Manning, "free governments" meant local control. He and other farmers worried about power concentrated in the hands of few, and power situated in distant urban locations.

Manning had good reason to worry. A powerful new federal government could, among other things, quell dissent and suppress working-class movements. It could also draft repressive legislation, as exemplified when Samuel Adams helped draft the Massachusetts Riot Act of 1786, designed to disperse and to control uprisings. The weight of this act came down on Daniel Shays, a former captain in the Continental Army who had fought at Bunker Hill and who in 1786 led a rural uprising of indebted farmers in rural western Massachusetts. Several hundred farmers armed themselves and marched on the courts in Springfield and Worcester (much as farmers had done in 1774) but were driven back by an army that was paid for by wealthy Boston merchants. Outnumbered, the men took flight, and took refuge in Vermont. Many of Shays's cohort surrendered and were put on trial; some were sentenced to death. Shays himself was pardoned in 1788.

Shays's discontent was shared by others. From 1798 to 1800, liberty poles were raised across the land in opposition to the Alien and Sedition Acts of 1798—a draconian law passed under President John Adams that allowed for the imprisonment of anyone who criticized the government. When the poles went up this time, the federal government cut them down and used the new law to go after those who had initiated the actions.

In Dedham, Massachusetts, David Brown rallied his community in 1798 to install a Liberty Pole that included text that read "No Stamp Act / No Sedition Act / No Alien Bills / No Land Tax / Downfall to the Tyrants of America / Peace and Retirement to the President / Long Live the Vice President."[30] For his actions, Brown was charged with sedition, fined $480, and jailed for eighteen months.

Examples of resistance were not limited to Massachusetts: poor people challenged federal authority all across the new nation in the late eighteenth century, from the Regulators in North Carolina to the Green Mountain Rebels in Vermont, and many more. Yet what was lacking was class solidarity between the rural poor and the urban poor. Artisans did not support Shays' Rebellion, nor did they support the tenant uprisings in rural New York in 1766.[31] Working-class men did not embrace Mary Wollstonecraft's "Vindication for the Rights of Women" (1792), and neither did they support the slave insurrection led by Gabriel Prosser in Virginia in 1800.[32] Meanwhile, free African Americans in Boston offered to "assist" Shays' Rebellion, but they did so not by joining the side of debt-ridden farmers but by offering their assistance to the militias in putting it down.[33] These tensions left working-class people divided and it left them weak. To paraphrase Alfred F. Young, it left the multiple radicalisms of the revolutionary era separate from one another.[34] And it left a revolution only partially completed.

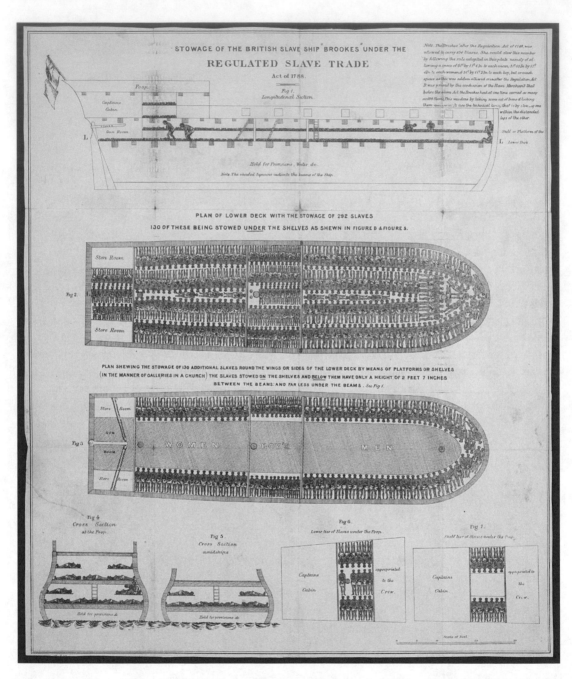

Unidentified artist/s, *Stowage of the British Slave Ship "Brookes" Under the Regulated Slave Trade Act of 1788*, etching, ca. 1788, (LC-USZ62-44000, Library of Congress)

# 3

## Liberation Graphics

IN THE LATE 1700S, abolitionists in the United States and the UK harnessed the power of the print illustration. Lithographs and illustrations became the predominant medium owing to the ease of reproduction and because they could be readily disseminated to a wide audience. Illustrations were also found in the multitude of antislavery newspapers and pamphlets, which in turn were spread across the U.S. North and the South. All of these images largely focused on three distinct tactical campaigns: creating empathy for those held in slavery; celebrating heroic African individuals; and vilifying the Southern character and way of life that endorsed the institution of slavery.[1]

The initial goal for the visual artists was to attempt to persuade a reluctant public to rally against an institution and ideology that had permeated and indoctrinated much of the American public for more than two centuries. This was no easy task, so abolitionists in the United States turned to another campaign for inspiration. The British abolitionist movement, which had begun in earnest as a small gathering of a dozen citizens in the 1780s, galvanized much of their country in only a few decades to rally against the slave trade in general and specifically England's role as the leading Atlantic slave-trade merchant from the 1730s to the early 1800s. The movement had perfected the use of visual graphics in its campaign, and many of the same tactics and images would serve the American cause.

However, the strategy for combating slavery differed in the United States. Slavery in England was more abstract, as relatively few African slaves were physically present on English soil. In the United States, slavery was part of the very fabric of life. U.S. abolitionists could expect opposition to their efforts in the South, but they also met a great deal of hostility in the North. Much of the industry of the North was explicitly tied to the Southern slave system; Northern textile mills and shipping merchants reaped tremendous profits from slave-grown cotton, which by the 1830s had become the nation's most valuable export crop.

"King Cotton," as it had come to be known, helped fuel the expansion of slavery within the United States as slaveholders moved westward in search of new fields for this highly profitable

crop.[2] Eli Whitney's invention of the cotton gin in 1793 no longer limited the crop's range to coastal regions. Southern planters relied heavily on investments from Northern businesses to help finance their expansion of cotton production. As cotton-derived industries in the North increased, so did the entire industrial sector, especially in New England. The same pattern was duplicated in England, where the textile factories were reliant on imported cotton.

The abolitionist movement attacked not only Southern slaveholders, but also the economic interests of the ownership class throughout the United States and abroad. Abolitionists were well aware of the inherent class issues at stake. Leading abolitionist voices, including Wendell Phillips, Henry Highland Garnet, William Lloyd Garrison, Lydia Maria Child, and Frederick Douglass, thus attacked not only the slave owner, but also the propertied class that profited from slavery's existence.

Abolitionists placed their lives on the line by confronting slavery. The Georgia House of Representatives placed a $5,000 reward for the capture of William Lloyd Garrison, the white abolitionist and founding editor of *The Liberator*. In his hometown of Boston, Garrison was beaten and dragged through the streets by a mob in 1835.[3] Between 1833 and 1838, the abolitionist press reported more than 160 instances of violence against antislavery groups, which included the murder of Rev. Elijah P. Lovejoy, a white newspaper editor from Alton, Illinois, who was shot defending his presses against a mob in 1837.[4] This was the climate that abolitionists operated in when they tried to reach the public with an antislavery message.

## Description of a Slave Ship

Though their enemies were everywhere, American abolitionists also had their allies, especially in the British movement. Galvanized by a fiery young clergyman named Thomas Clarkson, a small group of abolitionists in London formed the Society for Effecting the Abolition of the Slave Trade (SEAST) in 1787 and set out to dismantle the institution that was tied to the political, cultural, and financial structure of the British Empire.

Clarkson's primary role was to gather evidence about the slave trade to make a strong case to the public and to Parliament on why the practice should be abolished. He traveled to seaport towns across England and visited government buildings and merchant halls to obtain records on slave ships. There, he sought the details of expeditions, mortality rates, ship rolls, and names of those employed. He also sought out captains and merchants of the slave vessels, but they refused to talk to him once they realized his motives.

Undeterred, Clarkson sought out the common seamen who worked on the ships, and there he found allies. Seamen told Clarkson everything he wanted to know about the transport of slaves. They recounted the horrific conditions that they had witnessed, the reality that slaves faced—cramped conditions, beatings, deaths—as well as their own hardships under the brutal duress of the ships' captains. It was damming evidence, and merchants tried in vain to counteract it and convince the public that slave ships were safe, hospitable, and in the best economic interests of the nation and her colonies. Clarkson pressed on and convinced a number of seamen to testify before Parliament, yet he also employed *visuals* to

respond to the pro-slavery argument. His evidence took the form of a blueprint: an architectural rendering of the slave ship *Brookes*.

The image—commonly referred to as *Description of a Slave Ship*—visualized 294 Africans chained next to one another to illustrate the claustrophobic spaces beneath the decks. This was a view the English public could not see when slave ships were docked in its harbors. Ironically, the graphic underestimated the true horror of the *Brookes*, which carried upward of 740 slaves at its peak, not 294, and had a mortality rate of 11.7 percent.[5] Nonetheless, the image was not simply about the *Brookes*: it was about the slave trade generally and Britain's primary involvement in it. *Description of a Slave Ship* was meant to incite shock, create sympathy for those held captive, and spur people to become involved in the antislavery movement.

The image came from an unlikely source: The British government had sent Captain Parrey of the Royal Navy to Liverpool to record the dimensions of various slave ships, one of which included the *Brookes*—named after its owner, the merchant Joseph Brookes Jr.[6] The Plymouth and London committees of SEAST obtained Parrey's research and, realizing its potential, used it to create graphic abo-

William Elford, Society for the Abolition of the Slave Trade, Plymouth Committee, *Plan of an African Ship's Lower Deck with Negroes in the Proportion of only One to a Ton*, January 1789 (Bristol Record Office)

litionist propaganda. SEAST member William Elford made the first image in November 1788. His design was simple and depicted the *Brookes*'s lower deck, with two columns of text below the image describing the ship and urging the public to take action.

The image itself was powerful, but its dissemination and its adaptability are what made it so effective. Some 1,500 copies of the image were printed and disseminated in Plymouth in early 1789. Copies were also sent to the London Committee, which began printing their own version of the *Brookes* design.[7] The image also crossed the Atlantic. In May 1789, Mathew Carey published 2,500 copies of the *Brookes* image on a broadside in Philadelphia. Commenting on the graphic's success, Carey wrote, "We do not recollect to have met with a more striking illustration of the barbarity of the slave trade."[8]

The most famous adaptation of the image came from the London committee of SEAST, where Thomas Clarkson likely oversaw the design changes. This version magnified the effects of the image; instead of showing one view of the *Brookes*, it showed seven. Underneath the illustrations, four columns of finely printed text described the physical dimensions of the ship, the number of slaves stowed, and a personal account by Dr. Alexander Falconbridge—a sharp critique of the abysmal conditions that seamen faced on board the slave vessels.[9]

The brilliance of the image was multifaceted. The stark graphic alone communicated an antislavery message that could incite anger and compassion. The text was powerful but also

small enough as not to distract from the graphics. It served as written evidence to back up the imagery for those who took the time to read it.

Combined, the image and text served as *evidence*, mirroring Clarkson's efforts when SEAST sent him out to seaport towns on fact-finding missions. More important, Clarkson, Elford, and others who contributed to the design process made the important decision to create an image that did not point the finger at working-class people.[10] The image called for justice both for the enslaved Africans whose labor was stolen *and* the British seamen whose labor was exploited. By simply depicting the architectural design of the ship and the means by which slaves were stored, the image pointed the finger most prominently at the slave system's architect—the slave merchant—as the main culprit. Marcus Rediker, author of *The Slave Ship: A Human History*, explains:

> Here was the hidden agent behind the *Brookes*, the creator of the instrument of torture. He was the one who imagined and built the ship, he was the ultimate architect of the social order, he was the organizer of the commerce and the one who profited by the barbarism.[11]

In one fell swoop, the image addressed both race and class.

SEAST widely disseminated the image and provided copies of the London edition of the broadside to every MP prior to his vote on the slave trade on May 11, 1789.[12] They also included a copy of Clarkson's text, *The Substance of the Evidence of Sundry Persons on the Slave-Trade Collected in the Course of a Tour Made in the Autumn of the Year 1788*—a collection of twenty-two interviews of seamen who had taken part in or witnessed the slave trade. SEAST worked closely with MPs and developed important allies, most notably William Wilberforce, who was the most vocal antislavery advocate within the halls of government.

Blue glass sugar bowl, ca. 1830, Bristol, England (British Museum)

Not surprisingly, Wilberforce understood the power of images and abolitionist propaganda, and he had a wooden model made of the *Brookes* (complete with painted images of slaves on the decks) so that he could present it to his colleagues in the House of Commons as a means to strengthen his argument.

In addition, 8,000 copies were printed and distributed around England and beyond from 1788 to 1789.[13] Abolitionists in Paris, Glasgow, Edinburgh, New York, Philadelphia, Providence, Newport, and Charleston would distribute copies or print their own versions of the design. Rediker writes, "The *Brookes* became a central image of the age, hanging in public places during petition drives and in homes and taverns around the Atlantic."[14]

All of this graphic agitation produced results. Within five years after forming SEAST, abolitionists in the UK had pressured the House of Commons to pass its first law against the slave trade in 1792. Adam Hochschild writes:

The issue of slavery had moved to center stage in British political life. There was an abolition committee in every major city or town in touch with a central committee in London. More than 300,000 Britons were refusing to eat slave-grown sugar. Parliament was flooded with far more signatures on abolition petitions than it had ever received on any other subject.[15]

Other victories would follow. The Slave Trade Act of 1807 led to the banning of African slaves in the British colonies, and their transport to the United States in 1808, although slaves continued to be illegally transported for years to follow. In the British West Indies, slavery was abolished in 1827 (formalized in the Slavery Abolition Act of 1833) and in the French colonies fifteen years later. All of these victories in the UK would inspire their American counterparts. At a historic meeting of antislavery crusaders, Frederick Douglass and William Lloyd Garrison met with Clarkson in England as he approached the twilight of his life. Clarkson had spent sixty years of his life organizing against slavery and told his visitors, "And if I had sixty more they should all be given to the same cause."[16] Within British and American abolitionism, ideas, tactics, and *images* crossed the Atlantic in a shared coalition against slavery.

## The American Campaign

Whereas the iconic images of the British abolitionist campaign focused largely on creating a sense of empathy for African slaves, the U.S. campaign expanded upon that concept and added other visual tactics of moral persuasion. In the 1830s, U.S. abolitionist prints began documenting events that celebrated heroic African individuals. The *Amistad* slave ship mutiny in 1839 provided artists with a dramatic story and focal point to capture the imagination of the public.

The *Amistad* mutiny had occurred off the coast of Cuba, when fifty-three African men and women who had been illegally sold into slavery rose up against their captors aboard the Spanish ship *La Amistad*, killing both the captain and the cook and taking the rest of the crew hostage. The cook had taunted the slaves, telling them they were to be killed and later eaten by the Spanish. Believing the threat, the slaves—led by Sengbe Pieh, who was often referred to by his Spanish-given name Joseph Cinquez or Cinqué—violently overthrew their captors. The liberated slaves demanded that the ship be sailed to Africa, but the Spanish crew wound up deceiving them by altering the ship's course to the north during the evenings. Eventually, after two months at sea and facing near starvation, a patrolling American naval crew off the coast of Long Island captured the ship. The slaves were taken into custody in New Haven, Connecticut, and charged with murder and piracy.

Many observers believed the remaining slaves who survived the mutiny would face certain death. However, a U.S. Supreme Court trial followed, in which former president John Quincy Adams, acting as part of the legal team that defended the African slaves, won a landmark decision resulting in the slaves' freedom and return home to Sierra Leone.[17] Sengbe Pieh, the charismatic and powerful leader of the mutiny, became a central figure throughout the trial and was celebrated widely by the abolitionist cause.

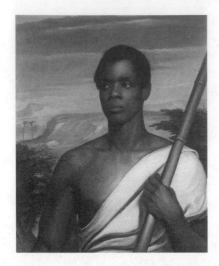

Nathaniel Jocelyn, *Cinque*, 1839 (New Haven Colony Historical Society, New Haven, CT)

Several portraits of Pieh were created during the trial, the most notable being one commissioned by Robert Purvis, a black abolitionist from Philadelphia. Purvis hired a local artist, Nathaniel Jocelyn, to create the painting. Instead of portraying Pieh in his cell as a prisoner, as a previous portrait by James Sheffield had done, Jocelyn depicted Pieh as a free and noble individual standing before an African landscape. Jocelyn's portrait, entitled *Cinque*, was meant to portray an African individual in a dignified manner in order to garner public support for the imprisoned slaves. In addition, John Sartain helped increase the image's circulation by producing five hundred impressions of a mezzotint copy of the painting that were sold and helped raise funds for the defense committee during the trial.[18]

Jocelyn was also purported to be involved in a plot to help break the *Amistad* slaves out of jail if the court ruled against them. Fortunately, this was not needed. The U.S. Supreme Court ruled in favor of Adams's argument that the Africans had been kidnapped and had acted in self-defense and could not be classified as slaves. In 1841, thirty-five survivors of the original fifty-three boarded a ship back to Africa and to freedom.

Jocelyn's painting would continue to champion the abolitionist cause even after the court victory. Robert Purvis submitted the painting to the Artists Fund Society in Philadelphia. To his dismay, it was rejected, a decision that drew the wrath of the abolitionist press. The *Pennsylvania Freeman* reported:

> Why is the portrait denied a place in that gallery? . . . The negro-haters of the north, and the negro-stealers of the south will not tolerate a portrait of a negro in a picture gallery. And such a negro! His dauntless look, as it appears on canvas, would make the souls of slaveholders quake. His portrait would be a standing anti-slavery lecture to slaveholders and their apologists.[19]

The rejection of the portrait, despite the widespread interest in and newspaper coverage of the *Amistad* court trial, led some abolitionists to question their tactics. The portrait of Pieh holding a bamboo cane had been left open to interpretation: was the cane a weapon, or was it a reference to his enslavement in the Caribbean? Abolitionists debated whether abolitionist art should portray the empowerment of African individuals, especially when it came to depicting violence and slave uprisings.[20] This echoed debates within the broader movement itself, where white activist leaders differed over whether slaves could or should participate in their own liberation.

In the print realm, another visual tactic of moral persuasion employed by abolitionists in the United States was to attack the character of the antebellum South. Bernard F. Reilly Jr. notes that "abolitionists carefully developed and cultivated an image of the South as a world in decline, a place of deteriorating physical and moral conditions, exhausted soil, and

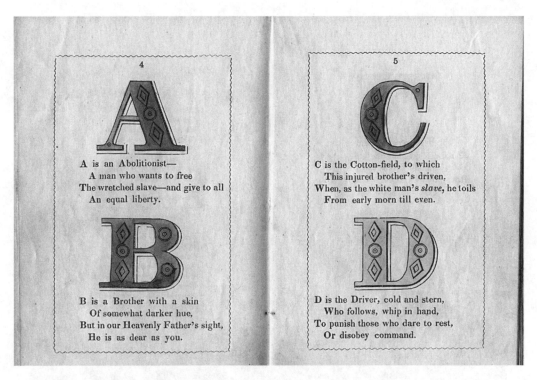

Hannah Townsend and Mary Townsend, *The Anti-Slavery Alphabet* (Philadelphia: Printed for the Anti-Slavery Fair, 1846; American Antiquarian Society)

a dispirited working class."[21] In the mid to late 1830s, a multitude of antislavery books and newspapers appeared in the North that were designed both to inform and to awaken Northerners from their complacency toward slavery. These publications utilized print illustrations and woodcuts to complement the text and to help expose the cruelty inflicted upon slaves.

Prominent abolitionist publications included *The Anti-Slavery Record*, *Human Rights*, *Emancipator*, *The Liberator*, and *The Anti-Slavery Almanac*, along with publications directed toward a children's audience such as the *Anti-Slavery Alphabet* (1846) and the magazine *The Slave's Friend*.

Theodore Weld's *American Slavery As It Is: Testimony of a Thousand Witnesses*, published by the American Anti-Slavery Society in 1839, was a scorching indictment of the institution of slavery. The document was an anthology of testimonies from slaveholders and former slaveholders in the form of written statements, judicial testimonies, speeches by politicians, and clippings selected from Southern newspaper articles.

In 1835, abolitionist groups launched the "great postal campaign," mailing antislavery papers and pamphlets to every town in the country. In an action that severely threatened civil liberties, President Andrew Jackson responded by urging Congress to ban all abolitionist literature from the U.S. mail. Jackson also insisted that the names of sympathetic Southerners who had received abolitionist mail be made public, thereby compromising their physical

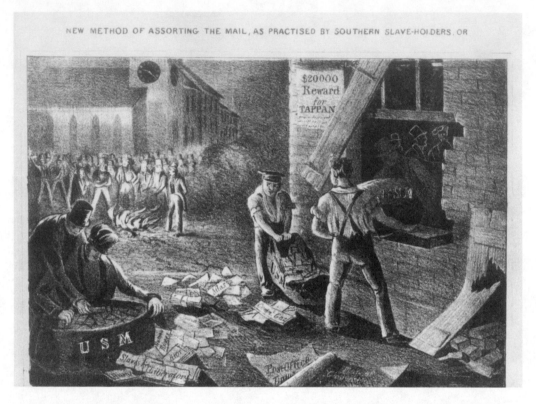

NEW METHOD OF ASSORTING THE MAIL, AS PRACTISED BY SOUTHERN SLAVE-HOLDERS, OR

$20000 Reward for TAPPAN

Unidentified artist, *New Method of Assorting the Mail, As Practised by Southern Slave-holders*, 1835 (LC-USZ62-92283, Library of Congress)

safety. In an expression of the hatred that he felt toward abolitionists, Jackson purportedly stated that they should "atone with their lives." Indeed, this was the climate in which abolitionists operated, making their gains against slavery all the more remarkable. In South Carolina, a $1,500 reward was offered for the arrest of anyone distributing William Lloyd Garrison's paper *The Liberator*, and Georgia had passed a law allowing the death penalty to be enacted against a person who encouraged slave insurrections through printed material.[22]

In response to the abolitionists' postal campaign, many Southern postmasters seized antislavery mail, and in Charleston, South Carolina, a mob raided a post office in the middle of the night and set fire to the bags of mail from the abolitionists. A print mocking the midnight raid, entitled *New Method of Assorting the Mail, As Practised by Southern Slave-holders*, blasted the participants in this action.

The image acts as a quasi-eyewitness account and depicts the crowd burning various abolitionist papers. On the side of the post office building, a Wanted poster hangs for the American Anti-Slavery Society founder Arthur Tappan. The lithograph was circulated with another print vilifying the slaveholder, entitled *Southern Ideas of Liberty*.

In this image, a Southern judge, depicted with horns and his foot resting upon the Constitution, sentences a white abolitionist man to the gallows before a restless mob. Both

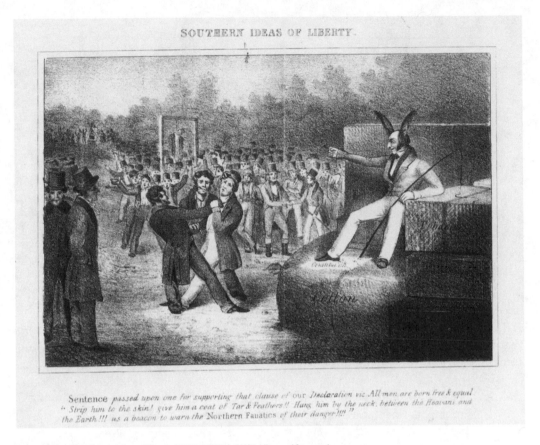

SOUTHERN IDEAS OF LIBERTY.

Sentence *passed upon one for supporting that clause of our Declaration viz. All men are born free & equal " Strip him to the skin! give him a coat of Tar & Feathers!! Hang him by the neck between the Heavens and the Earth !!! as a beacon to warn the Northern Fanatics of their danger!!!"*

Unidentified artist, *Southern Ideas of Liberty,* 1835 (LC–USZ62–92284, Library of Congress)

prints are unsigned, but may be the work of J.H. Bufford of Boston, whose lithographic style closely resembles the prints.[23]

The fact that the two prints remained anonymous suggests that the artist felt safer not revealing his or her identity. Indeed, the experience of Charles Sumner exemplifies the physical risks faced by opponents of slavery. Sumner, a Massachusetts senator who was arguably the Senate's leading opponent against slavery, drew the wrath of Southern politicians. Prior to being elected to Congress, Sumner was an attorney whose efforts included working with African Americans in an attempt to desegregate the Boston public schools. As a senator, he spoke out against the spread of slavery into the Kansas Territory, and in a caustic speech blasted South Carolina senator Andrew P. Butler for his support of slavery's expansion. On May 22, 1856, Senator Butler's cousin, Preston Brooks, U.S. representative from South Carolina, retaliated. As Sumner sat at his desk on the floor of the U.S. Senate, Brooks attacked Sumner and beat him unconscious with a walking cane. Sumner's severe injuries would keep him out of the Senate for the next three years.

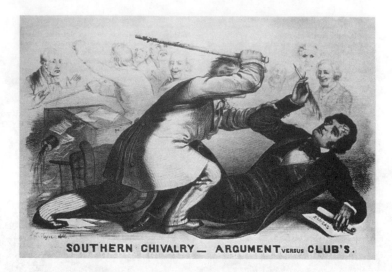

SOUTHERN CHIVALRY _ ARGUMENT versus CLUB'S.

John L. Magee, *Southern Chivalry—Argument versus Clubs*, 1856 (Boston Athenaeum)

The attack on Sumner helped to widen the divide between the North and the South that would lead to secession and war. Historians James Oliver Horton and Lois E. Horton recount the contrasting views of the attack:

> Five thousand gathered in the New York City Tabernacle to express their outrage at what most considered an act of southern violence. This perception seemed to be confirmed when southern supporters celebrated Brooks's attack. The *Richmond Whig* called it an "elegant and effectual canning," and southern groups, including students at the University of Virginia, presented Brooks with a number of ornately carved canes.[24]

Prints depicting the caning of Charles Sumner quickly emerged.[25] One notable image was John L. Magee's 1856 lithograph *Southern Chivalry—Argument versus Club's* [*sic*].

The caricature portrays Brooks savagely beating the defenseless Sumner as he lays bloodied on the floor holding a pen and a document against slavery's expansion in Kansas. In the background, Congressman Lawrence Keitt of South Carolina brandishes a cane to hold back other members of Congress who might come to Sumner's aid, yet most smile in amusement. Magee—a Philadelphia-based engraver and lithographer—projects an antislavery message. His goals were akin to those of others who had visualized an abolitionist stance: persuade the public to rally against the institution of slavery. This gentle form of persuasion—as visually striking as it was—would fall short in the United States, most notably in the South. The issue of slavery would be decided through war.

# 4

## Abolitionism as Autonomy, Activism, and Entertainment

GRAPHIC AGITATION WAS NOT the only visual method used by abolitionists to deliver an antislavery message. One of the more obscure media was the moving panorama, a precursor to the motion picture that employed paintings on canvas rather than negatives. Each image of the "moving picture" was painted, then the sequence was spliced together, installed on large spools, and mounted behind a cut-out stage that hid the mechanics of the operation. The audience would watch a series of continuous images—sometimes ten feet in height and five hundred to eight hundred feet in length—scroll past, accompanied by music and narration.

Illustration of Banvard's Moving Panorama Machinery (*Scientific American*, volume 4, issue 13, December 16, 1848; University of Wisconsin–Milwaukee Libraries)

One of the most unique performers to harness this medium was Henry "Box" Brown. Brown himself had quite a story to tell. He was born into slavery and escaped by an ingenious method. On March 29, 1849, he *mailed* himself to freedom. Devastated by his forced separation from his wife and children, who had been sold to a plantation in North Carolina in 1848, Brown fled slavery by enclosing himself within a small wooden box, three feet long by two feet wide, and shipping himself by rail from Richmond, Virginia, to Philadelphia. He arrived twenty-seven hours later at the doorstep of an abolitionist sympathizer.

Brown's arrival and "resurrection" from the box made him a celebrated figure among abolitionists, who championed his escape as further proof of the extreme measures that slaves would take for their freedom. His fame was even further heightened when his book, *The Narrative of Henry Box Brown, Who Escaped Slavery Enclosed in a Box 3 Feet Long and 2 Wide. Written from a Statement of Facts Made by Himself. With Remarks Upon the Remedy for Slavery*, was released in 1849. However, Charles B. Stearns, the ghostwriter who penned the illiterate Brown's story, took liberties with the text and employed it as a vehicle to emphasize his own convictions on how to end slavery. Stearns's patronizing text mirrored the often unequal power dynamics that fugitive slaves faced when they collaborated with white abolitionists who felt entitled to direct the movement.

Brown faced a further predicament: his appearances at abolitionist events served the movement's greater agenda, yet he was dependent on others for the invitations to these events and beholden to the formats they followed. Brown likely realized that he could not financially survive off the small donations given to him by abolitionists, so he created other income sources. He sold copies of his book and had a lithograph, *The Resurrection of Henry Box Brown at Philadelphia* (which is assumed to be the work of Samuel W. Rowse), produced.

The print depicted Brown's celebrated arrival in Philadelphia and, much like Stearns's version of Brown's story, blurred fact with fiction. The image showed Brown when he first arose from the box, yet failed to correctly identify the people who were in the room at the time. Instead, three stand-ins are added to the scene, the most notable being Frederick Douglass, who replaces abolitionist William Still.[1] The addition of Douglass was an odd choice, for he was outspoken in his belief that aboli-

Unidentified artist, assumed to be Samuel W. Rowse. *The Resurrection of Henry Box Brown at Philadelphia*, 1850 (LC–USZC4–4659, Library of Congress)

tionists and fugitive slaves should never reveal to the public their means of escape. In his own narrative, Douglass had concealed his escape method, and in 1855 he wrote, "Had not Henry Box Brown and his friends attracted slaveholding attention to the manner of his escape, we might have had a thousand *Box Browns* per annum."[2]

Other abolitionists disagreed and felt that publicizing Brown's remarkable escape would stir public resentment against slavery more than keeping the story quiet would. More so, Brown felt it imperative to broadcast his method of escape because it was his main source of income. Regardless of the debates within the abolitionist community, Brown was determined to forge his own path on his own terms.

The lithograph print was in fact part of Brown's larger plan to raise funds to create a mammoth antislavery panorama that would both help the abolitionist cause and earn him a living. In 1849, he partnered with James C.A. Smith, a free African American who had aided him with his escape from Richmond, to go into business touring an antislavery production. The two men hired Boston-based painter Josiah Wolcott to lead a team of artists to create the panorama to their specifications, and on April 11, 1850, the six hundred-foot-long panorama *Mirror of Slavery* opened at Washington Hall in Boston.

Based in part on an obscure fictional poem, "The Nubian Slave," the panorama contained forty-nine scenes that took the viewer on a journey from African life before capture to the Atlantic slave trade and daily life enslaved in the South to escape and a hopeful vision of universal emancipation. Brown included two scenes from his own life that illustrated his escape from slavery. He also included a scene of Henry Bibb's escape, as well as a scene celebrating the abolition of slavery within the British Empire. The paintings themselves were eight to ten feet tall. Brown would narrate the panorama, and both he and Smith would sing songs. The evening often ended with Brown answering questions from the audience.

Reviews from the show's first run were positive and hailed the panorama as an effective piece of antislavery propaganda. The *Boston Daily Evening Traveler* wrote, "We wish all the slaveholders would go and view their system on canvas," and the *Worchester Massachusetts Spy* added, "No one can see it without getting new views and more vivid conceptions of the practical working of the system than he had before."[3] The latter review also commended Brown for his ability to "carry out so ingenious a mode of providing for the public amusement at the same time that it brings home to the people a representation so faithful, of the great evil, to which most of them are, directly or indirectly, accessory."[4]

The *Spy* review adequately understood the show as both activism *and* entertainment. Brown and Smith were gifted performers, and they tailored the show to specific audiences, improvising and improving their craft as they toured *Mirror of Slavery* throughout New England by train and wagon.

Brown and Smith's *Mirror of Slavery* tour had been going less than six months when it came to an abrupt halt after the Senate passed the Fugitive Slave Bill of 1850. This law was designed to ease slaveholders' ability to recapture slaves in the North. It replaced the Fugitive Slave Act of 1793, which gave state officials the option (taken by few) to enforce the law. The new bill provided no such option. It forfeited the rights of African Americans to a jury trial and allowed a slave catcher to claim ownership simply by means of an affidavit, whereas

the person accused had to produce paperwork documenting his/her freedom. It also called for Northerners to play an active role in the capture of fugitive slaves, turning ordinary citizens into slave catchers. Abolitionists immediately denounced the law, vowing instead to protect fugitives from slave hunters who were prowling the North.

The effects of the law were felt immediately. Less than a week after the bill's passage, Brown barely escaped being kidnapped by slave catchers in Providence, Rhode Island. Realizing that it was no longer safe to be a fugitive in the United States, Brown and Smith fled to England and arrived in Liverpool on November 1, 1850. Among the few possessions they brought with them was the panorama, and by November 12, less than two weeks after their arrival, the two were performing before their first British audience and making plans to tour the panorama throughout the British Isles with the help of abolitionist contacts.

Favorable press helped their cause. The *Liverpool Mercury* wrote, "We would urge our readers to visit this panorama; and if any of them have thought lightly of the injustice done by America to three millions and a half of our fellow-creatures, we feel assured they will leave the exhibition in another frame of mind."[5]

Organizing a tour and competing against other traveling shows was not an easy task. Brown and Smith's income depended upon ticket sales, and they had to constantly update their show, adapt it to changing tastes, and hope that positive reviews continued.[6] Both men quickly realized that audiences were drawn to the songs, so they changed their promotional advertisements to read "Mr. Henry Box Brown, The Fugitive Slave, and Mr. James Boxer Smith, Who Sing Plantation Melodies, Serenades, Duets, and Anti-Slavery Songs"[7] Thus their production was aimed at their market, and they made full use of both the power of their story and antislavery sentiments in the UK. In essence, they were selling Brown's escape and abolitionism, retold numerous times and packaged as entertainment.

Brown could also play the sympathy card. A reviewer in the *Liverpool Mercury* noted that proceeds from the show would help Brown purchase his wife and three children, who were still held in slavery, for the fee of $500 each.[8] This cast the performance and its intentions in a different light. Jeffrey Ruggles explains:

> By describing the exhibition as a means to rescue Brown's children, the Liverpool letter cast *Mirror of Slavery* as a charitable rather than as a commercial enterprise. With local antislavery activists thus assured that their assistance served a higher purpose, Brown would more readily gain their help.[9]

The problem was that the report in the *Liverpool Mercury* was disingenuous, for there is little evidence that Brown had ever sought to purchase his family. If anything, he seemed intent on forgetting his past family life, especially once he'd arrived in England. His obsessive rehashing of his personal narrative began at the moment of his escape and continued throughout his life. Perhaps revisiting the memory of his family being sold away was too painful, or maybe he simply did not want to give credence to the slave system by offering payment.

Brown eventually married an Englishwoman, had a daughter, and did not return to the United States until 1875, a decade after slavery had ended. No evidence exists that he ever

attempted to reconnect with his prior family. Did the reporter simply make up the story of Brown's intentions to purchase his family out of slavery? Did Brown mention it in passing to gain traction for his tour? Any answer would be speculative.[10]

---

What remains clear is that Brown's relationship with Smith and his good standing within the abolitionist community began to unravel during his first year in England. Brown haggled with Smith over money, broke the partnership, and took sole ownership of the production, leaving Smith flustered, hurt, and with little income to show for his work. Meanwhile, abolitionists complained bitterly about his excessive showboating.

Brown perhaps fulfilled his critics' accusations by reenacting his famous escape. On May 22, 1851, Brown had himself placed inside the original box he used to escape. Next, Brown was loaded onto a three-hour train from Bradford to Leeds. At Leeds, the box was then placed onto a wagon and paraded through the streets, accompanied by a marching band. Finally, Brown emerged from the box onstage before an audience that had gathered to watch the *Mirror of Slavery* panorama. In doing so, Brown held nothing back in celebrating his freedom as both an escaped slave *and* an artist.

These theatrics were only the start of Brown's transformation as a showman and, nearly two years after his initial escape, the abolitionist community seemed ready to completely distance themselves from him. Some of the harshest criticism came from William Wells Brown. The African American abolitionist and author (who also was in England at the time) wrote to the Boston abolitionist Wendell Phillips in 1852:

> Brown is a very foolish fellow, to say the least. I saw him some time since, and he had a gold ring on nearly every finger on each hand, and more gold and brass round his neck than would take to hang the biggest Alderman in London. And as to ruffles about the shirts, he had enough to supply any old maid with cap stuff, for half a century. He had on a green dress coat and white hat, and his whole appearance was that of a well dressed monkey. . . . Poor fellow, he is indeed to be pitied.[11]

Criticism aside, "Box" Brown elected to move even further into the realm of popular entertainment, a direction he may have taken with or without abolitionist support. He took on the role of magician and mesmerizer, experimenting with human magnetism and electrobiology. Brown even produced a moving panorama in late 1858, early 1859, that addressed India's mutiny against the British occupation, but did so from the position of supporting Britain's right to colonial rule. By doing so, Brown confused his political message and contradicted the call for freedom in his first panorama. He revealed himself as an opportunist and chameleon who would adapt his message to the whims of the current political climate.

Brown made it easy for people to dismiss his work. At the same time, Brown was in survival mode, as he had been his entire life. He was viewed as abandoning the abolitionist movement, but one wonders whether the movement would have eventually abandoned him,

even if he had stuck to a more conventional script. This is impossible to gauge, but Box Brown's desire to create opportunities on his own terms was not unlike what motivated Frederick Douglass to break from William Lloyd Garrison. Nor was it a far cry from Martin Delany's call that "every people should be the originators of their own designs, the projector of their own schemes, and creators of the events that lead to their destiny."[12] Indeed, Brown was like the multitude of artists who seek their own path—but are instead *celebrated* for their sense of individuality. Brown gained his independence from both slavery and the abolitionist movement, and in the process raised numerous questions relevant to his time and ours. How does one's own activism become compromised or enhanced when it breaks from the mainstream direction of a movement? How does one's activism change when it becomes a commercial enterprise and/or the source of one's income?

The fact that Brown continuously toured *Mirror of Slavery* throughout the British Isles for decades—retelling his escape story more than two thousand times—makes it apparent that the public responded favorably to his work.[13] His path allows us to consider the importance of those who veer away from the standard approaches and boundaries that often define social activism. Brown's antislavery message reached tens of thousands of people through an accessible medium that was rooted in popular culture. Ruggles concludes:

> There was no other antislavery advocate quite like him, with his combination of personal experience of slavery and dramatic escape, a pointed and graphic antislavery exhibition, and longevity on the show circuit. Surely Brown was the only abolitionist to lead a parade through a town dressed as an African prince and brandishing a huge sword. Brown the showman no doubt reached audiences not addressed by more proper lecturers. Unsanctioned by any antislavery organization, Henry Box Brown continued to act in the campaign against slavery throughout the 1850s.[14]

# 5

# The Battleground over Public Memory

A WAR MEMORIAL MIGHT be viewed as a peculiar symbol of social justice, but the Shaw Memorial in Boston is precisely that. The Shaw Memorial honors the 54th Massachusetts Regiment, a regiment of African American soldiers who had to fight to be *allowed* to join the Union armies during the Civil War. The memorial, unveiled in 1897, sits across from the Massachusetts State House on Beacon Street and features Col. Robert Gould Shaw on horseback with twenty-three black soldiers from his regiment marching beside him.

The monument symbolizes how black soldiers helped shift the objective of the Civil War from preserving the Union to ending slavery by force. For more than a century, the Shaw Memorial carried this message through decades of white supremacy, Jim Crow laws, and the suppression of the historical memory of the pivotal role of African American soldiers in the war.[1] The Shaw Memorial was unveiled two decades after the collapse of Reconstruction, one year after the *Plessy v. Ferguson* Supreme

Augustus Saint-Gaudens, the Shaw Memorial, 1884–1897, Boston Commons (LC-D4-90157, Library of Congress)

Court decision, and during the height of Confederate Lost Cause propaganda. It was one of thousands of soldier monuments built after the war, nearly all of which whitewashed the role of black soldiers and ignored the issue of slavery. At stake was control over public memory and the meaning of the Civil War. Cast in bronze, the Shaw Memorial asserted a powerful countermessage. It asserted that the root cause of the war was slavery and the outcome of the conflict was its abolition. It stood as a symbol of racial justice and reasserted an emancipation narrative into the landscape and the contested terrain of public memory.

## Recruiting Black Soldiers

From the outset of the Civil War, the abolitionist community had fought to define the meaning of the Civil War *during* and *after* the conflict. On March 2, 1863, Frederick Douglass, the ex-slave, author, renowned orator, and abolitionist, published a broadside "Men of Color, to Arms!" that began with the following appeal:

> When first the Rebel cannon shattered the walls of Sumter and drove away its starving garrison, I predicted that the war then and there inaugurated would not be fought out entirely by white men. Every month's experience during these two dreary years has confirmed that opinion. A war undertaken and brazenly carried on for the perpetual enslavement of colored men, calls logically and loudly upon colored men to help suppress it.[2]

Douglass's appeal had arisen out of his frustration with black soldiers being denied the opportunity to enlist in the Union armies from 1860 to mid-1862.[3]

Abolitionists knew that as long as blacks were barred from fighting in the war, the issue of defeating slavery would be marginalized. Abolitionists consistently pressured Lincoln to do more. They urged him to frame the Union cause around defeating slavery, and they urged him to add provisions to the final Emancipation Proclamation that would allow blacks to join the Union armies. When the opportunity to form black regiments in Massachusetts finally presented itself, abolitionists became the key recruiters.[4]

Massachusetts governor John A. Andrew (1861–1866), a fervent abolitionist supporter, and George L. Stearns, a businessman who had helped finance John Brown's failed raid at Harpers Ferry, led the efforts to form the 54th. Key recruiters who reached out to potential recruits included Frederick Douglass (who helped recruit more than one hundred soldiers, including his sons, Lewis and Charles); Rev. Samuel Harrison (who later became the chaplain of the 54th); Henry Highland Garnett; Martin R. Delany; and T. Morris Chester, to name a few.

Recruiting tactics included visual appeals. Frederick Douglass's broadside "Men of Color, to Arms!" called on black men throughout the North to come to Massachusetts and to enlist—an appeal that connected their struggle to those in the past who had combated slavery with force: "Remember Denmark Vesey of Charleston. Remember Nathaniel Turner of South Hampton; remember Shields, Green, and Copeland, who followed noble John Brown, and fell as glorious martyrs for the cause of the slaves . . . This is our golden opportunity."[5]

Douglass's words found their way onto other broadsides. A recruiting poster in Pennsylvania featured his slogan "Men of Color, to Arms!" in bold text, along with the added slogans "Now or Never," "Fail Now, & Our Race is Doomed," and "Are Freemen Less Brave Than Slaves." These slogans did not mince words. They pronounced the war as the singular opportunity to end slavery and suggested that free black men who failed to enlist would be considered cowards.

This recruiting drive was successful, as 1,007 black soldiers and 37 white officers signed up for the 54th from across the North and the South. Four percent of the regiment hailed from Massachusetts (133 men), 294 recruits came from Pennsylvania, 183 from New York, 155 from Ohio, 64 from Michigan, and the rest from other states. Thirty-seven men listed their residency in slave states and 30 of these men had once been held in slavery.[6] Chosen to lead the regiment was twenty-six-year-old Col. Robert Gould Shaw, Harvard educated and a person of privilege, whose family was part of the New York and Boston abolitionist communities.

*Men of Color, to Arms!*, broadside, 1862 (Library Company of Philadelphia)

The 54th, however, continued to face barriers of discrimination that prevented them from actually fighting. When the regiment arrived in South Carolina they were assigned to menial labor, digging trenches and other tasks that fell outside of combat. Shaw and his men protested. Shaw lobbied Governor Andrew and his superiors to allow his regiment to fight, and on July 16 this request was granted when the 54th fought bravely in skirmishes on James Island, outside Charleston.

Two days later, the 54th would again see combat in a battle that defined their legacy. On July 18, 1863, the 54th led a nighttime charge on Fort Wagner (a Confederate battery on Morris Island, South Carolina) that would turn into a slaughter. The well-defended fort easily repelled the assault by the 54th and other Union regiments that followed. Shaw was shot in the chest and killed when he scaled the side of the battery. His regiment was decimated; 274 men were killed, wounded, or captured out of the 600 members of the 54th assigned to storm the fort.

Although defeated on Morris Island, the extraordinary courage exhibited by the 54th earned black soldiers the respect of the military and led to an increase in other black regiments being deployed to combat situations. Black soldiers eventually accounted for 10 percent of the total number of Union soldiers, an increase in military strength that helped the Union armies deliver the final blow to the Confederacy and slavery. And when the war ended, black soldiers and the abolitionist community had to fight another battle: the battle over the meaning of the Civil War and its root cause.

## Greater Cause and Lost Cause

"If war among the whites brought peace and liberty to the blacks, what will peace among the whites bring?"

—Frederick Douglass, July 5, 1875[7]

Following the Civil War, the South was occupied by federal troops to ensure that ex-slaves were granted their freedom. Three Constitutional Amendments were passed between 1865 and 1870: The Thirteenth Amendment that outlawed slavery, the Fourteenth Amendment that guaranteed citizenship rights to all persons born or naturalized in the United States, and the Fifteenth Amendment that granted voting rights to men regardless of "race, color, or previous condition of servitude." A Freedmen's Bureau was also established that provided food, medical care, schools, and other services to ex-slaves.

However, Reconstruction was bitterly contested. President Andrew Johnson (1865–1869), a self-avowed white supremacist, repeatedly vetoed Reconstruction measures. He encouraged Southern states to enact black codes that would curb black political rights and restrict their economic opportunities. He also overruled the Freedmen's Bureau plan to re-distribute small portions of land from slave masters to former slaves.

Reconstruction collapsed in 1877, when Republican politicians sold out the civil and political rights of African Americans when they agreed to remove federal troops from the South in return for electoral commission votes for the Republican Rutherford B. Hayes in the disputed Tilden-Hayes presidential election. This ensured that equal protection guaranteed by the Fourteenth Amendment all but disappeared, ushering in black disenfranchisement and labor conditions that equated to peonage.

Black civil liberties were also attacked on the *cultural* front. White Southerners viewed themselves as victims. The white South reeled from the physical destruction of the war, the trauma of defeat, the occupation by federal troops, and the federally imposed measures. In response, a "Lost Cause" ideology painted the Confederate war effort as heroic, one that fell short only because of lack of military might. Worse, it portrayed the 250-plus years of slavery in the South as genteel and slaves as content and faithful to their masters.

This racist ideology sought to assert political power for Southern whites by rewriting the historical past and by attacking the gains made by African Americans during Reconstruction. From 1867 to the mid-twentieth century the Lost Cause ideology caught fire across the United States and was disseminated by well-organized groups, including the United Daughters of the Confederacy (UDC) and the United Confederate Veterans (UCV), who published countless books, organized speaking tours, and influenced the rewriting of school textbooks that reflected a Lost Cause stance. Additionally, these groups, led by elite white women, erected thousands of monument campaigns that codified a Lost Cause reading of the war in towns and cities across the South and the North. "In late 1895, in Fort Mill, South Carolina," writes David W. Blight, "a hundred miles or so inland from Battery Wagner (where originally a plan had existed to build a memorial to Shaw), a monument to the 'faith and loyalty' of the southern slave in the war was erected."[8] This was only the beginning.

From 1905 to 1925 the UDC organized a campaign to erect "mammy" memorials in every state—monuments to "loyal" African American women who took care of their slave masters' children. The UDC lobbied Congress for a national mammy memorial in Washington, DC, to be erected on Massachusetts Avenue, near Sheridan Circle. The appropriation for the monument passed the U.S. Senate in 1922 but failed in the House of Representatives and was never built, but it did signify just how pervasive the Lost Cause ideology had become.

Black leaders and their allies, aghast at how the gains of Reconstruction were being dismantled one by one, spoke out against the barrage of Lost Cause propaganda. Frederick Douglass constantly addressed the attacks on Civil War memory and the climate of reconciliation and forgetting. He described the American public as "destitute of political memory."[9] In speech after speech he reminded his audience about the root cause of the Civil War and its moral outcome. In NYC in 1878, Douglass stated, "It was a war of ideas, a battle of principles . . . a war between the old and new, slavery and freedom, barbarism and civilization."[10] Douglass knew that those who controlled the memory of the war could shape the country's future. He also knew that the sacrifices of 180,000 black soldiers (37,000 of whom died during the war) and the mass carnage of the war (the death of 618,000 to 750,000 soldiers) would be in vain if black citizenship and civil rights were not protected.

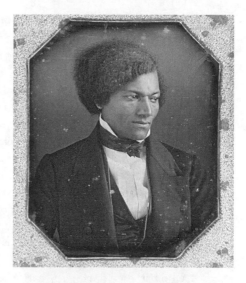

Frederick Douglass, ca. 1848, daguerreotype (Chester County Historical Society, West Chester, PA)

## A Monument to Emancipation

The Shaw Memorial offered a ray of hope. It portrayed the black freedom struggle during the Civil War and acted as a countermemorial to the barrage of Lost Cause ideology.[11] From its inception, both blacks and whites worked together on its concept. In 1863, almost immediately after Shaw's death at Fort Wagner, the call for a monument dedicated to him came from his own men. Despite the fact that the soldiers, along with Shaw, had not been paid for more than a year and a half (as part of a protest against the unequal salary rates that black soldiers received compared to their white counterparts) the regiment began the process of raising funds for a memorial to their fallen commander.[12]

In Boston, the vision of a memorial to Shaw also begun to take root shortly after the story of Fort Wagner became widespread. Joshua B. Smith, a prominent black abolitionist and friend to the Shaw family, spearheaded the project and brought in the Massachusetts senator Charles Sumner and Governor Andrew to help raise funds and form a committee to select an artist. The committee decided upon a local sculptor, William Wetmore Story.

Story was the first of four white artists who would be rejected due to a host of problems, including diminished funding and controversies over the proposed designs. Each of these artists presented drawings and models for a potential memorial focusing exclusively upon Shaw on horseback with no reference to the soldiers who served under him.

When the committee selected Augustus Saint-Gaudens in 1882, its fifth candidate, he too proposed a monument that emphasized Shaw on horseback, but the large sculpture set within an arch also included three relief tablets near the base that presented at least fleeting evidence of the regiment. The relief section depicted the 54th leaving Boston, storming Fort Wagner, and in the final panel, the survivors of the regiment returning from war. The design, however, was also rejected. The most stinging criticism came from the Shaw family, who said the equestrian pose "seemed pretentious" and excessive for their son, whose rank of colonel did not merit such a grandiose statue.[13]

More important, the Shaw family resisted the notion that their son was more significant than the troops he commanded. When Shaw had been killed at Fort Wagner, Confederate soldiers had thrown his body into a large unmarked grave with the other Union soldiers who had died during the battle. This action, burying a colonel with the common soldier, and a white commanding officer with black soldiers, was done out of spite, as a way to show Shaw the ultimate disrespect. The Shaw family viewed the action differently: they believed that their son should be, and would have wanted to be, buried with his men.

Augustus Saint-Gaudens, the Shaw Memorial (detail), 1884–1897, Boston Commons (photograph courtesy of Michael Lampert)

To the Shaw family, the monument proposals that either excluded or greatly diminished the importance of black troops were examples of the racism that they abhorred. The family had been part of the abolitionist movement, and was not willing to let the significance of the black soldiers in the war become dismissed and forgotten.

A new design by Saint-Gaudens provided a solution that the Shaw family deemed acceptable. Kirk Savage explains that Saint-Gaudens

> devised a solution that would integrate into one image the two separate elements of the 1882 design. The sculptor hit upon the idea of representing an infantry march with Shaw on horseback and his soldiers on foot, the whole scene in one large relief panel. In this way the commemorative content shifted further, as Shaw and the troops now melded into one sculptural statement.[14]

Showing the regiment marching in a profile view, Saint-Gaudens depicted the moment in which the 54th departed from Boston on May 28, 1863, en route to Boston Harbor, from where they would then travel by sea to South Carolina.

Saint-Gaudens viewed the new composition as an aesthetic challenge, one that would cement his legacy as one of the most renowned sculptors of his day. He was neither an abolitionist nor particularly connected to the Boston community or its history.[15] His concerns were for the formal elements of art and classical realism. His desire to sculpt Shaw and the black soldiers in a realistic manner proved to be the saving grace of the memorial.

———

On May 31, 1897, a massive crowd of approximately 3,500 cadets, seamen, policemen, and spectators attended the dedication of the Shaw Memorial.

Present also were 140 survivors of the 54th, the 55th, and the 5th Cavalry. Following the dedication, the event segued to the Boston Music Hall. Two keynote speakers addressed the crowd; William James, the noted Harvard philosophy professor whose brother had been an officer in the 54th and was badly wounded at Fort Wagner, and Booker T. Washington, the charismatic and controversial African American leader and head of the Tuskegee Institute in Alabama.

James complimented the monument for focusing attention on the Civil War as a battle to end slavery, and remarked that it served as a contrast to the common soldier monuments that lulled Americans into forgetting the "profounder meaning of the Union cause."[16] Booker T. Washington's speech took a different angle. Washington, who was much maligned by other black leaders, most notably by W.E.B. Du Bois, for accommodating white supremacy by not demanding full equal rights for African Americans, stayed true to form and addressed the need for reconciliation between the North and South and the black and white populations. He urged both races to put aside their hate:

> Until that time comes, this monument will stand for effort, not victory complete. What these heroic souls of the 54th Regiment began, we must

James H. Smith and William J. Miller, dedication of the Memorial to Robert Gould Shaw and the 54th Massachusetts Regiment, Boston, May 31, 1897 (Massachusetts Historical Society)

complete. It must be completed not in malice, nor narrowness, nor artificial progress, nor in efforts at mere temporary political gain, nor in abuse of another section or race. Standing as I do to-day in the home of Garrison and Phillips and Sumner, my heart goes out to those who wore the gray as well as to those clothed in blue, to those who returned defeated to destitute homes, to face blasted hopes and shattered political and industrial system. To them there can be no prouder reward for defeat than by a supreme effort to place the negro on that footing where he will add material, intellectual, and civil strength to every department of state.[17]

In the audience sat many veterans of the 54th Regiment. When Washington referred to Sgt. William H. Carney, he stood up and raised the same flag that he had carried at Fort Wagner. The emotions of the event were so intense that Washington later highlighted the event in his book *Up from Slavery*:

It has been my privilege to witness a good many satisfactory and rather sensational demonstrations in connection with some of my public addresses, but in dramatic effect I have never seen or experienced anything which

equaled this. For a number of minutes the audience seemed to entirely lose control of itself.[18]

The sculptor Augustus Saint-Gaudens was also in the audience. Perhaps he left changed after witnessing the events of the dedication unfold. Reflecting on the veterans of the 54th reenacting the march down Beacon Street, Saint-Gaudens later wrote, "The impression of those old soldiers, passing the very spot where they left for the war so many years before, thrills me even as I write these words. . . . They faced and saluted the relief, with the music playing 'John Brown's Body,' a recall of what I had heard and seen thirty years before. . . . It was a consecration."[19]

Richard Throssel, *Sees with His Ears—Crow*, ca. 1905–1911 (Richard Throssel Collection, American Heritage Center, University of Wyoming)

# 6

# Photographing the Past During the Present

IN EVERY PHOTOGRAPH, the photographer frames the scene; thus, an image can often tell us more about the person behind the camera than those depicted in front of it. Images can be doctored, and they can be staged. An image can blur reality, or the photographer can simply ignore one scene in favor of another. All of these factors mean that a photographic image should not be taken at face value. Instead, an image should be cross-examined, along with the ideology of the artist and the political and cultural climate in which the artist worked. This is especially important for historical photographs that are well circulated—images that have been republished over and over and have the power to affect the present by serving as visual guides and quasihistorical records of past events, peoples, and cultures.

An examination of the widely known white photographer Edward S. Curtis and the much lesser-known, if not obscure, Native photographer Richard Throssel (Cree), reminds us of the importance today of looking at the social conditions, the politics, the funding, and the motives that hide behind the images. Curtis documented more than eighty Native tribes during a thirty-year span from the position of an outsider; Throssel, a Cree Native who was given land and formally adopted by the Crow, took more than one thousand images of the Crow tribe as an insider to the culture that he visualized for future generations. Each photographer created his own distinctive body of work, yet the parallels and divergences of their two approaches are as significant as the images that they captured with their cameras.

———

Edward S. Curtis began photographing Native peoples in the West in the late 1890s, a decade or more after the reservation system had been firmly entrenched, but one would never sense this by looking at his images. Curtis is famous (if not infamous) for portraying Native people as untouched by white society: before encroachment, acculturation, and reservations.

His drive to document Native people was similar to that of many other white photographers, researchers, and ethnologists who feared that the sudden shift from traditional cultures to the reservation era would cause Native cultures and perhaps the people themselves to "vanish"—that they would either be absorbed into the white mainstream or annihilated. The irony and hypocrisy of this sentiment is hard to ignore: European Americans fretting over the loss of a Native culture and way of life that they had sought and helped to destroy.

Forced acculturation took many forms. Native customs and religions were banned, and children were separated from their parents and their communities and sent away to boarding schools. Adult men who had been warriors and buffalo hunters were coerced into becoming farmers and ranchers as the West became industrialized and was populated by more and more white settlers. Gerald McMaster notes that enforcing this sudden transition was asking the impossible: "It had taken centuries for Europeans to develop in this direction, but Native peoples were expected to change overnight."[1]

At the same time that the United States was forcibly denying the practice of Native traditional culture and religions, a mad rush of photographers and scientists came out west to document what they feared would soon no longer exist. James C. Faris writes that the impulse to document occurred only once it was safe to do so:

> Now a people successfully conquered, the photographs for public consumption of Native Americans were to be sentimental and nostalgic (mighty warriors as victims) but also shells of their former selves—no longer a threat to European-American expansionism and evidence of the success of European American expansionism, of Manifest Destiny. This meant that Native Americans could not appear happy, prosperous, flourishing—or even simply persisting or surviving—they had to appear "vanishing."[2]

Edward S. Curtis, *The Offering—San Ildefonso*, ca. 1927, photogravure (LC-USZ62-61129, published in *The North American Indian /* Edward S. Curtis. [Seattle, Wash.]: Edward S. Curtis, 1907–30, Suppl. v. 17, pl. 586; Library of Congress)

Edward S. Curtis helped propagate this myth. From the late 1890s to 1930, Curtis took more than 40,000 photographs of Native peoples, a number of which were included within his twenty-volume folio set *The North American Indian*. Limited to five hundred sets, the folios were sold by subscription for either $3,000 or $4,000, placing the photographs in the hands of only wealthy elites who could afford the steep cost. Curtis's work itself was funded by the financier J.P. Morgan, championed by Theodore Roo-

sevelt, and his subscribers included Andrew Carnegie and the railroad magnates James Hill and Edward Harriman—all of whom were instrumental in advocating, orchestrating, and financing western expansionism.[3] Curtis's work, although rooted in elite culture, also reached a popular audience. Reprints of his images could often be found within magazine articles. He gave visual lectures and even performed a musical. His single-minded drive is hard to comprehend. Curtis crossed the continent by train more than 125 times, dedicated to his work at the cost of his marriage, finances, and health.[4] Curtis died in 1952, leaving his indelible pictorial record of Native people and cultures to the public to decipher. Popular interest in his work goes through waves, as the Standing Rock Sioux scholar Vine Deloria Jr. noted:

> Everyone loves the Edward Curtis Indians. On dormitory walls on various campuses we find noble redmen staring past us. . . . Anthologies about Indians, multiplying faster than the proverbial rabbit, have obligatory Curtis reproductions sandwiched between old clichés about surrender, mother earth, and days of glory. This generation of Americans, busy as previous generations in discovering, savoring, and discarding its image of the American Indian, has been enthusiastic in acquiring Curtis photographs to affirm its identity.[5]

Yet within the same explanation of his work, Deloria cautions that Curtis's images "[suggest] a movie still rather than a historical event."[6] In this regard, his photographs appeared more like a Hollywood western film and were a far cry from the realities that Native people faced living on reservations. Printed in sepia tones with India ink and shot with a soft focus, Curtis's photographs froze his subjects in the distant past.

Common images within Curtis's arsenal included portraits of stoic Native Americans staring into the lens of the camera or isolated in a natural setting with no evidence of reservation life or the industrialization of the West. The often-reproduced *The Vanishing Race—Navaho* (1907) from volume 1 of *The North American Indian* presents a typical formula.

Edward S. Curtis, *Vanishing Race—Navaho*, ca. 1904, photogravure. (LC–USZ62–37340, published in *The North American Indian* / Edward S. Curtis. [Seattle, Wash.] : Edward S. Curtis, 1907-30, Suppl. v. 1, pl. 1.; Library of Congress)

A line of Native people on horseback slowly walks off into the distance toward the mountains, "vanishing" into nature. With their backs turned to the camera, their individual identities become erased, reinforcing Deloria's critique that we are viewing a scene from the director's vision and not a true documentation of life at the time. The altered background only adds to the sense of a fabricated scene. Above the mountains, Curtis retouched the photograph and added a white glow to provide the images with a heightened sense of drama. This type of photographic manipulation has drawn its share of criticism, as Lucy R. Lippard explains:

Curtis is attacked most often, and most legitimately, for his lack of ethnographic veracity. . . . He staged scenes, routinely retouched and faked night skies, storm clouds, and other dramatic lighting effects. He erased unwelcome signs of modernity, although late in life he finally became resigned to change and photographed people as they were. In his heyday, however, he was an emotional formalist, not an objective documentarian. Curtis was distressed when he arrived "too late" and found customs and ceremonials no longer in use. With the help of the tribes, he sometimes re-created them.

When working in the Pacific Northwest, he carried with him wigs (for those who now had white man's haircuts), "primitive" clothes, and other out-of-date trappings.[7]

Edward S. Curtis, *Upshaw—Apsaroke*, ca. 1905 (LC-USZ62-124178, published in: *The North American Indian*/Edward S. Curtis. [Seattle, Wash.]: Edward S. Curtis, 1907–30, Suppl. v. 4, pl. 139; Library of Congress; Christopher M. Lyman writes in *The Vanishing Race and Other Illusions*, "A.B. Upshaw, a Crow Indian, worked for Curtis as an interpreter. For this portrait he wore a costume so as to appear 'Indian' to Curtis's viewers." See *The Vanishing Race and Other Illusions: Photographs of Edward S. Curtis*, New York: Pantheon Books, 1982, 92)

Does this mean that we should completely dismiss Curtis's massive body of work? Deloria is helpful here when he notes, "Perhaps Curtis was less a liar and more an American dreamer, who felt impelled—as we all do—to create a reality for himself in lieu of the substance of observable things."[8] Likewise, George P. Horse Capture (Gros Ventre) adds, "Real Indians are extremely grateful to see what their ancestors looked like or what they did" and notes that one of Curtis's images is that of his great grandfather.[9] Curtis himself remarked that a number of tribes supported his efforts in preserving a pictorial record for future generations: "Tribes that I won't reach for four or five years yet have sent word asking me to come and see them."[10]

Yet this support was far from unanimous. Many Native tribes and individuals resisted the camera, whether it was Curtis or other white photographers determined to document their culture. Some individuals, such as the Oglala Lakota warrior Crazy Horse, refused to allow his photograph to be taken; many others believed that the camera was a "shadow catcher" and was to be avoided at all costs. Curtis had rocks thrown at him on a number of occasions, and arguably his most interesting photographs (and ones that are the least frequently reprinted) are those that document individuals covering their face and taking other actions to avoid the camera.[11] Lippard notes that resistance to the camera was not an isolated instance:

By the turn of the century, Indians were already officially protesting the presence of photographers. In 1902 the Hopi restricted photographers to a specific area so they could not interfere with the ceremonies. In 1910 they banned photography of the ceremonies altogether, as a result of a trip to Washington where they saw "a congressional hearing room plastered with a selection of photographs of religious ceremonies . . . [which] they found to their dismay, were being used by Bureau officials and missionaries to discredit their religion.[12]

George L. Beam, *Taos Pueblo Fiesta Races Dancers*, ca. 1920–1930, GB–7852 (Western History/Genealogy Department, Denver Public Library)

Today, in many pueblos and reservations in the Southwest, outsiders are completely banned from taking photographs, results of a lingering memory of how photography was used against Native people.[13]

Jaune Quick-to-See Smith (Flathead-Cree-Shoshone) explains: "Government surveyors, priests, tourists, and white photographers were all yearning for the 'noble savage' dressed in full regalia, looking stoic and posing like a Cybis statue. . . . We cannot identify with these images."[14] Photographer Hulleah J. Tsinhnahjinnie (Seminole-Muscogee-Diné) adds that the photographs that perpetuated the myth of the "noble savage" became the standard pictorial representation, whereas other possible focuses were virtually ignored: "The photographic evidence of U.S. genocidal practices is not extensive, if there is no evidence of genocide then there was no genocide."[15] In contrast, Tsinhnahjinnie notes:

> The focus of my relatives was the reality of survival, keeping one's family alive. Time to contemplate Western philosophy or the invention of photography was, shall we say, limited. Because of the preoccupation with survival, Native people became the subject rather than the observer. The subject of

judgmental images as viewed by the foreigner—images worth a thousand words. As long as the words were in English.[16]

As with every moment in history, there are exceptions to the rule. A small number of Native people did become accomplished photographers and documented their communities in a way that white photographers could not—as *insiders*. Native photographer Richard Throssel worked during the same era as Edward S. Curtis, and presented a view that went beyond the "vanishing" notion by responding to present-day realities that existed in the lives of those he was documenting.

Throssel was born in 1882 in Marengo, Washington, and grew up in Roy, a small farming community just east of Olympia. His Cree grandparents had been employees of the Hudson Bay Company and moved to Washington in 1841. Throssel, however, had to move away from home due to health reasons. He suffered from rheumatism, and in 1902, at the age of twenty, he sought out a drier climate and moved to the Crow Reservation in Southeast Montana, where he lived until 1911.[17] His first job was as a clerk for the Crow Agency Offices, where he was one of many newcomers to the area. The Crow Reservation was a hub of activity for outsiders, non-Native researchers, ethnologists, anthropologists, and artists alike who sought to learn more about the traditions and cultures of the Crow that they feared would soon be lost to acculturation. Also working on the reservation and also employed at the Crow Agency Offices were the European American photographers Fred E. Miller and Lorenzo Creel, along with Joseph Henry Sharp. Sharp, who would later become one of the founders of the Taos School of Art, documented the Crow through paintings and photography.[18] All told, more than fourteen professional and amateur photographers—including Edward S. Curtis, who visited the reservation between 1905 and 1909—documented the Crow Reservation between 1900 and 1910 in what some residents described as a "stampede of photographers."[19]

All of these individuals had an influence on Throssel, who quickly taught himself the medium. He began photographing the Crow by 1904, taking advantage of his unique position. As a Native person and as an adopted member of the Crow, Throssel gained access to events, people, and ceremonies of the Crow and other tribes that others would not have been granted permission to attend, let alone photograph. In 1909 he photographed the Northern Cheyenne Massaum ceremony, also termed "The Animal Dance"—a five-day ritual that involved participation by the entire tribe. Peggy Albright, author of the biography of Richard Throssel, *Crow Indian Photographer,* writes:

> It would be difficult to overstate the significance of this photographic image, a recording of one of the Cheyenne's rarest and most sacred ceremonies, which was then banned by government regulation. This image and twelve others taken by Throssel that year comprise the first visual records of the Massaum and the only known images of the 1909 offering. Throssel's description also represents the first eyewitness account in literature. In addition to these images, he took seven extremely rare images of the now-extinct Contrary Society, whose members also participated in the ceremony.[20]

One of Throssel's signature images of the Massaum documents a group of nine people running across a field, some blowing through eagle-bone whistles.

Albright notes that this image could only have been made with the cooperation of his subjects, who told Throssel where to set up his camera to best photograph the event.[21] This important image gave notice that, despite efforts to ban traditional customs and religious practices, Native people resisted many of these forced measures. Throssel gave a copy of this image to Curtis, and Curtis copyrighted it under his own name and published it within volume 6 of his folio *The North American Indian*.[22]

However, the photographs that set Throssel apart from Curtis and his other contemporaries are, ironically, photographs that both *documented* and *encouraged* acculturation: work that undermined tribal sovereignty. In 1909, Throssel was hired as a field photographer for the Indian Service (a position in which he reported to officials in Washington, DC) to document day-to-day living conditions, particularly health problems, within the reservation.[23] Health issues such as tuberculosis and trachoma were at epidemic levels on a national scale, but they were even more severe on reservations, where poverty, lack of medical clinics, and crowded, unsanitary boarding schools only served to heighten the problem.[24] Throssel's photographs showed sick and dying individuals and acted as public-service messages to encourage healthier living habits.

Richard Throssel, *Cheyenne Animal Dance*, 1909 (Richard Throssel Collection, American Heritage Center, University of Wyoming)

On the Crow reservation, Throssel worked under the direction of Dr. Ferdinand Shoemaker, a physician who previously had worked at the Carlisle Industrial School.[25] The goal of their work was summed up by the commissioner of Indian Affairs, Robert G. Valentine, in his annual report:

> A series of illustrated lectures for a traveling health exhibit are being prepared. A special physician and photographer are in the field securing photographs from which these stereopticon slides and moving pictures can be made. This exhibit will be sent to the different schools and reservations. One of the most important results of this educational work will be that it will instruct the employees at the schools and agencies of the Indian Service as to the methods of preventing disease, and in this way unite the entire service in the health campaign.[26]

One of Throssel's most persuasive images from the series is *Interior of the Best Kitchen on the Crow Reservation.*

The photograph documents a Crow family within a modern kitchen who refuse to engage with the camera and appear at first glance to be out of place, although buildings of these

Richard Throssel, *Interior of the Best Indian Kitchen on the Crow Reservation,* 1910 (photo no. 4644, Smithsonian Institution, National Anthropological Archives)

types were becoming increasingly common on reservations. However, the interior used in the photograph was indeed out of place: it was a stage set. Prior to the photographic shoot, a room with walls and a floor were constructed, and furniture, wallpaper, and decorations were added. A roof was never built, for the sun provided better light for Throssel's camera.

Viewers of the image at the time would never have known this was a staged image. Instead, they would see an *instructive* image that discouraged traditional living habits that were thought to be one of the main reasons behind the spread of diseases. They would have seen this image contrasted with other public-service images on what not to do: images of Crow members eating on the ground and sharing cups in a tepee, and images of passing of the pipe—a spiritual practice and part of the Crow Tobacco Society that was discouraged for fear of spreading disease.[27]

It is ironic that Curtis's staged images pictured a nostalgic look at traditional life, whereas the staged photographs of Throssel advocated for assimilation as part of a federal campaign to address the spread of disease.[28] Yet while Throssel's images backed federally imposed measures, they also addressed present-day realities and were meant to help his community and the overall health of Native peoples. Throssel's images acted as a form of community activism. They responded to immediate needs, in stark contrast to Curtis's images that revolved around his own self-interest and were intended to build up his folio, establish his reputation, and sell to a wealthy clientele. Throssel's images reached a Native audience and were shown on fifty-two occasions to more than 10,000 people.[29]

Despite the success of the photographs, Throssel resigned from his position in February 1911. He complained justifiably that he was not given public recognition for his work, noting that the program director, Dr. Shoemaker, had received the bulk of the recognition.[30] Soon after his resignation, Throssel and his family moved to Billings, Montana, where he established his own photography business and marketed his vast collection of photographs of the Crow to the public under his own name.

Richard Throssel, *The Rustler*, ca. 1911. (Richard Throssel Collection, American Heritage Center, University of Wyoming)

Richard Throssel, *Indian Sitting Outside Teepee with Meat Drying on Racks*, ca. 1905–1911 (Richard Throssel Collection, American Heritage Center, University of Wyoming)

Richard Throssel, *Plenty Coups—Crow*, ca. 1907–1911 (Richard Throssel Collection, American Heritage Center, University of Wyoming)

Here, Throssel's work took another confounding turn: he marketed a series of photographs that could easily have been mistaken for the work of Edward S. Curtis. Throssel's series of thirty-nine photographs, *Western Classics from the Land of the Indian*, focus upon a nostalgic look at Crow life. Throssel was well aware that a non-Native audience sought out these types of images, and he provided a set of images that followed Curtis's mold: dramatic images of a "vanishing" culture, retouched photographs, and scenes that ignored reservation life and signs of industrialization.[31]

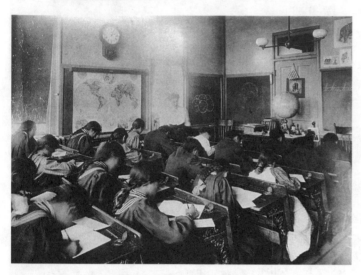

Richard Throssel, *School Room, Crow Indian Reservation*, 1910 (photo no. 95–1384, (Smithsonian Institution, National Anthropological Archives)

These images stood in sharp contrast to other photographs that Throssel had taken that were so significant for *showing* signs of modernization—images of tepees next to log materials for new construction, a portrait of Chief Plenty Coups standing outside his two-story home, and Crow children inside a reservation classroom.

Throssel, however, knew that white tourists and those who ordered his images by mail would not purchase his more realistic images, so he sold images in the "Curtis mold," while still advertising himself as an insider to the people he documented. His *Western Classics* brochure included the information: "Richard Throssel is an Indian, Crow allottee No. 2358; Esh Quon Dupahs as the Indian knows him. He belongs to them. His home is among them. Their lives he knows, their traditions and folklore."[32] This text was included to give him additional credibility to his customers and to set him apart from his contemporaries.

Other facets of Throssel's complex life indicate that his dedication was to his people. In 1924, Throssel ran for political office and was elected Yellowstone County's representative to the nineteenth session of the Montana State Legislature. While in office, he advocated for increased sovereignty rights and land rights for Native people and spoke out against corporate power. He opposed opening up the Crow Reservation to the Big Horn Canyon Power and Irrigation Company, which wanted to generate hydroelectric power in the region. He also advocated for an increase in the metal tax for the large mining corporations to help pay for Montana's schools—a tax initiative that the mining interests greatly resisted. In 1924, he achieved a major victory when the tax was enacted by a popular vote—a rare people's victory over the massive Anaconda Copper Mining Company. Throssel's short political career, which ended in 1928 when he was defeated in a primary, included introducing a bill that directed federal funds for health care for Native people in Montana, and persuading a four-year col-

lege (now Eastern Montana College) to locate its campus in Billings, in close proximity to the Crow Reservation, as opposed to another region in the state.[33]

Throssel's concerns, whether expressed through his photography or his public service, were focused on the present, responding to the conditions that affected those within his community. In contrast, Curtis's camera ignored the everyday realities that faced the people he was documenting. His images were selective, ignoring issues of modernization and issues of poverty. He even ignored everyday joys, choosing to overlook photographs of his subjects smiling, and opting instead for the stoic image of Native people. These images created lasting stereotypes and the damaging myth of a "vanishing people." Throssel's photography, in contrast, revealed a more accurate documentation of what life was like for the Crow in the early 1900s. He did not ignore the very real problems that existed on the Crow Reservation. His motives were to provide immediate help, yet his photographs (outside of his public-health images) reached a much smaller audience than Curtis's work.

In fairness, both photographers created a complicated legacy, one open to an equal dose of compliments and criticism. We should not discredit the fact that many Native and non-Native people appreciated the extensive record of Native peoples that Curtis has left for the public, and neither should we downplay how invasive his camera and his methods were at times. It is best if we view both Curtis's and Throssel's work as complicated. Both bodies of work invite contemporary audiences to interrogate the past and the people who documented it with a more critical eye.

# 7

# Jacob A. Riis's Image Problem

"I began taking pictures by proxy. It was upon my midnight trips with the sanitary police that the wish kept cropping up in me that there were some way of putting before the people what I saw there. A drawing might have done it, but... a drawing would not have been evidence of the kind I wanted."

—Jacob A. Riis[1]

FROM THE LATE 1870S until his death in 1914, Jacob A. Riis was one of the leading voices in the tenement-reform movement. He was a police beat reporter for the *New York Tribune* who reported from an office directly across from police headquarters on Mulberry Street, in the heart of one of the roughest sections of the city. He was also the author of numerous books, including *How the Other Half Lives* (1890)—a bestseller that remained in print throughout his life. His other books included, among others, *The Children of the Poor* (1892), *Out of Mulberry Street* (1898), *A Ten Years' War* (1900), *The Battle with the Slum* (1902), and *Children of the Tenements* (1903). Riis was also an amateur photographer whose work nonetheless became highly influential over time. He was one of the first people in the United States to photograph urban poverty and one of the first to utilize photographs together with text. Together these made an emotional appeal that urged his audience to become active in the tenement-reform movement. In the process, Riis helped launch a new genre—social documentary photography.

However, Riis was first and foremost a reformer, and a successful one at that. His many accomplishments during his lifetime included campaigns that led to the demolition of some of the most notorious tenement buildings in New York City, the establishment of truant schools, the building of small parks within tenement neighborhoods, the closure of police lodging houses, and the cleaning up of the Croton Reservoir—a filth-ridden location from which the city received its water supply.

Riis's work was not without controversy or contradiction. His writings were littered with racist stereotypes and his photographs were often intrusive and undermined the individuality of his subjects. Indeed, much of his work addressed an audience that did not include the tenement residents

themselves. Instead, Riis directed his work toward middle- and upper-class charity groups and government officials. For this reason, Riis is often maligned in our own time. However, simply dismissing Riis's work would be a mistake. He created far too great of an influence in the tenement-reform movement, as well as the genre of photography, for his efforts to be negated.

———————

To understand Riis we must understand the conditions that he sought to change. In the late 1800s, close to two-thirds of the city's population (1 million out of 1.5 million) lived in tenement houses. Tenement neighborhoods stretched from lower Manhattan to Fifty-Ninth Street. Upward of 60,000 new immigrants—mostly Italians, Eastern and Southern Europeans, and Russians—arrived per month, making parts of the city, particularly the Lower East Side, one of the most densely populated places in the world.

Derelict buildings, overcrowding, and unsanitary conditions created a death rate that was astronomical—one in twenty and one in five or worse for children younger than five.[2] Epidemics were rampant. Outbreaks of typhus, cholera, smallpox, and yellow fever killed

Jacob A. Riis, *Waiting to be Let into a Playground,* ca. 1890 (Museum of the City of New York)

thousands each year, and few government programs existed to assist those in need. Likewise, building codes were inadequate and those that were in place were rarely enforced. To remedy this void, upward of five hundred charity groups in New York City alone provided varying degrees of assistance.

Riis exposed these conditions of the tenements through his writing, but he also turned to another medium: photography. His goal was simple: allow the public to see what he saw—to visualize the deplorable conditions, the crowded rooms, basement dwellings, taverns, and sweatshops that existed behind closed doors.

In 1877, Riis began asking friends and associates to follow him and the sanitary police into tenement buildings and take photographs late at night, when his party would break into a room unannounced and take pictures—or, what Riis referred to as evidence. Riis recalls:

> I recall a midnight expedition to the Mulberry Bend with the sanitary police that had turned up a couple of characteristic cases of overcrowding. In one instance two rooms that should at most have held four or five sleepers were found to contain fifteen, a week-old baby among them. Most of them were lodgers and slept there for "five cents a spot." There was no pretense of beds. When the report was submitted to the Health Board the next day, it did not make much of an impression—these things rarely do, put in mere words—until my negatives, still dripping from the dark-room, came to reinforce them. From them there was no appeal. It was not the only instance of the kind by a good many. Neither the landlord's protests nor the tenant's plea "went" in the face of the camera's evidence, and I was satisfied. I had at last an ally in the fight with the Bend.[3]

Riis had a more difficult time convincing his friends to return to the tenement slums on a nightly basis, so he decided to learn the medium himself. In January of 1888, he paid $25 for a camera, tripod, plate holders, and a simple darkroom kit. However, he ran into technical limitations; cameras could not take photographs at night or within dark spaces, therefore making images within the dark tenement rooms and cellars next to impossible. His problem was solved when he came across a newspaper advertisement for a newly invented flash called Blitzlichtpulver—an explosive mixture of powdered magnesium and two other substances that created a bright blue light when it was ignited. To create a flash of light the powder was put into cartridges and shot from a gun. Riis wrote:

> It is not too much to say that our party carried terror wherever it went. . . . The spectacle of half a dozen strange men invading a house in the midnight hour armed with big pistols which they shot off recklessly was hardly reassuring, however sugary our speech, and it was not to be wondered at if the tenants bolted through windows and down fire-escapes wherever we went.[4]

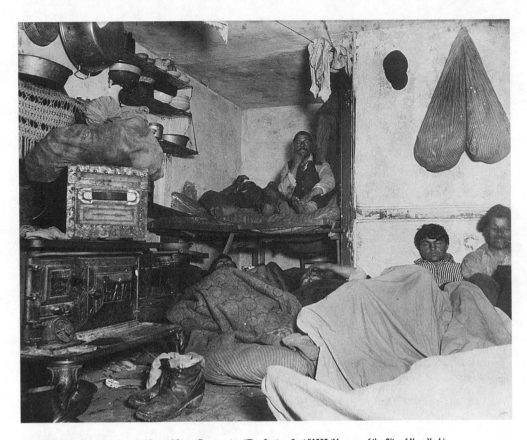

Jacob A. Riis, *Lodgers in a Crowded Bayard Street Tenement—"Five Cents a Spot,"* 1889 (Museum of the City of New York)

Riis's photographs and those by his associates documented this terror. One of his more iconic images, *Lodgers in a Crowded Bayard Street Tenement—"Five Cents a Spot"* (1889), embodied the tactics of the midnight raid.

The image documents residents rudely awakened in the dead of night. Four sets of beds are pictured in the frame, with an untold number of occupants crammed into a small room. The "raiding party" awakens five of the occupants, who look at the camera with a mixture of surprise, distrust, and anger. All told, the image is combative and undermines the individual identity of those pictured. Riis "shoots" his subjects without their permission; to him, the people in the room are simply statistics, part of the fabric of the tenement problem.

Riis's camera was not just aimed at the residents of the room. It was aimed at the walls, the condition of the building, and the landlord who profited from overcrowding. Riis, who at this time had moved his family to the suburbs, detested unclean environments. He later wrote, "I hate darkness and dirt anywhere, and naturally want to let in the light."[5]

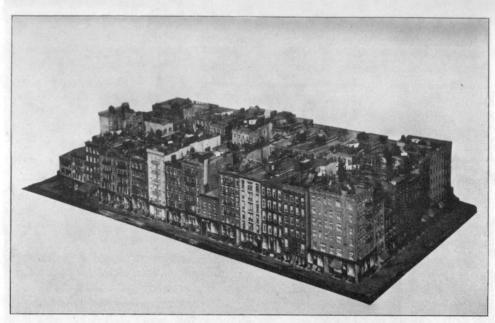

A Typical East Side Block.

Jacob A. Riis, *A Typical East Side Block*, halftone reproduction from *The Battle with the Slum* (New York, 1902)

To Riis, reform of the tenements meant literally cleaning up the neighborhood. He believed that a clean, ordered environment would produce good citizens with good morals.[6] Yet, Riis often contradicted himself on where to assign blame for the conditions of the tenements. At times, he blamed the physical environment of the tenements for trapping its residents into cycles of poverty and crime. Other times he blamed the wealthy for being greedy, exploiting the poor, or having a callous indifference to their plight. Riis also blamed the residents for the condition of their neighborhood and the choices that they made. He argued that individuals with poor character (and other times specific ethnic groups) were predisposed to live in and to remain in the tenements.[7]

## Speaking for Others, Speaking to the Wealthy

If Riis was consistent in any respect, it was that he regularly insulted the people he sought to help. His signature text, *How the Other Half Lives*, set the bar for insensitivity. Riis consistently criticized immigrant communities for not assimilating fast enough into American

culture and painted all people within an ethnic group with the same broad strokes. Riis described Russian and Polish Jews as those who "carry their slums with them wherever they go, if allowed to do it."[8] He ridiculed Jews as thrifty and blamed the plight of Bohemian immigrants on their landlord/employer—"almost always a Jew."[9] Italians garnered slightly more respect: "In the slums he is welcomed as a tenant who 'makes less trouble' than the contentious Irishman or the order-loving German, that is to say: is content to live in a pig-sty and submits to the robbery at the hands of the rent-collector without murmur."[10] Riis portrayed Chinese men as impossible to assimilate. To Riis they were opium addicts and individuals who would "rather gamble than eat any day."[11]

He added, "There is nothing strong about him, except his passions when aroused."[12] His opinions of African Americans were slightly more sympathetic, yet equally racist. He blamed both slavery and the individual for his negative appraisal. "With all his ludicrous incongruities, his sensuality and his lack of moral accountability, his superstition and other faults that are the effect of temperament and of centuries of slavery, he has his eminently

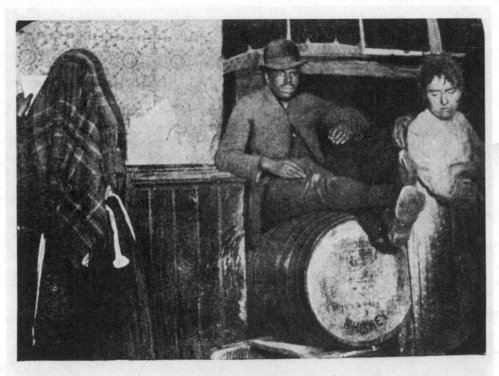

A BLACK-AND-TAN DIVE IN "AFRICA."

Jacob A. Riis, Richard Hoe Lawrence, and Dr. Henry G. Piffard, *Black and Tan Dive*, ca. 1887–1888, halftone reproduction from *How the Other Half Lives* (New York, 1890)

good points. He is loyal to the backbone, proud of being an American and of his new-found citizenship. He is at least as easily moulded for good as for evil."[13]

Between the lines and the overt racism, Riis leveled his harshest critique on groups that resisted assimilation. He wished for the tenement communities to be less foreign and more "American." He blamed both the slums and the ethnic background of its inhabitants for stalling this process. Ironically, he had a relatively progressive view of immigration policy.[14] Regarding the Chinese, he wrote:

> The Chinese are in no sense a desirable element of the population, that they serve no useful purpose here, whatever they may have done elsewhere in other days, yet to this it is a sufficient answer that they are here, and that, having let them in, we must make the best of it. . . . Rather than banish the Chinaman, I would have the door opened wider—for his wife; make it a condition of his coming or staying that he bring his wife with him. Then, at least, he might not be what he now is and remains, a homeless stranger among us.[15]

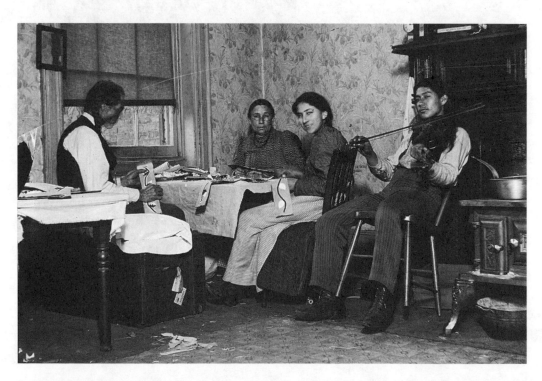

Jacob A. Riis, *Mountain Eagle and His Family of Iroquois Indians—One of the Few Indian Families in the City, Found at No. 6 Beach Street, December 1895*, 1895 (Museum of the City of New York)

In short, Riis was arguing for improving urban conditions that encouraged assimilation, while at the same time maintaining racial hierarchies.

This point was made clear by his text, but his photographs, seen alone, and not paired with his words, had the ability to communicate a different message: they inspire a sympathetic reaction—one that called upon his audience to lend assistance, and one where his racist messages were more diluted. Scholar Cindy Weinstein writes, "One is almost tempted to say that when his racism is in check, he finds the environment responsible for the ills of the tenants; when unchecked, the blame is placed squarely on the racial group."[16] This rings true for a photograph that Riis took of four Native Americans living in a well-kept apartment. Riis documents a family busy at work producing Native crafts while a young man plays the violin. In this image the tenements are pictured as *livable*.

The room is clean and the sunlight comes through the window. Here, Riis champions cleanliness and order as a solution to the tenement problem and downplays the faults that he sees in various ethnic groups.

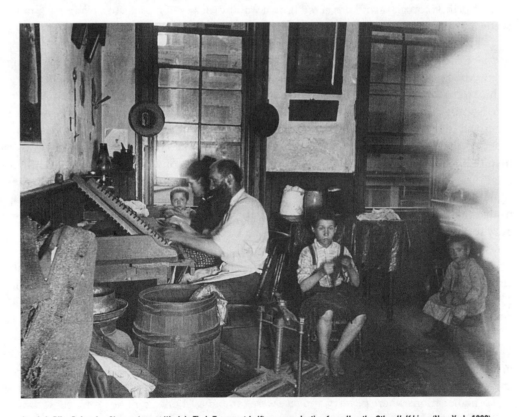

Jacob A. Riis, *Bohemian Cigarmakers at Work in Their Tenement*, halftone reproduction from *How the Other Half Lives* (New York, 1890)

Why did Riis frame his activism and his reform efforts around issues of race and racism? The answer could be found in his *audience* and the expectations that he had of them. Bill Hug argues that Riis's rhetoric was *strategic*.[17] That his well-do-do, Protestant, white, "American" audience would not be receptive to his message of compassion and charity if he presented the tenement population as their equals. Hug writes, "To publicize the predicament of the nation's newcomers, he would first have to appeal to his audience's assumptions about them, or appear to—then he might subvert those assumptions. Such a strategy would amount to an ironic reversal of the hypocrisy of those professed Christians who preached compassion but practiced complacency, especially in regard to poverty and suffering in the tenements of their own city."[18]

———

Starting in 1888, Riis lectured extensively in and around New York City and the Northeast. His mode of communication was lantern-slide lectures, which he gave to audiences of Protestant reform societies, church groups, civic improvement associations, and upper-class social clubs. Riis's two-hour lecture revolved around projecting one hundred slides—positive images printed on glass and projected onto a wall by means of a projector, either by a magic lantern or a stereopticon—accompanied by his own narration.

Riis, despite his privileged Nordic status, had experienced what it was like to be an outsider. He knew that as a recent immigrant himself (arriving in 1870 from Denmark at age twenty-one), he was not fully accepted in the eyes of his middle-class audience; early reviews of his lecture complained that his "German" accent made him difficult to understand. Riis consistently attempted to prove how he had assimilated, how he had become an "American." He urged his privileged audience to become active in the tenement-reform movement and asserted that helping the less fortunate would not alter their class position. His goal was to inspire his audience to care and to act. And once Riis had convinced his audience that immigrant enclaves in the tenements were inferior, he, in the words of Edward T. O'Donnell, "demolished those ideas with emotive, humanitarian photographs."[19] In essence, he appealed to his audience's deeper conscience and asserted that the powerful class had a moral duty to act against poverty.

Riis's slide lectures had a strong emotional effect, and audience members were purported to have cried, fainted, and talked back to the screen. But the lectures also acted as a *visual tour guide* of locations that the vast majority of his audience had never visited before. Many had likely traversed the Lower East Side's streets, but never gone into the crowded apartments, the sweatshops, the family cottage industries inside homes, the basement taverns, or the police lodges that housed the homeless.

Riis also took powerful people on actual tours of the slums. He befriended Police Commissioner Theodore Roosevelt (a position he held before becoming the governor of New York and ultimately president) and took him on midnight tours of crowded tenement buildings and other locations where poverty and vice were rampant. At one point he provided Roosevelt with a list of the sixteen worst slum areas of the city and by 1897, Roosevelt acted on this information and ordered many of the sites to be razed.[20] Riis also told Roosevelt about his

own traumatic experiences staying in police lodging houses when he first arrived in the United States in 1870, an incident where the police kicked him out of the lodge and killed his newly adopted dog in front of him. This retelling of a brutal story, along with the guided tour, convinced Roosevelt to permanently close down the police lodges in favor of more sanitary and humane night shelters that were run by the city.

Riis's appeal to Roosevelt and others was, ultimately, tactical. His goal was to push his audience—wealthy people—to act. His writings and photographs served as a warning: reform the tenement neighborhoods, or the anger from the residents of these neighborhoods will be directed at the audience.

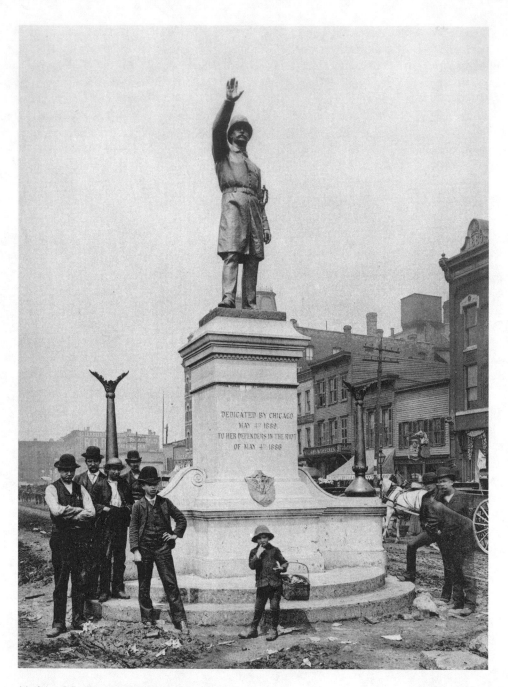

John Gelert, *Police Monument*, 1889 (Chicago History Museum)

# 8

# Haymarket: An Embattled History of Static Monuments and Public Interventions

On MAY 4, 1927, a Chicago streetcar driver rumbled down Randolph Street. The driver had routinely passed by the Police Monument, the daunting statue of a policeman that commemorated the 1886 Haymarket Riot solely from the perspective of the police. The monument had originally stood in Haymarket Square, the site of the riot, but due to congested traffic, the city moved it to Union Park, between Randolph and Ogden. Its new location did not calm the discontent that much of the city, with a strong working-class identity, felt toward the statue. It had been vandalized before, but this anger was about to be taken to a new level. Veering from his normal route, the driver suddenly jumped the tracks and directed his streetcar full speed ahead into the base of the monument, knocking the statue to the ground. The driver, whose name is only referenced in historical accounts as O'Neil, gave a simple reason: he was sick of seeing that policeman with his arm raised.[1]

In 1927, the memory of Haymarket still registered with much of the U.S. public, yet as the decades passed, it had begun to fade, even within Chicago. The distance of time, the failure of schools to teach its history, and a concerted effort by the city of Chicago and the federal government to erase its presence from public space all added to the steady disappearance of the memory, with consequences for future generations—primarily keeping the public uninformed about its own labor history.

## Haymarket as Unresolved History

The events at Haymarket in 1886 grew out of the international eight-hour workday movement. On May 1, Chicago was just one of many cities that participated in a national strike for the eight-hour day. The Chicago protest was massive and drew more than 80,000 marchers in a parade up Michigan Avenue. At the same time, solidarity strikes were occurring throughout the city. At the

McCormick Harvester Works, on the city's South Side, trouble broke out during a skirmish between striking workers and replacement scabs. Some 1,400 workers had been on strike since mid-February, and tensions were running high against the three hundred strikebreakers who had crossed picket lines. On May 3, two hundred police were called in. The police opened fire on the strikers, killing four and wounding many others. August Spies, one of the prominent anarchist leaders in the city, had been addressing strikers at another plant just down the road when the massacre took place. Outraged, he rushed to the printers and issued a flyer that began with the inflammatory headline, REVENGE! WORKINGMEN, TO ARMS!!! A second flyer called for a protest demonstration the next day (May 4) at Haymarket Square.

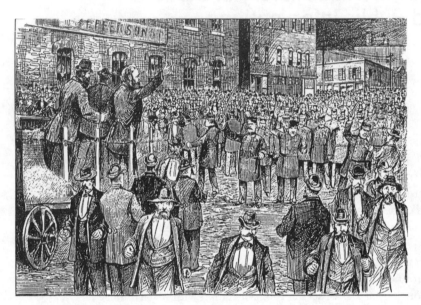

Unknown artist, the arrival of the police at the Haymarket Meeting (Lucy Parsons, *Life of Albert R. Parsons*, Chicago, 1889)

At Haymarket Square on May 4, Spies spoke to a crowd of 3,000, as did Albert Parsons, the editor of the largest anarchist newspaper in the country, *The Alarm: A Socialist Weekly*. Chicago was the epicenter of the anarchist movement in the United States, a highly organized radical movement whose most prominent leaders addressed massive labor rallies and agitated on behalf of many of the poor, the unemployed, and immigrants within the city. At Haymarket Square, Spies, Parsons, and others denounced the police violence of the day before. Mayor Carter Harrison showed up at the demonstration and reported to the police that the event was orderly and headed home for the evening. By ten p.m., two-thirds of the crowd had left, and rain began to fall.

The event likely would have wound down without incident had the police not opted for a show of force. One hundred and eighty officers marched toward the crowd demanding that it disperse. Someone, whose identity remains unknown to this day, threw a bomb into the crowd of charging policemen. Was it thrown by a worker seeking revenge for the police violence from the day before? Was it an agent provocateur willing to use violence to disrupt the gains made by the labor movement? More than 125 years later, no one can say for certain.[2] However, we do know that following the mayhem of the blast, police fired at will, killing many, including fellow officers. At least eight policemen died from the explosion and the spray of bullets, more than two hundred civilians were injured, and there was an uncounted number of deaths.

The ramifications of the blast would be profound. The police seized on the event to attack organized labor by shutting down labor newspapers and arresting hundreds of individuals, essentially crushing the anarchist movement within Chicago. Eventually, eight anarchists (the majority of whom were German immigrants) were brought to trial, including some who were not even present at the demonstration. On November 11, 1887, a date that became known as Black Friday, the defendants were found guilty. August Spies, Albert Parsons, and two others—Adolph Fischer and George Engel—were sentenced to death after a grossly unjust trial. Another man sentenced to die, Louis Lingg, committed suicide in jail, and three others—Michael Schwab, Samuel Fielden, and Oscar Neebe—received prison sentences. In the aftermath, the men who were executed became martyrs to labor movements throughout the world, their memory kept alive by images, poems, and songs. Yet in Chicago, the battle over the martyrs' memory, particularly over the building of monuments that referenced Haymarket, would be bitterly contested.

## Taking Sides: The Police Monument and the Haymarket Monument

Since 1886, organized labor, anarchists, and the police have clashed over opposing visions about how the Haymarket tragedy should be remembered. Unions and labor historians have largely come to view Haymarket as part of the overall struggle for the eight-hour day and workers' rights, and have distanced themselves from the radical anarchist principles that the martyrs had called for in the late 1800s. Spies, Parsons, and others had agitated for a collective society to replace capitalism and private property; they viewed the U.S. government as a hostile entity that perpetuated a society based on inequality and a class system. Their call for a radical restructuring of society ran counter to the goals of the modern labor movement, which generally lobbies for higher wages, better working conditions, and other policies that benefit unionized workers.

The labor movement has long argued that an official monument should exist at Haymarket to represent the history and concerns of workers from a vast range of professions and political viewpoints. Many anarchists, however, have argued that the martyrs who died for their convictions would abhor any type of official monument that was sanctioned by the government.

The police, in yet another view, insist that Haymarket be remembered simply as the event where an anarchist-led labor movement murdered their fellow officers. In their estimation, if a monument should exist, it should honor the police officers who died. For more than a hundred years, the police viewpoint held sway in Chicago. Haymarket Square either featured a monument to the police or it remained bare, without any notice of what had transpired there. Labor and anarchists were barred from placing a monument representing their perspectives on the riot anywhere within city limits.

Anarchists responded to this ban by erecting a monument in 1893 in the nearby suburb of Waldheim (now Forest Park) at the gravesite of the executed martyrs at Waldheim Cemetery. The Pioneer Aid and Support Association, an anarchist group that provided aid for the widows and the children of those executed and jailed following the Haymarket trial,

Martyrs' Monument at Waldheim, ca. 2006
(photograph courtesy of the author)

organized the monument campaign. Albert Weinert was selected to sculpt the Haymarket Monument, and in his design, he depicted an allegorical figure of Justice placing a laurel wreath over the head of a dying worker.

The female figure of Justice (also interpreted as Liberty, Anarchy, or Revolution) looks into the distance with an intense gaze, and is portrayed as a protector of working-class people.

This powerful monument would quickly become a focal point for the ceremonies of working-class people and radical movements, starting with its dedication on June 25, 1893. The date coincided with the World's Columbian Exposition in Chicago, which allowed thousands of visitors who were in town from around the world to attend the monument's unveiling. James Green explains the importance of the ceremony, along with the city's effort to neutralize its effect:

> The martyrs' families and supporters ritualized the act of remembering and began to do so immediately with a funeral many witnesses would never forget. After struggling with city officials who prohibited red flags and banned revolutionary songs, the anarchists led a large parade silently through Chicago's working-class neighborhoods on the long walk to Chicago's Waldheim Cemetery . . .[3]

More than 3,000 people marched in the parade, and 8,000 were present at the cemetery during the dedication. On the base of the monument were chiseled Albert Parsons's final words before he was hanged: "The day will come when our silence will be more powerful than the voices you are throttling today."

The day after the ceremony, Gov. John Peter Altgeld pardoned the three men who remained in jail. He knew this action would ruin his political career, but Altgeld stood by his convictions, stating that the trial was a travesty of justice. His pardon would later be inscribed on the back of the monument. For his action, he was scorned by the power structure and celebrated by labor, who tried in vain to have a monument built to him at Haymarket Square. But as with the martyrs' monument, the city of Chicago would refuse.

In the years to come, the Haymarket Monument at the Waldheim Cemetery would continue to serve as a symbol of resistance for the labor movement. The monument has often been the site for May Day celebrations and remembrance of May 4 and November 11. The cemetery also would become the resting place of many of the country's most radical labor leaders and revolutionaries, including Emma Goldman, Lucy Parsons, Elizabeth Gurley Flynn, Joe Hill, Big Bill Haywood, and many others who were buried there or had their ashes spread in the cemetery.

In comparison, the Police Monument, sculpted by Johannes Gelert, was dedicated in 1889, three years before the Haymarket Monument. It also had annual remembrance celebrations and was cherished by those it best represented—the police. The *Chicago Tribune* and

the Union League Club of Chicago had organized the fund-raising drive for the monument, which was to be placed in the center of Haymarket Square—a working-class section of town, home to farmers' markets and numerous union halls.[4]

The placement of the monument of a police officer with his hand raised in a "halt" pose was an overt message to the people of Chicago that if they rebelled and went on strike, there would be consequences. Thus, it was no wonder that the Police Monument received little fanfare from working people—the majority of the population of Chicago. After the Police Monument was first toppled in 1927, it was moved away from the streetcar lanes so renegade drivers could not destroy it so easily. Eventually, it was moved to Jackson Boulevard, where it was ironically placed facing a statue of Mayor Carter Harrison, who had once testified against police corruption.[5] The two figures stared at each other, engaged in a silent dialogue.

In 1956, the Police Monument was moved once again, and returned to the Haymarket area, two hundred feet west of its original location. The Chicago Police Department had lobbied for the monument to be moved back to Haymarket Square, but by the 1950s, a new disruptive force—the construction of the Kennedy Expressway—had carved up the downtown neighborhood, erasing many landmarks from the original site.

Haymarket Square, ca 1893, photogravure (LC–USZ62–134212, [b&w film copy neg.], LC–USZ62–29792 [b&w film copy neg.], Library of Congress)

May 17, 1963, Ceremony at the Police Monument at Randolph Street and Kennedy Expressway (Chicago History Museum)

Set among high-rise buildings, the monument rested on a special platform overlooking the freeway, on the north side of Randolph Street a block west of Desplaines. On May 5, 1965, the city council designated the monument a historical landmark, but this designation meant little to those set to start a new wave of attacks. The Police Monument soon fell prey to 1960s radicalism.

On October 6, 1969, the Weathermen, a radical, underground splinter of SDS (Students for a Democratic Society), stuck dynamite between the monument's legs and blew it up, sending the legs of the statue flying onto the freeway below.

Although the Weathermen had yet to make a statement, Sgt. Richard Barrett, president of the Chicago Police Sergeants Association, directed the blame toward SDS. In a statement (which was later retracted by his superintendent) Sergeant Barrett stated:

The blowing up of the only police monument in the United States by the anarchists . . . is an obvious declaration of war between the police and the S.D.S. and other anarchist groups. We feel that it is kill or be killed regardless of the Jay Millers [director of the Illinois ACLU], Daniel Walkers [author of a federal report that blamed the police for the rioting during the Democratic National Convention], and the so-called civil rights acts.[6]

In the midst of this mounting tension between the police and anarchists, Mayor Richard J. Daley ordered that the monument be rebuilt. In his statements to the press, he asked for private donors to help with the costs and eventually received funds from many, including the International Brotherhood of Teamsters and a number of other unions. On May 4, 1970, the statue was rededicated on the anniversary date of the Haymarket Riot. At the dedication ceremony, Daley told the crowd:

> This is the only statue of a policeman in the world. The policeman is not perfect, but he is as fine as individual as any other citizen. Let the younger generation know that the policeman is their friend, and to those who want to take law into their own hands, let them know that we won't tolerate it.[7]

The Weathermen apparently ignored Daley's threat because on October 6, 1970, exactly one year after they first demolished the monument, they blew it up again. This time, shortly after the blast, the press received a call from a Weatherman stating, "We destroyed the Haymarket Square Statue for the second year in a row in honor of our brothers and sisters in the New York Prisons. . . ."[8]

In what was clearly becoming a battle of sheer will and determination between the two sides, Daley ordered round-the-clock police security to protect the statue—at a $67,440 annual cost. The media ridiculed the twenty-four-hour guard, noting that there were more important matters for the police to attend to. This dilemma generated a series of imaginative and humorous ideas for how to protect the beleaguered monument, which included placing a large plastic dome over it, or casting a series of disposable fiberglass police statues, which could be easily replaced.[9]

Realizing that the monument would continue to be attacked as long as it remained in Haymarket Square, the city moved the Police Monument in February of 1972 to a new location—inside the lobby of Central Police Headquarters on Eleventh and State Street, where it was completely removed from public sight and a visitor's pass was required to view it. This location also proved to be temporary, and in 1976 it was moved again and placed within the exterior courtyard of the Police Academy at 1300 West Jackson. However, the massive concrete base for the monument remained at Randolph Street for two more decades, a *visual reminder* of how contested the space had been and continued to be.

## The Temporary Monument: Public Interventions 1972–2004

> "I really don't trust monuments."
> —Michael Piazza, organizer of the "Haymarket 8-Hour Action Series"[10]

The lack of a monument at Haymarket from 1972 to 2004 did not mean that the site was any less contested or active. For some, the empty site presented an opening to cast one's own perspective within public space. A monument, by its nature, is already defined, static, and rarely allows for participation.[11] A monument may allow for critique, for the viewer to respond to it, but it does not allow one to take an active role in adding to the dialogue and inserting one's voice into the landscape, unless of course one does something drastic. In this manner, monuments often define a singular point of view that shuts out other perspectives. The *lack* of a statue at Haymarket, however, allowed for multiple perspectives through the creation of ephemeral monuments—temporary actions, performances, and other types of decentralized public interventions—that many individuals and groups have undertaken to put forward different "unofficial" versions of the Haymarket history into the physical space

and the collective memory. These actions, lacking any type of permission or government role, were in many respects much more closely aligned with the ideals of the Haymarket martyrs.

One such action took place in 1996, just before the Democratic National Convention that was being held in Chicago. Kehben Grifter (who works with the Beehive Design Collective) and Evan Glassman created a small, hand-cut stone mosaic to the anarchist martyrs and installed it within the sidewalk at the Haymarket site without attempting to go through any official channels to obtain permission.[12] At the time, both were working nearby the Haymarket site and noticed that the sidewalks were being redone and that wet cement was in the process of drying, creating the perfect opportunity to install the mosaic. However, when

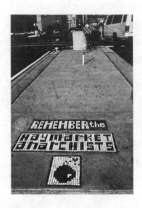

they went to place the piece, they were spotted by city workers and were questioned. They quickly talked their way out of trouble by citing names in the city bureaucracy and falsely stating that the project had been given city approval. To verify their claims, the workers called their superior and described the mosaic and its content. To the artists' luck, the city official did not comprehend the illicit nature of the project, and neither did he understand the mosaic's message or the significance of the Haymarket site. Better yet, the official insisted that the workers on site install the mosaic for them! For five weeks it remained at the Haymarket site and would likely have lasted longer had not a *Chicago Tribune* article brought attention to the mosaic, prompting the city to remove it.

*Remember the Haymarket Anarchists*, hand-cut stone mosaic installed at the Haymarket site, 1996 (Kehben Grifter)

The pedestal of the Police Monument was also removed in 1996, just before the Democratic National Convention. The city must have finally realized how inviting the site was and likely feared that a large demonstration would take place there. To many, the removal of the pedestal was a great loss, for it represented just how contested the history of the Police Monument had been, and it had served as a grand stage for performances and other public interventions. However, when the cement slab was removed, it left a giant circle, eighteen feet in diameter, clearly marking where it once stood. Artists quickly realized that the circle was an ideal stage.

Michael Piazza, a Chicago artist, employed the circle for the "Haymarket Eight-Hour Action Series" that he initiated in 2002. Piazza was inspired to launch the series after seeing the Chicago printmaker Rene Arceo perform on the circle during a May Day celebration. Arceo's performance was simple but poignant. He pulled up in a car, then ran up and started stomping on the circle as a crowd watched. Piazza's tribute to the "Arceo Stomp" was to put out a call inviting other artists to do separate eight-hour actions at the site. Piazza notes that:

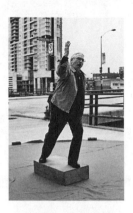

John Pitman Weber's reenactment of a Eugene Debs speech, part of the Haymarket Eight-Hour Action Series, 2002 (Michael Piazza)

Ever since 1986, I had been monitoring this blank pedestal and I realized that there was a division between a small group of people in town who knew what it represented, who had this local knowledge and

memory, while there was a whole other group who just thought it was an empty pedestal. That always fascinated me.[13]

Piazza reasoned that artists, with their talents and creativity, could reclaim this history and make it more visible. Yet after Piazza surveyed the site and measured the diameter of the circle, the city, either intentionally or coincidentally, paved it over, leaving no physical evidence of where the Police Monument had once stood. Undeterred, the first project of the Eight-Hour Action Series, involving Javier Lara and students from the School of the Art Institute, held a sewing bee at the site and constructed a large orange circle that became a visual reminder of the monument's existence. In other performances, the new circle served as a stage for a number of soapbox presentations, including William Adelman's historical presentation on Haymarket and John Pitman Weber's reenactment of a Eugene Debs speech.

Other performances that were part of Piazza's Eight-Hour Action Series used the circle as an end point. Larry Bogad did a project entitled *The Police Statue Returns* for which he created a giant puppet that resembled the original police statue. Bogad paraded the puppet along from the Daley Center, through downtown and eventually ending on Randolph Street. At the former location of the Police Monument, a large anarchist flag was placed over the circle in an act of reclamation.

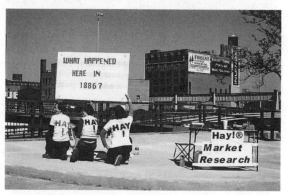

Lauren Cumbia, Dara Greenwald, and Blithe Riley, *Hay! Market Research Group*, part of the Haymarket Eight-Hour Action Series, 2002 (Michael Piazza)

Another Eight-Hour Action Series project that spoke of the changing dynamics within Chicago was *Hay! Market Research Group*, a collaborative action by Lauren Cumbia, Dara Greenwald, and Blithe Riley. The group set up a table and a sign on Randolph Street at the location of the former Police Monument. The sign acted as a visual component, similar to a billboard, which first caught people's attention. Various slogans on the sign were interchanged, including: "What Happened Here in 1886?"; "Guilt by Association: Who Died for Your Eight-Hour Workday?"; "4 Hung, 1 Suicide, 3 Pardons"; and "Public Hanging, Lethal Injection, Indifference?" Once people walked up to the information table, they could fill out surveys on Haymarket and issues that were connected to the present.

Javier Lara and students from the School of the Art Institute hold a sewing bee and create a large orange circle that marks the former location of the former Police Monument, part of the Haymarket Eight-Hour Action Series, 2002 (Michael Piazza)

In nearly every intervention, the artists involved were responding to far more than just the Haymarket history. These actions responded to the entire city landscape and the culture at large. For some of these performances, Haymarket was simply a starting point. Brian Dortmund's project for the Eight-Hour Action Series was a May Day bike ride that traveled from Haymarket to the Waldheim Cemetery. In subsequent years, Dortmund has continued to do the ride, but changes the route, so that the riders travel to different locations in the Chicago vicinity that are specific to labor and other radical struggles. In this manner, those who participated in the action formed a community, learned about various histories, engaged in dialogue, and had a shared experience.

The works in the Eight-Hour Action Series, as compelling and creative as they are, come with built-in limitations. Any action that is seen by such a small number of people has the potential to be easily forgotten and its effect may be minimal in creating widespread change. Mary Brogger's monument at Haymarket, installed in 2004, allows us to compare these two divergent approaches.

## Mary Brogger's Haymarket Monument: The Monument That Forgot Class Struggle

"I think we're showing a new way to do monuments at historic sites. You make them open rather than pressing a precise meaning on people or directing them toward a specific feeling or reaction"
—Nathan Mason, special projects curator of Chicago's Public Art Program[14]

Nathan Mason's quote accurately describes the scope and the vision of the new monument, sculpted by Mary Brogger, that now resides on Desplaines Street. The historic location, which had been empty for so long, now features an abstract monument of bronze, genderless figures colored in a red patina, constructing and deconstructing a wagon. At the base of the monument, a series of cautiously worded plaques explains the history of Haymarket. Its mere existence—a monument to Haymarket within a city that had long since refused to acknowledge the history except from the perspective of the police—is startling and leads us to wonder, Why now?

To better understand how this drastic change came to be, it is important to first examine the complicated decade-long process that led up to Mary Brogger's public artwork that was funded and approved by the city. When talking about the new monument's content, it is all too easy to focus attention on Mary Brogger, the sculptor herself. But it was the coalition of government agencies, labor organizations, and historians that first agreed upon a series of parameters that ultimately led to the monument's realization and the content that it would project. A key player in this process was the Illinois Labor History Society.

The ILHS had lobbied the city government for a permanent monument at the Haymarket site since the organization's founding in 1969. Despite the fact that the city and the police had created a formidable obstacle to any type of monument to Haymarket from the perspective of labor or anarchism, there were some in Chicago who were willing to challenge this blockade. Les Orear, a Packinghouse Union activist, and William Adelman, a labor his-

torian, decided to pool their resources and energy to form the Haymarket Workers Memorial Committee. This project soon became part of a larger vision, and on August 5, 1969, the Illinois Labor History Society was formed. The ILHS, along with other local activists, including Bill Garvey, an editor of the newspaper *Steel Labor*, began the long process of lobbying the city government for a monument at Haymarket that represented the position of labor. One of the first steps toward revitalizing interest in a potential monument was a public performance in 1969 at the site where the bomb had exploded in 1886. Studs Terkel stood on top of a makeshift wagon and spoke of Haymarket's history. Terkel's performance, a public intervention in its own right, would foreshadow the many future actions that would take place in ensuing decades as others reclaimed the space's history by means of temporary installations and performances.

Around the same time, the ILHS began organizing events at Waldheim Cemetery for people to meet and listen to speeches in front of the Haymarket Monument on significant dates that corresponded to Haymarket's history. The ILHS role of promoting Haymarket's labor history became even more "official" in 1973, when the deed for the Haymarket Monument at Waldheim was transferred to the ILHS from the last surviving member of the Pio-

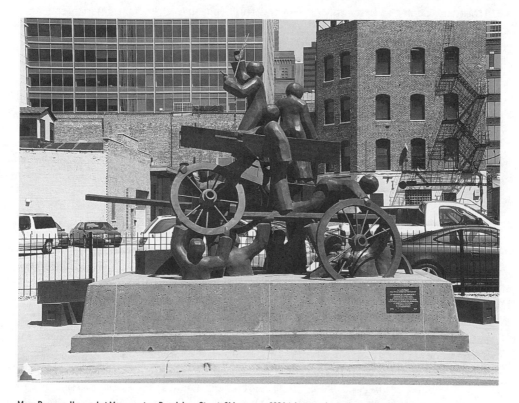

Mary Brogger, Haymarket Monument on Desplaines Street, Chicago, ca. 2006 (photograph courtesy of the author)

neer Aid and Support Association, Irving S. Abrams. The ILHS assumed the role of its owner and became responsible for the monument's upkeep and annual commemorations.[15] Yet as Lara Kelland notes, this was not without opposition:

> Anarchists have responded in kind. . . . A small group often appears at Waldheim during the ILHS events, jeering and interacting with the monument in an attempt to disrupt the proceedings in protest of the ILHS ceremonial work.[16]

Despite these constant jeers from anarchists, the ILHS made inroads in lobbying the City of Chicago to also have a monument to Haymarket commissioned at the original Haymarket site. This goal likely would have been reached had it not been for the untimely death in 1987 of Mayor Harold Washington, one of the rare high-profile politicians who advocated for the public recognition of Chicago's labor history.[17]

However, in 1998, the ILHS, which had teamed up with the Chicago Federation of Labor, found an unlikely audience in Mayor Richard M. Daley's administration. Daley (the son of Richard J. Daley, who had been mayor from 1955 to 1976) gave the go-ahead to listen to various proposals for a monument, and a coalition developed that would include representatives from the Chicago Historical Society and the Chicago Police Department. And rather than focusing attention on the anarchist martyrs, the police, the explosion of the bomb, or the subsequent trial, the group settled on the broad-based theme of a speaker's wagon representing "free speech." The wagon alluded to the place where Samuel Fielden had addressed the crowd on May 4, 1886, just before the bomb exploded, but the concept of free speech is much more elusive and abstract. Don Turner, who at the time was the president of the Chicago Federation of Labor, notes the significance of this choice for the proposal's eventual approval:

> I think the key issue was removing the focus from the anarchists and making it a First Amendment issue—though it's not unlike we still don't have anarchists.[18]

Turner further explained: "We brought everybody into the process—the police, the labor community, historians—and we came up with this idea of the wagon as the symbol of freedom of speech. That's how we really put our arms around it."[19] Everybody, that is, except the anarchists whose political forebears were at the heart of Haymarket's historical significance.

In 2000, with the concept established, funding was secured from a state program, Illinois FIRST, which designated $300,000 toward the project. By 2002, the project was under the jurisdiction of the "Haymarket Tragedy Commemoration of Free Speech and Assembly Monument," directed by Nathan Mason, the special projects curator for Chicago's Public Art Program. With the funding and theme in place, the next step was to select an artist to sculpt the vision that the committee had already established. Ten artists were selected to submit proposals, and an eight-member project advisory committee composed of representatives from

labor, the police, historians, and community members chose the local sculptor Mary Brogger.[20]

Despite the fact that this was Brogger's first figurative public commission, her Haymarket Monument satisfied the conditions of the committee's vision of a nonconfrontational monument focused on the speaker's wagon and free speech. Brogger states:

> I was pretty adamant in my own mind that it would not be useful to depict violence. The violence didn't seem important, because this event was made up of much bigger ideas than one particular incident. I didn't want to make the imagery conclusive. I want to suggest the complexity of truth, but also people's responsibility for their actions and for the effect of their actions.[21]

She further explained the symbolism and the message of the monument:

> It has a duality to it. From the standpoint of the wagon being constructed, you see workers in the lower part are working cooperatively to build a platform from which the figures on top can express themselves. And for the viewpoint of the wagon being dismantled, you see [how] the weight of the words being expressed might be the cause of the undoing of the wagon. It's a cautionary tale that you are responsible for the words you say.[22]

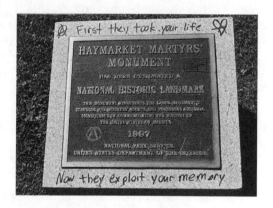

Graffiti on the plaque noting the National Historic Landmark status of the Martyrs' Monument at Waldheim, 1997 (Bogdan Markiewicz)

Brogger's comments are as ambiguous as the monument itself; they could be understood to say that the anarchist labor activists had it coming to them for directly challenging the power structure. Although Brogger clearly seems more troubled by the speech of the anarchists than the indiscriminate gunfire of the police, a focus on the artist is not helpful here. Brogger was a minor player in the ongoing debate over the new monument. In the majority of public art projects today, the artist is simply hired to carry out the subject matter and the content that someone else has already determined. The artist can add an aesthetic quality to the work, and only in this regard can we critique Brogger's efforts. Michael Piazza's humorous commentary describes her sculpture as a "Gumby version of a romantic Civil War memorial" but that aside, the real issue raised by her Haymarket Monument is the nature of public art itself and the pitfalls of allowing a small group of individuals to decide what is placed within civic spaces.[23]

The small committee of government agencies, historical societies, and labor organizations (the ILHS, the Chicago Federation of Labor, the Chicago Historical Society, and the Chicago Police Department) that agreed upon the monument's content was not a broad cross-section of the population. Instead, the process-by-committee was guarded and exclusive. For

example, only ten artists were invited to submit proposals for the design. However, the bigger issue was the exclusion of voices that might have differed with the committee's opinions. From the start, anarchists were shut out of the discussion. Nathan Mason, Chicago's Public Art Program curator for the project, remarked in early 2004, "Who would they choose to represent themselves?"[24] His dismissive comment indicates a lack of serious effort on the committee's part to solicit the input of anarchists and also assumes that the committee itself was more qualified to visualize Haymarket's history. The committee, with little effort, could have reached out to anarchists within Chicago and beyond. It didn't.

On September 14, 2004, the new monument was dedicated. Not surprisingly, the public reaction to the dedication was deeply divided.[25] During the official dedication ceremony, city officials, representatives of organized labor, and police officers were self-congratulatory with one another. A central theme of many of their speeches was reconciliation, the notion that the wounds of the past and the divisions between labor and the police were beginning to heal. A small group of anarchists in the crowd held up black flags to voice their disgust with the entire proceedings. Anthony Rayson was quoted in the *Chicago Sun-Times* as saying, "This is a revisionist history thing. They're trying to whitewash the whole thing, take it away from the anarchists and make it a free-speech issue."[26] A *New York Times* article quoted another dissenting voice in the crowd, Steve Craig:

> Those men who were hanged are being presented as social democrats or liberal reformers, when in fact they dedicated their whole lives to anarchy and social revolution. If they were here today, they'd be denouncing this project and everyone involved in it.[27]

Those present also heard Mark Donahue, president of the Chicago Fraternal Order of Police and a member of the monument's project advisory board, state, "We've come such a long way to be included in this. . . . We're part of the labor movement now, too, and glad to be there."[28] The question remains, however, would Donahue have said this had the monument given a more pronounced focus to either the anarchist martyrs or the class conflict between labor and the police that had resulted in the Haymarket riot?[29] Moreover, Donahue's notion of the police as having now become *part* of the labor movement is also duplicitous. While it is true that police officers are "workers" and are unionized, his comments promote the notion that the police and other workers in society share the same interests and class goals. Today, the police still protect the interests of capital and the state. At labor demonstrations, their batons and pepper spray fall squarely upon the heads of workers. Perhaps Donahue's biggest error was that he attempted to speak for a larger entity, when in fact he was speaking solely as an individual. Diana Berek, a Chicago-based artist and coeditor of *Chicago Labor and Arts Notes*, explains, "Individuals can reconcile their wounds, but not classes, not institutions, and certainly not the entities of organized labor and the police."[30]

If anything, Donahue's statements reinforce just how easy it is to oversimplify and blur history, especially events as complex as Haymarket. The new monument only adds to this confusion, and the attempt to make it appear objective is one of its greatest flaws, for it is not possible to be neutral on the issue of Haymarket. As Berek notes, "Battles for social justice,

conflicts around economics, and political class conflict will never be easy to tidy up so that they can be objectified, sensitized, and made emotionally uplifting to every point of view."[31] While much has changed over the 120 years since Haymarket, we do not live in a society where class conflict is a thing of the past. If anything, the division between the haves and the have-nots has become increasingly pronounced, and the methods for marginalizing working-class people, unions, and social movements have become increasingly sophisticated. A monument can proclaim that Haymarket was about free speech, but that does not make it necessarily true.

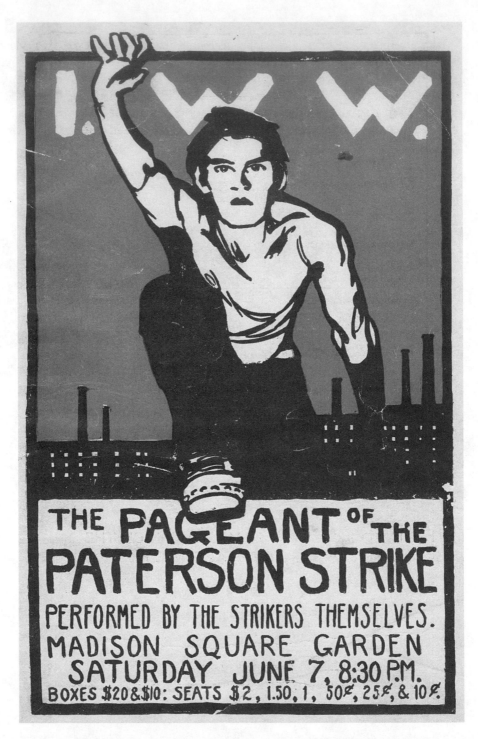

Robert Edmond Jones, Paterson Pageant program cover, 1913 (American Labor Museum/Botto House National Landmark)

# 9

# Blurring the Boundaries Between Art and Life

ON JUNE 7, 1913, an event occurred that completely blurred the boundaries between performance and protest. Journalist and poet John Reed led a procession of more than a thousand striking workers through the streets of Paterson, New Jersey, to board a special thirteen-car train destined for New York City. When they arrived in the city, they gathered for a rally at Union Square, followed by a march up Fifth Avenue toward Madison Square Garden, while the Industrial Workers of the World (IWW) band played "La Marseillaise" and "The Internationale."[1] On top of Madison Square Garden's tower, the IWW initials glowed in red lights. Inside, the venue was transformed into a Wobbly hall, with red IWW banners, sashes, and ribbons throughout the building. The stage included a massive two-hundred-foot painted backdrop of a large silk mill, flanked by smaller mills. Up and down the aisles, volunteers walked, selling copies of the program, *The Masses*, and other radical publications. When the house lights went down and the curtain opened, Reed went to work directing the massive crew of striker-actors and actresses—playing the role of themselves, reenacting their struggle—the Paterson strike *during* the strike itself.

Four months prior, 25,000 of their fellow workers had walked off their jobs in a strike that had crippled the Paterson silk industry. Workers had united over a number of issues that affected the lives of the ribbon weavers, broad silk weavers, and dyers. Together they protested the long hours (the ten-hour day), the three-to-four-loom system that replaced the double looms, the dangerous conditions of the dye houses, the "docking system" for female apprentices, and the different wage scales found within individual shops.[2] Combined, they went on strike.

IWW leaders had been invited in as strike organizers, arriving with much fanfare following the momentum of the Lawrence textile strike in Massachusetts in 1912, in which workers had won the majority of their demands, in part due to the leadership and tactics of the IWW. In Paterson, the IWW invited another group to help them in their efforts: Greenwich Village artists. This alliance led to the creation of a pageant—a theatrical performance to re-create recent history and

Strikers march up Fifth Avenue en route to Madison Square Garden, June 7, 1913 (UPI/Bettmann Newsphotos)

a production to make history—to help raise money for a strike relief fund, help publicize the strike, and help inspire the workers to continue to hold out.

Throughout the performance, the audience of 15,000 sang in unison with the cast and berated the police and the strikebreakers. On the main floor, a large central aisle led directly up to the stage, serving as a street for the cast of a thousand striking workers to march down, and was later utilized during a funeral scene. Here, the performers could stand side by side with the audience in unity, an action that further blurred boundaries: was the pageant indeed a drama, or had the strike itself been transported from Paterson to New York City? When IWW strike leaders Elizabeth Gurley Flynn, Bill Haywood, and Carlo Tresca addressed the crowd of 15,000, their speeches were similar, if not identical, to those they had given in the weeks and months prior in Paterson. Were they part of the drama or was it a recruitment pitch for the strike? These questions were what made the pageant so exceptional. It was also what made it so problematic. A pageant is not a strike, and vice versa, and the stakes were extremely high. A pageant could aid the workers' demands or it could harm them. Additionally, it could either help or harm the fragile alliance of those who came together to put on the pageant—striking workers, IWW organizers, and artists.

## Wobblies, "Poets," and Silk Workers

To understand the Paterson Pageant, one must first understand the IWW and what made the organization so unique and so critical. The IWW (nicknamed the Wobblies) was formed in 1905 in Chicago during a convention at Brand's Hall, where more than two hundred socialists, anarchists, and labor leaders gathered, including William "Big Bill" Haywood (secretary of the Western Federation of Miners), Daniel DeLeon (leader of the Socialist Labor Party), Mother Jones (organizer for the United Mine Workers), Eugene V. Debs (socialist labor leader), and Lucy Parsons (labor organizer and widow of the Haymarket martyr Albert Parsons).

Those in attendance established a revolutionary union meant to confront the capitalist class. The opening sentence of the preamble read: "The working class and the employing class have nothing in common." Instead of negotiating with the bosses, the IWW envisioned a new society based upon workers' cooperatives and free of capitalism, bosses, exploitation, and racism. The IWW set out to recruit workers that the American Federation of Labor (AFL) largely ignored—the unskilled, recent immigrants, women, and workers of non-European heritage.

The three years following the IWW's 1905 founding convention were marred by internal strife and defections that nearly spelled the demise of the organization. Eugene Debs allowed his dues to lapse. For many, a major point of division was whether the union should be affiliated with the electoral process and function as the labor arm of the Socialist Labor Party. Anarchists within the IWW opposed this direction and argued that the organization should remain outside electoral politics. Instead, anarchists advocated that the IWW organize a revolutionary movement through industrial unionism and general strikes. The 1908 convention sealed the split when the IWW sided with anarcho-syndicalism.

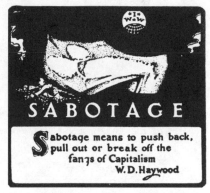

Unsigned, likely created by Ralph Chaplin, *Sabotage*, sticker, ca. 1910s (courtesy of Charles H. Kerr Publishers Company)

The split ensured that the IWW would not be a top-down organization and its structure would drastically differ from the majority of unions, where elected union officials held decision-making power over the rank-and-file membership. Instead, the IWW allowed for workers' control over their own affairs, and autonomy for the many branches that were spread out throughout the country (and world) that allowed them each to respond to their unique situation, location, and work conditions. However, a common spirit still existed throughout the many branches of the organization. Irving Abrams, an IWW member who helped organize the local in Rochester, New York, described this commonality:

> The priority . . . was agitation. That's what it was. The priority was let's bring the storm. . . . The idea was as long as you had the footloose rebel traveling from one place to another . . . you could make a big noise. That was the theory that was underlying at the time, more than anything else. It wasn't the idea to build a labor organization as such, per se. . . . While we talked about

unions, while we talked about industries, ultimately at that time, the slogan was, "Bring the revolution."[3]

IWW culture helped to spread this message. The Wobbly publication *The Industrial Worker* wrote in 1913, "The strength of the IWW is not in its thousands of memberships—it is in its revolutionary ideas as they are translated into action against the employing class and all its institutions."[4] Revolutionary ideas were broadcast through the written word, but also through songs, poetry, soapbox speeches, theatre, graphics, cartoons, posters, slogans, and stickers—all of which became part of the IWW's arsenal. Most significantly, IWW culture came from within. Culture was created from the bottom up. Hundreds, if not thousands, of different rank-and-file members created the culture—an approach that echoed the nonhierarchical structure of the union. Culture reflected the spirit of the Wobblies, but it also was part and parcel of IWW tactics. Culture kept a degree of unity and commonality among the many branches. It helped the IWW to maintain solidarity within, and promoted its goals far and wide to potential recruits, many of whom were migrant workers who traveled throughout the country in search of work. These migrant workers became the IWW artists, poets, and musicians.

---

In Paterson, the IWW entered a labor conflict where their membership numbers were not strong. Instead of organizing their own rank and file, a handful of talented IWW organizers—chief among them Elizabeth Gurley Flynn and Bill Haywood—served as tacticians and speakers to help a strike already in progress. Their role was to help with strategies and to give speeches that would keep up the workers' spirits during the hardships of the strike. This was critical, for workers who spoke out against their employers in public and through the press faced the threat of being blacklisted. IWW speakers from out of town did not face this threat. They could be arrested, but their livelihood was not on the line.[5] Eventually, 9,000 workers in Paterson signed up as card-carrying IWW members, but this should not confuse the fact that prior to the strike Paterson workers had little to no prior affiliation with the IWW.

The IWW leaders recognized this dynamic. During the strike a Central Strike Committee of two workers from each of the three hundred shops made the final decisions and ultimately led the strike. Bill Haywood stressed this point in an address to the workers at Turn Hall:

> I have come to Paterson not as a leader. There are no leaders in the IWW; this is not necessary. You are the members of the union and you need no leaders. I come here to give you the benefit of my experience throughout the country.[6]

Elizabeth Gurley Flynn also addressed the workers. At one point she delivered more than nineteen speeches during a one-week span.[7] Flynn, twenty-two years old at the time and al-

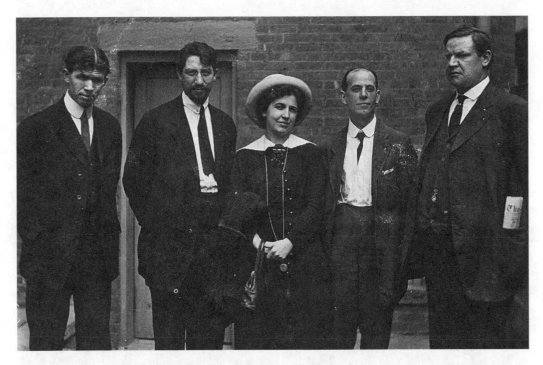

IWW leaders pause for a portrait during the Paterson Silk Strike, Paterson, New Jersey, 1913—left to right: Pat Quinlan, Carlo Tresca, Elizabeth Gurley Flynn, Adolph Lessig, and Big Bill Haywood (Joseph A. Labadie Collection, University of Michigan)

ready a veteran of labor struggles, having joined the IWW at age sixteen, helped break down the male-dominated labor movement by holding women-only meetings that encouraged women to assert their voices.

To Flynn and the IWW, the strike represented workers taking control of their own lives—a path toward worker control of industry and society. However, not all of the Paterson silk workers shared these same aspirations. To many, the strike was about "looms, wages and hours."[8] Thus, the immediate task at hand was to win the strike, to convince the workers to stay out on the picket line, and to hope that the will of the owners of the silk industry would break first.

This was a difficult task, for the strike had hurt manufacturers' profits, but it did not completely stop production. While the factories were shut down in Paterson, the owners continued to operate their mills in eastern Pennsylvania. As the strike wore on, workers and their families faced a dire situation: some were on the brink of starvation, and many were dependent upon relief funds for their subsistence. Other problems also existed: the strike received little national coverage, and when it did it was often from a pro-business, corporate perspective. The Paterson press and the New York papers blasted the IWW, vilifying them as outside agitators who had come from out of town and whom the workers had foolishly followed against their better judgment.

———

In response, the IWW and its allies in the bohemian artistic and intellectual subculture in Greenwich Village conceived of a project to counter the negative press attention around the strike: a pageant that re-created the strike for a New York audience. This production, they envisioned, could cast the struggle in a favorable light. It could also raise much-needed relief funds to sustain the strike.

Artists in Greenwich Village admired the IWW, but they did so largely from afar. They knew about the IWW from the Lawrence textile strike but they did not know them personally. This changed due to Mabel Dodge's weekly Wednesday-night salon gatherings. Dodge, a wealthy socialite who had spent the previous decade living in Florence, Italy, hosted weekly gatherings in her Greenwich Village home that attracted artists and writers, including those from the socialist publication *The Masses* and Emma Goldman's publication, *Mother Earth*. Wobbly strike leaders also frequented many of these gatherings. Dodge's salons, open to all, gave artists the chance to meet the IWW leaders, including Bill Haywood, who frequented the events, and this is where the idea for a pageant developed, although it remains open to debate if Haywood or Dodge was the first to suggest it.

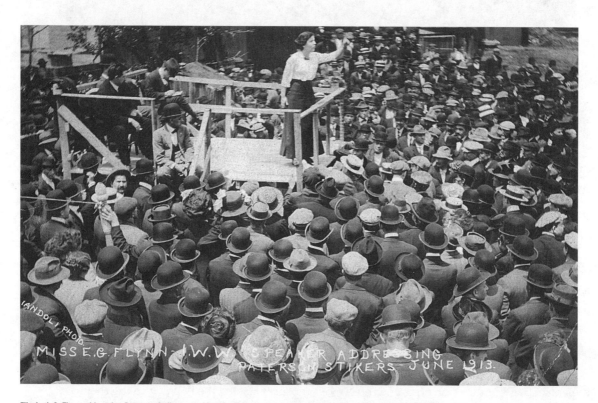

Elizabeth G. Flynn addressing Paterson Strikers, ca. 1913 (lpf0323, Joseph A. Labadie Collection, University of Michigan)

A key recruit to the project was John Reed. At the time, Reed was a twenty-six-year-old recent Harvard graduate who had moved to Greenwich Village in 1911. There he met Haywood, who invited Reed to Paterson to meet the strikers. In short order, Reed was arrested for refusing to vacate the streets during a picket outside the mill's gate. At his sentencing hearing, he was asked what his business was, being in Paterson. He replied, "Poet."[9]

Reed's answer did not keep him out of jail. He was given twenty days, but made bail after serving only four. During these four days, however, he received a valuable lesson in life—the reality of jail, juxtaposed with the solidarity of being part of a movement, imprisoned with more than a hundred other strikers, including Haywood and Carlo Tresca.

Reed's experience in jail had a profound effect on him. It inspired him to commit all of his energies to the cause of the Paterson strike and to reach out to like-minded artists he knew for their assistance. His recruits included John Sloan, who designed and painted a massive backdrop for a stage set, and Robert Edmond Jones, who designed the cover for the pageant's program. Dodge helped to raise funds to cover the steep production costs.

John Reed, ca. 1910–1915 (LC-B2-3521-4, Library of Congress)

Reed's task was also to direct the pageant, for which he wrote the script. Initially, he envisioned ten scenes that would tell the story of the strike from its early stages to the events leading up just prior to the pageant date. He set up shop in Paterson and rehearsed for weeks with more than a thousand workers. There, he practiced songs with them and navigated the difficult terrain of convincing the workers to re-create their own recent history. One striker, whose name was never noted in the interview, stated, "We know we can make a strike pageant because we're strikers. We're rehearsing every day, in the strike."[10]

Indeed, this became a moment that blurred all boundaries. Steve Golin explains:

> So close were life and art that at times they became indistinguishable. On Sunday in Haledon [the town just north of Paterson] the performers sang to a crowd larger than any that Madison Square Garden could hold. Was this the strike or a rehearsal?[11]

At times, witnesses to the events could not tell. Golin writes:

> During one of the last rehearsals, after strikers had filled all the roles—including the police—a New York reporter walked into Turn Hall and saw twenty big men charging a crowd of women and men and actually beating them, while the hall rang with boos. The reporter thought the police were breaking up the rehearsal and said so to a male weaver, who laughed and replied: "Police? Police nothing! They're just rehearsing the second tableau for the Pageant—that's all" . . . Completing the circle, a boy who was caught

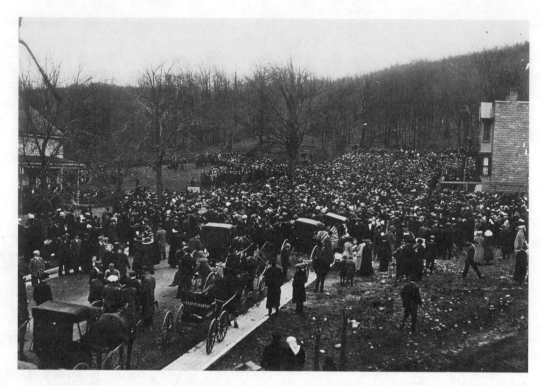

Meeting in Haledon in front of Botto house balcony, May 1913 (American Labor Museum/Botto House National Landmark)

booing a real Paterson policeman claimed in court that he was only rehearsing for the Pageant.[12]

Confusion was understandable; the rehearsal for the pageant had become part of the strike itself. The actual event in New York City would further complicate the matter.

———

The idea of transporting the strike to Madison Square Garden was not endorsed by all IWW leaders. Haywood had enthusiastically embraced the idea from the beginning, yet Elizabeth Gurley Flynn and Carlo Tresca were deeply skeptical of its overall benefit.[13] For one, financial concerns had existed up until stage time, when doubts were cast about whether the event itself would sell out. The high cost of the production had raised the ticket costs, placing it out of the range of many working-class people, prompting the organizers to drop the cost of many of the $1 to $3 seats to a quarter.[14]

The price reduction guaranteed a full house but left the profit margin in doubt. Regardless, the audience of 15,000 would not be disappointed with the show. The pageant opened with the start of the strike, followed by scenes of police violence, and the funeral of a fallen

worker. The third and fourth scenes included Haywood, Flynn, Tresca, and others reenacting speeches that they had given to the strikers, encouraging them to continue their hold-out. The fifth scene portrayed the evacuation of Paterson children to safe houses in New York City, and the last scene revolved around more speeches and the strikers vowing to continue their struggle.

When the pageant came to a close, it was likely that most, if not all, of the participants—performers and audience alike—were deeply moved by what they had seen. The New York press reflected this sense of optimism and largely hailed the pageant as a success. Many reviews were positive, and even the *New York Times* comment—that the production was meant to stimulate "mad passion against law and order"—could be construed as a compliment, an admission by the anti-IWW paper that the event had accomplished its intended goals.[15]

Other reviews understood that the pageant was unlike any event that had ever been witnessed before. The *New York Tribune* wrote, "Certainly nothing like it had been known before in the history of labor agitation . . . Lesser geniuses might have hired a hall and exhibited [a] moving picture of the Paterson Strike. Saturday night's pageant transported the strike itself bodily to New York."[16] And the *New York Evening Post* wrote, "It must be judged by its effect upon the performers as well as its effect upon the audience. Has any other art form so complicated a criterion?"[17]

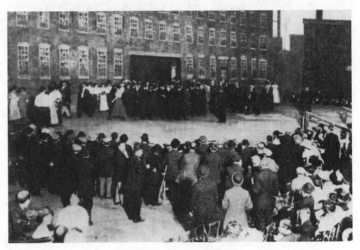

Pageant inside Madison Square Garden, June 7, 1913 (Tamiment Library and Robert F. Wagner Labor Archives and Radicalism Photograph Collection, Tamiment Library, New York University)

This review summarized the many complexities of the pageant, but in reality *any* press helped satisfy the IWW organizers' goal of generating more national publicity for the strike itself. The pageant had been devised to garner more press, to make new allies, and to raise much-needed money for the relief fund—all of which might hopefully break the deadlock within the strike.

The pageant succeeded in the first two goals, but not the last. A few days after the event, the pageant organizers learned to their dismay that the sold-out event had actually *lost* money. The high costs of the production had forced them to take out loans, and ticket sales and merchandise failed to generate enough of a profit. Dodge, Reed, and others had been frivolous with their spending and did not take the necessary precautions to make sure that the event earned a profit. They spent huge sums of money in renting Madison Square Garden, a special train, and an assortment of props. Fifteen thousand programs were printed at a high cost, yet the organizers didn't arrange for enough people to sell them on the night

of the show and ten thousand programs were later discarded. Additionally, the short three-week time span devoted to organizing an event of this scale was not enough time to cover all the bases needed to avoid any pitfalls.

The blame for the financial loss, however, fell largely upon the IWW, setting up a disastrous public-relations scenario that the corporate media took joy in exploiting. In Paterson, Haywood and other IWW leaders received a cold reception from the strikers, who expected that their work would at the very least generate money for the relief fund.

The strikers became even more inflamed when they learned that Reed and Dodge had bolted to Florence, Italy, the following day for vacation.

Reed later noted that he suffered from exhaustion and the trip was a way to recover both physically and mentally, but the timing was poor. To the silk workers who did not

have the opportunity to go on such a vacation, Reed's and Dodge's departure symbolized the privileged position that many Greenwich Village artists and intellectuals occupied, and contributed to the sense that their involvement had simply been temporary—that they could abandon the struggle at their own convenience. This was not the case with Reed—he remained active, reporting on and partaking in both the Mexican Revolution and the Russian Revolution. Yet, the message that Reed and Dodge conveyed had deep consequences that influenced not only the workers' impression of them, but the Greenwich Village scene itself; they jeopardized the trust

A. Lessig, Bill Haywood, Patterson, ca. 1913 (LC-B2- 2658-9 [P&P], Library of Congress, Flickr Commons Project)

and collaboration that had been built between the Paterson workers and the New York artists over the duration of the strike.

---

The strike collapsed seven weeks after the pageant, with workers returning to their jobs without making significant gains. The 25,000 silk workers and their families were in desperate need of food and holding out in these conditions proved to be impossible. During the aftermath of the strike, IWW organizers searched for answers as to what had gone wrong. Flynn offered her perspective in a speech entitled "The Truth About the Paterson Strike," delivered on January 31, 1914, at the New York Civic Club Forum.[18] Flynn examined a number of factors in the strike's collapse, one of them being the Paterson Pageant, which she referred to as both the high point of the strike's success as well as the source of its decline. She emphasized the loss in morale when funds were not received, but her other points are both

compelling, and contentious, for she raised doubts about the overall value of using art—a pageant—to aid with workers' struggles.

Flynn criticized the pageant for distracting the workers from focusing on the strike itself. She explained that while the workers were engaged in rehearsing, maintaining the picket lines was cast aside, allowing the first scabs to enter into the mills. She labeled the workers' shift in priorities as "turning to the stage of the hall, away from the field of life."[19]

Flynn also pointed out that while 1,000 strikers took part in the pageant, others were left behind. Her criticism was aimed at the Greenwich Village artists and intellectuals when she stated, "I wonder if you ever realized that you left 24,000 disappointed people behind? The women cried and said, 'Why did *she* go? Why couldn't I go?' . . . Between jealousy, unnecessary but very human, and their desire to do something, much discord was created in the ranks."[20] Flynn noted that the pageant itself was "splendid propaganda for the workers in New York," yet she stressed that its overall effect upon the strike was negative.[21]

Flynn's analysis, however, merits critique.[22] She failed to acknowledge the pageant's success in both generating press for the strike and the influence that it had on those who took part in the performance.[23] One wonders if her critique would have been so harsh had the pageant earned a substantial amount of money for the relief fund. More significantly, had the pageant raised money—would that have boosted the silk workers to victory?

A case can be made that it would not have. A boost in relief funds would have extended the strike, but the manufacturers showed little evidence that they would move from their position of nonnegotiation. Their ability to operate mills in Pennsylvania had allowed them to stonewall the strikers. Additionally, silk cloths were not viewed as a necessity and the general public was not exactly clamoring for an end to the strike.

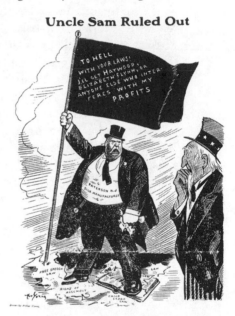

Art Young, *Uncle Sam Ruled Out* (*Solidarity*, June 7, 1913, courtesy of Charles H. Kerr Publishing Company)

The manufacturers were dead set against negotiating with the IWW, which they viewed as a hostile group of outside agitators who had misled Paterson workers—despite the fact that it was the workers who initiated and led the strike. Many workers might have been single-mindedly focused on their conditions, but the manufacturers clearly understood the larger implications of the strike. To them, it was *also* about broader class struggle. If the Paterson mill owners caved in to the IWW, other labor victories might follow in the future. At stake was maintaining management's position within the capitalist order. Manufacturers felt it imperative to confront the revolutionary tide of the IWW, immigrant workers, socialism, and anarchism, and they did so with the force of the government, the law, and the corporate press lined up behind them.

Paterson represented a major defeat for the IWW. Its reputation among workers suffered, and the months following the strike saw divisions and infighting within the organization. The year 1913 would mark the IWW's decline from prominence on the East Coast, and it never truly recovered.[24] After Paterson, the IWW turned its focus to the West, organizing migrant laborers in mining and lumber towns.

Paterson was also a tremendous loss for those who believed in the revolutionary potential of artists collaborating with working-class movements in the United States. The bitterness that swept Paterson poisoned the positive memories of the pageant and the possibilities that it presented. Artists involved with the strike had left the isolation of their studios and their small circles, and had used their talents for a greater cause. The defeat sent many of these same artists, although not all, back to the confines of their studios and isolated scenes.

Also forgotten was the initial reason for becoming involved. Hadn't artists become active with the Paterson strike because they were deeply inspired by the actions of the silk workers and signs that revolution was moving beyond theory and into practice? It had, and the Paterson strike gave artists the opportunity to actively engage in a working-class struggle of national and international significance.[25] However, the defeat of the strike made it seem as if the very involvement of artists with strikes was problematic—a notion that was further encouraged by Flynn's critique of the pageant.

This notion was one of the many tragedies of the Paterson strike for solidarity *matters*. The Paterson Pageant represented a unique collaboration between three different groups— artists, IWW organizers, and silk workers—each with their own strengths and weaknesses. This collaboration—an act in solidarity in itself—allowed each group to learn from the other, and forced them to question their previous biases and assumptions about each other.[26] The pageant gave these different groups the opportunity to work together, with each side contributing its own set of skills. It presented the opportunity for trust and understanding to exist between working-class people and bohemian artists, something that was as uncommon then as it is today.[27]

In Paterson this collaboration ultimately fell short, and a defeat—any defeat—raises doubts about the merits of specific alliances. In hindsight, one wonders what would have happened had the IWW allowed creative forms of resistance to emerge out of the 25,000 silk workers on strike? In Paterson, the IWW negated a key aspect of their own practice: allowing IWW culture to emerge from within—from their own workers. In Paterson, they brought in artists from New York City and "instructed" the silk workers how to use culture in their struggle. In essence, they placed greater trust in outsiders than the workers themselves. This decision caused anger and distrust to boil over when the pageant failed to deliver on its promise of funds, but the benefit of hindsight is always 20/20. What if the fragile alliance had worked? At the very least, the pageant served as a moment when outside artists *attempted* to aid a working-class struggle. It fell short, but the lessons should not be to abandon these types of alliances and acts of solidarity, it should be to improve upon them, and to persist, especially in defeat.

# 10

## *The Masses* on Trial

IN THE 1910S, THE GREATEST threat to labor and anticapitalist movements was the United States' entry into World War I. War, as it always seems to do, brought forth a tidal wave of patriotism that the government used as an excuse to stifle dissent.

World War I is particularly extreme example. President Woodrow Wilson lobbied heavily for the passage of the Espionage Act in 1917 and the Sedition Act in 1918, which made speaking out against the war illegal. Part of section 3 of the Espionage Act reads:

> Whoever when the United States is at war, shall willfully cause or attempt to cause, or incite or attempt to incite, insubordination, disloyalty, mutiny, or refusal of duty, in the military or naval forces of the United States, or shall willfully obstruct or attempt to obstruct the recruiting or enlistment services of the United States, and whoever, when the United States is at war, shall willfully utter, print, write or publish any disloyal, profane, scurrilous, or abusive language about the form of government of the United States or the Constitution of the United States, or the military or naval forces of the United States, or the flag of the United States, or the uniform of the Army or Navy of the United States into contempt, scorn, contumely, or disrepute, or shall willfully utter, print, write, or publish any language intended to incite, provoke, or encourage resistance to the United States . . . shall be punished by a fine of not more than $10,000 or the imprisonment for not more than twenty years, or both.

These acts were part of the "Red Scare," a domestic battle against antiwar and anticapitalist activism. The weight of these draconian laws came down especially hard upon labor leaders, socialists, and anarchists. More than 2,000 people were persecuted under the Espionage Act.[1]

In 1919, Eugene V. Debs of the Socialist Party was sentenced to ten years in prison, and served three, for making a speech that obstructed recruiting. In 1920, he campaigned for president from a

prison cell in Atlanta and received 913,664 votes (3.4 percent), the largest total ever for a Socialist Party presidential candidate in the United States. His famous campaign pin featured a portrait of him behind bars with the slogan, "For President Convict No. 9653."

Also during the Red Scare, Industrial Workers of the World (IWW) members became, in the words of labor historian Franklin Rosemont, "members of what is probably the single most incarcerated organization in US history."[2] In September 1917, the government raided IWW offices in more than fifty cities in an attempt to destroy the organization. Documents and artwork were seized or destroyed and leaders were rounded up, put on trial, sent to prison, and sometimes killed. All told, more than one thousand IWW members would be arrested under the Espionage Act.

FELLOW WORKERS:

Remember!

WE ARE IN HERE FOR YOU; YOU ARE OUT THERE FOR US

Ralph Chaplin, poster for the IWW defense effort, (*Solidarity*, August 4, 1917, courtesy of Charles H. Kerr Publishing Company)

The Espionage Act ensured that war resisters would be jailed, and that antiwar publications would be banned. This was the fate of the socialist magazine *The Masses*, founded in 1911, and silenced in 1917 after government harassment forced it out of business. During its run, however, *The Masses* was a vital publication, a clearinghouse of radical art and politics, one that painted a picture of the spirit of dissent found in the 1910s, prior to World War I.

Located in Greenwich Village—the epicenter of bohemian culture in New York in the 1910s—*The Masses* was a group of artists and writers who sought to promote both socialism and individual free expression. In an eclectic format, political essays coexisted with poetry and visual art, some of which was didactic, some more experimental and whimsical. The subtext of the magazine was an internal conflict over its identity. Was it a socialist publication dedicated to revolutionary politics and working-class movements? Or was it a journal that honored the creative arts, expressed through the spirit of bohemian lifestyles and individuality? This dilemma was never truly resolved, creating tension from within the group and generating criticism from outside; yet this hybrid approach was precisely what made the publication so vital.

*The Masses* was unique, for it embraced the socialist movement while rejecting the doctrine of a strict ideological stance, rejecting both the Socialist Party line and the conservative cultural norms of the day.[3] Other publications filled the role of party building, most notably the *International Socialist Review* and magazines that followed in the wake of *The Masses*—*The Liberator* and *The New Masses*. Yet *The Masses* was different, for it chose to operate around the periphery of socialism. There, it could both critique and champion the socialist movement. Most important, it made individual freedom the ground rule for its engagement in the movement.

*The Masses* was unique, but it was not the first socialist magazine to merge politics with art and poetry. *The Comrade* (1901–1905) had earlier blazed this path and was more utopian

with its message. Prints by the British artist Walter Crane complemented poems and essays from people ranging from Walt Whitman and Jack London to Eugene Debs and Mother Jones.[4]

*The Comrade* was ahead of its time, but a small circulation of only a few thousand copies limited its overall influence, and after four years of existence it merged with the *International Socialist Review*. The *Review* (a Chicago-based Charles H. Kerr publication) had also pioneered the use of visual art within a political magazine, primarily photographs taken by amateurs documenting labor strikes. *The Masses* followed more closely in the footsteps of *The Comrade* and utilized illustrations as a central feature.

Piet Vlag (a Dutch immigrant who championed small workers' cooperatives) founded *The Masses* in 1911, and for the first year it existed as a relatively safe and mainstream socialist publication. Vlag's tenure was short-lived. The magazine failed to generate much interest, and he left the

· A · GARLAND · FOR · MAY · DAY · 1895 ·
· DEDICATED · TO · THE · WORKERS · BY · WALTER · CRANE ·

Walter Crane, *A Garland for May Day*, 1895 (Interference Archive)

project behind him. Luckily, artists on the staff, including Art Young and John Sloan, resurrected the magazine and recruited Max Eastman (who at the time was a philosophy instructor) to become the editor in December 1912, a job opportunity that started without pay.

Eastman wanted both to move the publication toward the far left and to "make *The Masses a popular* Socialist magazine—a magazine of pictures and lively writing."[5] Key artists, in addition to Young and Sloan, included Maurice Becker, Henry Glintenkamp, Robert Minor, Boardman Robinson, and two artists who would, along with Sloan, later become synonymous with the Ashcan School: Robert Henri and George Bellows. All of these artists donated their time and energy, and the magazine honored both their politics and their art. The layout of the art was exceptional, as was the printing quality and the space afforded to the images.

Most important, the magazine belonged to the artists. Decisions, including which images and articles were to be included, were voted upon, although the editor's opinions carried more weight. The credo of *The Masses* at the time that Eastman took over as editor read:

> A revolutionary and not a reform magazine; a magazine with no dividends to pay; a free magazine, frank, arrogant, impertinent, searching for true causes; a magazine directed against rigidity and dogma wherever it is found; printing what is too naked or true for a money-making press; a magazine whose final policy is do as it pleases and conciliate nobody, not even its readers—there is room for this publication in America.[6]

An average of 14,000 readers a month supported this sentiment. *The Masses* reached out to a middle-class audience, those in the loop and those who had yet to commit to socialism.[7] *The Masses* hoped that their editorials, essays, poems, and illustrations would persuade many to join the socialist movement. Their approach was to publish a wide array of stories and art to appeal to a wide audience. Eastman emphasized this point:

> We shall print every month a page of illustrated editorials reflecting life as a whole from a Socialist standpoint. . . . In our contributed columns we shall incline towards literature of especial interest to Socialists, but we shall be hospitable to free and spirited expression of every kind—in fiction, satire, poetry and essay.[8]

A commitment to free expression was what made the magazine so important, but it also left it open to criticism by those who desired a more disciplined approach to revolutionary organizing and Socialist Party–building. One conservative socialist critic, W.J. Ghent, wrote that *The Masses* mixed:

Bain News Service, *Max Eastman*, no date recorded (LC-DIG-ggbain-05770, Library of Congress)

> Socialism, Anarchism, Communism, Sinn Feinism, Cubism, Sexism [free love], direct action and sabotage into a more or less homogenous mess. It is peculiarly the product of the restless metropolitan coteries who devote themselves to the cult of Something Else; who are ever seeking the bubble Novelty at the door of Bedlam.[9]

Another letter mailed to the magazine, in November 1916, took aim at its choice in lifestyle as truncating its sincerity to politics. "As to your actual ideas, you are, I fear, merely sentimentalists in revolt. The poses that you assume may be indigenous to Greenwich Village, but they can only repel everyone who is seriously at work."[10]

This letter had a point. The commitment of *The Masses* to controversial issues, including its support of free love and birth control, did alienate certain people, including some industrial workers and recent immigrants who tended to be more socially conservative. Yet the letter failed to recognize *The Masses'* genuine commitment to revolt through cultural resistance. Lacking in the letter's analysis is that culture works in tandem with politics, and can influence public opinion in ways that politics alone cannot. *The Masses* consistently challenged societal norms—from conservative attitudes over marriage, dress, sexuality and birth control to the public willingness to embrace the government's entrance into World War I.[11]

*The Masses* covers expressed the magazine's uncompromised position and its commitment to a wide range of approaches and ideas. Some covers were politically vague—an image of fashionable women, for example—whereas others responded to political flash points. One of the more riveting cover illustrations to appear on *The Masses* was John Sloan's drawing for the June 1914 issue; it depicts the Ludlow Massacre in Colorado, which had taken place only five weeks before, on April 20, when the Colorado National Guard opened fire on

a tent colony of 1,200 striking coal miners and their families, killing an estimated eighteen men, women, and children.[12]

Sloan's illustration depicts a miner as he holds a dead child in his arms. Behind him, the sky is ablaze with flames. Everything about the image is meant to elicit sympathy toward the striking miners. Below the illustration, the title of Max Eastman's article, "Class War in Colorado," further framed the meaning of the illustration.

These types of stories and illustrations made *The Masses* a target for governmental scorn and censorship. The Magazine Distributing Company in Boston and the United News Company in Philadelphia refused to carry it, as did two major distributors for the New York City subway stands, ostensibly because they objected to a poem and a cartoon that they deemed unpatriotic and blasphemous.[13] Likewise, the Canadian mails refused to deliver it.

The Associated Press (AP) went after Art Young and Max Eastman for a cartoon and an editorial that blasted the AP for siding with the interests of the government and corporate power during a coal miners' struggle in West Virginia in 1913. Young's image depicted the Associated Press pouring a bottle of lies into a reservoir that a large city depended upon for its news information, and Eastman explained the story in an editorial entitled "The Worst Trust."[14] The case might have gone to court, but the AP backed away from pressing charges for libel when supporters rallied around Young and Eastman, and realized that press coverage from the court case would likely do it more harm than good.

Yet these attacks seem trivial compared to the internal strife at *The Masses*, which came to a head in 1916. John Sloan and a number of other artists, including Stuart Davis, resented the fact that the editors would add captions beneath their drawings. They argued that the captions compromised their artistic independence and obstructed the open-ended reading of the illustrations. At the core of the debate was whether the content of the magazine should fulfill socialist propaganda needs, or if some items could stand alone as art and poetry, regardless of whether it included radical content. This dispute was ironic, for the strength of the publication was the fact that it honored both.

Nonetheless, egos got in the way. Pay also created friction. Max Eastman and Floyd Dell, the managing editor of *The Masses*, were paid a monthly salary, but the visual artists did not receive any financial compensation. Sloan argued for more monthly meetings and the elimination of the position of the editor and the managing editor. However, Eastman countered that everything could not be done by consensus, that the editor had to make decisions over the quality of submissions whereas consensus would mire the entire process in endless debates. He also justified his salary based upon the work that he did in fund-raising and the daily operations of running the magazine.

The division was not simply between artists and editors. Art Young, one of the main illustrators, blasted those in Sloan's camp: "To me this magazine exists for socialism. That's why I give my drawings to it, and anybody who doesn't believe in a socialist policy, as far as I go, can get out."[15] In the end, socialism won. The group voted in favor of Eastman, ultimately resulting in Sloan, Stuart Davis, Glenn O. Coleman, and others walking away from the magazine.

Their departure proved to be relatively inconsequential, as other talented artists, including Robert Minor and Boardman Robinson, were brought into the fold. The renewed

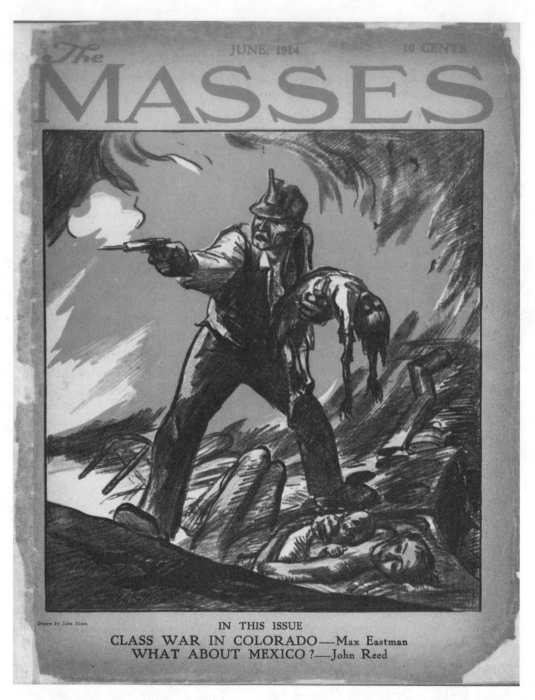

John Sloan, *Ludlow, Colorado* (front cover of *The Masses* 5, June 1914, courtesy of American Radicalism Collection, Michigan State University Libraries)

*Masses* became even more dedicated to politics, and advocated strongly against the U.S. entry into World War I. Floyd Dell vocalized the importance of the magazine's antiwar stance:

> All that could be done was, in a world gone insane, to keep alight a little flame of intelligence—to keep on telling the truth as long as we could. . . . And *The Masses* became, against that war background, a thing of more vivid beauty. Pictures and poetry poured in—as if this were the last spark of civilization in America. . . . A few of us could be sane in a mad world.[16]

*The Masses* labeled the conflict as a "bankers' war," a war that served the wealthy at the expense of working-class people, regardless of their nationality.

This position was consistent with that of the Socialist Party of America, which denounced World War I at an emergency convention in St. Louis in 1917. Yet this position was not universal among socialists. Many socialists feared that an antiwar stance would erode support for socialism and that it would potentially open them up to government harassment. This fear became a reality for many socialists, including *The Masses*, in 1917.

In July, the United States Postal Office informed *The Masses* that the August 1917 issue would not be allowed access to the mails. The Post Office claimed that the issue had violated the Espionage Act and urged the government to prosecute. Specifically, the Post Office claimed that four cartoons and four editorials were treasonous.[17]

Those charged included Max Eastman, for an article about resisting the draft; Floyd Dell, for writing a foreword to a collection of letters by conscientious objectors in English prisons; John Reed, for an article on the high levels of mental illness found among soldiers; and Josephine Bell, for a poem celebrating Emma Goldman and Alexander Berkman. Merrill Rogers was indicted for simply being involved with the publication. Finally, Art Young and Henry Glintenkamp were charged for cartoons that were deemed seditious material.

Art Young's cartoon "Having Their Fling" was singled out for ridiculing the hypocrisy of people in power, including a politician, editor, businessman, and a minister who preach dignity and goodwill while at the same time supporting the carnage of warfare.

Will Hope, *Glory* (front cover of *The Masses* 8, June 1916, courtesy of American Radicalism Collection, Michigan State University Libraries)

Glintenkamp's offending cartoon, "Physically Fit," depicts a skeleton measuring a young soldier for his coffin size before the soldier goes off to the war.

The image did not stray far from reality—it referenced a mainstream newspaper article noting that the Army had placed a large order for coffins in anticipation of a high death toll.[18]

The looming April 15, 1918, court date did not stop *The Masses* from continuing to voice its dissent against the war. The September 1917 issue mocked the Post Office's refusal to carry the August issue, and a statement on the back cover let readers know that *The Masses* would not be easily intimidated:

> Twelve to fifteen hundred radical publications have been declared unmailable. *The Masses* is the only one which has challenged the censorship in the courts and put the Government on the defensive. Each month we have something vitally important to say on the war. We are going to say it and continue to say it. We are going to fight any attempt to prevent us from saying it. *The Masses* has proved in the last few issues that it stands as the foremost critic of militarism.[19]

Robert Minor, *Army Medical Examiner: "At Last a Perfect Soldier!"* (back cover of *The Masses* 8, July 1916, courtesy of American Radicalism Collection, Michigan State University Libraries)

The threat of jail did not dim their sense of humor. Those facing indictment mailed postcards to one another that read "We expect you for the—ssh!—weekly sedition. Object: Overthrow of the Government. Don't tell a soul."[20] Not to be outdone, Art Young circulated a form letter that read "Dear Bill: Come to the conspiracy Tuesday night. Yours, The Conspirators."[21]

The trial itself, held in New York City, also had moments of pure absurdity. On the first day of the trial, the solemn mood of the courthouse was disrupted by patriotic songs that echoed from outside provided by a band (unrelated to the trial proceedings) that was hired to help sell Liberty Bonds on the busy New York streets. Merrill Rogers decided to poke fun at the irony of the situation by jumping from his seat and saluting the flag every time "The Star-Spangled Banner" was played. This was not exactly the behavior the jury might expect from someone being charged with sedition against the government.

Art Young offered even more comic genius. Falling asleep during most of the trial, his first impulse upon waking up was often to sketch scenes from the courtroom as if he were

a reporter. His best courtroom drawing, entitled "Art Young on Trial for His Life," depicts him sound asleep in his chair.

One of Young's lawyers, Dudley Field Malone, later attempted to sell the jury on Art Young's congenial personality by stating, "Everybody likes Art Young. Look at him. There he sits—like a big friendly Newfoundland dog. How could anyone conceive of him playing the role of a conspirator?"[22]

Floyd Dell also proved difficult to cast as a conspirator. His opinions against the war had changed drastically once Germany had attacked the Soviet Union, inspiring him to enlist in the military. Dell believed the war "was going to help Soviet Russia and the cause of Revolution."[23] These views may seem naïve today, considering how authoritarian the Soviet Union became, but at the time, the promise of what appeared to be a genuine worker-led coup in Russia in 1917 inspired people throughout the world to support the Bolshevik Revolution. Furthermore, Merrill Rogers had come to support the war; as did Max Eastman, who bent over backward to express his shift toward patriotism when he appeared in court on charges of violating the Espionage Act:

> My sentiments have changed a great deal. You notice when it [the national anthem] was played out there in the street the other day, I did stand up. Will you let me tell you exactly how I felt? I felt very sad; I felt very solemn, very sorrowful because I thought of those boys over there dying by the thousands, perhaps destined to by the millions, with courage and even with laughter on their lips, because they are dying for liberty. And I thought how terrible a thing it is that while they are dying over there . . . the Department of Justice should be compelling men of your distinguished ability, and others like you, all over the country, to waste their time persecuting upright American citizens, when they might be hunting up spies in this country, and prosecuting them.[24]

However, Eastman's comments in court did him little good. He alienated himself from many of his supporters, including John Reed, who was so revolted by Eastman's comments, and his support for Wilson, that he resigned from the magazine.[25] The judge, Augustus Hand, also showed little sympathy. He advised the jury as they deliberated, "And so, gentlemen of the jury, I confidently expect you to bring a verdict of guilty against every one of the defendants."[26] Forty-eight hours later, the jury of twelve returned without a verdict. Although ten had cast a guilty vote, two jurors refused to cooperate, resulting in the case being deemed a mistrial, and the stage was set for a second trial against *The Masses*.

Art Young, *Having Their Fling* (*The Masses* 9, September 1917)

Henry Glintenkamp, *Physically Fit* (*The Masses* 9, October 1917)

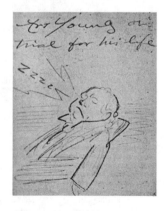

Art Young, *Art Young on Trial for His Life* (*The Liberator*, June 1918)

Crystal Eastman, Art Young, Max Eastman, Morris Hillquit, Merrill Rogers, and Floyd Dell outside courthouse, ca. November 1917 (*New York Call,* November 22, 1917)

The second trial differed from the first and placed more emphasis on putting the war itself on trial. This time John Reed was present. He had missed the first trial while he was in Russia, but made the decision to return to the United States and face prosecution with his comrades.

All of the defendants assumed that they would be convicted, but once again the jury could not reach a verdict, resulting in another mistrial. One juror remarked to the defendants, "It was a good thing for you boys that you were all American-born; otherwise it might have gone pretty hard with you."[27] This comment illuminates the privileged position that many of the artists and editors of *The Masses* held. Their politics went against mainstream America, but they also shared many similarities to the jury that determined their fate. They were white, middle-class, and well educated. Had they not been, it is unlikely that they would have been spared.

The courtroom trials spelled the end of the magazine. The U.S. Postal Service, fulfilling the Red Scare tactics of the federal government, ended *The Masses,* declaring that it was no longer in circulation because it had not been in circulation during the month of August. Denied access to the mails, *The Masses* could not stay financially afloat. In 1918, *The Masses*

resurrected itself as *The Liberator*, and continued until 1924, but *The Liberator*'s content and approach differed greatly from *The Masses*. *The Liberator* included art, but the overall content of the magazine showed blind support for the Bolshevik Revolution—a direction that was cemented when the publication was turned over to the Workers' Party in 1922. Another follow-up publication, *The New Masses* (1926–1948), took this approach to the extreme, becoming an organ for the Communist Party USA. Gone was *The Masses* that had reached a middle ground—open to both activism and bohemian culture—one whose credo in 1913 boldly stated: "A magazine directed against rigidity and dogma wherever it is found." Those days ended with the First Red Scare, the Russian Revolution, and World War I.

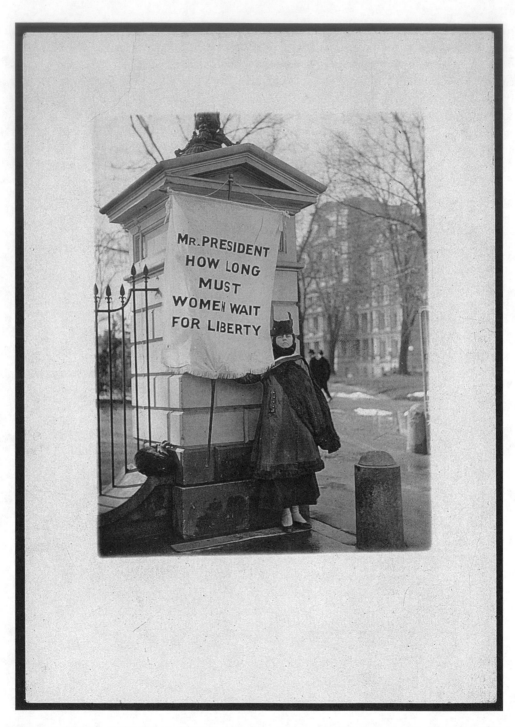

"Silent sentinel" Alison Turnbull Hopkins at the White House on New Jersey Day, January 30, 1917 (photograph published in *The Suffragist*, 5, no. 56, Feb. 7, 1917)

# 11

## Banners Designed to Break a President

ON JANUARY 10, 1917, the National Woman's Party (NWP) initiated the first-ever long-term picketing of the White House. Twelve women, led by Alice Paul, went to the east and west entrances in the midmorning, where teams of three stood silently by each side of the two gates. Dressed in all white, they stood with two four-by-six banners attached to long poles. One banner read: MR. PRESIDENT, WHAT WILL YOU DO FOR WOMAN SUFFRAGE? The other: MR. PRESIDENT, HOW LONG MUST WOMEN WAIT FOR LIBERTY? President Woodrow Wilson reacted as the women hoped he would when he passed by in his motorcade. He was surprised, and unnerved that well-dressed, middle-class women would stand in the cold and picket his residence. His response was to invite them in for hot tea. The women refused.

The next day more women from the NWP returned with banners. One featured the quotation "Resistance to tyranny is obedience to God." Susan B. Anthony had said this to a federal court in 1873 when she was tried for attempting to vote.[1] Another simply stated DEMOCRACY SHOULD BEGIN AT HOME.

The White House pickets would continue for the next three years. Doris Stevens summarized their effect: "What politicians had not been able to get through their minds we would give them through their eyes . . . Our first task seemed simple—actually to show that thousands of women wanted immediate action on their long delayed enfranchisement."[2]

---

The public call for woman's suffrage had been voiced for more than a half century. In 1848, the Woman's Rights Convention in Seneca Falls, New York, adopted a resolution calling for the right to vote. Among those gathered were Elizabeth Cady Stanton, Lucretia Mott, and Frederick Douglass. Advocacy groups followed in these footsteps, most notably the National Woman Suffrage Association (led by Stanton and Anthony) and the American Woman Suffrage Association (led by Lucy Stone) that combined forces as the National American Woman Suffrage Association (NAWSA) in

1890. NAWSA pushed for states to pass suffrage amendments. It found modest success in the West; in 1869, Wyoming became the first state to pass a suffrage amendment while still a territory. Its territorial legislature declared, "We will remain out of the Union a hundred years rather than come in without the women."[3] Other western states followed their lead and passed their own amendments: Utah (1870), Colorado (1893), and Idaho (1896). However, from 1896 to 1910, the movement stalled: no new states won amendments and the six states that attempted all failed.[4]

In the 1910s, the movement was reenergized, in part, by the experiences of American women who took part in the British woman's suffrage movement. In England, the Women's Social and Political Union (WSPU), led by Emmeline Pankhurst, demanded the vote in ways that the media and the male power structure could not ignore: they employed civil disobedience and violence. WSPU tactics included pickets, shouting down politicians, hunger strikes in jail, smashing windows, destroying property, burning down buildings, and destroying art by disfiguring sculptures and slashing paintings. Two Americans, in particular, were forever changed by their experience in England: Alice Paul and Lucy Burns, both of whom would become leaders in the American movement.

Alice Paul, ca. 1915 (photograph published in *The Suffragist* 3, no. 52, Dec. 25, 1915)

Paul was a Quaker who was committed to nonviolence and women's rights. She was a trained social worker and had been jailed with the Pankhurtsts in England. In 1910, while in her later twenties, she returned to the United States and brought with her the militancy of the British movement. She went to work in 1913 with the NAWSA-affiliated Congressional Committee that was renamed the Congressional Union later that year.

One of Paul's first responsibilities was to organize a national suffrage parade in Washington, DC, on March 3, the day before President Wilson's inauguration. Her direction ensured that the event would create a highly choreographed *visual* spectacle that foreshadowed how women would keep the issue of suffrage before Wilson throughout his presidency.

Prior to the event, city officials had tried to route the parade down side streets, but Paul had refused. Instead, she had it directed down Pennsylvania Avenue from the U.S. Capitol Building to the White House. The theme of the parade, "The Ideals and Virtues of American Womanhood," focused on women as active participants in society. She instructed the 5,000 to 8,000 participants to dress in a single color based on their occupations or group affiliation: factory workers, doctors, artists, teachers, and various organizations and colleges. She had tried to discourage African American women from taking part in the event, but when they refused, she moved them to the back of the parade—indicative of how leaders in NAWSA, and later the NWP, completely turned their back on African American women.[5]

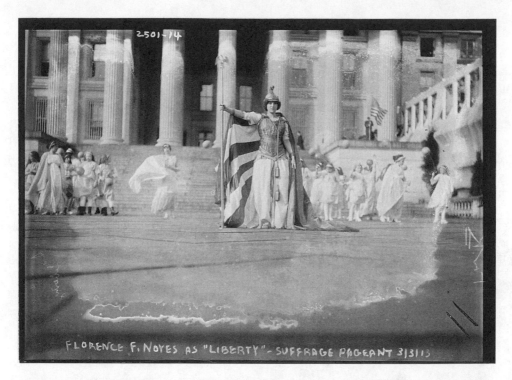

Bain News Service, publisher. "[Hedwig Reicher as Columbia] in Suffrage Pageant," March 3, 1913 (LC-B2- 2501-14, Library of Congress)

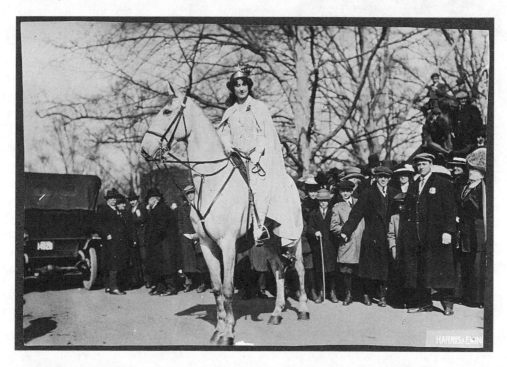

Harris and Ewing, Washington, DC. "Inez Milholland Boissevain Preparing to Lead the March 3, 1913, Suffrage Parade in Washington, DC," March 3, 1913 (photograph published in *The Suffragist* 8, no. 8, Sept. 1920)

The most prominent *visual* element of the parade became the participants themselves—the primarily white, middle-class women—marching in the streets for suffrage. Situated in the front were the NAWSA leaders. Behind them were thousands of marchers, twenty-six floats, six golden chariots, ten all-women bands, a model of the Liberty Bell, and a banner behind it that read WE DEMAND AN AMENDMENT TO THE CONSTITUTION OF THE US ENFRANCHISING THE WOMEN OF THE COUNTRY.[6] Inez Milholland, a New York labor lawyer, presented a striking image, dressed in a white robe and riding a white horse.

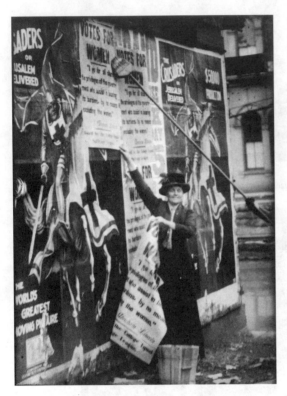

Bain News Service, publisher, "Suffragettes Posting Bills," ca. 1910–1915 (photograph published in *The Suffragist* 5, no. 83, Aug. 25, 1917)

Before the parade, Harriot Stanton Blatch had stated, "We wished to make the procession a great emotional appeal. The enemy must be converted through his eyes."[7] Instead, an unruly crowd of men largely rejected their demands. During the event, thousands of men lined the streets; some berated the women marchers with insults, projectiles, and physical attacks while the police stood idly by. The end result was a storm of media coverage, a much greater focus on woman's suffrage, a congressional hearing on the failure by the police to protect the marchers, and a movement more committed than ever to lobby for woman's suffrage.

In 1914, Alice Paul and Lucy Burns were kicked out of NAWSA for being "too British."[8] Immediately thereafter they formed the Congressional Union as an independent organization with its headquarters based in Washington, DC. The Congressional Union—renamed the National Woman's Party (NWP) in 1917—became the antithesis of NAWSA, whose cautious approach was to politely lobby government officials, including the president, for change. Under Paul's leadership, the NWP meanwhile embraced nearly all of the British suffrage tactics, except for violence. Paul particularly endorsed *escalation*, forcing their opponents—the government—to respond, often in repressive ways that strengthened the argument for the suffragists.

This course of action was, in part, forced on the movement by the obstinate response of the nation's leadership. During Wilson's first year in office, Congressional Union leaders had met with him, informed him about the issues, and implored him to advocate for a federal suffrage amendment. He responded by arguing that suffrage was

not for the federal government to pass legislation on but was up to each individual state to decide. The NWP knew that a state-by-state approach would keep suffrage off the table, and so it kept the pressure on Wilson until he finally refused to meet with them.

The NWP next resorted to harassment—shouting Wilson down and embarrassing him when he appeared in public. On December 4, 1916, NWP activists dropped a banner that read MR. PRESIDENT, WHAT WILL YOU DO FOR WOMAN SUFFRAGE? from the balcony of the visitors' gallery at the U.S. Capitol as he addressed Congress. The banner was quickly torn down, but it caused the room to fall silent as attendees turned their attention away from the president and toward the message that the NWP thrust upon him.

The press ridiculed these actions as offensive and unladylike. Others agreed—including NAWSA, whose members abhorred the NWP's tactics. NAWSA leaders Carrie Chapman Catt and Anna Howard Shaw feared that the NWP would alienate Wilson and Southern Democrats, whose support would be needed for a federal amend-

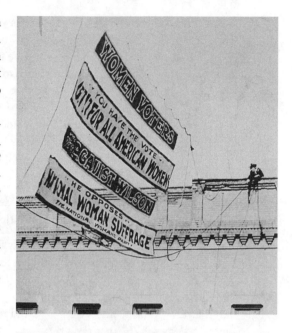

"Campaign in Illinois. One of the big Woman's Party street banners being swung into place in Chicago by Miss Virginia Arnold, of Washington, national executive secretary of the Congressional Union for Woman Suffrage." ca. October 1916 (photograph published in *The Suffragist* 5, no. 54, Jan. 10, 1917)

ment. Paul disagreed, and the NWP felt that Wilson could make suffrage happen if he wanted to. The Democrats controlled the Senate, the House, and the presidency, and Wilson had already pushed through items that concerned him with little resistance. He had secured tariff legislation, the Panama Canal, and the U.S. entry into an unpopular war—World War I.[9] Thus, the NWP goal was to make the Democrats pay for their inaction. They organized a boycott of all Democrats, even those who supported suffrage, and advocated that women in western states who had the vote should support any candidate other than the Democrats.

## Silent Sentinels

"We have got to keep the question before him all the time."

—Harriot Stanton Blatch[10]

The NWP escalated its tactic of standing next to the White House gates with banners after their first "silent sentinel" on January 10, 1917. The first banners had been relatively polite, but that approach soon dissolved. The NWP began instead to mock Wilson with his own

words. They reprinted phrases from his war speeches that showcased the hypocrisy of his support for democracy abroad while failing to support it at home.

On June 20, 1917, a representative of the new Russian government visited the White House. Outside the gates, Lucy Burns, Dora Lewis, and others stood with a large banner.

> To the Russian Envoys
> President Wilson and Envoy Root are deceiving Russia when they say
> "We are a democracy, help us win the world war so that democracy may survive."
>
> We the women of America tell you that America is not a democracy. Twenty-million American women are denied the right to vote. President Wilson is the chief opponent of their national enfranchisement.
>
> Help us make this nation really free. Tell our government it must liberate its people before it can claim free Russia as an ally.[11]

On June 22, Burns and Katherine Morey were arrested for "obstructing traffic." Three days later, twelve more women were arrested for carrying banners. In court, the women were ordered to pay a $25 fine; they refused and spent three days in jail. When one group of six women was brought before the court, one responded by stating, "Not a dollar of your fine will we pay. To pay a fine would be an admission of guilt. We are innocent."[12] From that point on NWP women began to fill the jails.

Wilson detested the tactics of the NWP and the press attention that they received. His secretary and political aide Joseph Tumulty called for a partial press blackout of the pickets, pressuring Washington-area newspapers to keep stories on the NWP to a minimum. Many obliged. The *Washington Post* refused.[13]

The Russia banner also enraged conservative suffragists. NAWSA president Anna Howard Shaw wrote to Dora Lewis in 1917 and accused the NWP of treasonous activity.[14] NAWSA printed objections to the White House pickets in 350 papers across the United States.[15] Carrie Catt went a step further. She would at times notify the White House of planned embarrassments by the NWP.[16]

Despite their detractors, the NWP stepped up their agitation. They followed a pattern of escalation: pickets, jail time, and capitalizing on the press that their actions received. In July and August of 1917, Wilson finally attempted to break this cycle by calling for an end to the arrests and consequently the press attention. So Paul, in turn, upped the ante. The NWP created a banner that compared Wilson to the enemy, German Kaiser Wilhelm II. One banner read FOR 20,000,000 AMERICAN WOMEN WILSON IS A KAISER. This created an uproar. Women who held the banners were attacked. Paul was knocked down three times, and on one occasion she was dragged the length of the White House sidewalk by an enraged sailor. After each attack, Paul sent out a press release detailing what had transpired.

The courts responded to these new tactics with longer jail sentences. Women were charged with a $25 fine or sixty days in prison at the Occoquan Workhouse in Virginia.

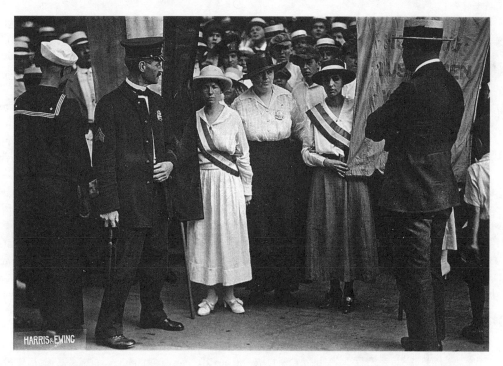

Harris and Ewing, Washington, DC, "Arrest of White House pickets Catherine Flanagan of Hartford, Connecticut (left), and Madeleine Watson of Chicago (right)," ca. August 1917 (mnwp 160038, Library of Congress)

Those arrested were charged with obstructing traffic and were denied the right to a trial by jury. Instead, they were sent to prison and housed with the general population.

On October 20, Paul and three others left the NWP office with a banner carrying a phrase that the Wilson administration had used on a poster for a Second Liberty Bond Loan: THE TIME HAS COME WHEN WE MUST CONQUER OR SUBMIT. FOR US THERE CAN BE BUT ONE CHOICE. WE HAVE MADE IT. Paul was arrested and sentenced to seven months at the Occoquan Workhouse.

## Jailed for Freedom

"Things took a more serious turn than I had planned but it's happened rather well because we'll have ammunition against the Administration, and the more harsh and repressive they seem the better."
—Alice Paul, letter to Dora Lewis from prison, 1917[17]

When Paul arrived at Occoquan, she initiated a hunger strike. Fourteen other women joined her. Each was force-fed three times a day—an extremely painful procedure in which

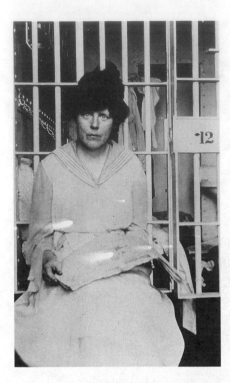

Harris and Ewing, Washington, DC, "Miss [Lucy] Burns in Occoquan Workhouse, Washington," ca. November, 1917 (mnwp 274009, Library of Congress)

a hard tube is placed down one's throat and food is deposited into the stomach against one's will. All of the NWP women who were jailed refused to work. They also demanded to be classified as political prisoners, a demand that was denied.

Paul received particularly brutal treatment. She was placed in solitary confinement and, eventually, a psychopathic ward—a terrifying prospect, considering that prisoners in this ward could be held indefinitely. Paul, however, recognized the tactical advantages of her harsh treatment—news of the force-feeding and the horrid conditions of the prison resulted in a public outcry and greater approval for the suffrage cause.

Still, the government would not relent. NWP activists in Washington, DC, who demonstrated against Paul's treatment in prison were arrested and also sent to jail. When they entered Occoquan they endured a "Night of Terror" when the warden instructed more than forty guards to brutalize the women, by beating, kicking, choking, and dragging them across the jailhouse floor.

On November 23, many of these same women were brought before a judge. In the courtroom, the press reported on their poor conditions and noted that many were too weak to stand or sit. The judge ordered three women immediately released due to their ill health. Twenty-five others were transferred to the district jail. On November 27, most of the prisoners were released, including Paul, who was on day twenty-two of her hunger strike.

By the end of 1917, the movement was taking a toll on the women, but it was also taking a toll on Wilson to the point where he changed his position on woman's suffrage. He spoke out in support of a federal amendment for the first time and lobbied his colleagues to do the same. In January 1918, the amendment passed the House 274 to 136. In June a filibuster by Democratic senator James A. Reed of Missouri prevented a vote in the Senate.[18]

The NWP decided to keep a watch fire (an urn) lit in Lafayette Square as a reminder to Wilson, and to themselves, that they would not quit until an amendment was passed. There, the demonstrators burned copies of Wilson's speeches and burned an effigy of him in protest. More arrests followed. Paul, Burns, and others were sentenced to ten to fifteen days in prison and placed in underground cells that had been deemed too unsanitary for the general prison population.[19] The women initiated a hunger strike and were released after five days.

During the fall of 1918, a federal woman's suffrage amendment failed to pass the Senate, but it finally succeeded in 1919. On May 21, the House passed the amendment 304 to

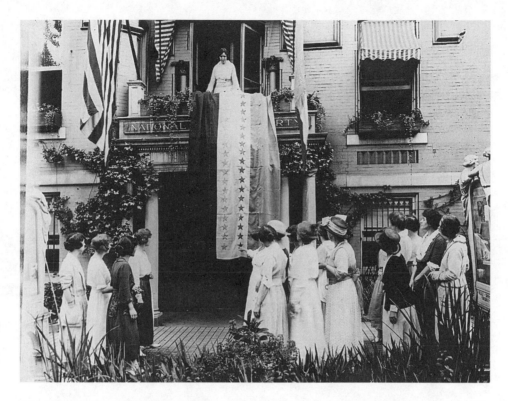

National Photo Co., Washington, DC. "When Tennessee the 36th state ratified, Aug 18, 1920, Alice Paul, National Chairman of the Woman's Party, unfurled the ratification banner from Suffrage headquarters," August, 18, 1920 (mnwp 160068, Library of Congress)

89. On June 4, the Senate passed it 56 to 25. From there, the constitutional amendment needed three-fourths of the states to ratify it. The NWP then focused their attention away from Wilson and directed their campaign toward the states where votes were needed most. By March 1920, thirty-five states had ratified, and the struggle came down to Tennessee. The close race was decided when Harry Burn, a twenty-four-year-old legislator, changed his vote in favor of ratification at the insistence of his elderly mother. In August, Tennessee would ratify.[20] In celebration, the NWP hung a ratification banner outside its Washington, DC, office.

Reflecting on the movement, Doris Stevens noted, "It was the women, not the president, who were exceptional . . . We pushed him the harder."[21] The NWP, and to a lesser degree NAWSA, had forced Wilson to act. They proved that radical tactics were the necessary boost to help the movement succeed. Banners became an essential part of the woman's suffrage

movement. Words led to arrests and arrests led to press coverage about the issues. The media image of the pickets focused both on the banners and the women who held them until the two became indistinguishable. Doris Stevens asserted, "It is our firm belief that the solid year of picketing, with all its political ramification, did compel the President to abandon his opposition and declare himself for the measure."[22]

# 12

# The Lynching Crisis

"Ah, the splendor of that Sunday night dance. The flames beat and curled against the moonlit sky. The church bells chimed. The scorched and crooked thing, self-wounded and chained to his cot, crawled to the edge of the ash with a stifled groan, but the brave and sturdy farmers pricked him back with the bloody pitchforks until the deed was done. Let the eagle scream! Civilization is again safe."[1]

—W.E.B. Du Bois

THIS VERSE—INTENTIONALLY SARCASTIC AND GRIM—appeared in the September 1911 issue of the NAACP publication *The Crisis* and was penned by its editor W.E.B. Du Bois, one of the towering intellectual figures of the twentieth century. Du Bois was the first African American PhD from Harvard University, the architect of Pan-Africanism, and a founding member of both the Niagara Movement and the NAACP. He was a historian, a sociologist, a poet, and an artist (the director of the pageant *The Star of Ethiopia*).[2] He was the author of numerous books, including *The Souls of Black Folk* and *Black Reconstruction in America*. He was also served as editor of *The Crisis* for nearly a quarter of a century (1910–1934), a position that allowed him to reach a vast audience and a position where he advocated on behalf of numerous social causes, including the campaign against lynching. His primary weapons against this crime: words, emotional appeals, statistics, and *visual images*.

———

The horrific crime of lynching in the United States was aimed at upholding white supremacy during the Jim Crow era, particularly in the Deep South.[3] African Americans outnumbered whites in many rural communities, yet occupied the lowest rung of the agricultural labor force as sharecroppers, a position that allowed white wealthy planters to prosper.[4] Southern Democrats and plantation owners successfully convinced a large percentage of the white working class to view the black working class as the primary threat to their economic well-being. Laws

W.E.B. (William Edward Burghardt) Du Bois, ca. May 31, 1919 (LC-USZ62-16767, Library of Congress)

were enacted that legalized segregation. Laws prevented interracial marriage. Voting rights for African Americans were suppressed. And worst of all, African American men were demonized as rapists—a threat to white women. This climate of race hatred led to race terrorism, exemplified by the proliferation of lynch mobs that threatened African Americans, as well as Jews, gay people, immigrants, Catholics, labor organizers, and radicals. The Tuskegee Institute estimated that 4,742 people were lynched in the United States between 1882 and 1968. Of these victims, 3,445 were black.[5] African Americans were lynched for any suspected "crime"—from the serious (murder or rape) to the benign (petty theft or even the failure to step aside for a white man on a sidewalk). Even protesting the lynching of a family member could lead to death. Local law enforcement turned a blind eye or participated in the lynchings.

Du Bois sought to change this.[6] Two incidents during his first teaching appointment at Atlanta University had shaken him to his core. One was the 1899 lynching of an illiterate sharecropper, Sam Hose, who was accused of killing his landlord and raping the man's wife. Others professed his innocence, and said that he defended himself during a violent argument with his landlord over wages. Nonetheless, the white community assumed his guilt and sent out a lynch mob. Hose was tortured, castrated, and killed before a massive crowd of white spectators, estimated at more than 4,000 people. Hose's liver and heart were cooked and pieces were sold for ten cents. Bones were sold for a quarter. His knuckles were then put on display at the local grocery store as a warning sign to all African Americans that they could be next.

The other incident took place in Atlanta proper. It erupted on September 22, 1906, when an estimated 10,000 whites roamed the city beating and killing every African American they could find, including children. The mob was responding to reports in the *Evening News* about a series of suspected rapes of white women by black men. Du Bois had been away when trouble first erupted, and rushed home to safeguard his wife and daughter. The terror lasted for several days in which Du Bois and his family could hear the screams and gunshots from their home. He later wrote, "I bought a Winchester double barreled shotgun and two dozen rounds of shells filled with buckshot. If a white mob had stepped on campus where I lived I would without hesitation have sprayed their guts over the grass. They did not come."[7] His summary: "One could not be a calm, cool, and detached scientist while Negros were lynched, murdered, and starved."[8]

W.E.B. Du Bois and staff in *The Crisis* magazine office, no date recorded (Schomburg Center for Research in Black Culture, New York Public Library)

In 1910, Du Bois left Atlanta for New York City and a job firmly rooted outside academia. He became the director of publicity and research for the NAACP and the editor of its monthly publication *The Crisis*.

Du Bois viewed *The Crisis* as a platform where he could debate the key issues of the day and engage his audience—primarily the black middle class—with controversial ideas and calls for action. His writings were opinionated and personal, and he rejected the calls for *The Crisis* to be a space simply to recite the NAACP meeting notes. "From first to last I thought strongly, and I still think rightly, to make the opinion expressed in *The Crisis* a personal opinion; because as I argued, no organization can express definite and clear-cut opinions."[9] His readers by and large absorbed his editorial stance. The first issue of *The Crisis* (November 1910) quickly sold out its 1,000-copy print run.

By July 1911, the print run was boosted to 15,000 copies. By November 1915, it was 35,000 copies, and by 1919, circulation reached its peak at just under 100,000.[10] Interest in the publication drove interest in the NAACP. By 1919, the NAACP had 300 branches throughout the United States, including 155 branches in the South. Its membership totaled 88,448.[11]

In the first issue of *The Crisis*, Du Bois wrote that the publication would set forth "those facts and arguments which show the danger of race prejudice."[12] Not surprisingly, Du Bois addressed lynching in the premiere issue—the murder of two naturalized Italian immigrants in Florida. "The inalienable right of every free American citizen to be lynched without tiresome investigation and penalties," wrote Du Bois in his patented sarcastic tone, "is one which families of the lately deceased doubtless deeply appreciate."[13]

The early issues of *The Crisis* also set the tenor of Du Bois's editorial slants and biases. Du Bois had an elitist view on how to agitate for change. He believed that change should be led from the top. In 1903, he stated that the Negro race

*The Crisis,* November 1910, front cover illustration assumed to have been drawn by W.E.B. Du Bois (digital ID# na0026, Library of Congress)

is going to be saved by its exceptional men . . . Can the masses of the Negro people be in any way more quickly raised than by the effort and example of this aristocracy of talent and character? Has there ever a nation on God's fair earth civilized from the bottom upward? Never; it is, ever was and ever will be from the top downward that culture filters.[14]

Du Bois believed that the "talented tenth" should lead the race and educate the other 90 percent. His choice of images in *The Crisis* visualized his bias. The pages of the magazine were packed with images of successful African American businessmen, college graduates, happy families, and signs of affluence, including photographs of luxurious middle-class homes. He also included photographs of weddings, graduation ceremonies, and baby pictures—all of which asserted a message of racial uplift and his own Victorian sensibilities that spoke to a well-educated class of people. His motives: combat racism and show African Americans as exceptional, as equals, and as positive contributors to the society at large.

## Visualizing the Lynching Industry

Du Bois's photographs of the "best and the brightest" were harshly juxtaposed next to horrific images of African Americans being lynched. Throughout the pages of *The Crisis*, Du Bois published accounts of lynchings—charts, maps, eyewitness accounts, drawings, and photographs—and he did so for decades, making *The Crisis* the most widely circulated publication to continuously combat lynching.

This Space For Writing Messages

This is the way we do them down here.
The last lynching has not been put on card yet.
Will put you on our regular mailing list. Expect one a month on the average.

Printed in Germany.

A 15718

POST CARD

Rev. John H. Holmes,
Pastor Unitarian Church
New York City.

This side for the Address Only.

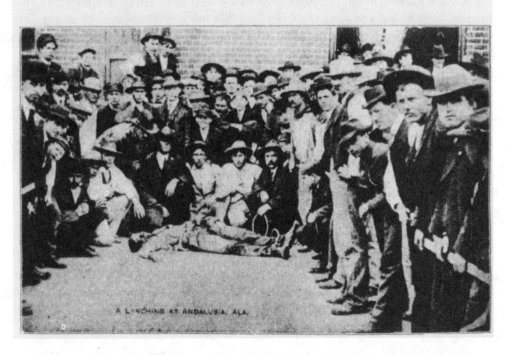

A LYNCHING AT ANDALUSIA, ALA.

"A Reply to Mr. Holmes from Alabama," reprinted from *The Crisis*, January 1912 (University of Wisconsin—Milwaukee Libraries)

One example was the January 1912 issue that featured a postcard that Du Bois reappropriated from its original intent. Entitled "A Reply to Mr. Holmes from Alabama," the postcard featured a photograph on the front of a lynch mob, faces uncovered, looking straight into the camera lens.

In the center, on the ground, lay the victim. Around him stood the crowd, one with the lynching rope still in hand. The back of the postcard was addressed to Rev. John H. Holmes, a pastor at the Unitarian Church in New York City, a founding member of the NAACP, and an outspoken critic of lynching. The typed message read:

> This is the way we do them down here. The last lynching has not been put on card yet. Will put you on our regular mailing list. Expect one a month on average.

The postcard had originally been sent to Holmes as a means of intimidation. In the aftermath of a lynching, photographers would print cards on site and sell copies to the crowd, which often numbered in the thousands. This trade became so widespread that in 1908, the U.S. Postmaster General forbade lynching postcards from being mailed, forcing the cards to go underground, or to be covered by an envelope.

The NAACP defined lynching as *community sanctioned murders*, and the Holmes postcard embodied this point. By reprinting the ghastly image, Du Bois reappropriated the souvenir postcard, redefined who the criminals were, and provided more visual evidence in the NAACP's anti-lynching crusade. Du Bois wrote that lynching images were "a gruesome thing to publish, and yet—could the tale have been told otherwise? Can the nation otherwise awaken to the enormity of this beastly crime of crimes, this rape of law and decency?"[15]

"Awaken" was the key word. Images of lynchings were not widespread in either the mainstream press or the black press before Du Bois made it a focal point in nearly every issue of *The Crisis*. Daisy Lampkin, a field secretary of the NAACP, noted, "We were so ashamed that whites could do that to *us*, that we hardly wanted to talk about it publicly."[16] Du Bois's response was the polar opposite. He was determined to publicize the crime of lynching until the evil practice was wiped off the earth. Du Bois wrote, "We place frankly our greatest reliance in publicity. We propose to let the facts concerning lynching to be known. Today, they are not fully known; they are partially suppressed; they are lied about and twisted. . . . We propose, then, first of all, to let the people of the United States, and the world, know WHAT is taking place. Then we shall try to convict lynchers in the courts."[17]

Readers of *The Crisis* had to force themselves to think beyond the initial shock of the gruesome images. They had to move past horror, shame, and grief in order to move toward anger and collective action. In practical terms, Du Bois's methods were designed to provoke a reluctant federal government to protect the lives of all of its citizens.

## The Waco Horror

"Lynching in the United States has resolved itself into a problem of saving black America's body and white America's soul."

—James Weldon Johnson, NAACP director[18]

In July 1916, Du Bois published a special supplementary issue to *The Crisis* called "The Waco Horror." It was in response to the May 15 lynching of Jesse Washington—a seventeen-year-old mentally handicapped teenager who was killed in front of a crowd of 15,000 at City Hall Square in Waco, Texas. Du Bois had sent the white journalist Elisabeth Freeman to Waco to investigate the murder. For ten days she gathered information, eyewitness accounts, and souvenir postcards that served as photographic evidence. Freeman's eight-page supplement to *The Crisis* was designed to transport the reader to the scene of the sadistic crime.

Washington had confessed to killing Mrs. Fryar, a white woman whom he worked for. He was later charged with raping her, despite no evidence that a sexual crime had taken place. A jury found him guilty after deliberating for four minutes. After the verdict was read, a packed courtroom of 1,500 people surged toward Washington. The judge and the sheriff slipped away, and the mob dragged Washington outside to the awaiting crowd of 15,000. There, Washington was brutally murdered. He was castrated. His ears and fingers were cut off. The crowd repeatedly stabbed him and struck him with shovels, bricks, and clubs. Next he was hanged from a tree by a chain in City Hall Square, right under the mayor's window, and lowered repeatedly into a fire while still alive. Once dead, the crowd cut up his body, distributed various parts as souvenirs, and finally his torso was dragged through the streets behind a horse.

"The Waco Horror" contained seven images of the lynching of Washington that Freeman had purchased from F.A. Gildersleeve while in Waco, including four gruesome photographs of Washington's charred body chained to a tree. The images shocked some members of the NAACP board, but Du Bois was unapologetic about printing them. The nation had to confront this type of brutality.

Du Bois arranged the photographs of "The Waco Horror" in chronological order, depicting a college town that had turned uncivilized due to its race hatred. The first three pages included photographs of important building in Waco—campus shots of Baylor University, City Hall, and the courthouse. This segued to scenes of the lynch mob, and then the killing itself.

Most shocking were the images of the lynching by the local white photographer, F.A. Gildersleeve, who had been instructed where to set up his camera before the murder had transpired. Gildersleeve was allied with the mob. His motive was to profit from the murder by selling photographs of the lynching, a practice that was derailed by the city government. Freeman quoted him as saying, "We have quit selling the mob photos, this step was taken because our 'City dads' objected on the grounds of 'bad publicity,' as we wanted to be boosters and not knockers, we agreed to stop all sale."[19] Gildersleeve's comments and his images

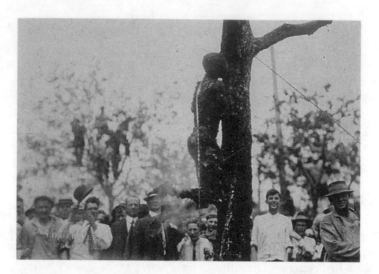

Fred A. Gildersleeve, "[Large crowd looking at the burned body of Jesse Washington, seventeen-year-old African American, lynched in Waco, Texas, May 15, 1916]" (LC-USZC4-4647, Library of Congress)

condoned the actions of the mob and served to further terrorize the black community. However, *The Crisis* was able to subvert the photographs from their original intent when they were recontextualized in the "Waco Horror" exposé.

Du Bois had the supplementary issue distributed to all members of Congress; he sent copies to more than seven hundred newspapers—including fifty black newspapers—as well as to prominent figures in the arts and politics. Additionally, it reached the 42,000 subscribers of *The Crisis*. The subsequent public outcry led to congressional consideration of the Dyer Bill in 1919 and 1921. The bill defined lynching as the murder of a U.S. citizen by a mob of three or more. It stated that sheriffs who failed to prevent a lynching were liable for felony charges, fines, and prison sentences. It also stated that the federal government could prosecute lynchers if states refused to, and counties were required to pay fines to the victim's family ranging from $1,000 to $10,000. The Dyer Bill passed the House, but a filibuster defeated it in the Senate. Southern senators argued, among other things, that lynching was necessary to protect Southern women.[20]

"The Waco Horror" represented a ramping-up of efforts by Du Bois and the NAACP. It also represented the continued use of graphic text and images to describe a lynching. Amy Helene Kirschke writes, "Du Bois believed that a photograph and a brief editorial were no longer enough. His readers needed to know every detail of lynchings and to know the victim, too, through photographs of the body from several vantage points."[21]

Du Bois's writings and editorial choices served as a call to action. He concluded the text of the supplementary issue with a paragraph that read: "This is an account of one lynching.

It is horrible, but it is matched in horror by scores of others in the last thirty years, and in its illegal, law-defying, race-hating aspect, it is matched by 2,842 other lynchings which have taken place between January 1, 1885, and June 1, 1916 . . . What are we going to do about this record? The civilization of America is at stake."[22] His plea ended with "Let every one read this and act."[23]

## Silent Parades, Flag Memorials, and Boycotts

Du Bois's use of visual materials on behalf of activism took many other forms as well. Some were rooted in the streets. Du Bois and James Weldon Johnson organized a large-scale demonstration following the East St. Louis massacre—a race riot in May and July of 1917 that left six thousand African Americans homeless and more than one hundred dead.[24]

On July 28, ten thousand African Americans marched down Fifth Avenue in the Silent Parade. The only sounds emitted were from the muffled drum line that led the parade. Men

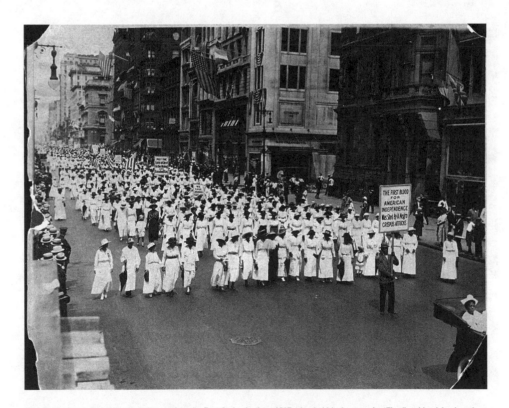

Silent protest parade in New York City against the East St. Louis riots, 1917; sign held in front reads, "The first blood for American Independence was shed by a Negro Crispus Attucks" (digital ID# cph–3a34294, Library of Congress)

were dressed in black suits with white shirts and black hats. Women and children wore white. Some of their placards read:

> MOTHER, DO LYNCHERS GO TO HEAVEN?
> MR. PRESIDENT, WHY NOT MAKE AMERICA SAFE FOR DEMOCRACY?
> YOUR HANDS ARE FULL OF BLOOD.

The last one was directed at President Wilson—or perhaps the entire nation. The quiet, peaceful march operated, in part, as a funeral for the victims of lynching and a show of strength and dignity in the face of racial violence. It was a call for action that generated media attention, and an action that highlighted the failure of the federal and state government to protect all of its citizens.

Another prominent visual tactic, presumably initiated by Du Bois, was the unfurling of a black flag that read A MAN WAS LYNCHED YESTERDAY outside the NAACP offices' window on Fifth Avenue.

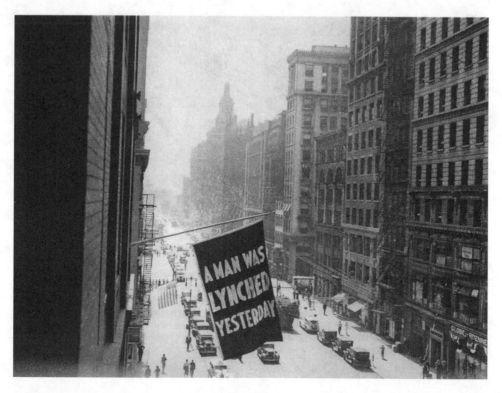

"Flag, announcing lynching, flown from the window of the NAACP headquarters on 69 Fifth Ave., New York City," ca. 1936 (LC-USZ62-110591, Library of Congress)

This stark message echoed the content of *The Crisis* and was meant to inspire the New York public to pay close attention to continued violence across the land.

Du Bois also led the 1915 boycott campaign against D.W. Griffith's film *The Birth of a Nation*—based on Thomas Dixon's 1905 bestselling novel *The Clansman*, which depicted the period of Reconstruction as an era of misrule by rapacious African American politicians, and the sanctity of white women as being threatened by black rapists. The protagonists of the film were the Ku Klux Klan, who were depicted as protecting white women, and by extension, the nation.[25] President Wilson had endorsed Dixon's book and had the film screened in the East Wing of the White House, which he described as "writing history with lightning," adding that it was "all so terribly true."[26]

The deplorable film had deadly consequences. A white patron in Lafayette, Indiana, shot and killed a teenage African American boy after seeing it, and crowds in Houston were reported to have yelled "Lynch him!" at the screen during the scene when the white actor in blackface was attempting to rape a white woman.[27] Du Bois called for the entire second half of film to be cut (which the Board of Censors refused to do) and led large demonstrations outside New York theaters. In New York, protesters tossed eggs at the movie screens, and they succeeded in banning the film temporarily in Chicago. Massachusetts went the furthest and completely banned the film in Boston, a move that forced President Wilson to retract his initial enthusiasm. Despite the boycott movement, *The Birth of a Nation* remained immensely popular.

## The Positive Image

> "We want everything that is said about us to tell of the best and highest and noblest in us."
> —W. E. B. Du Bois, "Opinion," *The Crisis*, June 1921

Du Bois understood that a key way to undermine racism was through culture. His editorial stance of presenting the "talented tenth" in the pages of *The Crisis* was a direct response to the racist manner in which African Americans were portrayed in mainstream culture. Even the radical press, in particular *The Masses*, presented African Americans as the "exotic other." Du Bois wrote, "White Americans are willing to read about Negros, but they prefer to read about Negros who are fools, clowns, prostitutes, or in any rate, in despair and contemplating suicide."[28]

*The Crisis* was designed to challenge this bias. Du Bois filled numerous issues with photographic images of the black middle class—from college graduates to star athletes to those who had achieved success in business, the sciences, and other careers. He intentionally turned a blind eye to examples of unlawfulness, decadence, despair, and self-destruction within the black community. He refused the request by then chairman of the NAACP, Oswald Villard, to include a list of crimes committed by African Americans in *The Crisis* to counterbalance the list of white crimes. Instead, Du Bois's emphasis promoted African Americans at their best.

Du Bois had been a master at using photographic images for political purposes long before he became editor of *The Crisis*. In 1900 he won a gold medal at the Paris Exposition for an exhibition he curated titled *Exposition des Nègres d'Amerique* [Exhibit of the American Negro]. He displayed photographs of ordinary African Americans, which countered the barrage of racist images that dominated the mass media and popular culture.[29] Du Bois, always the historian and sociologist, included charts, maps, and data on black life in the United States. In short, he curated an exhibition to refute racial stereotypes, and this was the driving force behind much of his later work in the pages of *The Crisis*.

As editor he focused on black subject matter and invited African American artists and authors to contribute their talents to the magazine. During the 1920s—at the peak of the Harlem Renaissance—he became one of the most important patrons of African American art and literature. He routinely highlighted the artwork of Aaron Douglas, Laura Wheeler, Albert Smith, and Hale Woodruff, among others, and published writings by Langston Hughes, Gwendolyn Bennett, Alain Locke, Arna Bontemps, Countee Cullen, Claude McKay, and E. Franklin Frazier. Yet Du Bois's editorial bias guided what he deemed acceptable. He encouraged artists to depict the "talented tenth" and to look to Africa for inspiration and subject matter. He wrote, "In *The Crisis* at least, you do not have to confine your writings to the portrayal of beggars, scoundrels and prostitutes; you can write about ordinary decent colored people if you want."[30]

Du Bois expressed a bias for a political art. In a famous speech, "Criteria of Negro Art," delivered in Chicago in 1926 (and reprinted in *The Crisis* in the October issue), he stated:

Thus all art is propaganda and ever must be, despite the wailing of the purists. I stand in utter shamelessness and say that whatever talent I have for writing has been used always for propaganda for gaining the right of black folk to love and enjoy. I do not care a damn for any art that is not used for propaganda. But I do care when propaganda is confined to one side while the other is stripped and silent.[31]

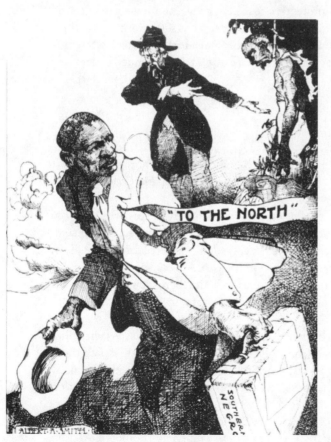

Albert A. Smith, "The Reason," *The Crisis*, February 1920 (University of Wisconsin–Milwaukee Libraries)

The problem was that many black artists did not want any type of *criteria* for art, and they did not want Du Bois to dictate what subject matter was appropriate. Instead, they wanted to freely express themselves and all aspects of black life—the good and the bad. Langston Hughes wrote:

> We younger Negro artists who create now intend to express our individual dark-skinned selves without fear or shame. If white people are pleased, we are glad. If they are not, it doesn't matter. We know we are beautiful. And ugly too. . . . If colored people are pleased we are glad. If they are not, their displeasure doesn't matter either. We build our temples for tomorrow, strong as we know how, and we stand on top of the mountain, free within ourselves.[32]

Other responses to Du Bois were less diplomatic. Claude McKay angrily wrote, "I should not be surprised when you mistake the art of life for nonsense and try to pass off propaganda as life in art!"[33] Du Bois, however, remained rigid. He felt that *any* negative portrayal of African Americans would empower white America to continue to view them as inferior, and furthermore, it would not uplift the race.[34]

In the context of lynch mobs and segregation Du Bois believed that the immediate climate was far too dangerous for artists not to focus full attention on propaganda that would aid the black freedom movement.

"To Du Bois, a literature which did not exist for a moral purpose was a decadent, socially dangerous activity," wrote Abby Arthur Johnson and Ronald Baberry Johnson.[35] Throughout his long tenure as editor he championed an activist agenda. He balanced sharp critiques of injustices with celebratory articles and images of the "best and the brightest"—an approach that drew an equal amount of praise and criticism from his peers.

Romare Bearden, "For the Children!" *The Crisis,* October 1934 (University of Wisconsin–Milwaukee Libraries) (courtesy of VAGA)

———————

On July 1, 1934, Du Bois resigned from the NAACP. He was tired of being censored by the Board of Directors, and they were tired of his editorial control over *The Crisis,* along with his drift toward radical Marxism and praise for the Soviet Union. Nevertheless, his influence and ideas carried over to subsequent issues of *The Crisis.* One of the young artists whom he championed—Romare Bearden—published the illustration "For the Children!" in the October 1934 issue, just months after Du Bois had resigned.

It depicted an African American man standing next to his son, holding a shotgun. In the distance are three KKK members, marked by the words *lynching, peonage,* and *segregation.* The

defiant image—a call for armed self-defense and a precursor to the actions of Robert F. Williams (author of *Negroes with Guns*) and later the Black Panther Party—was featured in a special issue dedicated to children. Du Bois's words echoed in Bearden's image—specifically his September 1919 editorial that read, in part, "When the murderer comes, he shall no longer strike us in the back. When the armed lynchers gather, we too must gather armed. When the mob moves, we propose to meet it with bricks and clubs and guns."[36] Du Bois ended his twenty-four-year reign at *The Crisis* as the NAACP's most prominent voice, a scholar and an activist, and a guiding voice to many, including the next generation. There was never a social-justice crusader quite like him, a leader who embraced the arts and a leader who, himself, was an artist.

# 13

## Become the Media, Circa 1930

ON DECEMBER 29, 1932, Samuel Brody reported in the *Daily Worker* on the second National Hunger March, a Communist-led march where 1,600 marchers representing the Unemployment Councils marched to Washington, DC, in columns leaving from Boston, Buffalo, Chicago, and St. Louis, calling on Congress to enact federal unemployment assistance. Brody wrote:

> Our cameramen were class-conscious workers who understood the historical significance of this epic March for bread and the right to live . . . we "shot" the March not as "disinterested" news-gatherers but as actual participants in the March itself. Therein lies the importance of our finished film. It is the viewpoint of the marchers themselves. Whereas the capitalist cameramen who followed the marchers all the way down to Washington were constantly on the lookout for sensational material which would distort the character of the March in the eyes of the masses, our worker cameramen . . . succeeded in recording incidents that show the fiendish brutality of the police towards the marchers.[1]

Brody was not an objective reporter. He was a member of the Workers Film and Photo League (F&PL)—a group of activist filmmakers and photographers who documented labor struggles and anti-capitalist demonstrations. His quote articulated how participants in marches and the mainstream media view the same event through different lenses. One largely glorifies demonstrators; the other vilifies them. One scorns the police; the other praises them. Brody represented the former in both cases.

The F&PL itself was part of the broader cultural movement that was sponsored by the Communist International or Comintern. It was a section of the Workers' International Relief (WIR), an American chapter of the Comintern-supported *Internationale Arbeiter-Hilfe* (IAH) that Lenin had called for in Berlin in 1921 to provide famine relief for the Soviet Union.[2] After that, it expanded to other countries providing relief—food, clothing, and shelter—to striking workers and their

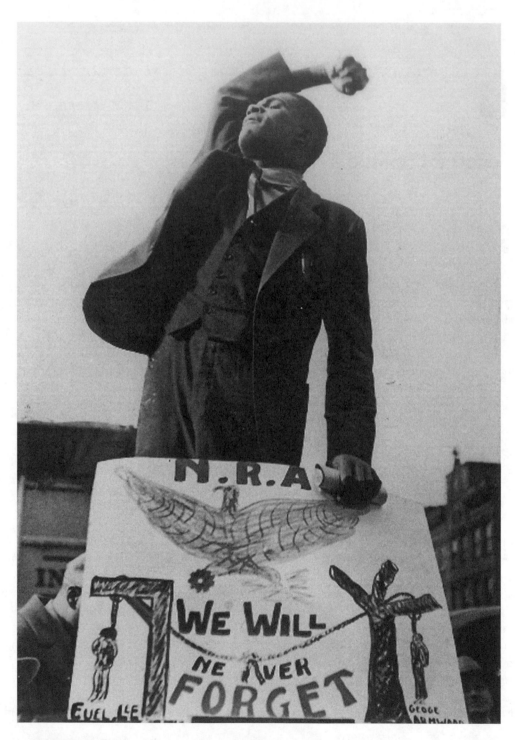

Leo Seltzer, *Harlem Demonstration*, 1933 (courtesy of Leo Seltzer, via Russell Campbell)

families. Early WIR relief efforts in the United States included aiding the textile strikes at Passaic, New Jersey (1926–1927), New Bedford, Massachusetts (1928), and Gastonia, North Carolina, in 1929, along with the miners' strikes of 1931–1932.[3]

The WIR also focused on agitprop. In Germany, under the leadership of Willi Münzenberg, the WIR produced films, theatre productions, newspapers, illustrated periodicals, and books—all of which promoted the ideals of the Russian Bolshevik Revolution.[4] In the Soviet Union, numerous feature-length, black-and-white silent films were released, including Vsevolod Pudovkin's *Mother* (1926), *The End of St. Petersburg* (1927), *Storm Over Asia* (1928*)*, and Dziga Vertov's *Three Songs About Lenin* (1934), among others. The WIR, besides helping to produce Soviet films, also began distributing them—most notably Sergei Eisenstein's *Battleship Potemkin* (1925)—using culture as a key tactic to spread the ideas of the revolution and to draw in new recruits. Russell Campbell writes:

> In the U.S. the WIR affiliate, at first known as the Friends of Soviet Russia, had been involved with film distribution since its founding in 1922. Throughout the decade it arranged nationwide releases of documentaries about the Soviet Union designed to counteract the hostile propaganda emanating from Hollywood, and beginning in 1926 it also handled nontheatrical distribution (and, effectively, exhibition) of Soviet features. This distribution arm of the WIR was to become closely allied with the Workers Film and Photo League.[5]

F&PL logo (image courtesy of Russell Campbell)

In New York City, the Workers' Camera Club, which was allied with the International Labor Defense (the Communist legal-aid organization), evolved into the Labor Defender Photo Group.[6] This group, in turn, evolved into the F&PL and began meeting at the WIR Building on 131 West Twenty-Eight Street.[7] The NYC branch would eventually include upward of 75 to 100 rotating members but the core of the group remained Samuel Brody, Lester Balog, Robert Del Duca, Leo Seltzer, and Tom Brandon—the latter of whom was a WIR organizer who helped fund and distribute their work. Also important was the film critic Harry Allan Potamkin, who was not technically a member but influenced the F&PL's direction as it quickly moved beyond just disseminating Soviet workers' films. A primary motive of the F&PL was to produce their own media. F&PL photographers and filmmakers took part in strikes and demonstrations and filmed their experiences. After shooting an action, the film was then edited into a short newsreel, a silent black-and-white film. The newsreels were then taken on the road and screened to working-class audiences in union halls, theaters, pool halls, and other makeshift venues across the country.

The same approach was applied to still photography. F&PL photographers documented strikes and demonstrations and supplied images through their National Photo Exchange to labor and Communist newspapers, including the *Daily Worker, Labor Defender, Der Arbeiter, Freiheit,* and *Labor Unity,* among others. Stills were also sold to mainstream newspapers and periodicals—including *Survey Graphic* and *Fortune*—both for publicity and to generate income for F&PL members. While New York City remained a hub of F&PL activity, other cities formed their own branches, including Detroit (which had upward of twenty members), Chicago, Boston, Philadelphia, Washington, DC, Los Angeles, and San Francisco. Smaller, less influential branches with a half dozen or so members also formed in Paterson and Perth Amboy, New Jersey; New Haven, Connecticut; Pittsburgh; Cleveland, Ohio; Laredo, Texas; and Madison, Wisconsin. The overarching goal that connected all of this work was expressed in the F&PL motto: "The Camera as a Weapon in the Class Struggle!"

## Black and Blue Filmmaking

> "For me, the Film and Photo League activity was a way of life, often working all day and most of the night, sleeping on a desk or editing table, wrapped in the projection screen, eating food that might have been contributed for relief purposes and wearing clothes that were donated."
>
> —Leo Seltzer[8]

Mass unemployment and labor unrest was the backdrop of the 1930s and the Great Depression. Between May 1933 and July 1937 more than 10,000 labor strikes occurred.[9] Demonstrations and marches were ever-present, as were activist-artists to cover these events.

In 1930, the F&PL reported on the March 6 International Unemployment Day that took place in cities around the world, including thirty U.S. cities. The New York City demonstration at Union Square drew tens of thousands of people and descended into a full-scale

Leo Seltzer, *Floating Hospital, New York City*, 1933 (courtesy of Leo Seltzer, via Russell Campbell)

riot when 1,000 police officers attempted to prevent demonstrators from marching down Broadway to City Hall. Police clubs and fire hoses battered the crowd, but no one outside the marchers and bystanders would know this from the mainstream media coverage: New York City police commissioner Grover Whalen had urged the media to minimize coverage of the demonstration and subsequent riot. Brody wrote in the *Daily Worker* on May 20, 1930:

> The capitalist class knows that there are certain things that it cannot afford to have shown. It is afraid of some pictures. . . . Films are being used against the workers like police clubs, only more subtly—like the reactionary press. If the capitalist class fears pictures and prevents us from seeing records of events like the March 6 unemployment demonstration and the Sacco-Vanzetti trial we will equip our own cameramen and make our own films.[10]

This is exactly what the F&PL did, against considerable odds, given that the police targeted the F&PL as members of the demonstration, not journalists. Leo Seltzer, one of the more daring cameramen of the group, later reflected, "People would look at my stuff and they'd say, how'd you get it? Did you have a zoom lens? No! and I have black and blue marks on my

hands from being beaten."[11] This degree of engagement produced striking film footage and still images. Seltzer adds:

> The commercial newsreels had those big vans for their equipment, and they set the camera up on top. They'd park about a block away with a tele-photo lens, and their films never really gave you a sense of being involved. My film had that quality because I was physically involved in what I was filming, and that's what I think gave it a unique and exciting point of view."[12]

Other F&PL members echoed this sentiment. Leo Hurwitz stated that F&PL work

> had energy derived from a real sense of purpose, from doing something needed and new, from a personal identification with subject matter. When homeless men were photographed in doorways or on park benches, feeling guided the viewfinder. The world had to be shown what its eyes were turned away from.[13]

He added, "When you put your hand in your pocket and you can touch your total savings, your life is revealed as not the private thing it seemed before. It becomes connected with others who share your problem."[14]

This cultural work was part and parcel with the aims of the larger Communist Party USA movement and was aimed at two intended audiences: those who partook in the same actions that the F&PL had filmed, and other workers who might be inspired by them. Seltzer recalls footage he took of a demonstration in support of the Scottsboro Boys—eight of whom faced the death penalty on trumped-up rape charges:

> After we marched into the area in front of the Capitol Building, I got out of the line and started shooting film. Then things started to happen. There were a lot of plainclothes men and police around. The cops jumped at this group and started ripping placards off, and beating people up.[15]

He continues:

> I was filming this one policeman. It was a rainy day, and he had on a heavy, rubberized raincoat. I was about ten or fifteen feet behind him and two or three feet beyond him was the line of pickets, with the Capitol Dome beyond that. That was the shot. And as I was shooting, the cop ran in and grabbed the placard from a black marcher and ripped the cardboard. And there was this marcher with the stick still in his hand. The marcher looked at the bare stick, and the cop was tearing up the placard which said, "Free the Scottsboro Boys," and suddenly the marcher turned and whacked the cop left and right with his stick. And the cop was so stunned, he just stood there.[16]

Seltzer was thrown in jail for two days, but his footage was well received by audiences when it was compiled into the film *America Today* and screened at theaters sympathetic to Communist campaigns. At the Acme Theatre on Fourteenth Street, Seltzer noted, "When that sequence was shown the audience jumped up and said, "Give it to him! Give it to him!"[17] Other venues for F&PL and Soviet films were not as friendly. Seltzer recalls an event outside Pittsburgh:

> I don't know who shot the Pittsburgh film, but I went back with a projector to show it to the miners who were still blacklisted. They were still living in tents for the second winter. And I remember I went into the town and stretched this sheet between two houses—the sheriff's and the deputy's house on either side—and we expected to be shot at any minute while projecting the film.[18]

Other cities were determined to stop the screenings. In New York, F&PL members were hauled into court in January 1935 for showing films in their own headquarters.[19] In Chicago, Mayor Edward Kelly enforced a ban on all newsreel films that featured rioting or large gatherings, making it impossible to project images of strikes and pickets within the city.[20] The situation was more volatile in the South: F&PL members were at times driven out of a town by a mob. To keep safe, Sam Brody would sleep with guns by his bed when he covered the textile strike in Gastonia, North Carolina.[21]

---

Threats of violence or arrest did not stop activist photographers and filmmakers from shooting footage, snapping photographs, or taking films on the road. Lester Balog made a cross-country trip from New York City to California in the spring of 1933 with Edward Royce, a WIR organizer, where they screened New York F&PL newsreels and a Soviet film—Pudovkin's *Mother*—in more than fifty cities and towns in workers' halls, community theaters, pool halls, and private homes.[22] At each stop, Balog would screen films and Royce would address the audience. In Milwaukee, the two presented to five hundred people during an antifascist demonstration. In San Francisco, their audience eclipsed one thousand at the Fillmore Workers' Center. For the next two months they would continue their tour down the California coast to Los Angeles and then up through the Central Valley.

Balog and Royce had arrived in California in the midst of the largest wave of agricultural strikes in the state's history. In October, they returned to Tulare County, the site of a major cotton strike in the San Joaquin Valley. Balog shot footage documenting the struggle, but he also took an active role in participating in the struggle: he created a ten-foot banner that was used during a funeral of a Mexican worker who had been killed. In the weeks that followed he continued to make graphics and took part in meetings of the strike committee.[23] Balog demonstrated a common thread with F&PL members: they *participated* in struggles, documented them, and promoted them to other workers.

In San Francisco, Balog helped energize the San Francisco chapter of the F&PL. They set up shop at the Workers' Cultural Center at 121 Haight Street—also called the Ruthenberg House—that included a workers' school, a restaurant, a library, a ballroom, classrooms, and a darkroom for the F&PL. Here Balog edited short newsreels of the 1933 cotton strike and worked on a more ambitious film—*Century of Progress*. He was also listed as a cinematography instructor for the workers' school in the spring 1934 catalog. Along with Otto Hagel, Balog taught a class that mirrored their activist-art practice; it was described as a study of the "criticism of bourgeois practices, analysis of Soviet newsreels, documentary and acted films, Montage, film production and projection of working class newsreels and films."[24]

Leo Seltzer, *New York City Demonstration*, 1933 (courtesy of Leo Seltzer, via Russell Campbell)

Leo Seltzer, *Rent Strike East Harlem*, 1933 (courtesy of Leo Seltzer, via Russell Campbell)

That spring, Balog, accompanied by Hagel, toured California again, traveling to Los Angeles and back up through the Central Valley. In a pool hall in Tulare County—the site of the cotton strike the prior year—they set up an impromptu screening of the F&PL film *Cotton-Pickers' Strike* and the Soviet film *Road to Life* and screened it to an audience of 75 to 100 Mexican migrant laborers, the majority of whom were under twenty years old.[25] The four-hour event ended when four police officers arrested Balog and Lillian Dinkin, a CP USA organizer, and charged them with running a business without a license. Both were jailed for thirteen days, then brought before a jury who deliberated for five minutes and found them guilty, handing out a forty-five-day sentence and a hundred-dollar fine. Their incarceration coincided with the San Francisco General Strike that was led by the International Longshoremen's Association and succeeded in completely shutting down the city from July 16 to July 19. Balog and Dinkin were released on July 17 and returned to a tense situation: vigilantes had completely destroyed the Ruthenberg House, leaving the F&PL's darkroom in ruins. With their space destroyed and much of their equipment impounded, the San Francisco F&PL fell apart less than a year after it had been started.[26]

## Newsreels or Art and F&PL Film Criticism

Other F&PL branches across the United States imploded over longstanding divisions over the artistic direction and the content of the films. In the New York F&PL, a number of filmmakers left to form Nykino—a more experimental, narrative film group—because they wanted the creative freedom to expand beyond agitprop work.[27] In other cases, individual artists who remained with the F&PL had to make numerous compromises. William Alexander writes:

Ruthenberg House after the 1934 attack (Sid Roger Photo Collection, Labor Archives and Research Center, San Francisco State University)

> When Lewis Jacobs went south to film in the straitened mining communities, he expected to return to edit his material and shape a film. Instead, he was asked to turn over the footage to the League, with no explanation of what was to become of it. Some of it was edited—supposedly under the eyes of those with the "correct" political savvy—along with other footage, into *Strike Against Starvation*. Jacobs, who gained some valuable shooting experience at League cost, did not complain.[28]

This strict approach often led to infighting and members being dismissed, which was the case in the F&PL. Isador Lerner was unanimously expelled from the F&PL after he returned from the Soviet Union and reported to the New York group that Russia was not the utopian state that many had proclaimed it to be, and that he had witnessed many people on the brink of starvation.[29]

Others criticized the quality of the F&PL's work. Novelist Michael Gold wrote in the *Daily Worker* in November 1934: "Our Film and Photo League has been in existence for some years, but outside of a few good newsreels, hasn't done much to bring this great cultural weapon to the working class. As yet, they haven't produced a single reel of comedy, agitation, satire or working class drama."[30] Gold, instead, praised Vertov's film *Three Songs About Lenin*, but neglected to stress that the F&PL operated on shoestring budgets, making it more difficult to produce features like their Soviet counterparts.

However, critiques and debates over art and propaganda alone did not derail the F&PL. Instead, the organization's last gasp was the demise of the Workers' International Relief (WIR) whose base operation in Germany was destroyed by the Third Reich, resulting in the F&PL losing much of its organizational and financial backing.[31] Had this not occurred,

however, the F&PL would still likely have changed course. In 1935, the Popular Front was introduced at the Seventh World Congress of the Communist International in Moscow, marking a sea change in international Communist strategy. Instead of combating capitalism and capitalist nations, communists were encouraged to enlist Western democracies to create a united front against fascism—specifically a front against Hitler, Mussolini, and the rise of militarism in Japan. CP USA members were instructed to bridge alliances with any and all progressive groups, from labor unions to governments. CP USA changed its approach toward the New Deal, shifting from harsh criticism to a willingness to support some of its agenda. Consequently, the Popular Front's call for building alliances ended much of the activity of sectarian cultural groups, including the John Reed Clubs and the F&PL, which all but folded by 1936. That year, the film division of the New York F&PL moved to 220 West Forty-Second Street in June, while the photography division remained at 31 East Twenty-First Street and was renamed the Photo League in 1937.[32] The Photo League became a major force in documentary photography for more than a decade, before being buried by the Second Red Scare in 1951. The film division, however, closed in 1936. In the decades that followed, much of the F&PL film reels and photographs produced by F&PL were lost or destroyed due to communist witch hunts.

In 1953, Lester Balog was listed as a Communist in the Un-American Activities hearings in California. In an interview with Tom Brandon, he conveyed what had happened to his work:

> Burned them! Believe it or not. I must have had seven or eight 400-foot reels, silent, 16mm. And what happens is, there were many people on it, some of whom were Lefts, Communists, Socialists, who were in demonstrations that may have had signs. . . . In '52, we had some "visitors" and that worried me, and my wife too . . . I didn't want to incriminate people who may have changed since then . . . after three or four days, I burned the stuff . . . it broke my heart.[33]

The film reels and negatives were gone, but the concept that lay behind the work—activists creating their own media—could not be so easily destroyed. It resurfaced many times in different forms, ranging from SNCC Photo in the 1960s to Paper Tiger Television in the 1980s and Indymedia in the 2000s. In some cases, F&PL members took a direct role in sharing their past work and tactics with others. In the 1960s, Balog screened *Century of Progress* during an organizing meeting for the United Farm Workers.[34] And Balog's photographs continued to influence others. In 1941, Balog took the now iconic photo of Woody Guthrie holding a guitar with the words "This Machine Kills Fascists" scrawled across the guitar's body. In the decades that followed, he remained committed to documenting the labor movement. Together with Otto Hagel, he worked as a photographer for the International Longshore and Warehouse Union, producing images for their newspaper *The Dispatcher*.

Others remained equally committed despite the harrowing experience of living through the Second Red Scare. Brody remarked in his seventies, "What the 'politically

committed artist' owes the people at this juncture is revolutionary art dedicated to revolutionary transformations of society. Any other formulation is mere intellectual obfuscation."[35] In words aimed at the younger artists, he added, "We need a new left film organization that would be tailored to the needs of our own time, with a 'rage' not merely for film for its own sake, but to put this powerful medium at the service of progress and change."[36]

David Robbins, *Philip Guston Sketching a Mural for the WPA Federal Art Project*, February 15, 1939 (Digital ID# 3027, Archives of American Art, Smithsonian Institution, courtesy of the Archives of American Art Wikimedia Partnership)

Eitaro Ishigaki standing before his painting *Harlem Court*, circa 1940 (Digital ID# 2174, Archives of American Art, Smithsonian Institution, courtesy of the Archives of American Art Wikimedia Partnership)

# 14

## Government-Funded Art:
## The Boom and Bust Years for Public Art

THE 1929 STOCK-MARKET crash that led to the Great Depression ushered in an economic crisis that plunged fifteen million people into unemployment by 1933. Yet the stock market was not the only market to crash. For artists, their market—the *art* market—also crashed. Galleries closed and private institutions that had once supported the arts became thrifty, leaving artists without patrons, without money for supplies, and without much hope.

This downturn was not new for artists, for their economic standing before the Depression had never been very stable. The printmaker and Artists' Union organizer Chet La More cautioned, "To the artists, 1929 does not represent an abrupt change, but merely a point of intensification in the process which has slowly been forcing them downward in the economic scale."[1] Yet the Depression was dire, as artists, like the majority of Americans, found themselves searching for work in a sea of unemployment. The solution, many argued, was for the government to fund the arts.

This idea was not without precedent; artists simply had to look south. Beginning in the early 1920s, the Mexican government employed numerous artists to decorate government buildings, a program that sparked the Mexican muralist movement, highlighted by the work of Diego Rivera, José Clemente Orozco, and David Alfaro Siqueiros.

In the United States a handful of artists, led by the Unemployed Artists Group, urged their government to follow the same path. The idea was proposed that artists be employed to decorate public buildings, including the new Department of Justice Building in Washington for "plumber's wages."[2] President Franklin D. Roosevelt's administration responded favorably to the idea, and in November of 1933, the first program dedicated to putting artists to work, the Public Works of Art Project (PWAP) was enacted under the direction of Edward Bruce within the Treasury Department. The program was limited, employing only a small number of artists and lasting only until May 1934, but it laid the groundwork for subsequent programs,

most notably the Works Progress Administration Federal Art Project (WPA-FAP), which marshaled in an unprecedented era of government funding of the arts between 1935 and 1943.

Combined, these programs had a significant effect beyond that of economic relief, for they fostered an environment in which artists were no longer isolated in the studio, or hidden within hermetic art scenes. Instead, they created an era of vast productivity in which artists created a wide range of public art. This art, in turn, reached a mass audience and ordinary Americans were exposed to a vast array of culture, whether it was visual art, music, dance, literature, or theatre. Together, the WPA cultural programs produced a brief window of time when the arts were considered an *essential* part of everyday life for many Americans across the nation. But the process of artists working for the government was a double-edged sword: a program that came with numerous controversies and compromises, and one that was incredibly short-lived.

## Art for the Millions: A New Deal for Artists

"For the present we are busy."

—Beniamino Bufano, sculptor[3]

The federally funded art programs followed the basic premise of other New Deal programs: temporary relief for unemployed workers. Artists were just one of many different factions who successfully lobbied for a share of the relief funds. Relief is one way of understanding the era, for the New Deal as a whole represented a major shift whereby the government directly intervened in the economy, giving the president a tremendous amount of executive power. Governmental intervention included the regulation of the stock market and the banking system, Social Security, pensions, unemployment compensation, laws against child labor, creation of public housing, minimum-wage standards, farm subsidy, and the Wagner Act that gave workers the right to collective bargaining. Some programs even hinted at socialism, such as the Tennessee Valley Authority, which involved government ownership of a major utility by operating a series of dams and hydroelectric plants in order to lower the cost of electric bills for consumers in the region.

Beniamino Bufano at work in WPA–FAP sculpture studio in San Francisco with Sargent Johnson behind to the right, ca. 1935–1940 (Archives of American Art, Smithsonian Institution)

For artists, the funding provided jobs and temporary economic security during a period where few other options were available. For most artists, galleries (the few that remained open) did not represent a viable option. The type of work preferred by many gallery owners was narrow and conservative. In New York City, the epicenter for visual art in the United States, fewer than ten galleries exhibited contemporary art during the 1930s on a regular basis, preferring instead to show the Great Masters and other art from the past.[4]

If anything, the 1930s brought to the forefront the hostility that many artists had long harbored toward the gallery system and their dependence upon it. The fact that many galleries went out of business during the Depression was welcome news to some. The surrealist painter Louis Guglielmi commented:

> The private gallery is an obsolete and withered institution. It not only encouraged private ownership of public property, but it destroyed a potential popular audience and forced the artist into a sterile tower of isolation divorced from society.[5]

Public funding offered a different path for the artist. Holger Cahill, the director of the WPA-FAP, praised public funding as a means by which to counter elitism in the arts.

In a speech entitled "American Resources in the Arts" he explained that

> many American artists, many American museum directors and teachers of art, people who would lay down their lives for political democracy, would scarcely raise a finger for democracy in the arts. They say that art, after all, is an aristocratic thing, that you cannot get away from aristocracy in matters of aesthetic selection. They have a feeling that art is a little too good, a little too rare and fine, to be shared with the masses.[6]

Cahill argued that this approach had distanced art from everyday people and had turned art into a "luxury product" found in a handful of metropolitan areas:

> Because, during the past seventy-five years, the arts in America have had to follow a path remote from the common experience, our country has suffered a cultural erosion far more serious than the erosion of the Dust Bowl. This erosion has affected nearly every section of the country and every sphere of its social life. There has been little opportunity for artists except in two or three metropolitan centers. With the exception of these centers, the country has been left practically barren of art and art interest. The ideas and the techniques of art have become a closed book to whole populations which have had no opportunity to share in the art experience, and which, in our industrial age, have become divorced from creative craftsmanship.[7]

Aubrey Pollard, *Holger Cahill Speaking at the Harlem Community Art Center*, October 24, 1938 (Digital ID# 12273, Archives of American Art, Smithsonian Institution, courtesy of the Archives of American Art Wikimedia Partnership)

Employment and Activities poster for the WPA's Federal Art Project, January 1, 1938 (Digital ID# 11772, Archives of American Art, Smithsonian Institute, courtesy of the Archives of American Art Wikimedia Partnership)

Cahill stressed that a country lacking in public funding in the arts excluded both the urban poor and those living in rural areas.[8] His alternative vision was for the WPA-FAP to reach out to every American, to give anyone who was interested the opportunity to participate in the arts.[9]

The WPA, acting as an umbrella for the Federal Theatre Project, the Federal Writers Project, and the Federal Art Project, accomplished many of these initial goals. Opportunities that had once been dormant now seemed unlimited for WPA employees. Projects ranged in scope from directing plays and writing novels to recording folk songs, recording the narratives of ex-slaves, and painting murals within post offices.

The Federal Art Project included a wide range of opportunities for artists to get involved.[10] A 1938 poster charted the various divisions within FAP and described the opportunities for artists to work in various mediums or as teachers, on production crews, and as administrators. Divisions included sculpture, murals, easel painting, photography, graphics, posters, and arts and crafts. Other options including positions devoted to building stage sets, frames, creating dioramas, modeling for artists, and serving as technical advisers (such as print technicians).

The WPA-FAP also established more than one hundred community art centers throughout the country, including the Harlem Community Art Center, the Walker Art Center in Minneapolis, and the Spokane Art Center.[11] Together, these centers were designed to encourage thousands of people to become involved in the arts and not to just cater to artists who were already well established.

Other projects were research-based. One of the more fascinating WPA-FAP projects was the Index of American Design, which employed upward of four hundred artists to record through detailed black-and-white and color drawings a visual record of American design history. Artists worked alongside researchers, cataloging the "his-

tory of American decorative and utilitarian design from the earliest days of colonization until the late nineteenth century."[12]

Research divisions were established throughout the country, where items ranging from glassware to furniture to clothing were all meticulously recorded. C. Adolph Glassgold, the national coordinator of the Index of American Design, explained the wide breadth of activity:

> The Pennsylvania unit, for example, is doing an exhaustive piece of work on the Pennsylvania-German culture; Northern California is busily engaged in re-constructing the era of mining . . . Minnesota is specializing in the early contributions made to American design by the Swedish immigrant . . . Utah is recording the applied arts of the Mormons; New England, with contributions from Ohio and Kentucky, is making what will probably be the first definitive compilation in color of the practical arts of the Shaker Colonies. . . . Were it not for the Index of American Design, the superb costumes, saddle trappings, furniture, and "santos" from the old Spanish Southwest might never have been recorded.[13]

Significantly, the fact that it was a government project ensured that the records and archives would be in the public domain. The Index of American Design embodied a common goal of the WPA-FAP: putting unemployed artists back to work, encouraging many different types of art forms that would be appreciated by a large audience, and fostering projects that had a social purpose.

A lesser-known project, the Art Caravan, also followed this model and served as a form of outreach for the WPA-FAP. The Art Caravan consisted of an old army ambulance that literally brought art to the people by transporting a traveling art exhibition.

Inside, the ambulance was converted so that it could haul "six large folding standards on which to hang oil paintings, a number of folding screens for

Magnus Fossum, a WPA artist copying the 1770 coverlet *Boston Town Pattern* for the Index of American Design, Coral Sables, Florida, February 1940 (National Archives, Records of the Work Projects Administration, 69-N-22577)

prints, watercolors, and Index of American Design plates, six boxes for packing sculpture, which were also used as stands for its display, a number of folding easels, and other necessary paraphernalia."[14]

The driver, Judson Smith, and later Kaj Klitgaard (both of whom were artists and lecturers), drove out to rural areas, where the exhibition was installed on the front lawns of public libraries and in town squares. In the evening, the driver would give a lecture on art to whomever cared to listen. Even more remarkable, a "ballot box" was set up to solicit responses from the audience:

Besides voting for the work they liked best, people were asked whether or not they would be interested in the establishment of a community art center or in obtaining any of the other services of the Project. In every case the vote was overwhelmingly in favor of the initiation of some art activity in the vicinity. The Art Caravan usually found a friendly and curious public during its visit, and some local person with organizing ability, such as the art teacher from the high school, would form a citizen's committee to develop plans for participating in some phase of the Project's programs.[15]

Eugene Ludins, a WPA-FAP supervisor in Woodstock, New York, concluded that it

proved over and over again that the very people who "know nothing about art" are the most easily interested when it is presented to them informally and they are encouraged to express their opinions . . . It has made an entirely new public aware of the WPA/FAP as a functioning cultural influence available even to the smallest village or township.[16]

Ludins viewed the Art Caravan as only the beginning:

If this experiment could be expanded and the technique improved through further experience, the Art Caravan would become a powerful medium for the introduction of new and vital interests into the lives of thousands of children and adults who are isolated from the big cities but who nevertheless make up the great majority of the people of this country.[17]

Art Caravan, ca. 1935–1940 (NARA Still Picture Branch of the Special Archives Division)

To others, the Art Caravan was elitist, for it assumed that rural people were lacking culture and that the art that was being exhibited would help to educate and enlighten them.[18] This argument exposes one of the contradictions of the WPA-FAP that proved difficult to resolve: the dilemma was how to increase artistic culture throughout the United States while at the same time remaining sensitive and open to a wide range of art forms, traditions, and cultural tastes.

To build a middle ground, administrators respected that different regions of the country

(and different communities within these regions) had their own distinct styles. Holger Cahill's overriding goal was consistent, and that was to encourage people to be involved in the arts through "active participation, doing and sharing, and not merely passive seeing."[19]

This inclusive approach allowed WPA-FAP projects to be diverse in style and content and allowed abstraction to coexist with representation, and fine art to coexist with craft. All styles were represented. Many problems and controversies arose, but the primary goal of the WPA-FAP was always to employ out-of-work artists and to expand art throughout the country.

In this regard, the WPA-FAP was incredibly successful. Robert Cronbach, who was employed in the Sculpture Division, reflected years later, "For the creative artist the WPA-FAP marked perhaps the first time in American history when a great number of artists was employed continuously to produce art. It was an unequaled opportunity for a serious artist to work as steadily and intensely as possible."[20] It also was an opportunity that ended quickly.

## Red Herrings

Nearly from its inception the WPA-FAP faced funding cuts and program changes that altered its original mission. Attacks against public funding began shortly after the program was launched in 1935.[21] Starting in 1936, Congress imposed the first cuts, and by 1937 Congress had slashed 25 percent of its overall budget.[22] Two years later, in 1939, more cuts were levied and much of the financial burden for funding the arts was transferred to the states, and artists were limited to an eighteen-month time span for consecutive work on a WPA-FAP project. This action alone disqualified the eligibility of more than 85 percent of New York artists.

Politicians who were hostile to the project's mission and work simply had to label artists and programs that they did not like as "Communist" in order to either bar them altogether or to greatly limit their influence. This accusation was enough to distance the majority of politicians from any support for the arts that they might have previously had. This attack, however, had a larger agenda, and was not targeted just at Communist groups: it was meant to stop the larger gains made by New Deal programs, along with labor and progressive movements—movements that could not be defined narrowly by a political ideology.

Red-baiting attacks had dire consequences for many, including artists who continued to remain actively engaged in social movements throughout the 1930s and 1940s, whether they had been affiliated with the Communist movement or not. Artists were put under FBI surveillance, blacklisted from jobs and teaching positions, dragged before the House Committee on Un-American Activities (HUAC), and faced external and internal pressure to censor their work.

All of the attacks against suspected "red" artists represented an affront to free speech that attempted to curtail First Amendment rights. WPA-FAP artists were made to take a loyalty oath to denounce any affiliation with Communist organizations. These draconian measures resulted in the WPA-FAP becoming cautious and fearful of approving any projects

Mischa Richter, *First Objective*, 1939 (New Masses, 30.5, January 24, 1939)

that had an inkling of political content. It also created a climate of self-censorship by the artists themselves.

Despite these attacks and the weakening of public art programs, artists demanded that the federal government *expand* the WPA-FAP and establish a permanent program. The Artists' Union crafted the language for a Federal Art Bill in 1935, and in January 1938, Rep. John M. Coffee of Washington and Sen. Claude Pepper of Florida introduced the Coffee-Pepper Bill (H.R. 8239) with the goal of establishing a permanent Bureau of Fine Arts.

However, when H.R. 8239 was introduced before the House, the bill was mocked and subsequently tabled by a vote of 195 to 35, which essentially killed it. Opponents labeled the very concept of arts funding during a depression as preposterous. One politician stated that "good art emerged from suffering artists, while subsidized art is no art at all."[23] Others attacked public art programs as harboring radicalism. Rep. J. Parnell Thomas accused the Theatre Project and the Writers Project of being a "hot bed for Communists" and added that the programs were "one more link in the vast and unparalleled New Deal propaganda machine."[24]

These attacks ended the possibility of a Federal Art Bill being reintroduced and turned the climate surrounding New Deal programs into a full-scale witch hunt led by the House Un-American Activities Committee, chaired by Rep. Martin Dies. The Dies Committee in 1938 accused 640 organizations, 483 newspapers, and 280 unions of being fronts for communist organizing.[25] The WPA-FAP was included in this list, and administrators and artists were forced to testify in its defense. The harshest attack was levied against the Theater and Writers Projects, resulting in the Theatre Program being cut, which spelled the beginning of the end for all federal art programs.

To protect the funding from cuts, WPA-FAP administrators offered the services of the art programs to the war effort to justify the public spending, and to deflect criticism that the programs were havens for Communist art and organizing. By June 1940, Holger Cahill recommended that all art projects focus on defense-related concerns, and by the end of the year the majority of WPA activities had shifted to the production of art for the armed forces and the Office of Civilian Defense.[26] Projects included graphic artists making training aids, posters, and silk screens of rifle-sight charts for target practice. Sculptors created models for war machinery, and painters worked on murals for military bases and painted camouflage on ships, tanks, and other objects. The Farm Security Administration (FSA) photographers were transferred to the

Office of War Information (OWI) and instructed to make glowing images of the nation preparing for war. One of the photographers, John Vachon, remarked, "We photographed ship yards, steel mills, aircraft plants, oil refineries, and always the happy American worker. The pictures began to look like those from the Soviet Union."[27]

As problematic as these OWI projects were, they did not last long. Roosevelt gave the orders that *all* federal art projects were to come to a close by 1943, noting that the WPA had served the country with distinction and "earned its honorable discharge."[28]

Arthur Rothstein, *War bond mural, Grand Central Station, New York, New York*, 1943 (LC-USF34-024494-D, Library of Congress)

The ease by which the art programs could be cut was telling. From the start, the government had envisioned the programs as temporary relief efforts, lacking longevity, which still left artists as marginalized members of society, engaged in a practice that was not valued as a essential part of the cultural well-being of the nation. Jacob Kainen of the Graphics Art Division stated:

> One of the tragedies of the WPA-FAP was that the artists were treated as beggars by the relief-oriented policies of the WPA ... their creative problems were not understood, and their work was grossly undervalued.[29]

Their work was also discarded. At the conclusion of the WPA-FAP, numerous paintings and other objects were sent to a government warehouse, where they were subsequently auctioned off for cheap to a handful of second-rate dealers who knew about the closeout sale. Work that didn't sell was then later destroyed. Discarded also was Cahill's progressive vision of a nation where art and culture would flourish in all corners of the country. Instead, a few epicenters for visual art would remain viable in New York City, Los Angeles, and to a lesser-degree Chicago. This left many visual artists at the mercy of the free-market system (galleries) to either sink or swim; most sank.

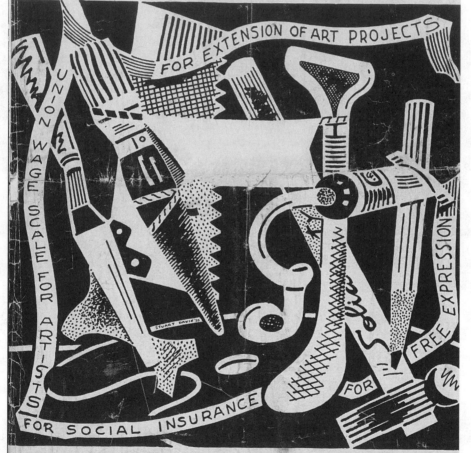

Stuart Davis, *Art Front* (cover), May 1935 (Beinecke Rare Book and Manuscript Library, Yale University)

# 15

## Artists Organize

"The Public Works of Art Project 'professional wage' was not food fallen from above. It was won by the persistent demands of organized artists."

—Boris Gorelick, Artists' Union organizer[1]

NONE OF THE RELIEF PROGRAMS that employed artists during the Great Depression—the Public Works of Art Project (PWAP) or the Works Progress Administration Federal Art Project (WPA-FAP)—were gifts from a benevolent government. Instead, artists demanded that these programs be created, and when they were, they lobbied to protect them. The Artists' Union—established in New York City and later expanded to other cities—was the leading voice for unemployed artists during the Great Depression. It was comprised of a militant group of artists organized into a trade union of painters, printmakers, and sculptors. Together, they advocated for more positions in the federal art projects, better pay, and better working conditions; as well, they organized against funding cuts and layoffs.

---

In 1933, a small group of around twenty-five artists and writers in New York City began meeting at the John Reed Club—named after the late journalist, founder of the American Communist Party, and the only American ever buried at the Kremlin—and drew up a manifesto. It read, in part, "The State can eliminate once and for all the unfortunate dependence of American artists upon the caprice of private patronage."[2]

The group settled on the name the Unemployed Artists Group (UAG) and began lobbying and demonstrating for federal and state jobs for artists. In September, they petitioned Harry L. Hopkins, one of Roosevelt's closest advisers and one of the architects of the New Deal, and called upon him to create opportunities for muralists, sculptors, graphic artists, and other visual artists to decorate public buildings and to work on public art projects. This call helped create the Public

Works of Art Project (PWAP)—a temporary relief program that was established in November 1933 and ended less than six months later.

The PWAP was flawed from the start. The selection process for the six-hundred-plus artists was left in the hands of Juliana Force, the director of the Whitney Museum, and much to the objection of the Unemployed Artists Group, she selected established gallery artists—many of whom were not in need of assistance. In response, the Unemployed Artists Group—renamed the Artists' Union—staged a total of nine demonstrations outside the Whitney that spurred a change in this procedure. Afterward, artists were called to work in order of their registration number. Eventually, 3,800 artists were assigned to projects, typically lasting from six weeks to three months, and that paid between $27 and $38.25 per week. And when the PWAP was left to expire, the Artists' Union helped lobby for a new program—the WPA-FAP.

In 1935, the Federal Art Project would launch a new era of temporary relief programs, albeit at a reduced wage—$24 per week for most areas of the country. That same year the Artists' Union drafted the framework for a Federal Art Bill designed to make government funding of the arts *permanent*. The Artists' Union felt that only the federal government had the resources to employ large numbers of artists. In addition, they believed a Federal Art Bill would help promote and distribute visual art throughout all corners of the nation. Artists' Union organizer Chet La More summarized, "We contend that painting, literature, and theaters do not belong to a top group; that they do not belong to people who can pay $1000 for a painting, and who can pay Broadway prices to see a play. The finer things in life belong to all the people in a democracy."[3] This vision—a permanent arts program—would not arise, but temporary relief programs under the banner of the WPA-FAP would.

## The Artists' Union

"Art has turned militant. It forms unions, carries banners, sits down uninvited, and gets underfoot. Social justice is its battle cry!"

—Mabel Dwight, WPA-FAP printmaker[4]

Prior to the start of the WPA-FAP, the Artists' Union in New York City was already a well-developed organization, and by the end of 1934 it had upward of seven hundred members. Meetings were held every Wednesday night, and attendance often fluctuated between two and three hundred people; crisis meetings would draw upward of six hundred.[5]

Locals were also formed across the country, in Philadelphia, Boston, Springfield (Massachusetts), Baltimore, Woodstock (New York), Cedar Rapids, Detroit, Chicago, Cleveland, St. Louis, Los Angeles, and elsewhere.

By 1936, the WPA-FAP employed more than five thousand artists and well over a thousand of these artists were Artists' Union members, spread out across eighteen states. Many of the Artists' Union members, though not all, were also affiliated with CP USA and

Communist campaigns. Others were fellow travelers, sympathetic to communism and so-cialism and the movement against war and fascism. The Artists' Union, however, distanced itself from direct Communist ties, stating that it would not align itself to any political party. Instead, its primary role was economic—helping unemployed artists obtain work in federal and state art programs, and advocating for the arts to reach all Americans. In short, the Art-ists' Union became the mediators between artists and PWAP (and then WPA-FAP) adminis-trators, settling grievances between workers and administrators and threatening to take direct action if needed.

On November 30, 1936, more than 1,200 artists, writers, actors, and actresses gath-ered in protest in New York City over WPA funding cuts and layoffs. Two days later, on De-cember 1, more than four hundred Artists' Union members gathered outside the WPA administration offices on Fifth Avenue and Thirty-ninth Street while 219 demonstrators stormed the offices and occupied them. The administration's response was to call in police, who proceeded to assault them. Twelve Artists' Union members were badly injured and taken away in ambulances, including Philip Evergood and Paul Block (who had led the dem-onstration), and all of the demonstrators were arrested.

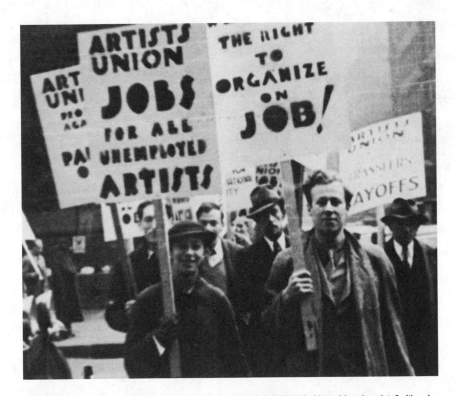

Artists' Union demonstration, ca 1936–1937; Byron Brown pictured right front (Archives of American Art, Smithsonian Institution)

In jail, some gave fake last names to the authorities, claiming to be Picasso, Cézanne, da Vinci, Degas, and van Gogh. A couple days later, the 219 individuals arrested were arraigned in court on December 3, found guilty of disorderly conduct, and given a suspended sentence.

More protests would follow. On December 9, some 2,500 WPA workers orchestrated a half-day work stoppage of all art projects to protest pending dismissals. Three days later, artists joined in with 5,000 other WPA workers in a picket at the central WPA office. The January 1937 cover of *Art Front*—the Artists' Union's official publication—documents their capacity to demonstrate. Visualized is a street packed with protesters; prominent among them are Artists' Union signs and red banners with the "AU" letters. Also held up high are cutout images of pigs with top hats—a likely reference to bankers.

These demonstrations produced results. The street protests, the police brutality at the WPA offices, and the resulting press caused Mayor Fiorello LaGuardia to make an emergency trip to Washington that resulted in funds not being cut. Gerald M. Monroe writes, "While average employment on the WPA as a whole decreased 11.9 percent from January to June 1937, employment on the four Arts Projects increased 1.1 percent."[6]

However, this temporary reprieve was short-lived. In April 1937, President Roosevelt and Congress pushed through a 25 percent cut of all WPA funding that did not spare artists. In late June, WPA-FAP employees began receiving their pink slips, setting off another wave of sit-ins by the Artists' Union and others—writers, musicians, actors, and actresses—who occupied the WPA offices in Washington, DC. In New York, six-hundred-plus demonstrators occupied the Federal Arts Project Office and held Harold Stein, a New York City Art Project administrator, captive for fifteen hours. There, he was ordered to call his superior in Washington, DC, and relay the strikers' demands that all cuts should be rescinded. Eventually, Stein signed an agreement that the layoffs would be delayed, but in reality Stein had no power in stopping the cuts from eventually going through.

These actions alone represented a new militancy among artists as they began to realize their collective strength. Stuart Davis, the first editor for *Art Front,* wrote:

*Art Front* (cover), January 1937. (Ben Shahn papers, Archives of American Art, Smithsonian Institution)

Artists at last discovered that, like other workers, they could only protect their basic interests through powerful organizations. The great mass of artists left out of the project found it possible to win demands from the administration only by joint and militant demonstrations. Their efforts led naturally to the building of the Artists' Union[7]

Others were less apt to pay compliments to these tactics, or to the Artists' Union. Olin Dows, an artist and the director of Treasury Relief Art Project (TRAP), believed the actions were counterproductive: "It was grotesque and an anomaly to have artists unionized against a government which for the first time in its history was doing something about them professionally."[8] And Audrey McMahon, head of the New York City Art Project, argued that the Artists' Union, along with other radical art groups, tarnished the image of the entire WPA-FAP, for it led the public and conservative members of the government to see all artists as radicals.[9] But, the Artists' Union represented the workers' perspective, not management's. They held little faith in the sincerity of government bureaucrats and believed that it was the artists' ability to organize that had led to artists being included in the WPA programs in the first place.

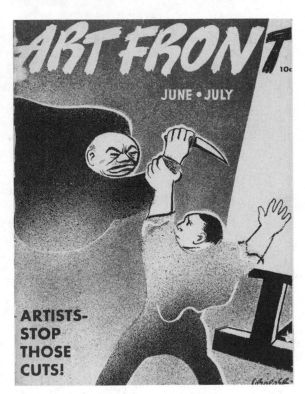

*Art Front* (cover), June/July 1937. (Ben Shahn papers, Archives of American Art, Smithsonian Institution)

## Rental Policies, Ambulances, and Solidarity Actions

Other campaigns and solidarity actions also defined the Artists' Union's efforts. The Artists' Committee of Action—a loose confederation of artists that was aligned with the Artists' Union and had been initially created in opposition to the destruction of Diego Rivera's mural at Rockefeller Center—led the call for Mayor LaGuardia to establish a city-funded, artist-run Municipal Art Gallery and Center in New York City. LaGuardia backed the idea, and on January 6, 1936, a municipal gallery was opened at 62 West Fifty-Third Street. However, two provisions irked Artists' Union members. First was an "alien" clause that prohibited foreign-born artists from exhibiting. The second was a clause that prohibited art that "might offend the administration" from being exhibited.[10] In response, Artists' Union members threatened

to withhold their work if the two clauses were not removed, and the LaGuardia administration, not wishing to generate negative press, relented.

Not content with this success, the Artists' Union called for an expansion of the Municipal Art Center in an article published in *Art Front*. The Artists' Union envisioned an additional building where a "Circulation Library could be maintained for the rental of art works, paintings sculptures, etc., to institutions and private individuals, at a rental payable to the artists."[11] They also envisioned that this space could house a free public art school that could double as a lecture space to help popularize visual art. Lastly, they envisioned the New York Municipal Art Center as a model that could be duplicated:

> The artists of New York made a good beginning. Let it be an incentive to all artists throughout the land. Build Municipal Art Centers in every city in the U.S.A.![12]

Municipal art centers were not established across the country, but other campaigns that the Artists' Union advocated for saw modest gains. The American Society of Painters and Gravers (ASPG), the Artists' Union, and the American Group led the charge for a rental policy whereby artists would receive a small fee for exhibiting their work in museum shows—1 percent per month of the price of the work with a $1,000 maximum and a $100 minimum. Einar Heiberg of the Minnesota Artists' Union reasoned:

> Should a group of musicians play without recompense, for instance, simply because a hall had been provided? Should a singer give a program without remuneration simply because of the donation of a stage and possibly an accompanist? The artists felt there was no logic in the protests of the museum directors, and felt there was as much value in a given work of art as there might be in an orchestration, or a song, or a dental extraction. Prestige acquired from the hanging of a picture might bring the artists a lot of pretty words and some encouragement, but very few groceries.[13]

Many museums immediately rejected the idea as preposterous, arguing that it lacked a precedent and insisting that artists should be thankful for the exposure and the prestige of showing within their halls. Some even threatened to stop showing contemporary art if the rental fee was insisted upon, but artists held their ground. They urged artists to refuse to show in museums that did not pay the fee. Chet La More wrote in the January 1937 issue of *Art Front*:

> Important national exhibitions have been badly dented by refusals to show. In Baltimore the 1936 Maryland Annual was reduced to a farce by the boycott. In Minnesota important concessions have been won regarding local exhibitions and in St. Louis the artists carried out a splendid public campaign, refusing to show, picketing the Museum, and running a counter exhibition.[14]

These nationally coordinated campaigns signified just how organized artists were in the 1930s and how successful they were in defending their rights to employment, but this should not confuse the fact that these same artists also rallied behind the economic rights of other workers. Joseph Solman explains:

> The Artists' Union and the National Maritime Union (NMU) were two of the most active participants in aiding striking picket lines anywhere in New York City. If the salesgirls went out on strike at May's department store in Brooklyn a grouping from the above-mentioned unions was bound to swell the picket lines. I recall some of our own demonstrations to get artists back on the job after a number of pink dismissal slips had been given out. At such times everyone was in jeopardy. Suddenly from nowhere a truckload of NMU workers would appear and jump out onto the sidewalk to join our procession.[15]

Other solidarity actions looked overseas. The Artists' Union raised $659.27, along with food and clothing donations, that were sent to two organizations allied with the Loyalist cause during the Spanish Civil War: the Spanish Anti-Fascist Committee and Labor's Red Cross for Spain.[16] More impressive, the Artists' Union sent two fully equipped ambulances to Spain as part of the Artists and Writers Ambulance Corp (under the sponsorship of the Medical Bureau of the American Friends of Spain) that aided the Loyalists in their fight against the Nationalists and General Franco.[17] All told, the Corp was comprised of twenty ambulances, fifteen surgeons, forty-five nurses, and medical supplies.[18]

Advertisement in *Art Front*, March 1937. (Ben Shahn papers, Archives of American Art, Smithsonian Institution)

Some Artists' Union members also volunteered to fight. Paul Block, who had led the December occupation of the New York WPA-FAP administration offices, became one of 2,800 Americans who traveled to Spain and joined the International Brigades. These U.S. volunteers formed several combat battalions and noncombat units (medical and transportation) and became collectively known as the Abraham Lincoln Brigade. Block, himself, became a commander, and was killed in action in 1937 in Belchite, Spain, while leading the Lincoln Brigade's 3rd Company into battle.[19] Block's sacrifice was not unique. Thirty-five members of the national Artists' Union went to Spain and served as ambulance drivers or soldiers, and half of them were killed during the war.[20]

## Artists and Organized Labor

Solidarity actions defined the ethos of the Artists' Union. The coalition of artists did not view themselves as acting in isolation: members largely self-identified themselves as *workers*

who were part of the labor movement. The Artists' Union logo made this clear. Centered between the "A" and "U" was a clenched fist that held the "U" for union, as if it were to be branded with an iron implement. This design showcased the Artists' Union's commitment to militant struggle and their emerging commitment to organized labor.

Their writings in *Art Front* did as well. Meyer Schapiro wrote in the November 1936 issue that artists needed to win over the support of other workers if they expected to win their own demands:

> It is necessary then, if workers are to lend their strength to the artists in the demand for a government-supported public art, that the artists present a program for a public art which will reach the masses of people. It is necessary that the artists show their solidarity with the workers both in their support of the workers' demand and in their art. If they produce simply pictures to decorate the offices of municipal and state officials, if they serve the governmental demagogy by decorating institutions courted by the present regime, then their art has little interest to workers. But if in collaboration with working class groups, with union clubs, cooperatives, and schools . . . then they will win the backing of the workers.[21]

Artists' Union membership card. (Harry Gottlieb papers, Archives of American Art, Smithsonian Institution)

This concept of visualizing the concerns of labor took root in the Artists' Union. Clarence Weinstock wrote in the December 1936 issue of *Art Front* that Artists' Union members had begun reaching out to other unions and asking trade unionists about what types of images they wished to see exhibited at their headquarters. The Artists' Union, under the subcommittee Public Use of Art Committee, received numerous responses. Weinstock explains:

The International Ladies Garment Workers Unions suggests five groups of subjects: emigration of garment workers from Europe in the 1890's and 1900's; working conditions in the garment industry at that time—the sweatshops; the fire which led to the dressmakers' strike of 1905 . . .

The Transport Workers Union wants: the history of transportation in New York City: the history of the union . . . scenes in the steel industry; the Irish transport strike of 1911–13 . . .

The Union of Dining Car Employees needs works showing the effect of speedup on dining car employees; the battle for union recognition on the Santa Fe . . . exploitation of women employed in hotel dining rooms and kitchens; anti-lynching subjects . . . Negro discrimination. . . .

The Amalgamated Housing Corporation of the Amalgamated Clothing Workers' Unions suggests a series showing how New Yorkers live and the contrast of life under a system of profit economy with that under a cooperative economic system.[22]

Other requests came in from the Brotherhood of Sleeping Car Porters, the Musicians' Local 802, and the Bricklayers' Local 37, among others. Here, the Artists' Union placed their efforts in the service of working-class movements, but other writings in *Art Front* situated the Artists' Union as not just in solidarity with organized labor, but as part of the movement itself. The June 1936 issue of *Art Front* included a report-back from the Artists' Union eastern district convention that read, in part:

> Artists' Unions should cooperate locally with the A.F. of L. on all possible measures. Affiliation will have to pend the formation of National Organization. As the building trades are opposed to the artists, while the other unions such as musicians and teachers and bookeepers [sic], etc. favor us, it is probable our best opportunity is through the Committee for Industrial Organization (Lewis). We will only enter on the basis that we maintain our own jurisdiction.[23]

The Artists' Union first became affiliated with organized labor when they voted to apply for a charter with the American Federation of Labor (AFL) in 1935 and the Congress of Industrial Organizations (CIO) in 1937. Yet because the Artists' Union had fewer than two thousand members, the majority of whom were based in New York City, they could not become a national charter, so they merged with a CIO local—the United Office and Professional Workers of America (UOPWA)—that was comprised of bookkeepers, stenographers, office workers, and insurance agents. In December 1937, Philip Evergood, the Artists' Union president, announced that the Artists' Union would be renamed the United American Artists–Local 60 and it was here that the concept of "artist as worker" became most realized.

Both advantages and disadvantages came with this merger. The artists within Local 60 had the backing of a strong union, but they lost much of their independence, which affected their militancy. The UOPWA placed the artists within a drab office space and suggested that meetings be held monthly, instead of weekly. UOPWA president Lewis Merrill demanded that the Artists' Union drop their clenched-fist logo, along with the red banners that they used in street demonstrations.[24] These calls from above curtailed the artists' creativity and signified how Merrill had completely failed to understand how artists worked or how their skill set could aid the broader labor movement.

The artists in the AU also had other adversaries. Their primary employer—the federal government—had cut the majority of artists' positions by 1939, sending artists back to the ranks of the unemployed. Lacking hope for permanent federal patronage, Merrill advocated in 1942 that artists should seek out work in private industries. This failed to

materialize in any substantial way, and later that year the United American Artists–Local 60 disaffiliated from the UOPWA, ending the artists' formal association with labor and ending much of the activity of what had been the Artists' Union. Left behind, however, was a legacy of one of the most successful groups to ever organize large numbers of artists around economic issues—one that became closely aligned with organized labor instead of isolated in a hermetic art scene. The Artists' Union signified a brief era when visual artists realized their collective power, and one where artists identified themselves as *workers*.

# 16

## Artists Against War and Fascism

IN 1935, THE NEW YORK–BASED art organization the American Artists' Congress put out a call to visual artists of "recognized standing" to join their ranks. The one-page printed call read, in part:

> We artists must act. Individually we are powerless. Through collective action we can defend our interests. We must ally ourselves with all groups engaged in the common struggle against war and fascism. There is a need for an artists' organization on a nation-wide scale, which will deal with our cultural problems. The creation of such a permanent organization, which will be affiliated with kindred organizations throughout the world, is our task. The Artists' Congress, to be held in New York City, February 15, 1936, will have as its objective the formation of such an organization.[1]

Below the call were the names of 110 artists who supported the Congress, including Margaret Bourke-White, H. Glintenkamp, Harry Gottlieb, Jerome Klein, Paul Cadmus, Hugo Gellert, Ben Shahn, Eitaro Ishigaki, Isamu Noguchi, Lewis Mumford, Lynd Ward, Elizabeth Olds, and Art Young. Listed as the Secretary of the Artists' Congress was Stuart Davis.

The response to the call was overwhelming: 360 artists attended the congress, and 600 would sign up as members by the end of the year. The February 15, 1936, congress was extended from a one-day event to a three-day event—a public gathering at Town Hall at 123 West Forty-Third Street, followed by two days of closed sessions at the New School for Social Research, where attendees broke into individual sessions, read papers, debated tactics, and learned from one another's ideas and experiences.

Artists from twenty-eight states and three other countries—Mexico, Peru, and Germany— were present at the conference. These included a delegation of twelve Mexican artists, including the famous muralists José Clemente Orozco and David Alfaro Siqueiros. Both had crucial experience in

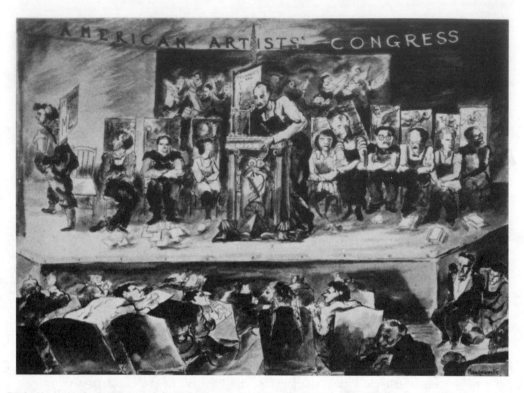

Peppino Mangravite, "Aesthetic Freedom and the Artists' Congress," *American Magazine of Art*, April 1936

organizing artists, forming radical art collectives, and producing publications. The Mexican Artists' Union, Syndicate, and the revolutionary paper *El Machete* all pre-dated the Congress and served as a key model for their U.S. counterparts to learn from.

At the end of the congress, members voted unanimously to establish a permanent organization. New York City was to be the base, with smaller chapters encouraged to start in other cities. The preamble for the congress listed six reasons for its formation, many of which echoed the Artists' Union goals:

1. to unite artists of all esthetic tendencies to enable them to attain their common cultural objectives;
2. to establish closer relationships between the artist and the people and extend the influence of art as a force of enlightenment;
3. to advocate and uphold permanent Governmental support for the advancement of American art;
4. to support other organized groups on issues of mutual interest in an effort to develop and maintain conditions favorable to art and human existence;
5. to oppose all reactionary attempts to curtail democratic rights and freedom of expression [in the United States] and all tendencies that lead to Fascism;

6. to oppose war and prevent the establishment of conditions that are conductive to the destruction of culture and detrimental to the progress of mankind.[2]

While the Artists' Union's goal was to primarily advocate for a Federal Art Bill and to serve as a mediator between WPA-FAP employees and administrators, the American Artists' Congress had a global agenda: to combat the rise of fascism and the threat of world war. The Congress took aim at the rise of fascism in Nazi Germany, fascist Italy, Franco's Spain, and right-wing, reactionary politics in the United States.

The unstated goal of the congress was to support the Popular Front mandate—the 1935 shift in international Communist strategy that aimed to create a united front against fascism. This mandate, however, was not stated in the widely disseminated call to attend the congress, but an earlier draft of the call read:

> The first Workers State: the Soviet Union, has instituted cultural activities on a scale unknown in history. All creative workers there are free from the deadening threat of economic insecurity and all art trends are encouraged. The artist must realize his interests in the fight carried on by the Soviet Union against Fascism.[3]

A number of presenters at the congress also stood in solidarity with the Soviet Union and its artists, most notably in the papers "An Artist's Experience in the Soviet Union" by Margaret Bourke-White and "Status of the Artist in the U.S.S.R." by Louis Lozowick.

However, an affiliation with CP USA or Communist campaigns was not a prerequisite to joining the congress. The congress, much like the Artists' Union, reached out to a wide range of Left and progressive artists, some with ties to CP USA, many without.[4] The expectation was that the artists invited to the congress were well known and respected in their field. This was not an organization for amateur or emerging artists. Stuart Davis noted in his address "Why an Artists' Congress?" at the Town Hall event:

Sol Horn, "[Stuart] Davis at work on a canvas for the Federal Art Project," ca. 1939 (digital ID# 2053, Archives of American Art, Smithsonian Institution)

> The members of this Congress who have come together to discuss their problems in the light of the pressing social issues of the day are representative of the most progressive forces in American Art today. The applicants for membership were accepted on the basis of their representative power, which simply means that they had already achieved a degree of recognition and esteem as artists in the spheres in which they function.[5]

Davis concluded with objectives for the congress:

To realize them, we plan to form a permanent organization on a national scale. It will not be affiliated with any political group or clique of sectarian opinion. It will be an organization of artists which will be alert to take action on all issues vital to the continued free functioning of the artist . . . It will be a strengthening element to the whole field of progressive organization against War and Fascism. It will be another obstacle to the reactionary forces which would rob us of our liberties.[6]

Davis then turned the stage over to addresses by Rockwell Kent, Joe Jones, Aaron Douglas, Margaret Bourke-White, Paul Manship, George Biddle, Heywood Broun, Francis J. Gorman, and Peter Blume.

Aaron Douglas's talk, in particular, stood out in terms of its criticality. In the talk entitled "The Negro in American Culture," Douglas—a celebrated Harlem Renaissance painter and graphic artist—began by highlighting the achievements by other black artists, musicians, actresses, and actors, as well as the economic and social conditions that they faced. He followed with a critique of how museums had shut out black artists and ignored black subject matter in exhibitions. He then segued to a critique of how white radical artists employed black imagery in simplistic ways—cutting words to Douglas's largely white audience. "It is when we come to revolutionary art that we find the Negro sincerely represented, but here the portrayal is too frequently automatic, perfunctory, and arbitrary," he declared. "He becomes a proletarian prop, a symbol, vague and abstract."[7] Douglas portrayed white radical artists as out of touch with the black community and critiqued the congress itself—an organization that lacked racial and gender diversity and placed leadership roles largely in the hands of white men, mirroring the racial and gender inequalities in American society. However, Douglas also complimented his audience: "Revolutionary art should be praised, however, for pointing a way and striking a vital blow at discrimination and segregation, the chief breeding ground of Fascism."[8]

The closed sessions at the New School for Social Research continued the debate. These sessions focused on three themes: "The Artist in Society," "Problems of the American Artist," and "Economic Problems of the American Artist." It concluded with "Reports and Resolutions of Delegates and Permanent Organization." In these sessions, delegates listened and responded to presentations, including discussions on the federal art projects: "Government in Art" by Arnold Friedman, "Municipal Art Center" by Harry Gottlieb, "Artists' Union Report" by Boris Gorelick, "The Rental Policy" by Katherine Schmidt; reports on the rise of fascism: "Art in Fascist Italy" by Margaret Duroc, "Fascism, War, and the Artist" by Hugo Gellert; and reports from the Mexican delegation: "The Mexican Experience in Art" by David Alfaro Siqueiros, and "General Report of the Mexican Delegation to the American Artists' Congress" by José Clemente Orozco.[9]

Orozco's report was particularly important, for he summarized some of the previous conversations that had taken place at the Congress in Mexico. Orozco stressed that it was essential for artists to organize into trade unions and to link up with other working-class organizations. Moreover, he argued that trade unions, *not* the government, should be the

primary backers to fund working-class art. In this scenario, artists and artists' organizations would provide cultural services to trade unions—theatre productions, books, lectures, mural decorations—and in turn, the trade unions would financially support the artists. Orozco envisioned a scenario where trade unions had a cultural component and part of the union dues would include the purchasing of "cultural stamps" that would fund artists to create work.[10]

Combined, all of these presentations set an agenda for artists to organize around and to form new alliances. The congress concluded with the formation of an executive committee of fifty-seven members, with Stuart Davis serving as the national executive secretary.

Max Weber was selected as the chairperson. Other branches were formed in Cleveland, St. Louis, New Orleans, Los Angeles, and Chicago. Members were asked to pay $2 in annual dues. In the months that followed the Congress, reports were mailed out to keep the members informed of upcoming events. One internal report to members, written by Davis, signified their role:

> The Artists' Congress has a cultural function, which is to promote the welfare of the artist and to increase the public understanding of the place of art in modern society. It is because of this purpose that it is necessary to fight relentlessly all the reactionary forces, wherever and in whatever form they appear, forces which would assign to the artist the role of sterile follower of tradition, or make him the propaganda instrument of a reactionary social force like Fascism.[11]

In a message aimed at the apolitical artist, it concluded:

> To the artist who still insists that he is only interested in art and does not want to be annoyed by other matters, it is necessary to point out that we too are interested primarily in art, but we realize that the creation of important art is a social phenomenon and does not begin and end in the studio of the artist.[12]

## Paper Politics

Momentum from the February 1936 congress carried over to staging group exhibitions. From 1935 to 1941, the congress organized twenty-two exhibitions, highlighted by a number of print shows that were staged in multiple cities.[13]

In 1936, the congress organized *America Today*, where artists were invited to submit upward of three black-and-white ten-by-fourteen-inch prints relevant to the title of the show. Those selected were then asked to pull thirty copies of their image so that *America Today* could open simultaneously in thirty cities during the month of December. Alex R. Stavenitz wrote in the show's catalog: "The American Artists' Congress is attempting to help

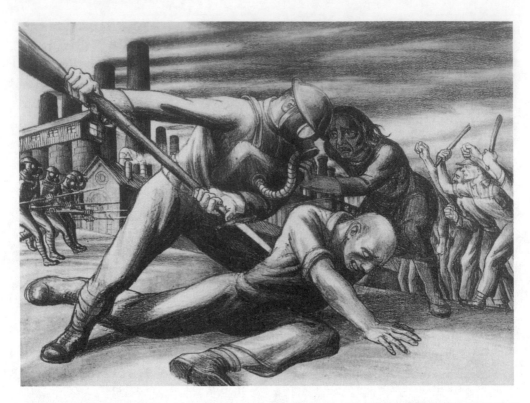

Harry Sternberg, "Industrial Landscape," lithograph, 1934. (Miriam and Ira D. Wallach Division of Art, Prints, and Photographs, The New York Public Library)

the artist reach a public comparable in size to that of the book and motion picture, and to bring the artist and public closer together by making the print relevant to the life of the people, and financially accessible to the person of small means."[14]

This same model was applied to *In Defense of World Democracy: Dedicated to the Peoples of Spain and China,* which was exhibited from December 15 to December 30, 1937, in simultaneous cities: New York City, Baltimore, Los Angeles, Cedar Rapids (Iowa), New Orleans, St. Louis, and Portland (Oregon).

Another show attempted to realize Stavenitz's goal of art reaching an audience comparable to that of motion pictures. The 1936 exhibition *Against War and Fascism: An International Exhibition of Cartoons, Drawings, and Prints* was exhibited at the New School for Social Research and also filmed. Organizers reproduced the one hundred works in the show onto 35 mm film, making it available for rent or purchase.

This facet of the show was incredibly innovative, but the print medium itself was also well suited for the large-scale dissemination of graphics. Congress member Harry Sternberg wrote, "No other medium has the adaptability of the print, which can be produced rapidly and inexpensively in large quantities, and can be widely distributed at low cost."[15]

He called upon artists to reject traditional ideas about printmaking:

Unidentified photographer, "Elizabeth Olds at work, New York City," 1937 (digital ID# 2309, Archives of American Art, Smithsonian Institution, courtesy of the Archives of American Art Wikimedia Partnership)

> The chief drag upon the development of the immense possibilities ready to hand in the print field today is the cult of rare prints. The fancy jargon of print connoisseurship is no more than a pretentious front for speculation with an artificial limited audience. Artists are induced to destroy their plates after pulling a ridiculously small number of proofs in order to appeal to the vanity of "connoisseurs," interested only in having things that no one else has.[16]

Sternberg's solution: move away from small editions and choose techniques that would allow for the largest output of prints to be produced and disseminated. In turn, this would keep the cost of prints down so that working-class people could afford them.

Other radical printmakers offered up similar advice. Elizabeth Olds, who joined the congress and was employed in the WPA-FAP Graphic Division, argued that the government could take an active role in disseminating prints. She advocated that the Government Printing Office "distribute original prints to public institutions and directly to the people along with its agricultural manuals and departmental reports."[17] The mass mailing of prints to citizens did not occur, but many prints did find their way into schools, libraries, hospitals, and housing projects, thanks to the WPA-FAP.

Prints would also be featured at the A.C.A. Galleries, an epicenter for radical art in New York City at 52 West Eighth Street that was started by Herman Baron in 1932.[18] In October 1936, the congress organized *To Aid Democracy in Spain,* which raised over $700 for Loyalist Spain. Three years later, the congress would help bring Picasso's *Guernica* to New York City, where it debuted at the Valentine Gallery in May 1939, one month after the Spanish Republic had fallen. This event helped raise money for the refugees of the Spanish Civil War.[19]

## Resignations

The Artists' Congress staged their second mass gathering on December 17, 1937, at Carnegie Hall and featured presentations by Mayor LaGuardia, Max Weber, Philip Evergood, George Biddle, and others. Pablo Picasso was scheduled to phone in an address, but he had to cancel at the last minute due to an illness.

However, momentum after this event would wane. Internal debates on whether to support international Communist policy, and the party line that came out of Moscow, began to tear the organization apart.

Between August 1936 and March 1938, Stalin purged the Communist Party of dissenting voices in a series of group trials in Moscow. He then banned modern art in 1938 in favor of Socialist Realism—a stance that should have made artists in the United States, regardless of affiliation to the CP USA, tremble. On August 23, 1939, Stalin signed a nonaggression pact with Nazi Germany, crushing the very reason behind a movement against fascism.

Many Artists' Congress members still defended the Soviet Union despite the numerous contradictions and the affront against many of the ideals that members stood by. Eventually, the CP USA issued a ban on public discussion on the infamous show trials in Moscow, and the May 1938 issue of *New Masses* published a document entitled "The Moscow Trials: A Statement by American Progressives" in which more than one hundred artists (including congress members Stuart Davis, Philip Evergood, Hugo Gellert, Harry Gottlieb, William Gropper, Paul Strand, Max Weber, Elizabeth Olds, and Louis Lozowick) justified some of the purges. Helen Langa writes that the article "sought to persuade readers not to condemn them [show trials]. It praised the accomplishments of the Soviet government, offered reasons for believing that the accused were guilty, and linked these explanations with the need to attack fascism both internationally and in America."[20] A year later, in August, many of the same artists, Davis excluded, signed a letter printed in the *Daily Worker* insisting that Russia was not spiraling downward into a totalitarian state.[21]

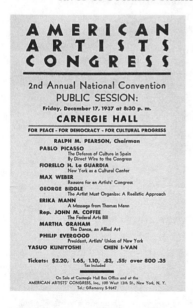

Flyer for the American Artists Congress 2nd annual national convention public session, December 1937 (digital ID# 12949. Gerald Monroe research material, Archives of American Art, Smithsonian Institution)

However, defending the Soviet Union's reputation became much more difficult after Stalin signed the nonaggression treaty with Hitler and invaded Finland. These actions shocked many CP USA members and sympathizers, yet some continued to stand behind the party line and were not openly critical. This silence or tacit support resulted in a field day for their critics, who ridiculed them as Stalinist apologists. Clement Greenberg and Harold Rosenberg (art historians who would eventually become synonymous with promoting abstract expressionism and artists moving away from political themes) signed a letter, along with Meyer Schapiro and others, in the summer 1939 issue of the *Partisan Review* that blasted these artists' support of Soviet policy. At first, Congress leadership tried to avoid public discussion of the issue. Stuart Davis explained that the group would focus solely on cultural issues.

Avoiding the issue proved impossible after the Hoover Committee for Finnish Relief (directed by former president Hoover) asked the congress for a donation. Within the congress, Schapiro directly challenged the leadership to address whether the organization stood behind Stalin's attack of Finland. This led to further stalling and finally a measure was put forth by the printmaker Lynd Ward that the congress should remain neutral on the Finnish issue (although he personally voiced support for the German Soviet Pact and the invasion of Finland). Additionally, Ward argued that the United States should remain neutral in the crisis of war looming in Europe.[22] Ward's measure passed 125 to 12 and led to numerous resignations within the congress, with members accusing the organization of following a Stalinist line. Davis resigned in a letter to the Congress board on April 5, 1940, followed by around thirty other members over the following two weeks. In response, those who left formed the Federation of Modern Painters and Sculptors. The Artists' Congress carried on for a few more years but lost much of its membership and its clout, finally folding in 1942.

The congress, despite its divisions, represented an intense period of artists organizing, and showcased the important role of artists contributing their talents to solidarity movements, both nationally and internationally. As a result, the public began to view artists and their role in society differently, and artists began to see themselves differently as well. The notion of artists as bohemian outcasts, a common label during the pre–World War I cultural movements, was fading. In its place a new identity—one much more tied to the working class—was forged, an identity that would be severely tested during the Second Red Scare, World War II, and its aftermath.

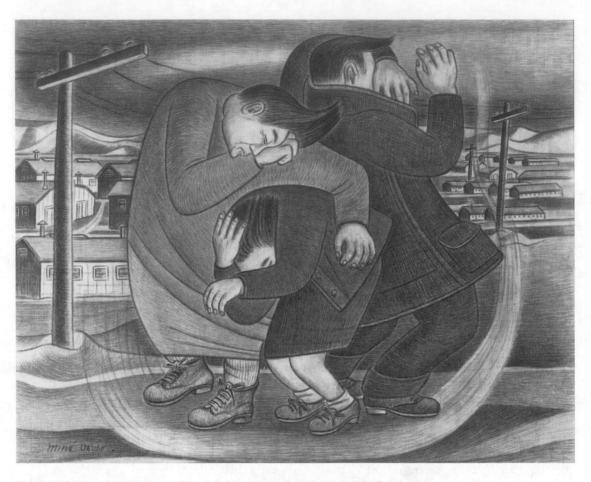

Miné Okubo, "Dust Storm," 1942, (University of California Berkeley, Bancroft Library) (courtesy of Miné Okubo Estate)

# 17

## Resistance or Loyalty:
## The Visual Politics of Miné Okubo

IN 1939, MINÉ OKUBO was studying art in Europe on a University of California–Berkeley scholarship when she faced a terrible predicament—how to escape a war zone. England and France had declared war on fascist Germany, and Okubo managed to flee, taking the last passenger boat from France back to the United States. Safe at home, she went to work painting murals for the Works Progress Administration–Federal Art Project (WPA-FAP). However, she had inadvertently returned to another war zone. The Japanese attacked Pearl Harbor in December 1941, shattering any sense of normalcy in the United States.

Days after the attack on U.S. soil, Okubo's father was taken into custody by the FBI and held without charges. Thousands of other Japanese Americans—primarily community leaders, fishermen, and newspaper editors—would also be apprehended.[1] In the weeks and months to follow, a curfew was established from eight p.m. to six a.m. for Japanese Americans on the West Coast and Hawaii. Bank accounts were frozen and individuals could not travel outside a five-mile radius of their home—an order that was initiated to prevent "possible" future attacks.

The federal government and the media depicted Japanese Americans as an enemy within. Lt. Gen. John L. DeWitt, head of the Western Defense Command, said:

> In the war in which we are now engaged racial affinities are not severed by migration. The Japanese race is an enemy race and while many second and third generation Japanese born on United States soil, possessed of United States citizenship, have become "Americanized," the racial strains are undiluted. . . . It, therefore, follows that along the vital Pacific Coast over 112,000 potential enemies, of Japanese extraction, are at large today."[2]

DeWitt's recommendation to the Roosevelt administration was that all Japanese Americans and Japanese aliens on the West Coast and Hawaii should be apprehended and placed into wartime concentration camps. His paranoia was met with skepticism.

Attorney General Francis Biddle wrote a memo to President Franklin D. Roosevelt opposing DeWitt's call for evacuation. FBI director J. Edgar Hoover also concluded that internment camps could not be justified for security reasons and there was little to no evidence to support the claim that Japanese Americans were aiding the Japanese emperor.

Nonetheless, the media beat the drum of wartime hysteria and racial profiling. The *Los Angeles Times* editorialized, "A viper is nonetheless a viper wherever the egg is hatched—so a Japanese American, born of Japanese parents—grows up to be a Japanese, not an American."[3] By March of 1942, a national survey found that 93 percent of Americans approved of internment camps for Japanese aliens, and 59 percent favored the internment of Japanese Americans.[4] Dissenting voices—apart from the American Civil Liberties Union (ACLU)—were few and far between.

President Roosevelt, however, had the final word. On February 19, 1942, he signed Executive Order 9066, allowing the secretary of war to prescribe military areas where "the right of any person to enter, remain in, or leave shall be subject to whatever restrictions the Secretary of War or the appropriate Military Commander may impose in his discretion."[5] In essence, Roosevelt allowed DeWitt and the U.S. military to strip Japanese Americans of their citizen rights, due process, and their civil liberties.

The evacuation process began promptly after Roosevelt's signature. Japanese American communities were often given just a matter of days to report to assembly centers, forcing them to lose everything—homes, businesses, farms, possessions, and careers. Despite no evidence of wrongdoing, more than 110,000 Japanese Americans, nearly two-thirds of whom were American citizens, were sent to assembly centers and then to wartime concentration camps run by the War Relocation Authority (WRA).[6]

On May 1, 1942, Okubo and her brother, Toku, were sent to the Tanforan Assembly Center in San Bruno, just south of San Francisco. Other family members were sent to different camps. As they boarded the buses, they wore tags that reduced their family name to a number: 13660.

Miné Okubo, "Waiting for Military Police Bus with Personal Belongings." *Citizen 13660* (courtesy of Miné Okubo Estate)

Throughout her time in the camps—at Tanforan and later at the Topaz concentration camp in Utah—Okubo produced more than two thousand sketchbook drawings with a specific audience in mind: "Being an artist, I decided to record my whole camp experience. I had many, many friends on the outside and I thought this would be a good way to repay them for their kindness in sending letters and food packages and telling us that we were not forgotten."[7] Okubo's audience would also extend beyond her immediate friends. She published her drawings in the *Topaz Times* (the official camp paper) and *Trek* (an arts and literary publication produced by internees at the Topaz camp) that reached the internee population. Most notably, she reached a mass audience when *Citizen 13660*, her personal narrative about her camp experience, was published in 1946, shortly after the end of the war and her January 1944 release.

*Citizen 13660* told Okubo's story, but it also performed another important function. It helped counter the government's sanitized version of the wartime concentration camps. The U.S. government had attempted to control the public image and memory of the camps by depicting them as places free of hardship, where Japanese Americans were enjoying a "pioneer" lifestyle in the western lands of the United States.[8] Okubo told a different story—images and text about internees living behind barbed wire and guard towers, in extreme weather conditions, where sorrow, boredom, and anxiety were commonplace. She also documented stories of survival and perseverance—internees adapting to the harsh environment, making do, and creating community and culture within a concentration camp. She documented the human spirit and captured the humor, creativity, and ingenuity of thousands of people confined within a one-mile radius.

Significantly, *Citizen 13660* was not a "history" of Tanforan and Topaz. It was Okubo's personal narrative of her experience during wartime—one that tells the story of an ordinary citizen who, at age thirty, found herself confined within a camp. Okubo was not an activist or an organizer when she was imprisoned. She was a passive observer and a model prisoner. Her drawings and text critiqued the internees who organized and spoke out as much as they critiqued the racist federal policy that had created the camps. *Citizen 13660* presents an odd, but compelling, case for the role of art within movements and in recording history—especially a history that the U.S. government did not care to broadcast. Her images and text directly challenge the historical amnesia and the control of the images of the internment camps by the federal government. Okubo also obscures aspects of the internment history itself by giving little attention to the actual resistance that took place in the camps, leaving readers with an incomplete, yet still important, portrait of camp life.

## Tanforan

Okubo's *Citizen 13660* presents a chronological timeline of her wartime experience—one that guides the reader from her travels through Europe during the fall of 1939 to Berkeley to the Tanforan Assembly Center, and finally to her imprisonment at the Topaz wartime concentration camp. In nearly every image, Okubo is present in the picture plane acting as a guide, either as the central figure or standing on the edge of the frame, showing the viewer what she herself was looking at. A good example is a drawing of the first time she entered her "living quarters" at Tanforan. Okubo places herself at the far left of the page, looking into two small rooms that had recently housed horses at the racetrack-turned-prison. Okubo cuts away the wall of "stall 50" so the viewer can see the poorly constructed room in its entirety. By presenting herself in each

Miné Okubo, "First View of Stall 50 at Tanforan," *Citizen 13660* (courtesy of Miné Okubo Estate)

Miné Okubo, "Army Inspection at Tanforan," *Citizen 13660*
(courtesy of Miné Okubo Estate)

image, she encourages the viewer to empathize with her situation, and she presents herself as both a participant and observer.[9]

This was a political act. Okubo's self-positioning says, "I can't believe this is happening to me," as well as, "This should *not* be happening to me," thus defending her rights to American citizenship. But Okubo presents herself as more than just a citizen; she presents herself as an artist.

In one image, Okubo documents the Army conducting a routine search of the barracks for contraband, a list that included weapons, ammunition, shortwave radios, Japanese literature, and cameras.

She shows us an inspector studying one of her letters as a military policeman stands guard. Okubo sits on the bed and presents herself as a naïve, childlike artist cutting paper with a scissors. Around her is her art: paper streamers hang from the ceiling, a paper hat coiled like a snake is on her head, a cut-out animal sculpture sits on the floor, and an overly simplistic drawing of a horse hangs on the wall. Significantly, the drawings and sculptures that she presents in her room were not representative of her illustrative style or chosen subject matter that formed the basis of *Citizen 13660*. Neither were they like the sophisticated illustrations that she would later do for the *Topaz Times* or *Trek*.

Instead, Okubo seems to be playing a trick on the inspectors, making them believe that she (and by extension her art) was harmless and not worthy of their attention. Her approach paid off, for none of her drawings were confiscated, and neither was she ever reprimanded. Whether this was due to the content and style of Okubo's images or the military police failing to see anything subversive in her work is unknown. What is clear is that Okubo was free to sketch throughout Tanforan and the next internment camp that she and her brother were sent to: Topaz.

## Pro-Japanese or Pro-Administration

"After being uprooted, everything seemed ridiculous, insane, and stupid. There we were in an unfinished camp, with snow and cold. The evacuees helped sheetrock the walls for warmth and built the barbed wire fence to fence themselves in. We had to sing 'God Bless America' many times with a flag. Guards all around with shotguns, you're not going to walk out. I mean . . . what could you do? . . . I tried to make the best of it, just adapt and adjust."

—Miné Okubo[10]

At Topaz, Okubo found herself in a barren, hostile environment of high winds, little vegetation, and alkaline dust that covered everything in sight, including the ten thousand internees who were crammed into one square mile comprised of forty-two blocks of housing barracks, mess halls, and administration buildings. When she arrived, she was handed a copy of the *Topaz*

*Times* that described Topaz as the "Jewel of Utah."

Okubo's drawings depict these hardships. One visualizes internees hard at work, putting up the very wires and posts that would keep them fenced in.

Another shows her and her brother scavenging late at night, and against camp rules, for materials to build rudimentary furniture for their room. Another drawing, created near the end of her imprisonment, depicts a high school graduation ceremony. Lacking are any signs of joy that one might associate with a celebration marking an important life achievement. Okubo depicts the graduates with serious expressions—some downcast—and is careful to document the barbed-wire fences and the housing barracks in the background, informing her readers that these were high school graduates behind bars.

Yet even within this image it is difficult to know what Okubo is really thinking about the scene and the circumstances that she documents. Elena Tajima Creef writes: "Throughout the pages of *Citizen 13660*, we are allowed a glimpse of the personal and the public spaces inside the camp, but we are never allowed any such glimpse into the private space of Okubo's interior self. . . . Okubo never shows or tells us what she is actually feeling; instead, she gives us a brilliantly detailed—though somewhat detached—record of the internment experience."[11]

However, readers of *Citizen 13660* can make assumptions about Okubo's thought process through the topics that she omits or those she pays minimal attention to. Page after page depict her and other internees resisting the harsh elements of the Utah desert, but few images depict people resisting the actual internment process itself. And when she does depict people resisting, she *criticizes* rather than supports them.

For example, one of her images from Topaz depicts her railing against an older male prisoner who was attempting to organize other prisoners against the government's "loyalty"

Miné Okubo, "Evacuees Fencing Themselves in at Topaz," *Citizen 13660* (courtesy of Miné Okubo Estate)

Miné Okubo, "Topaz High School Graduation," *Citizen 13660* (courtesy of Miné Okubo Estate)

questionnaire and the call for male internees to register for the armed services. In this image, Okubo sticks her tongue out at the organizer and the group of men that gathers near him. Her text reads, "Strongly pro-Japanese leaders in the camp won over the fence-sitters and tried to intimidate the rest. In the end, however, everyone registered."[12]

Here, Okubo greatly oversimplifies the matter and places the organizer in the role of the antagonist. She labels him as "Pro-Japanese"—akin to the "enemy"—and presents him as a troublemaker, someone whose efforts are detrimental to the other internees. Her position was not unique; a political divide did exist within the camp, especially between the Nisei (children born to Japanese people in a new country) and the Issei (first-generation immigrants from Japan). Scholar Laura Card writes that officers of the Nisei-led Japanese American Citizens League (JACL) urged cooperation with the government—including turning in dissenters—as well as peaceful acceptance of internment. They felt that cooperation was necessary to dispel any stereotypes of disloyalty and "mitigate the present circumstances and perhaps have a lien on better treatment later."[13] Okubo chose the route of cooperation, raising questions about how resistant her artwork was compared to those who put much more on the line. Individuals who spoke out and organized against their imprisonment, the "loyalty" tests, and registration into the armed forces risked being sent to other camps, physical violence, and even death.[14] Okubo, by contrast, risked very little by quietly documenting her displeasure with the camps in a book that was published after her release. Her chosen tactic was to "adapt and adjust," but she does a disservice to those who did organize by either not telling their stories or by stereotyping them simply as "Pro-Japanese" and disloyal, for their position was far more complex than she allows her readers to see.

Miné Okubo. "Okubo Reaction to 'Pro-Japanese' Camp Leaders." *Citizen 13660* (courtesy of Miné Okubo Estate)

## Organized Resistance

Other stories and experiences by internees fill in the gaps missing in Okubo's text. During the evacuation order, Minoru Yasui (Oregon), Fred Korematsu (California) and Gordon Hirabayashi (Washington) all refused to leave their homes, stating that Roosevelt's order was unconstitutional. The three individuals filed a lawsuit and took their case all the way to the Supreme Court, which sided against them in *Hirabayashi v. United States* (1943), *Yasui v. United States* (1944), and *Korematsu v. United States* (1944)[15] In the assembly centers and the ten wartime concentration camps, resistance was omnipresent, particularly during the summer of 1943. This was when internees were forced to fill out a questionnaire that tested their "loyalty." For example, question 27 was directed at draft-age males and asked, "Are you willing to serve in the armed forces of the US or combat duty, wherever ordered?" Question 28 was directed to all internees: "Will you swear unqualified allegiance to the United States of America and faith-

fully defend the United States from any or all attack by for-
eign or domestic forces, and forswear any form of allegiance
or obedience to the Japanese emperor, or any other foreign
government, power, or organization?"[16] This created a seri-
ous predicament for nearly one-third of all residents in the
camps. Heather Fryer explains that it "asked non citizens to
renounce all ties of loyalty to the Empire of Japan. Ineligible
for citizenship in the United States, these older Japanese
were asked to make themselves stateless in order to regain
their freedom."[17]

Miné Okubo, "Topaz Meeting In Response to Loyalty Tests,"
*Citizen 13660* (courtesy of Miné Okubo Estate)

The results of the questionnaire had profound conse-
quences. Those who answered "yes" were slowly released
and resettled predominantly in the Midwest and Northeast.
Those who answered "no" were sent to the Tule Lake camp
in California. Close to 1,300 detainees, one-tenth of all Topaz residents, were sent to Tule
Lake during the fall of 1943. Included were all those who said they wished to return to Japan
along with the "no-no's"—those who were given a second chance to change their answers to
the questionnaire but refused to do so. Family members wishing to stay together also were
sent to Tule Lake. Okubo reduces this epic moment at Topaz to a handful of pages. She shows
outright disdain toward those who resisted the questionnaire and those who resisted joining
the military. In one key image, she depicts an all-male audience—older internees (presum-
ably a large percentage of whom were Issei)—listening to a camp organizer in a meeting
space. The speaker and the audiences are upset and crying and Okubo depicts herself holding
her nose in disgust. Her text reads, "Center-wide meetings were held, and the anti-
administration rabble rousers skillfully fanned the misunderstandings."[18] Here, she again
casts organizers in a negative light and grossly oversimplifies them as disloyal—that is, "anti-
administration rabble rousers."

Consider the case of Frank Emi, who was imprisoned at the Heart Mountain Intern-
ment Camp in Wyoming. Emi, much like those interned at Topaz, spoke out against the
questionnaire. He posted his questionnaire on the camp's mess-hall doors with a handwrit-
ten message that read: "Under the present conditions and circumstances, I am unable to an-
swer these questions."[19] This act of resistance was not isolated. Kiyoshi Okamoto, a California
high school teacher and former soil tester in Hawaii, became a leader in Heart Mountain
against unjust and racist policies. He gave a speech during a mass meeting and urged Nisei to
stand up for their rights as U.S. citizens. He then taught those in attendance about their consti-
tutional rights. Together, Okamoto, Emi, and others helped form the Fair Play Committee
(FPC), which declared that internees would not cooperate with the draft unless their citizenship
rights were honored first. More than four hundred Nisei attended the meetings; the group had
two hundred dues-paying members, and three hundred FPC members refused to be drafted.

Camp administrators responded by going after the leadership. Emi and six other lead-
ers of the FPC at Heart Mountain were arrested and "indicted for conspiracy to violate the
Selective Service Act and for counseling others to resist the draft."[20] In court, Emi continued
to speak out:

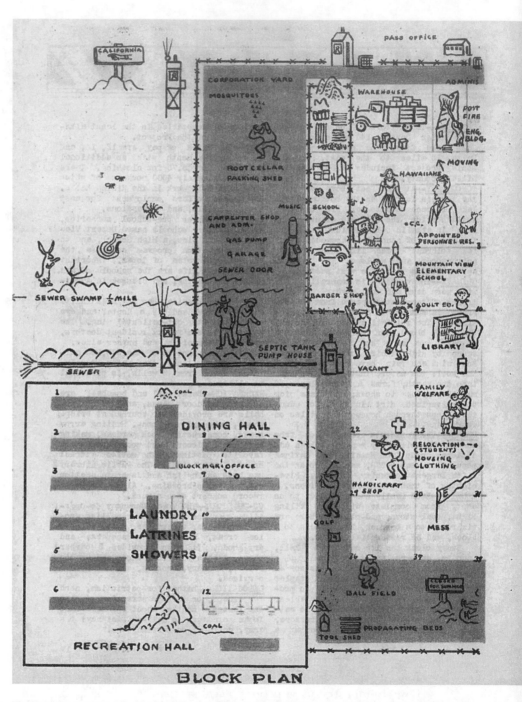

Miné Okubo, (map) *Trek*, Vol. 1, No. 2 February 1943, Central Utah Relocation Center, Project Reports Division, Historical Section, Special Collections and Archives, Topaz Internment Camp Documents, 1942–1943 (MSS COLL 170) (Utah State University Merrill-Cazier Library, courtesy of Miné Okubo Estate)

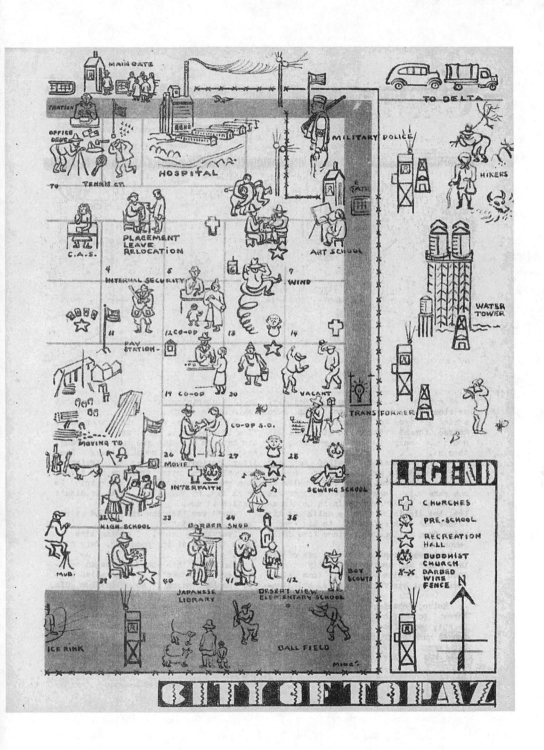

We, the members and other leaders of the FPC are not afraid to go to war—we are not afraid to risk our lives for our country. . . . We would gladly sacrifice our lives to protect and uphold the principles and ideals of our country as set forth in the Constitution and the Bill of Rights, for on its inviolability depends the freedom, liberty, justice, and protection of all people including Japanese-Americans and all other minority groups."[21]

His courageous act of resistance led to him and six other FPC leaders being sentenced to four years at Leavenworth Federal Penitentiary in Kansas. They were housed with the general population, considered criminals for refusing to fight for a government that had placed them in concentration camps without due process. After the war, an appeals court overturned their conviction and President Truman granted a presidential pardon on December 24, 1947, to all draft resisters, including the Nisei.

However, Okubo chastised similar individuals who organized at Tanforan and Topaz. Her text following the loyalty questions at Topaz is instructive. She notes "the 'disloyal' were finally weeded out for eventual segregation."[22] She adds in a later illustration, "The program of segregation was now instituted. One of its purposes was to protect loyal Japanese Americans from the continuing threats of pro-Japanese agitators."[23] And she comments on the "loyal" internees who were transferred from another camp to Topaz: "Twelve hundred loyal citizens and aliens were transferred from Tule Lake to Topaz. Their arrival once more brought excitement to our now relatively peaceful city."[24]

Miné Okubo, "Evacuees Arrives from Tule Lake," *Citizen 13660* (courtesy of Miné Okubo Estate)

At the same time, she devoted only two pages to the murder of sixty-three-year-old James Wakasa, who was shot in the chest and killed when he walked too close to the barbed-wire fence that defined the perimeter of the camp. Instead, her drawings focuses on the women who made paper wreaths for his funeral—a passive response that documents the chain of events but offers up little critique when it was needed.

## Visual Testimony

Okubo was rewarded for her decision not to agitate those who controlled her freedom. She, along with all the other internees who answered "yes" to the key questions on the loyalty tests were slowly transitioned out of the camps. Okubo herself was given the opportunity to leave Topaz in 1943, but she decided to stay until January 1944 to finish her sketches of camp life before moving to NYC for an illustration job. *Fortune* magazine had seen her illustrations in *Trek* and offered her the chance to illustrate their special issue on Japan. The publication wanted Okubo to shine a light on the internment experience, and the WRA was not only aware of her new opportunity but also approved of it. Each internee who left the camp had to provide the WRA with references (be it their new landlords, employers, or education programs), and all references were carefully

screened. Greg Robinson argues that this process indicates that the WRA promoted Okubo's work and viewed it as beneficial, for it aligned with their new objectives to reintegrate Japanese Americans back into society.[25] Many Japanese Americans were dissuaded from returning to their homes on the West Coast, and were sent to the East Coast instead. Again, Okubo is remarkably subdued with regard to this gross injustice. In her introduction for the 1983 reprinting of *Citizen 13660*, she writes, "For the Nisei, evacuation had opened the doors of the world. After the war, they no longer had to return to the Little Tokyos of their parents. The evacuation and the war had proved their loyalty to the United States."[26]

Miné Okubo, "Women Creating Paper Floral Wreaths for Funeral," *Citizen 13660* (courtesy of Miné Okubo Estate)

Okubo's quote epitomizes the ironies and contradictions that surround her work. She both criticizes and compliments federal internment policy. Moreover, she both exposes and obscures this history. Her perspective on how the camps personally affected her is equally mixed. She states that it was positive from a creative standpoint. "I am not bitter. Evacuation had been a great experience for me because I love people and my interest is people. It gave me the chance to study human beings from cradle to grave, when they were all reduced to one status."[27] Yet, she also writes that the internment camps were a "tragic episode" and that "some form of reparation and an apology are due to all those who were evacuated and interned."[28]

This stance is admirable, but her critique came late. Okubo's drawings and writing were not outspoken against WRA policy in the 1940s. That said, it was dangerous to be outspoken, considering that Okubo was a prisoner and she had no way of knowing when or if she would be released. Thus understanding her text first and foremost as a prison memoir is important—that by simply detailing her experiences she shined a negative light on the policy of the federal government. Additionally, her text became more influential as the decades passed, for it introduced the chilling history of the internment camps to a new generation of readers, ones who knew little to nothing about the camps' existence.

And despite the shortcomings of Okubo's text that demonstrated little solidarity with other internees whose politics differed from hers, she nevertheless told *her* story and did so in a manner that was accessible and allowed readers to empathize with her situation. In doing so, she opened up a host of questions, including how one defines resistance. Certainly Okubo was not engaged in the "resistance" in the camps if we define resistance through an activist perspective of organizing and directly challenging power. But her book did expose the history of internment camps to a large audience. Her images and text acted as a call for *never again*—a stance that she echoed in a 1983 interview: "I am a creative, aware person . . . an observer and reporter. I am recording what happens, so others can see and so this may not happen to others."[29] Throughout her adult life, Okubo continued to tell the story of the internment camps through interviews, illustrations, and testimonies. In 1981, she testified before the United States Commission on Wartime Relocation and Internment of Citizens at the New York City hearing. Okubo stressed the need for the public to be informed about the history of the camps and, to close her testimony, she presented the Commission with visual evidence—a copy of her book, *Citizen 13660*.

# 18

## Come Let Us Build a New World Together

IN MID-JULY 1962, DANNY LYON had just finished his junior year at the University of Chicago, studying photography and history, when he decided to hitchhike south 390 miles from Chicago to Cairo, Illinois. A friend in Chicago had been arrested in Cairo while demonstrating against segregation, and Lyon wanted to see the emerging civil rights movement for himself. He brought with him a Nikon F camera, film, and the name of a contact person.

In Cairo, Lyon's contact brought him to a community-organizing meeting, where he heard Charles Koen, a sixteen-year-old high school student and leader in the Cairo Nonviolent Freedom Committee, address a small crowd. He also heard John Lewis speak. Lewis was a student leader of the Nashville lunch-counter sit-in movement and the Freedom Rides and had joined the Student Nonviolent Coordinating Committee (SNCC) in June, a month prior, as a field secretary. Following the speeches, Lewis and Koen led the group to the city's only public swimming pool—one that was still segregated, despite a state mandate demanding otherwise. Lyon recalls:

> There was no press . . . no film cameras, no police, and no reporters. I had my camera, and I ran along as this brave little group marched through the sunlit and mostly empty streets of a very small American town. With the exception of a few young black men, everyone else who was watching seemed to hate and deride the demonstrators, many of whom were children.[1]

When the group arrived at the pool, they stopped outside the building and prayed. Afterward, the group went into the middle of the street and sang. The peaceful demonstration was ruptured when a white man drove his pickup truck at the crowd. Everyone stepped aside, except for a thirteen-year-old African American girl, who stood her ground, refused to move, and was knocked down by the truck.

Lyon's signature photograph of the day featured this thirteen-year-old girl kneeling down in prayer with Lewis to her left and Koen to her right. A year later, SNCC printed ten thousand copies

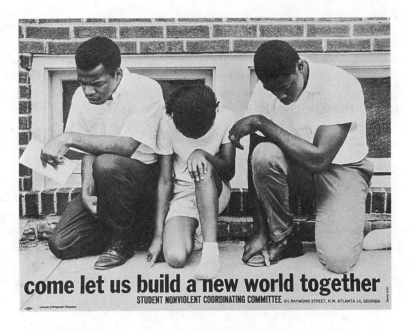

SNCC poster, *Come Let Us Build a New World Together*,1962, photograph by Danny Lyon (copyright Danny Lyon/Magnum Photos; image reproduction: Joseph A. Labadie Collection, University of Michigan)

of the image as a poster with text that read COME LET US BUILD A NEW WORLD TOGETHER. Posters sold for $1 and helped raise much-needed funds.[2]

SNCC chose Lyon's image for good reason. It documented themselves (student activists) and their chosen tactics for the movement (nonviolent direct action.) The text of the poster was an invitation and recruitment pitch, pulling activists into the movement. For Lyon, the photograph signified day one of a two-year journey that would send him across the far expanses of the South, working as a white artist within a black-led movement to end segregation and racial discrimination.

SNCC was the most radical of the Southern civil rights organizations, one that began as a student group and evolved into a cadre of full-time organizers.[3] SNCC focused on direct-action campaigns and embedded itself in rural communities of the Deep South and for months, if not years, engaged in long-term campaigns that sought to develop and support local leaders.[4] This work was exceedingly dangerous, for it existed outside the gaze and the protection of the mass media that typically added a certain level of safety from violence as perpetrators sought to keep their most heinous acts out of sight. Thus, SNCC, by necessity and by its own ingenuity, had to create media to provide protection and document its work on the ground. Mary King, SNCC communications secretary, stated, "It is no accident that SNCC workers have learned that if our story is to be told, we will have to write it and photograph it and disseminate it ourselves."[5]

When SNCC was first launched in 1960, three administrative departments were established at the Atlanta office: coordination, communications, and finance. SNCC director of communications Julian Bond and his staff worked around the clock, sending out press releases to media contacts across the country. They also edited the monthly SNCC newsletter *The Student Voice*, produced promotional materials, printed posters, and created other forms of ephemera. All of this work was dependent on field reports.

In 1962, Bond issued a twelve-point internal memo to SNCC workers in the field:

> It is absolutely necessary that the Atlanta office know at all times what is happening in your direct area. When action starts, the Atlanta office must be informed regularly by telephone or air mail special delivery letter so that we can issue the proper information for the press. (Atlanta has the two largest dailies in the South; we have contacts with the *New York Times, Newsweek,* UPI, and AP, the two wire services; we have a press list of 350 newspapers, both national and international).[6]

Bond added:

> Please delegate one or two people to take photographs of the action. If you have facilities to develop films *immediately* where you are, have the pictures developed and send the shots to us. If there are no facilities, send the roll(s) of film to us in manila envelopes air mail special delivery addressed personally to James Forman or Julian Bond, along with descriptions of what the photographs are about.[7]

The Atlanta office did the rest, disseminating the images to the nation and the world.

———

Danny Lyon's introductory experience in Cairo had propelled him to head farther south in August—to the SNCC office in Atlanta. The only problem was that when he arrived, the office was empty. The entire staff was in Albany, Georgia, another 150 miles south. When he finally located SNCC workers in Albany, he met James Forman, executive secretary of SNCC, for the first time. Lyon recalls:

> Forman treated me like he treated most newcomers. He put me to work. "You got a camera? Go inside the courthouse. Down at the back they have a big water cooler for whites and next to it a little bowl for Negroes. Go in there and take a picture of that."[8]

Based on the photos that Lyon took in Cairo and Albany, SNCC asked him to join the organization. A darkroom was set up in the closet of the SNCC office, and Lyon was given a credit card for air travel, allowing him to rush to hot spots across the South at a moment's notice.

With Forman's blessing, I had found a place in the civil rights movement that I would occupy for the next two years. James Forman would direct me, protect me, and at times fight for a place for me in the movement. He is directly responsible for my pictures existing at all.[9]

Forman understood the power that photographic images had on the public's visual consciousness. He was one of a handful of civil-rights activists/leaders who carried a camera with him, a short list that included Malcolm X, Robert Zellner (SNCC), Wyatt Tee Walker (SCLC), and Andrew Young (SCLC).[10] In late March 1963, one of his photographs appeared in the *New York Times*, exposing how local sheriffs had used police dogs to attack black demonstrators who were attempting to register to vote in Greenwood, Mississippi. Forman was arrested, but SNCC field secretary Charles McLaurin managed to wrestle his camera away from the police officer during the tussle. "Knowing that those photographs—later to be seen around the world—would get into the right hands," reflects Forman, "was one of the biggest help to my morale in jail."[11]

Lyon documented similar types of events in other locations, including Albany—actions with the camera in mind. When tense moments were not available, SNCC created them. "Albany was quiet when I was there, so two people went out and got arrested on my behalf. The

Danny Lyon, *Eddie Brown Calmly Being Carried off by the Albany Police*, 1963 (from *Memories of the Southern Civil Rights Movement*, copyright Danny Lyon/Magnum Photos)

picture of Eddie Brown, a former gang leader, being carried away by police with a look of beautiful serenity on his face was reproduced in college papers and SNCC fund-raising flyers."[12]

Much of Lyon's best work took place off the beaten path. In August 1963, Lyon traveled to southwest Georgia to investigate a report that thirty-two teenage African American girls had been locked up for weeks in the county stockade outside of Leesburg. The girls had been arrested for demonstrating in Americus in July and August and were being held without charges in abysmal conditions—a single room without beds, no working sanitation facilities, and one meal allotted per day. Lyon writes, "For all practical purposes the girls, many as young as thirteen . . . had been forgotten by the world, including SNCC's Atlanta office, which had its hands full."[13]

On route to Leesburg, Lyon met up with an activist from Americus, and the two devised a plan. Lyon would hide inside the car as they approached the jailhouse. His companion would go inside and distract the lone jailer while Lyon snuck out of the car and walked behind the building to take pictures through the bars.

The plan worked. Lyon went undetected, and in a matter of days his photographs were delivered to a U.S. congressman, who promptly entered them in the Congressional Record. The uproar that followed resulted in the girls being released in early September. Lyon wrote:

Danny Lyon, *Leesburg, Georgia Stockade*, 1963 (from *Memories of the Southern Civil Rights Movement*, copyright Danny Lyon/Magnum Photos)

Until that moment I don't think I had really been accepted into SNCC. After all, SNCC people were activists. Most of them went to jail routinely. They *did* things. It was one of their finest qualities. All I did was make pictures. But in Americus, my pictures had actually accomplished something. They had gotten people out jail.[14]

Lyon was being too self-critical. His photographs and those of other SNCC photographers played a prominent role in the success of the organization. Besides, SNCC photographers were not simply documentarians, they were artists *and* fieldworkers, entrenched in the daily work of community organizing and movement-building. Photographers had become the eyes of the civil-rights movement.

## Mississippi

"When you made a move on Mississippi, one of the things you had to do was come to grips with your own mortality . . . This is not going to be big demonstrations with lots of television cameras with people around watching . . . when we went on those highways in the middle of the night . . . you had to think that you would never live to see your home again."

—Charles McDew, SNCC[15]

In the summer of 1960, SNCC organizer Bob Moses toured Alabama, Mississippi, and Louisiana to seek out and cultivate local leaders. In Cleveland, Mississippi, he met Amzie Moore, head of the Cleveland NAACP. Moore persuaded him that the greatest asset that SNCC could provide them was to help organize a voter registration campaign. Moses agreed, and by August 1961, SNCC opened its first voter registration school in McComb, right in the heart of Klan country.[16] By fall 1962, Moses was in charge of six offices and twenty field secretaries.[17] He described his philosophy as such:

You dig into yourself and into the community to wage psychological warfare, you combat your own fears about beatings, shootings and possible mob violence; you stymie, by your mere physical presence, the anxious fear of the Negro community . . . you organize, pound by pound, small bands of people . . . you create a small striking force . . . The deeper the fear, the deeper the problems in the community, the longer you have to stay to convince them.[18]

Fear was an understatement, for violence upheld white supremacy. On June 12, 1963, Mississippi NAACP leader Medgar Evers was assassinated by a gunshot blast to his back. The year before, federal protection was required to guard James Meredith when he became the first African American to enroll at the University of Mississippi. White students rioted. Two people were killed, 160 people were injured, and 28 gunshot wounds were reported. The majority of those wounded were federal marshals.

Danny Lyon, *On the Road to Yazoo City, Mississippi*, 1963 (from *Memories of the Southern Civil Rights Movement*, copyright Danny Lyon/Magnum Photos)

This was the climate that SNCC operated in when they chose Mississippi to be their primary location to launch a voter registration drive. SNCC offices were firebombed and SNCC workers were routinely jailed, beaten, and shot at. Some were killed. SNCC fieldworker Frank Smith stated, "There is no protection against Mississippi . . . Only the Federal government can protect us and it won't."[19]

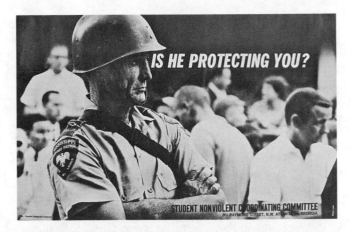

SNCC poster, *Is He Protecting You?*, ca. 1963, photograph by Danny Lyon (copyright Danny Lyon/Magnum Photos; image reproduction: Tamiment Library and Robert F. Wagner Labor Archives and Radicalism Photograph Collection, Tamiment Library, New York University)

One would expect that the vast majority of photographs that SNCC took in Mississippi would have documented the extreme levels of violence and police brutality. Instead, the opposite was the case. The majority of photographs that Lyon and other SNCC photographers took were images of organizing drives and movement-building: mass meetings, literacy training workshops, canvassing, voter-registration drives, and time spent simply hanging out together.

Lyon's photographs in 1963 include, among others, an image of James Forman talking on the phone inside the Greenwood office; Bob Moses, Charles Sherrod, and Randy Battle conversing with an elderly woman on her porch during a voter-registration drive in rural Georgia; and a young Bob Dylan playing guitar behind the Greenwood office while a small crowd gathers, some listening, some talking among themselves.

What is so remarkable about these images is how ordinary the scenes are. One would never get the sense that these individuals were operating within one of the most dangerous counties in the United States. They are almost contemplative, lacking any sense of fear or violence—the antithesis of the types of photographs that mainstream media outlets were running in their coverage of the civil-rights movement. Instead, Lyon's images project the "nit-and-grit" of daily organizing work, by the people who built the civil-rights movement.

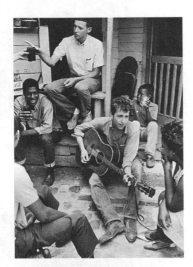

The reality of life behind the work was quite different, of course, in a place where simply possessing a camera could lead to arrest or worse. In 1962, Lyon was arrested in Cleveland, Mississippi, for taking photographs in the street near Amzie Moore's house. The police officer told Lyon that he had to pay $1,000 bond to be "engaged in the business of photography."[20] His final warning to Lyon after letting him go: "If I see you anywhere I'm going to kill you."[21]

Danny Lyon, *Bob Dylan Behind the SNCC Office, Greenwood, Mississippi*, 1963 (from *Memories of the Southern Civil Rights Movement*, copyright Danny Lyon/Magnum Photos)

## Mississippi Summer Project

Lyon did not heed the police officer's advice. He returned regularly to Mississippi throughout 1963 and 1964 and photographed SNCC activities throughout the state. In 1964, he documented SNCC's most ambitious and controversial activity to date—the Mississippi Summer Project.

In late 1963, SNCC laid the groundwork for a summer campaign that was designed with three goals: a statewide voter-registration drive, the establishment of freedom schools throughout the state, and the formation of a new political party—the Mississippi Freedom Democratic Party.[22]

The most controversial aspect of the plan was the recruitment of 1,000 white, middle-class college students, primarily from northern states, who would fill the volunteer ranks. Many in SNCC felt that the addition of so many white volunteers would disrupt SNCC's race and class balance. SNCC was a black-led organization, and many of its positions in Mississippi were filled by those who were native to the state and had grown up as sharecroppers. Bob Moses, the director of the Summer Project, held the final word in the matter; he would not be part of an organization that was not integrated.

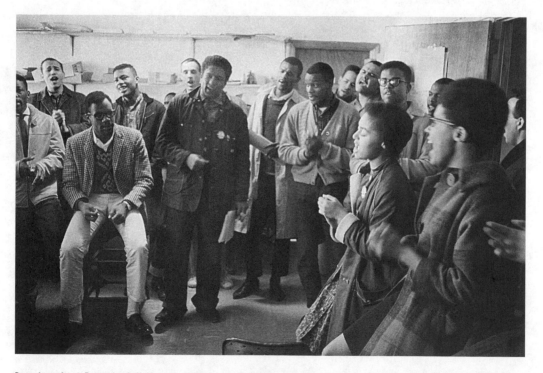

Danny Lyon. *James Forman Leads Singing in the SNCC Office on Raymond Street in Atlanta*, 1963 (from *Memories of the Southern Civil Rights Movement*, copyright Danny Lyon/Magnum Photos)

There were also tactical reasons for bringing in a thousand white volunteers. The mass media would scarcely cover events taking place in rural Mississippi, so SNCC reasoned that the "heated atmosphere caused by the presence of many volunteers, especially whites, would force the federal government to intervene—possibly with the use of troops."[23] Confrontation would result in media attention. Forman asserted:

> White people should know the meaning of the work we were doing—they should feel some of the suffering and terror and deprivation that black people have endured. We could not bring all of white America to Mississippi. But by bringing in some of its children as volunteer workers, a new consciousness would feed back into the homes of thousands of white Americans as they worried about their sons and daughters confronting "the jungle of Mississippi," the bigoted sheriffs, the Klan, the vicious White Citizens' Councils.[24]

In early 1964, SNCC began visiting northern college campuses to recruit students. Each volunteer had his or her portrait taken and was asked to fill out a list with "names of the applicants' Congressional representatives, the names of their college and hometown newspapers . . . organizations they belonged to . . . and ten people who would be interested in receiving information about their activities."[25]

The worst possible news to report came early on. On June 21, days before many of the volunteers had arrived in Mississippi, three civil-rights workers disappeared—two affluent white college students from New York (Michael Schwerner and Andrew Goodman) and one black Mississippian (James Chaney). The three had been arrested by the police in Philadelphia, Mississippi, and released late at night into the waiting hands of the Klan, who worked in collusion with the local police sheriffs.

The FBI found their bodies six weeks later. Each had been shot at point-blank range. The terrible outcome and the fear that it generated might have scared away many of the summer volunteers, but the opposite occurred. It strengthened their resolve. SNCC itself grew stronger, and its work expanded.

SNCC's emphasis on photography also grew in 1963 and 1964. Lyon was no longer the principal SNCC photographer. SNCC Photo was established and enlisted more than a dozen photographers to also document the movement. The multiracial group included black photographers Clifford Vaughs, Joffre Clark, Fred deVan, Rufus Hinton, Bon Fletcher, Julius Lester, Norris McNamara, and Francis Mitchell; the Latina photographer Mary Varela; the Japanese Canadian photographer Tamio "Tom" Wakayama; and the white photographer Dee Gorton.[26] Additionally, Matt Herron, a white photojournalist from New York, organized the Southern Documentary Project, modeled after the Farm Security Administration's (FSA) photography work in the 1930s.[27] The

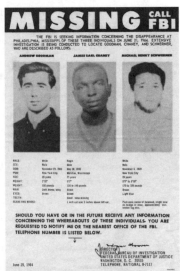

Chaney, Goodman, and Schwerner, *Missing, Call FBI* poster (call number: Ephemera/Civil Rights/1964/Box 5, 1961–1969, MDAH Collection)

driving concept behind the project was to document organizing activities other than demon-
strations—in other words, everyday life. For a project adviser, Herron consulted with Doro-
thea Lange.

Other photography "heavyweights" who lent assistance to SNCC included Richard Ave-
don, who helped train a number of SNCC photographers in his studio. He also convinced
Marty Forscher, the owner of a famous camera shop in NYC, to donate film and more than
seventy-five cameras to SNCC over a three-year period.[28]

As photographers spread out across Mississippi and the southeast, darkrooms were
built in Tougaloo, Mississippi, and Selma, Alabama. Photographers became active partici-
pants in the movement. According to Leigh Raiford, "Almost all served in the field on voter
registration, literacy training or direct action programs, visually documenting the people
they worked with and the events, demonstrations, and projects they helped organize."[29]

Some of the images produced that summer included one by Matt Herron that docu-
ments a freedom school in Mileston—one of forty-one schools that were established that
summer in Mississippi and were attended by more than 2,000 students.[30] Other images de-
pict door-to-door canvassing. During the course of the summer 1,600 African Americans
were successfully registered to vote out of the approximately 17,000 who attempted to do
so.[31] But the numbers are misleading. Long-term gains ultimately eclipsed short-term loses.
A flood of media attention focused upon Mississippi when Schwerner, Goodman, and
Chaney went missing. During the Summer Project, the SNCC Jackson office received two to
three visits or calls per day from the AP, UPI, NBC, ABC, and CBS, along with extensive re-
ports in the *New York Times* and the *Washington Post*, among others.[32] As a result of the me-
dia rush and the organizing campaign, the stranglehold that whites had over state and local
politics began to crumble in the years that followed as more and more African Americans
registered to vote and black candidates were elected into public office.

Following the Summer Project, SNCC would undergo a sea change. A weeklong SNCC
staff meeting in Waveland, Mississippi, in November ended with eighty-five new members—
mostly white, northern college students who had been with the organization for less than six
months—being added to the staff. This decision ruptured the racial and class composition of
the group and led to future tensions that would tear the organization apart.[33] Lyon left after
the Summer Project. The SNCC that would emerge would become almost unrecognizable to
him, and many others. In December 1966, Stokely Carmichael replaced John Lewis as SNCC's
chairman. Nonviolence became a thing of the past. SNCC now stood for black power and the
right to self-defense.[34] By 1969, SNCC fell apart, for all intents and purposes, but their legacy
and many accomplishments remain intact. From an art perspective, SNCC stands as one of the
rare examples of a social justice organization that placed a premium on artists as key contribu-
tors within a movement. SNCC understood how images worked, and how they should be dis-
seminated. While most organizations let outsiders from the mainstream press cover their
struggles, SNCC knew better. It created staff positions for photographers—a decision that
aided the movement and enriched the lives of the artists who joined their ranks. In a letter to
his parents in February 1964, Danny Lyon wrote, "The Danville pamphlet, a poster that makes
money for SNCC, even selling pictures and passing the check on to SNCC; these things have,
for a brief moment given me a satisfaction previously unknown to me."[35]

# 19

## Party Artist: Emory Douglas and the Black Panther Party

EMORY DOUGLAS, MINISTER OF CULTURE and revolutionary artist for the Black Panther Party (BPP), was not one to make subtle images. Rather, his art was designed to rip the heart out of those oppressing the black community. Douglas's July 4, 1970, poster image for the *Black Panther Community News Service* illustrates this point. In the foreground is a defiant African American woman staring angrily ahead, holding three weapons, including a butcher knife. On her shirt is a button that reads DEATH TO THE FASCIST PIGS. Behind her is a man without a weapon, foregrounding the woman as the primary defender of the household, and by extension the community. The text above the figures reads ALL THE WEAPONS WE USED TO USE AGAINST EACH OTHER WE NOW USE AGAINST THE OPPRESSOR. The text below paraphrases Malcolm X: BY ALL MEANS AVAILABLE.

Behind Douglas's veneer of violence is the ideology of the BPP's Ten-Point Program and Platform—the manifesto that launched the BPP and a revolutionary movement out of Oakland, California. Huey P. Newton and Bobby Seale, founders of the BPP, had coauthored the program and on October 15, 1966, printed more than a thousand copies and distributed them throughout inner-city Oakland.[1] Each of the ten points, framed by the phrases "What We Want" and "What We Believe," began with a concrete demand followed by how each demand would be realized. Point seven read:

> We want an immediate end to POLICE BRUTALITY and MURDER of black people.
>
> We believe we can end police brutality in our black community by organizing black self-defense groups that are dedicated to defending our black community from racist police oppression and brutality. The Second Amendment to the Constitution of the United States gives a right to bear arms. We therefore believe that all black people should arm themselves for self-defense.[2]

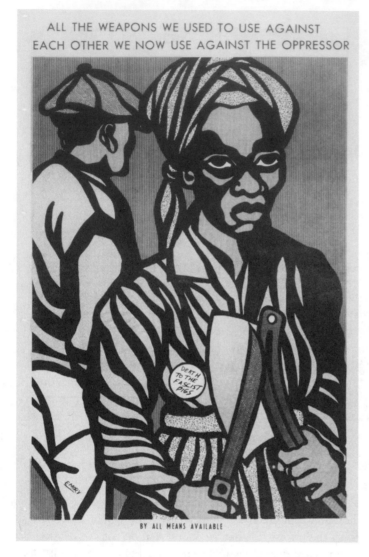

ALL THE WEAPONS WE USED TO USE AGAINST
EACH OTHER WE NOW USE AGAINST THE OPPRESSOR

DEATH TO THE FASCIST PIGS

BY ALL MEANS AVAILABLE

Emory Douglas, poster from *The Black Panther*, July 4, 1970 (copyright 2013 Emory Douglas/Artists Rights Society [ARS], New York; image courtesy of the Center for the Study of Political Graphics)

Starting in 1966, BPP members began shadowing Oakland Police Department squad cars as they patrolled the inner city. When a police officer would pull over a black motorist or stop to question a pedestrian, the Black Panthers would also pull over. Panther members would then step out of their car armed with law books, cameras, tape recorders, and loaded shotguns to make sure that the police were not violating the rights of a community member. In each case, their guns would be in plain view and pointed upward—all of which was legal under California law. If the person being questioned was arrested, the Panthers would bail him or her out of jail.

This community service was born out of necessity. The civil rights movement brought about progressive legislation (the Civil Rights Act of 1964 and the Voting Rights Act of 1965, among others), but it did not end poverty, unemployment, substandard housing, and social programs. Neither did it end the climate of despair and anger in poor black communities across the United States. This created a tinderbox waiting to explode—riots or, better stated, rebellions—erupted in numerous cities, including Watts (1965), Newark (1967), and Detroit (1967), among others. The spark that ignited the fuse was often police harassment, police brutality, or the death of a resident at the hands of the police. In Oakland, the police force was notoriously racist; it contained nineteen African American officers out of a total of six hundred.[3] Local white retailers all but refused to hire African Americans, and the city's paper of record, the *Oakland Tribune*, avoided addressing issues and concerns relevant to the inner-city population.

Newton and Seale's response was to form the Black Panther Party for Self-Defense—a revolutionary party based on Marxist-Leninist principles. It called for community control of all institutions—including the police—a complete redistribution of wealth, and solidarity with all oppressed peoples and nations fighting U.S.-led capitalism and imperialism. Central to the formation of the party was the gun. Panther members holding a loaded shotgun, dressed in a black leather jacket, black pants, black beret, and a blue shirt sent a powerful visual message. To those outside the inner city it pronounced: *We will protect ourselves and stand up to racism and police brutality with force*—a message intended to make police officers think twice before brutalizing the black community. To those inside the community, the gun and the uniform served as a recruitment tool and said: *Join us*. One of the earliest BPP recruits was a twenty-two-year-old artist from San Francisco, Emory Douglas.

## Revolutionary Artist

"I was drawn to it [the Black Panther Party] because of its dedication to self-defense. The Civil Rights Movement headed by Dr. King turned me off at that time, for in those days non-violent protest had no appeal to me. And although the rebellions in Watts, Detroit, and Newark were not well organized they did appeal to my nature. I could identify with them."

—Emory Douglas[4]

Douglas was a California transplant. When he was eight, he and his mother moved to San Francisco from Grand Rapids, Michigan. In 1955, at age twelve, he landed a nine-month sentence for truancy and fighting and was sent to the Log Cabin Ranch, a juvenile correctional facility north of the city. Later, Douglas was sentenced to fifteen months at the Youth Training School in Ontario, California. Both provided work experience for his future role in the BPP. At the Log Cabin Ranch, Douglas's job was to take care of the pigs on the farm. At the Youth Training School, he worked in the print shop and learned the basics of commercial printing.

His interest in the printing trade led him to enroll at the City College of San Francisco, where he studied graphic design. He also joined the Black Students' Association and designed theater sets for LeRoi Jones (Amiri Baraka), who was a visiting professor at San Francisco State University and one of the leading voices in the black arts movement.

Douglas also frequented the Black House in the Lower Haight neighborhood of San Francisco—a space established by author Eldridge Cleaver, playwright Ed Bullins, and Willie Dale in early 1967.[5] Douglas happened to stop by when Newton and Seale were visiting with Cleaver, and when Seale was laying out the first issue of the *Black Panther Community News Service*—a crudely produced mimeographed paper with a print run of 1,000. Douglas took interest and told Seale that he "could help improve the quality of what was being done."[6] Douglas's talents quickly gained Newton and Seale's confidence. He was asked to join the Party and become the "Revolutionary Artist" and minister of culture,

responsible for creating the images, graphics, posters, and visual iconography for the BPP, along with the layout, design, and overall production for the weekly newspaper.[7] By May 1967, he was at work redesigning the *Black Panther*. He shifted production for the third issue to web press, which allowed for two-color printing and a more polished, professional-looking newspaper where photographs and graphics could flourish.[8] He also redesigned the masthead and included an image of Huey P. Newton in the far right corner. Most significantly, Douglas reserved the back cover and much of the front cover for full-size reproductions of his drawings and collages that visualized the campaigns and the ideology of the BPP. In this space, he created the iconography of the party: Panther warriors, community members battling the police, the bootlickers gallery, and most notably, the image of the pig.

## Creating a Revolutionary Consciousness

Newton and Seale wanted the black community to view the police as occupying the ghetto in ways similar to how the U.S. military was occupying South Vietnam. At first they labeled the police "fascists" and "swine," but these terms did not catch on in the community. So Newton and Seale settled on "pig" and asked Douglas to visualize it. Douglas recalls:

> We were going to put the badge number on this pig each week, who was harassing people in the community. So after that, doing that pig, I had in my mind, how can I improve it? And it just came to me that I could just stand the pig up on his hoofs, and dress him up like a cop, but still have the character of a pig.[9]

This image appeared in the second issue of the *Black Panther* (May 1967) and was accompanied by the definition "A low natured beast that has no regard for law, justice, or the rights of people . . . a foul, depraved traducer, usually found masquerading as a victim of an unprovoked attack."[10]

Soon thereafter, the verbal definition would not be needed. Douglas routinely filled the *Black Panther* with images of the police, politicians, and the U.S. military as pigs. Many images were nothing short of brutal: a pig covered in flies, hanged from a tree by a noose and riddled by bullets.

Behind the hyperviolent representation lay Panther politics. Douglas's images illustrated numerous aspects of the Ten-Point Program, including community control of the police, self-determination, decent housing and social services, and the end of imperialist wars. For instance, Douglas's January 3, 1970, illustration for the *Black Panther* features a pig labeled "U.S. imperialism" and dressed in a stars-and-stripes shirt. Four assault rifles point at its head, one stabbing his snout with a bayonet. In the background is a board of spikes that also pierce his head. The text interwoven with the weapons are messages to the United States: "Get Out of the Ghetto," "Get Out of Latin America," "Get Out of Asia," and "Get Out of Africa."

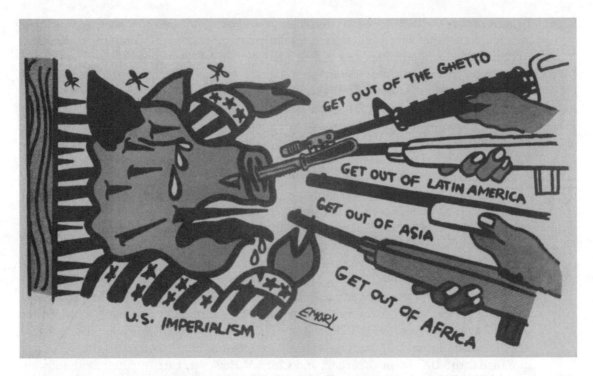

Emory Douglas, poster from *The Black Panther*, January 3, 1970 (copyright 2013 Emory Douglas/Artists Rights Society [ARS], New York; image courtesy of the Center for the Study of Political Graphics)

Here, Douglas aligns the black ghetto and the BPP with Third World liberation struggles, and the revolutionary anticapitalist movements in the 1950s and 1960s—the Chinese Revolution (1949), the Algerian anticolonial movement (1954), Kenyan Mau Mau rebellions (1955), Ghanaian independence (1957), the Cuban Revolution (1959), and the protracted independence struggle of the Vietnamese against the French and then the United States.[11]

However, an organized armed revolution in the United States was not seen as possible at the time, and Newton and Seale sought to change this. They aimed to create a black revolutionary consciousness, starting in Oakland. Seale wrote

> Huey understood that you answer the momentary desires and needs of the people, that you try to instruct them and politically educate them, that these are their basic political desires and needs, and from the people themselves will rage a revolution to make sure that they have these basic desires and needs fulfilled.[12]

But there was a problem: the majority of the black community was not nearly as radical as the Panthers. Many likely shared similar grievances against the police and against social inequalities, but this did not lead to a large percentage turning toward socialism or taking up arms against the state and its agents of control—the police, the courts, and the military.

Because of this, the BPP viewed the cultural front—creating images and authoring essays, poetry, and music that would help foster a revolutionary consciousness within the black urban working class—as a key component of their mission. Eldridge Cleaver notes, "Huey was always conscious of the fact that he was creating a vanguard organization, and that he was moving at a speed so far beyond where the rest of Afro-America was at, that his primary concern was to find ways of rapidly communicating what he saw and knew to the rest of the people."[13]

The mainstream media almost always vilified the BPP, making the *Black Panther*'s role critical to the organization's objective. It was the only print medium that was completely under the party's control, and it allowed them to lambaste their enemies, shape their own image, and represent their own programs in a positive light.[14]

The *Black Panther* also served another key function: fund-raising. At its circulation peak, upward of 50,000 copies of the paper were published each week. The BPP received five cents for every twenty-five-cent paper sold. This provided much needed funds that went to pay rent on offices, bills, and other expenses.[15] Rank-and-file members would sell papers, as would neighborhood kids on bikes who kept ten cents for every copy sold. The rest went to printing costs.[16]

Nearly one-third of all papers sold were in the Bay Area; the rest were shipped around the United States and the world via commercial airlines. Bundles of papers were sent out on jets leaving the Bay Area to BPP chapters in Chicago, Detroit, New York, Boston, Philadelphia, Washington, DC, Los Angeles, and New Orleans, along with shipments to locales in Canada, the UK, France, Sweden, and China.[17] However, this shipping method came with a risk. The airlines, working in concert with local authorities and the FBI, would at times hold up bundles for weeks, making issues outdated and difficult to sell. Seale also noted in 1970 that "thousands of issues were received soaking wet."[18] The remedy to this problem was to ship the papers out COD (cash on delivery). This allowed the BPP to collect insurance from the airlines, and not surprisingly, damaged papers and late shipments came to a near halt.

Communication also came from the posters, postcards, and event flyers that Douglas designed. Runs of 10,000 to 20,000 copies of his posters were printed, and he and other BPP members would wheat-paste them as well as the back-cover posters of the *Black Panther* throughout inner-city Oakland.

These images served key functions. They recruited new members, spread Panther news and ideas, and broadcast the notion that the party had mass support in the black community. In 1970, Douglas wrote:

> The People are the backbone to the Artist and not the Artist to the People . . .
> the Revolutionary Artist must constantly be agitating the people, but before
> one agitates the people, as the struggle progresses, one must make strong
> roots among the masses of the people.[19]

The question becomes: Did Douglas and the BPP synthesize and articulate the ideas of the community? Or were they attempting to reeducate the community and shift black working-class individuals toward a more revolutionary ideology? The answer is both.

Though Douglas took inspiration from the local community, he and the Panther leadership shared a broader, more radical ideology, heavily informed by the work of Malcolm X, Mao Zedong, Che Guevara, and Frantz Fanon. In 1964, Malcolm X stated, "We must launch a cultural revolution to un-brainwash an entire people."[20] Four years later, Newton would say virtually the same thing: "The sleeping masses must be bombarded with the correct approach to struggle through the activities of the vanguard party . . . The party must use all means available to get this information across to the masses."[21]

Art became a critical mode of outreach and propaganda, and Douglas drew upon a wide range of graphic sources from Third World liberation struggles—most notably the poster art coming out of Cuba, Vietnam, and Palestine.

Specifically, inspiration came from the Cuba-based group OSPAAAL (the Organization of Solidarity of the People of Asia, Africa, and Latin America), who produced solidarity posters with text in Spanish, English, French, and Arabic that were folded up and included copies inside of their publication, *Tricontinental*, which was mailed to subscribers all over the world, including the Black Panther office in Oakland. These images and these revolutionary movements fueled Douglas, and he and the BPP promoted these struggles with the hope that the black inner-city community would launch their own uprising.

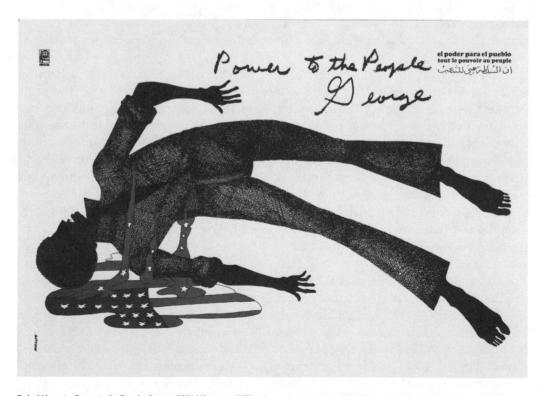

Rafael Morante, *Power to the People. George.* OSPAAAL poster, 1971—image depicts the murder of George Jackson in the San Quentin prison

## Violent Images, Era, and Outcome

"To draw about revolutionary things, we must shoot and/or be ready to shoot when the time comes. In order to draw about the people who are shooting, we must capture the true revolution in a pictorial fashion. We must feel what the people feel who throw rocks and bottles at the oppressor so that when we draw about it—we can raise their level of consciousness to hand grenades and dynamite to launch at the oppressor."

—Emory Douglas, "Position Paper No. 1 on Revolutionary Art,"
*The Black Panther,* January 24, 1970[22]

Douglas's violent images and words were not just rhetoric; they reflected the Panthers' position on revolutionary violence and the confrontations that raged between the BPP and the police. Tensions began the first time the Panthers carried their guns in public on community patrols. It escalated when a group of Panthers, including Douglas, arrived at the State Capitol Building in Sacramento on May 2, 1967, armed to the teeth. The Panthers—protesting a vote by the State Assembly on the Mulford Act that would make carrying loaded guns in public illegal—marched into the assembly chamber with their guns visible and pointed upward, all in accordance with the soon-to-be-altered California law. This action caused a flood of media coverage that worked to the Panthers' advantage. In the words of Greg Jung Morozumi, the media image of an organized, armed cadre of black inner-city radicals confronting the power structure was meant to "deter state violence and heal the battered Black psyche."[23] But it also had a countereffect: it escalated the police and FBI violence toward the BPP.

On April 6, 1968, seventeen-year-old BPP member Bobby Hutton was killed during a gun battle with the Oakland police. Three police officers were wounded, and eight Panthers were jailed, included Eldridge Cleaver. In 1969, Bunchy Carter—founder of the Southern California chapter of the BPP—and John Huggins were killed in a shoot-out with the black nationalist group US Organization (or Organization Us) on the UCLA campus. Documents later revealed that the FBI had inflamed tensions between the BPP and US by mailing both groups death threats and humiliating cartoons, as if they were sent from each other. That same year, Fred Hampton, deputy chairman of the Illinois chapter of the BPP, was brutally murdered in his apartment in Chicago, in what has been widely accepted as an assassination by the Chicago Police Department and the FBI. All in all, an estimated twenty-five Panthers would die—killed at the hands of the police, rival groups, and other BPP members.

The police were victims too. On October 28, 1967, Newton engaged in a shoot-out with the Oakland police in the late hours of the morning during a routine traffic stop, just one year after cofounding the BPP. Details of the event remain murky, but when the smoke cleared, one officer lay dead and another officer was wounded. Newton fled the scene with a gunshot wound in his abdomen and was later arrested at the hospital and handcuffed to his bed. He was jailed, convicted in September 1968 for voluntary manslaughter and sentenced to two to fifteen years in prison, but was released in August 1970 after two retrials ended with hung juries.

Douglas's images seen in the context of these events change their meanings. They do not seem so imagined or exaggerated. Instead, they mirror the violent climate that engulfed the Panthers, and by extension the nation and its foreign policy. However, Douglas's graphic images are arresting with their stark depiction of violence against the police and the state. His images set a clear narrative: African Americans as the aggressor and the victor.

His December 19, 1970, *Black Panther* illustration depicts an African American man riddling a police officer with bullets as a young child watches from a window. This image becomes even more harrowing for the victim is drawn as a person, not a caricature of a pig, making the reality of the violence all the more intense.

Equally so his November 21, 1970, image "Shoot to Kill" acts as a how-to manual for killing police officers and depicts various scenes of African Americans killing the police via guns, knives, dynamite, and strangulation. The text reads, "Our Minister of Culture, Emory Douglas Teaches . . . We Have to Begin to Draw Pictures That Will Make People Go Out and Kill Pigs."

Less brutal is his June 27, 1970, image "Warning to America," which depicts a woman standing defiantly with her finger on the trigger of a machine gun. She wears a button that reads SELF-DEFENSE.

At the top of the poster is an unattributed quote: "We are from 25 to 30 million strong, and we are armed. And we are conscious of our situation. And we are determined to change it. And we are unafraid." Here, the viewer is expected to read the quote as com-

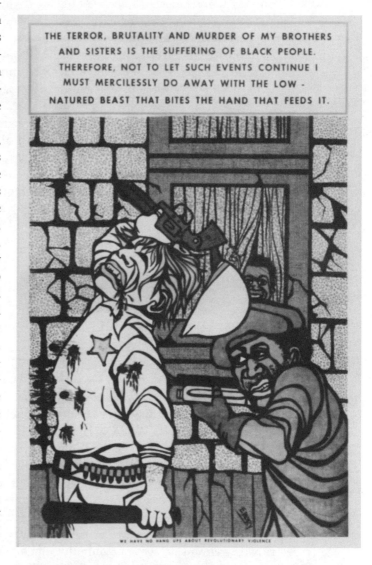

THE TERROR, BRUTALITY AND MURDER OF MY BROTHERS AND SISTERS IS THE SUFFERING OF BLACK PEOPLE. THEREFORE, NOT TO LET SUCH EVENTS CONTINUE I MUST MERCILESSLY DO AWAY WITH THE LOW - NATURED BEAST THAT BITES THE HAND THAT FEEDS IT.

WE HAVE NO HANG UPS ABOUT REVOLUTIONARY VIOLENCE

Emory Douglas, poster from *The Black Panther*, December 19, 1970 (copyright 2013 Emory Douglas/Artists Rights Society [ARS], New York; image courtesy of the Center for the Study of Political Graphics)

ing from the fictionalized warrior. She is not identified, but could represent any woman in the community, or one of the Panther rank-and-file women or party leaders, including Kathleen Cleaver or Elaine Brown. The quote, however, is the most imagined aspect of the image. The entire African American population was estimated to be around 30 million in the early 1970s. BPP membership, meanwhile, fluctuated between 1,500 and 5,000.[24] This is far short of the 25 to 30 million armed African American revolutionaries as the image purports. But Douglas was visualizing what he hoped would transpire.

Common themes emerge in many of his images, including the three discussed. Douglas by and large avoids presenting black people as victims. Instead, he presents a lopsided conflict in which the BPP and the community are able to easily crush their foes. The trouble with this narrative was that it strayed from reality. It presented a false sense of security that gun battles with the police were simple, heroic, and came with few consequences. This narrative may have helped the black psyche, but it did not adequately address the toll that state violence had taken on the Panthers.

Neither did it focus primary attention on the rampant police brutality that afflicted minority communities across the United States. In reality, gun battles with the police had proved to be disastrous for the BPP, forcing Newton to call for an end to these confrontations when he emerged from jail in 1970. Instead, he refocused the BPP on the community survival programs. Yet ending the culture of violence proved to be a difficult, if not impossible, task.

## Shift to Survival Programs

"My art was a reflection of the politics of the party, so when the party changed to community action so did my art, from pigs to kids."

—Emory Douglas[25]

From 1970 on, the BPP redirected its goals toward community survival programs. These included a free breakfast program, liberation schools for children, free health clinics, free sickle-cell testing, free legal aid, a free clothing program, free bags of groceries given away at rallies at DeFremery Park in West Oakland, and a free ambulance program. Oakland once again became the party's focal point. Eldridge Cleaver, whom Huey Newton blamed for isolating the BPP from the immediate community and for extolling a policy of violence toward the police, was expelled from the party, creating divisions between those members loyal to Cleaver and those loyal to Newton.

Douglas's images in the *Black Panther* reflected the shift in BPP policy. By the spring of 1971, guns were close to absent in his images. Instead, his work documented the survival programs: images of community members receiving free food, clothes, and medical services. For example, Douglas's May 27, 1972, hand-drawn image for the *Black Panther* depicts an African American woman who holds groceries from the free food

program and shoes from the free shoe pro-
gram. She also carries a sign that reads,
VOTE FOR SURVIVAL.

The image doubles as a campaign poster;
Douglas includes text that promotes two BPP
candidates for office (Seale for mayor of Oak-
land and Elaine Brown for councilwoman). The
poster also endorsed BPP allies Ron Dellums
for congressman and Shirley Chisholm for
president.[26]

In 1972, when Seale ran unsuccessfully
for mayor of Oakland, he received more than
47,000 votes. Douglas asserts that the people
were not simply voting for an individual, in-
stead, "Those people were voting for our pro-
grams, and our ideals."[27] Also notable in the
drawing is Douglas's new approach toward
listing the media that he used to make the
image. Listed on the bottom of the image is
"Drawing done with black point ink pen plus
graphite pencil powder." Here, Douglas be-
comes a teacher, instructing the community
in his techniques for making art.

Douglas and the BPP viewed their
community-based survival programs as part
of their revolutionary practice. The state did
so as well, and targeted the BPP for elimina-
tion. In early 1969, the FBI sent a memo to
twenty-seven field offices that called the

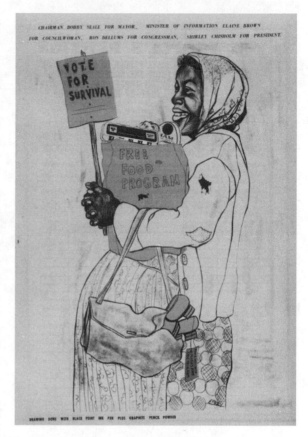

Emory Douglas, poster from *The Black Panther*, May 27, 1972 (copyright 2013 Emory Douglas/Artists Rights Society [ARS], New York; image courtesy of the Center for the Study of Political Graphics)

breakfast programs the "best and most influential activity going for the BPP and as
such, is potentially the greatest threat to efforts by authorities . . . to neutralize the
BPP and destroy what it stands for."[28]

In the late 1960s, early 1970s, 233 out of the 295 FBI counterintelligence operations
aimed at black liberation groups were directed toward the BPP. FBI tactics included sur-
veillance, infiltration, agents provocateurs, false testimonies, harassment, planting stories
in the media and coercing journalists, and political assassinations, among others. All of this
weakened the BPP.

Newton had predicted this scenario in 1968 when he stated, "The party must exist
above ground as long as the dog power structure will allow, and hopefully when the party is
forced to go underground the message of the party will already have been put across to the
people. The vanguard party's activities on the surface will be necessarily short lived."[29] This
held true. The FBI was able to derail the Panthers through jailing, killing, and forcing their

leadership into exile; but the *culture* of the BPP could not be as easily destroyed. Instead, it was disseminated throughout the world. For thirteen years, Douglas visualized the BPP ideology through the *Black Panther* and other forms of visual media. His work was revolutionary. It was part of a revolutionary struggle against racism, capitalism, and imperialism, and served the needs of the party, or in his words, it served "a purpose that was bigger than yourself."[30]

# 20

## Protesting the Museum-Industrial Complex

ART IS NEVER NEUTRAL. Neither are art museums. On October 31, 1969, Jon Hendricks and Jean Toche of the Guerrilla Art Action Group (GAAG) entered the Museum of Modern Art (MoMA) and went up to the third floor, where Kazimir Malevich's painting *Suprematist Composition: White on White* was on display.[1] When the guard turned his back, Hendricks and Toche carefully removed the famous painting, rested it up against the wall, and attached a signed manifesto in its place. The text read, in part:

> We demand that the Museum of Modern Art decentralize its power structure to a point of communalization. Art, to have any relevance at all today, must be taken out of the hands of an elite and returned to the people. The art establishment as it is used today is a classical form of repression. Not only does it repress the artist, but it is used:
> 1.) to manipulate the artists themselves, their work, and what they say for the benefit of an elite working together with the military/business complex.
> 2.) to force people to accept more easily—or distract them from—the repression by the military/business complex by giving it a better image.
> 3.) as propaganda for capitalism and imperialism all over the world. It is no longer a time for artists to sit as puppets or "chosen representatives of" at the feet of an art elite, but rather it is the time for a true communalization where anyone, regardless of condition or race, can become involved in the actual policy-making and control of the museum.[2]

The manifesto closed by stating:

> We demand that the Museum of Modern Art be closed until the end of the war in Vietnam. There is no justification for the enjoyment of art while we are involved in

the mass murder of people. Today the museum serves not so much as an enlightening educational experience, as it does a diversion from the realities of war and social crisis. It can only be meaningful if the pleasures of art are denied instead of reveled in. We believe that art itself is a moral commitment to the development of the human race and a negation of the repressive social reality. This does not mean that art should cease to exist or to be produced—especially in serious times of crisis when art can become a strong witness and form of protest—only the *sanctification* of art should cease during these times.[3]

Seconds after the painting had been removed from the wall a plainclothes museum guard ran up to the two artists, ripped the manifesto off the wall, and instructed Hendricks and Toche to leave the room for further questioning. They refused. Instead, they calmly explained that they wanted a representative of the museum to meet with them and receive their demands. More guards arrived and asked the artists for their names, addresses, and phone numbers. At the same time, Hendricks furnished another copy of the manifesto and held it up for museum patrons to read. Eventually the director of public relations, Elizabeth Shaw, and the director of exhibitions, Wilder Green, arrived on the scene, and Hendricks and Toche explained to them that they had no intention to harm the painting. Instead, they had chosen the once-revolutionary work of art as a symbolic site to present their manifesto. Shaw and Green promised to deliver the document to the Board of Trustees, everyone shook hands, and Hendricks and Toche left the museum.

————————

A month later, on November 18, GAAG returned to MoMA, this time accompanied by two other artists, Poppy Johnson and Silvianna. In the midafternoon, the four participants walked to the center of the main lobby. The two men were dressed in suits and ties, and the women were dressed in street clothes. Hidden beneath their clothes were bags of beef blood. Simultaneously the four participants threw 100 copies of their manifesto, "A Call for the Immediate Resignation of All the Rockefellers from the Board of Trustees of the Museum of Modern Art," onto the ground.

Next they began screaming, slamming into one another, and tearing at one another's clothes. The bags of blood burst all over them and onto the floor. In short order, a crowd of museum patrons, responding to the disturbance, formed a large circle around GAAG and watched in silence. Screams turned to moans as the four participants sank to their knees and slowly tore at their own clothes in acts of individual anguish. Each participant then laid down in the pool of blood, breathing heavily from the sudden burst of physical exertion.

The action directly referenced the carnage in Vietnam and the violent imagery that was broadcast to millions of Americans via the evening news: a handcuffed Vietcong prisoner executed on a Saigon street, a nine-year-old girl running naked down a village road after being severely burned by a South Vietnamese napalm attack, Buddhist monks setting

themselves on fire to protest religious discrimination by the Roman Catholic president Ngô Đình Diệm in South Vietnam. From 1965 to 1975, more than seven million tons of bombs were dropped on Vietnam—twice the total used in World War II. The result of the decade-long war: more than one million civilian casualties, more than 1.1 million dead Vietcong soldiers, and more than 58,000 U.S. soldiers killed in action.

Thus GAAG's *Bloodbath* performance was meant to suggest a literal interpretation of current events. When the four artists stood up, the crowd applauded in unison. An unidentified man, presumably a museum employee, shouted, "Is there a spokesman for this group?" Hendricks responded, "Do you have a copy of our demands?" The man replied. "Yes, but I haven't read it yet."[4] GAAG then left the museum and shortly thereafter two policemen arrived. The manifesto left by GAAG read, in part:

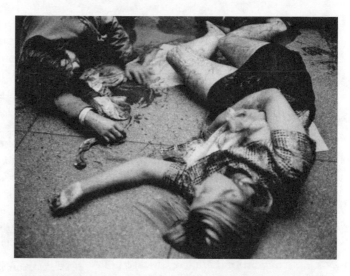

GAAG, *A Call for the Immediate Resignation of All the Rockefellers from the Board of Trustees of the Museum of Modern Art,* November 18, 1969 (photograph by Hui Ka Kwong, copyright Guerilla Art Action Group)

> We as artists feel that there is no moral justification whatsoever for the Museum of Modern Art to exist at all if it must rely solely on the continued acceptance of dirty money. By accepting soiled donations from these wealthy people, the museum is destroying the integrity of art. These people have been in actual control of the museum's policies since its founding. With this power they have been able to manipulate artists' ideas; sterilize art of any social protest and indictment of the oppressive forces in society; and therefore render art totally irrelevant to the existing social crisis.[5]

The text included information that connected the dots between the Board of Trustees and militarism. It noted that David Rockefeller served as the chairman of the board of Chase Manhattan Bank as well as chairman of the Board of Trustees for the Museum of Modern Art. The Rockefellers owned 65 percent of the Standard Oil Corporation, a company that had leased one of its plants to United Technology to manufacture napalm. David and Nelson Rockefeller also owned 20 percent of McDonnell Aircraft Corporation, which was involved in chemical and biological warfare research. GAAG called on artists to boycott MoMA. "If art can only exist through their blood money, then no art. Let's take art out of their bloody hands," declared Hendricks. "Let's not let them use us."[6]

Hendricks and Toche had formed GAAG in 1969, and they remained the core of the group throughout its existence. Toche was born in Belgium and came to the United States in 1965 when he was thirty-three. The FBI described him on March 27, 1974, as a "professional troublemaker, foreign agitator, peacenik, dirty commie, flag-burner, big tall burly bearded hairy man called Toche/Hendricks."[7] Toche, for the sake of clarification, later added that he was a "dissident artist, twice a political prisoner in the USA, human and civil rights activist, and civil liberties worker."[8]

GAAG was formed during a critical stage of the protest movement against the Vietnam War. The Tet Offensive of January 1968 had cast doubt on claims that the war would soon be over, much less "won." Shortly thereafter, CBS Evening News anchor Walter Cronkite told his audience, "The bloody experience of Vietnam is a stalemate" and the war was "unwinnable." President Johnson remarked to an aide, "If I've lost Cronkite, I've lost Middle America." In late March, Johnson announced that he would not run for reelection. Later that year, the Democratic National Convention in Chicago would be defined by what took place outside the convention hall: the Chicago police brutally dispersing tens of thousands of antiwar demonstrators. In 1969, the rising number of U.S. casualties, the unpopularity of the draft, and news of the My Lai massacre cemented public opposition against the war. On November 16, 1969, three days after the My Lai story broke, 500,000 people demonstrated in Washington, DC.

GAAG's activism against the museum took place within this context. They had no desire to march peacefully but chose instead to agitate people in positions of power. On one occasion, GAAG asked MoMA director John Hightower to hold a press conference and pour a gallon of beef blood over his head, slowly repeating the line "I am guilty, I am guilty, I am guilty." Hightower easily (and unfortunately) dismissed this request, but he could not help but be affected by the interventions that took place within and just outside MoMA's doors.

On May 2, 1970, GAAG participated in a staged "battle" outside MoMA that called on the museum to establish a "Martin Luther King Jr.–Pedro Albizu Campos" Study Center for Black and Puerto Rican Art. In typical GAAG fashion, Hendricks and Toche pulled up to MoMA in a rented white Cadillac limousine. Hendricks stepped out wearing a sign that read THE DIRECTOR. Toche wore a sign that read THE TRUSTEE. GAAG then placed a chicken-wire fence in front of one of the doors to protect the museum from the "enemy." The "enemy" in this case was the large crowd of African American and Puerto Rican artists who had assembled on the sidewalk as part of the protest/performance. Hendricks "The Director" and Toche "The Trustee" began yelling hysterically, "There is no such thing as black and Puerto Rican artists" (an actual quotation from the director of MoMA's Department of Architecture and Design, Arthur Drexler).[9] At one point, Adrian Garcia and Ralph Ortiz rushed the chicken-wire barricade and planted a Puerto Rican independence flag at the barricade. All the while, Hendricks fired a toy gun at the crowd and set off smoke bombs. Toche "The Trustee" was eventually dragged into the crowd, his clothes ripped apart, and then once "dead," he was thrown into the limousine, along with Hendricks.

GAAG recalled, "At this point, several police cars were already surrounding the area. A policeman peered into the limousine at 'The Trustee' crumbled up on the floor and

asked: 'Is he dead?' As the limousine sped off, 'The Director' was able to throw an ignited smoke-bomb into the crowd."[10] Remarkably, GAAG was not arrested for this action. Art had provided the cover—the confused police did not know whether the action was a protest or a sanctioned performance.

## Art Workers and Art Strikes

GAAG's controversial performances shared little in common with the typical solitary studio artist. They related more to the draft resisters and the activists who demon-

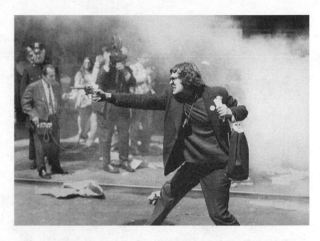

GAAG, *Staged "Battle" Outside of MoMA*, May 2, 1970 (photograph by Jan van Raay, copyright Jan van Raay)

strated in the streets, occupied college administration buildings, and burned draft records. GAAG asserted that the overwhelming majority of artists and museums were complicit with the dominant system and were thus part of the problem. They asserted that the museum could change if it wanted to; that MoMA—as a nonprofit institution—was in fact a *public* institution and should represent and listen to the public's concerns. They also asserted that art could change, that it could become autonomous from the moneyed interests of the art world.

Other activist art groups in NYC echoed these concerns. The Art Workers' Coalition (AWC), a group with which GAAG associated, was active from January 1969 to late 1971 and was open to any artist, filmmaker, writer, critic, or arts administrator who wished to join. The anarchic structure and rotating cast of players created myriad projects, but fostered less group identity and cohesion. And unlike GAAG, its three-hundred-plus members were divided between those who had a stake in the art world and those who "wished to tear it down."[11]

Artists' rights and critiquing the power structure of the museum (the Board of Trustees) lay at the heart of the AWC. On January 3, 1969, at 3:45 in the afternoon, Greek artist Vassilaki Takis stunned museum guards at MoMA when he and five of his cohorts walked up to his *Tele-Sculpture*, clipped the wires, unplugged his work from the wall, and carried it down the hall to the museum's garden. There, he and his supporters staged a sit-in, demanded to meet with a museum administrator, and were eventually met by Bates Lowry, Director of MoMA. Takis explained that although the museum owned his sculpture, he did not want his work included in that particular exhibit. Takis insisted that the work not be exhibited in the museum without first seeking his consent. Furthermore, he demanded that MoMA host a public hearing on artists' rights to discuss the strained relationship between artists and the museum. The impromptu meeting ended when Takis received a verbal agreement that his work would not be reinstalled in the show, and that the museum would consider a public hearing.

This action inspired the call to form the AWC. It led to a series of meetings at the Chelsea Hotel, where artists discussed how they could assert their rights and make the art world more accessible to the communities who felt excluded by art institutions. Those who helped form the AWC included Takis, Hans Haacke, Lucy R. Lippard, Carl Andre, Tsai Wen-Ying, Faith Ringgold, Irving Petlin, Dan Graham, and John Perreault, among others.

The name of the group itself was compelling—artists as workers and artists united as a coalition. However, visual artists, unlike theatre artists or professional actors and actresses, were not represented by organized labor in the 1960s.[12] Instead, artists worked largely alone and were *celebrated* for their individuality. The AWC represented an opportunity to break with this model: for individual artists to come together collectively and to agitate for change.

The AWC chose the museum as a site of protest for numerous reasons. The critic and former AWC member Lucy R. Lippard writes, "Artists perceived the museum as a public and therefore potentially accountable institution, the only one the least bit likely to listen to the art community on ethical and political matters."[13] Many artists considered the museum as their own, arguing that without artists, an art museum would cease to exist. Artists also chose museums as a site to demonstrate for many of the same reasons students chose to demonstrate on college campuses: familiarity, ownership, and organizing a natural constituency of potential supporters. As Robert Morris stated in May 1970, "Museums are our campuses."[14]

However, artists, as a collective body, did not have easily defined occupations or places of work. Instead they were scattered across hundreds of occupations. They could not shut down an industry the way unionized workers could.[15] In fact, much had changed since the 1930s and the examples set forth by organized artists, including the Artists' Union. The militancy of labor unions and strikes had been curtailed in the late 1930s and 1940s with the Second Red Scare and the Wagner Act that gave workers the right to collective bargaining but impeded their ability to strike.

The Vietnam War helped fuel an upsurge in activism, but the antiwar movement was largely disconnected from organized labor and workers' issues. Instead, as Roman Petruniak writes, the "AWC were founded upon a more diffuse sense of social angst and frustration."[16] The tipping point was the Vietnam War. "For many of those on the Left, by 1969 the War in Vietnam had eventually come to represent everything that was wrong with America. Analogously, for the art-workers of the AWC, MoMA had come to symbolize everything that was wrong with the art world."[17]

One of the first actions by the AWC was to present a list of thirteen demands to MoMA in February 1969 (a list that was later modified to nine demands aimed at all art museums). The original thirteen demands included artist representation on the Board of Trustees, an artists' curatorial committee, two free evenings a week, the creation of an artists' registry, artists' control of the exhibition of their own work, and rental fees given to artists for exhibiting their work. The AWC also called on the museum to become active in advocating for artists' economic welfare and housing, the creation of an African American and Puerto Rican art section in the museum, and museum programs in African American and Puerto Rican neighborhoods. The modified list of nine demands eventually called for equal gender representation in exhibitions, museum purchases, and selection committees.[18]

The majority of these demands fell on deaf ears at first, although some ideas were enacted in the years to come in many art museums, including one free day per week and marginal improvements in representing more women artists and artists of color. The AWC, however, was not looking toward changes to occur decades down the road. They were advocating for immediate change during a period of crisis.

On May 22, 1970, the AWC called an "art strike" in response to the U.S. invasion of Cambodia, as well as the events at Kent State University and Jackson State College, where the National Guard opened fire and killed student demonstrators. Specifically, the AWC called on New York City art museums and galleries to shut their doors for a one-day moratorium in protest of the war.

The Art Strike was inspired by Robert Morris, who had asked the Whitney Museum to shut down his solo show on May 15, several weeks before it was scheduled to close. Julia Bryan-Wilson writes that Morris "declared himself 'on strike' against the art system and further demanded that the Whitney close for two weeks to hold meetings for the art community, to address both the war and general dissatisfaction with the art museum as an agent of power. In Morris's view, 'A reassessment of the art structure itself seems timely—its values, its policies, its modes of control, its economic presumptions, its hierarchy of existing power and administration.'"[19]

The Whitney refused Morris's request but relented when he threatened to organize a sit-in at the museum. The following week, the "New York Art Strike Against War, Racism, and Repression" (Art Strike) was launched. Museums that participated included the Whitney Museum of American Art and the Jewish Museum, along with fifty commercial art galleries. Others museums partially closed down. MoMA and the Guggenheim remained open but waived their admission fees. MoMA also screened an antiwar film program and the Guggenheim, in GAAG-like fashion, removed all the paintings from its walls.

The Metropolitan Museum of Art, however, refused to close down, and was targeted by the AWC as a result. On the day of the Art Strike, Robert Morris and Poppy Johnson led a demonstration at the Met; protesters crowded onto the front steps, held up signs, and made speeches. Visitors who wished to attend the museum had to "cross the picket line."

However, the idea of an art strike was ripe with contradictions and symbolic of the marginalized position of the AWC, that in the words of Petruniak remained "vague and unproductive due to the lack of a viable or organized Left."[20] For one, those calling the strike against the Met were not museum employees. If anything, the action was more closely aligned with a consumer boycott, one that prevented the public from consuming art for the day.[21] As a targeted boycott, the action served as a litmus test to see which institutions would follow through with the AWC call and which institutions would side with the antiwar cause. Those that did were temporary allies. Those who refused were targeted for protests. Yet the real issue was not the name but the choice in tactics. At best, the Art Strike was symbolic; at worst, the one-day boycott offered these institutions an easy way to show solidarity with the antiwar movement while forestalling substantive change. Yet the demonstration let the Met know that the public was watching and holding it accountable. Moreover, the action

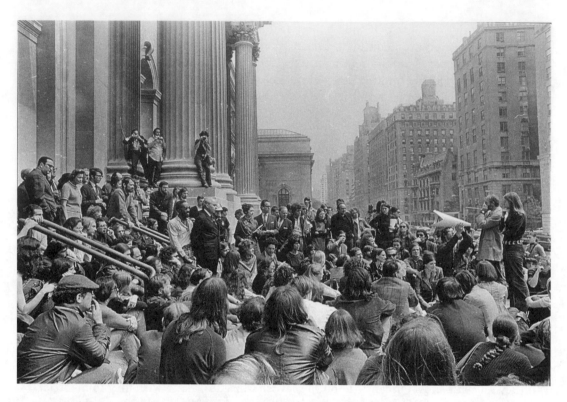

New York Art Strike, Metropolitan Museum, May 22, 1970 (photograph by Jan van Raay, copyright Jan van Raay)

mobilized hundreds of artists and directed attention to the issue of artists' rights and the power structure of the museum and its relationship to war.

Fundamentally, the AWC exposed another key contradiction: they identified as workers, but workers did not necessarily identify with them. Meaning that the largely white, college-educated "art workers" were the ones who were radicalized, not the blue-collar working-class population. The AWC likely identified more with the Old Left—the idea of the 1930s worker who was tied to organized labor (and the CP USA)—instead of the 1960s or 1970s working class that was largely perceived by the Left as being antagonistic to the counterculture and the antiwar movement. This was the same perceived "silent majority" that would later help elect Richard Nixon and later Ronald Reagan.

This gap between the "art workers" and other workers was made clear when the AWC had an antiwar poster printed by the Amalgamated Lithographers Union in NYC. They agreed to print it, but were largely dismissive of the AWC and their cause: protest against the war. If anything, the AWC could relate more to the "workers" at MoMA. They both shared a common interest in art and intellectualism. Thus, the art world became their audience and their target for reform. Lucy R. Lippard stated that the AWC "provided an extremely important consciousness-raising experience for the art world."[22] She adds:

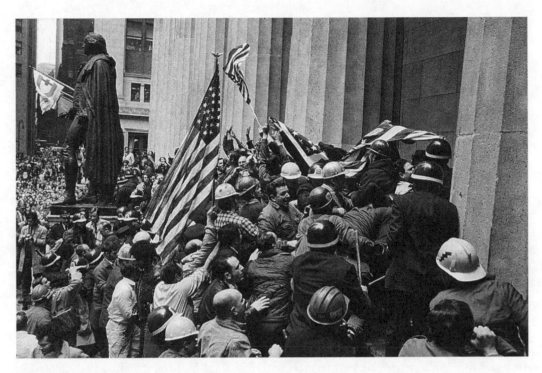

Carl T. Gosset Jr., *Construction Workers Protesting an Anti-War Rally at the Subtreasury Building, New York Times*, May 9, 1970 (copyright Carl T. Gosset Jr./*New York Times*)

Before 1969, very few people were aware that artists had any civil rights whatsoever, few knew how the political structure of the art world affected the art, or related art to the politics of real life. Very few people were aware of the economic enmeshment of the arts institutions and trustees in things like wars and military coups and exploitation all over the world—and how these things were reflected in the insidious commodity image of art objects.[23]

The AWC spurred this public awareness, but they also *influenced* MoMA employees. In June 1971, MoMA employees formed PASTA (Professional and Staff Association) that organized 112 out of 461 museum employees. Significantly, their internal publication, *ORGAN*, featured the AWC on the front and back cover of their July 1970 issue, signifying how the AWC had inspired their own efforts to organize. Ironically the "art workers" became the MoMA employees in the fall, when PASTA was formally recognized by MoMA as a labor union.

PASTA union button

Meanwhile, the AWC remained outside the boundaries of organized labor yet crucial in inspiring other workers to organize.[24]

## Q: And Babies? A: And Babies.

Confrontation against the museum was one political tactic of the AWC, another was to *collaborate* with the museum on antiwar projects. In November 1969, the AWC Poster Committee, a subcommittee of AWC, invited MoMA to co-sponsor the poster *Q: And Babies? A: And Babies* that addressed U.S. war atrocities in Vietnam, specifically the My Lai massacre. The collaborative approach was significant. Protest posters and graphics from twentieth-century movements in the United States nearly always derived from below—from groups and individuals who are marginalized. In the case of the AWC Poster Committee, a small activist-art group collaborated with a powerful cultural institution that embodied the upper-class art world. Hence, AWC's tactics was to ask MoMA to forgo its class interests and to place its institutional name and credibility behind the protest movement. In essence, the AWC asked MoMA to join the antiwar movement.

The image that the AWC selected for the poster was a color photograph by Army photographer Ronald L. Haeberle; it showed dozens of Vietnamese women, children, and babies gunned down by U.S. soldiers on a rural dirt road. Superimposed over the photo was text from a Mike Wallace CBS News interview with Pvt. Paul Meadlo, who had participated in the My Lai massacre. When Wallace asked Meadlo if the order was to kill women and babies. His answer was "And babies."

This harrowing response helped expose an incident that the U.S. military had tried to keep suppressed for more than a year: the day that a U.S. Army platoon under the command of Lt. William Calley entered the village of Sơn Mỹ (or My Lai), March 16, 1968, and opened fire on everyone present. Men, women, children, and babies were gathered up, made to stand next to a ditch, and then were shot to death with M16 rifles and M60 machine guns. The U.S. military estimated that the number of Vietnamese killed was between 175 and 500; reports from Vietnamese civilians put the death toll at 567.

Haeberle documented the gruesome aftermath with a government-owned camera and turned the black-and-white negatives over to the Army. Yet he also took color photographs with his own camera and film. These images existed outside the Army's knowledge, and he later released them to the media. On November 12, 1969, journalist Seymour Hersh broke the story of the My Lai massacre to a global audience. Thirty-five newspapers carried the story, and some, including the *Plain Dealer* (Cleveland), reproduced Haeberle's images. A week later, on November 20, *CBS Evening News* with Walter Cronkite began its newscast with some of Haeberle's images from the massacre. Four days later, Mike Wallace's interview with Pvt. Paul Meadlo appeared on the same network. Additionally, a ten-page spread of Haeberle's color photos appeared in *LIFE* magazine.

The effect of the photos on the U.S. public was intense. The public had seen brutal images of the war on the nightly news and in print, but Haeberle's photographs were different.

These images struck a moral chord, triggering profound questions: How could the U.S. Army consider children and babies to be the enemy? How could soldiers shoot babies? How could this action win the "hearts and minds" of the Vietnamese people?

The AWC, recognizing the power of the My Lai images for furthering the antiwar cause, quickly set up a meeting with administrators at MoMA, with the intention to create a poster that could be widely distributed through museum and art networks. Irving Petlin noted, "I feel the museum [MoMA] should issue a vast distribution of a poster so violently outraged at this act [My Lai] that it will place absolutely in print and in public the feeling that this museum—its staff, all the artists which contribute to its greatness—is outraged by the massacre at Sơn Mỹ."[25]

On November 25, 1969, the AWC Poster Committee (Irving Petlin, Jon Hendricks, and Frazer Dougherty) sat down with Arthur Drexler (director of the Department of Architecture and Design) and Elizabeth Shaw (director of public relations), along with other members of the museum's staff.[26] By the end of the meeting it was decided that the AWC would design the poster and cover printing costs for 50,000 copies. MoMA would handle shipping costs and would distribute the poster to other museums in the United States and around the world. MoMA would also lend its name to make it easier for the AWC to seek out a printer and gain permission rights for the photograph. The meeting ended, however, without MoMA fully committing to the project.

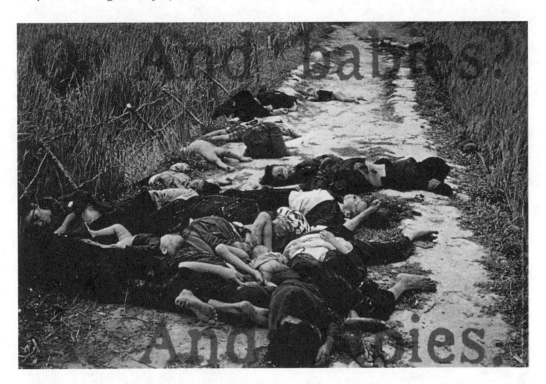

Artists' Poster Committee: Irving Petlin, Jon Hendricks, Frazer Dougherty, *Q: And Babies?*, 1970, offset lithograph (photograph by Ron L. Haeberle, image courtesy of the Center for the Study of Political Graphics)

Nonetheless, the AWC moved forward. Haeberle gave the AWC permission to use his image free of charge, the Amalgamated Lithographers Union in NYC agreed to print the image—reportedly in exchange for a drawing donated by Alexander Calder—and business-man Peter Brandt covered the paper costs.

At the same time Arthur Drexler began to get nervous about associating MoMA's name with the project. He began to question what his bosses—the Board of Trustees—specifically MoMA's board chairman and founder of CBS Inc., William S. Paley—would think of the poster. In fact, when Drexler did finally present the image to the board, the project was immediately canned. A follow-up MoMA press release read, in part:

> The Museum's Board and staff are comprised of individuals with diverse points of view who have come together because of their interest in art, and if they are to continue effectively in this role, they must confine themselves to questions related to their immediate subject.[27]

In short, the board stated that antiwar art was not "art." Ironically, perhaps, the AWC had made a similar claim, arguing that "The Coalition [AWC] is under no illusion that the poster is art. It is a political poster, a documentary photograph treating an issue that no one, not even the most ivory tower esthetic institution, can ignore."[28]

However, the issue at hand was not whether the poster was "art" but the power dynamics within the museum. The AWC had shined a light, much in the same way that GAAG had, on the issue of corporate power—specifically the top-down decision-making process of the Board of Trustees and the control that they wielded over the museum. The statement by the board was a calculated effort to deflect attention away from their own complicity in an unpopular war. They falsely asserted that the board and the museum staff were one and the same and that the duty of a museum was to concern itself with issues of art and aesthetics only. In short, they tried to present the idea that MoMA was neutral on the war, when in fact MoMA, as directed by the Board of Trustees, was anything but. The board at MoMA (much like the boards at the vast majority of elite cultural institutions) was comprised of hyperwealthy individuals who represented some of the most powerful corporate and media entities in the country. If anything, the AWC should have expected the board to turn down their project. Their only misstep was not to inform the 700 to 1,000-plus staff members at MoMA who knew little to nothing about the collaborative project, and would have more than likely supported it and pressured the board to try to allow the curators to carry through with the co-authored project.

Undeterred by the rejection, the AWC went ahead and distributed 50,000 copies of the poster through informal art networks and activist networks. The AWC also issued a press release that chastised the board's decision, calling it a "bitter confirmation of this in-stitution's decadence and/or impotence."[29]

Unable to collaborate with MoMA, the AWC returned to the familiar role of a margin-alized group fighting against a powerful institution. On January 3, 1970, a group from the AWC gathered on the third floor of MoMA in front of Picasso's famous antiwar painting *Guernica* and held up copies of the *Q: And Babies? A: And Babies* poster in front of it.[30]

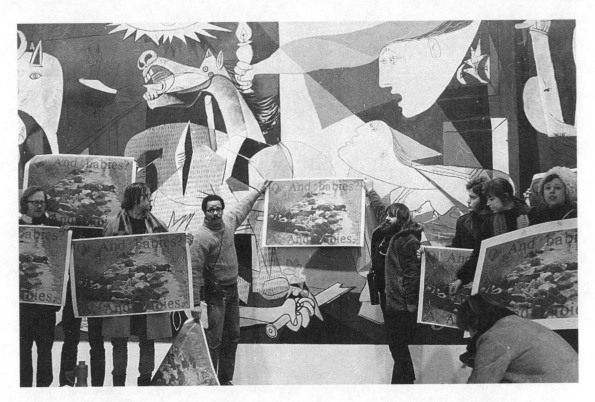

Demonstration at the Museum of Modern Art in front of Picasso's *Guernica* by a group from the Art Workers' Coalition protesting the Museum of Modern Art's reneging on their agreement to co-produce the Artists' Poster Committee's poster *Q: And Babies?*, January 3, 1970 (photograph by Jan van Raay, copyright by Jan van Raay)

They also set four wreaths beneath it. Artist Joyce Kozloff sat in front with her eight-month-old baby, and Father Stephen Garmey, an Episcopalian minister and chaplain at Columbia University, read a memorial service in honor of the victims at My Lai. His service interspersed verses from the Bible with horrific extracts from the My Lai article from *LIFE* magazine, and closed with a poem by Denise Levertov. As he read, supporters held up copies of the AWC poster in the air. MoMA chose not to have museum guards stop the demonstration. Less than a week later, on January 8, the AWC returned to *Guernica* and staged a lie-in on the day of a Board of Trustees meeting. The AWC demanded to speak with the board, but were refused. In an interview given forty-plus years after this action, Jean Toche conveyed succinctly the political motives of the AWC, GAAG, and the broader movement that had inspired it: "They [museums] have become essentially a capitalist tool—a tool for entertainment and a tool to augment the financial wealth of the art world. Change them or destroy them."[31]

# 21

## "The Living, Breathing Embodiment of a Culture Transformed"

IN THE EARLY 1970S THERE WERE three epicenters for feminist art: Los Angeles, New York, and Fresno. Fresno, a mid-sized city in California's Central Valley—far removed from San Francisco and Los Angeles—became essential due to the efforts of sixteen women: Judy Chicago and her fifteen students. In 1970, Chicago took a one-year teaching appointment at Fresno State University (now California State University–Fresno) to purposely remove herself from the art world. There, she started the Feminist Art Program—the first program in the country dedicated to a feminist art education.

Chicago did this for personal and political reasons. She had faced gender discrimination in her own art education, and in the male-dominated Los Angeles art world. Art historians rarely discussed the work of women artists, designers, and architects. Male art professors, who made up the vast majority of faculty appointments, treated female art students differently. Expectations were lower. Mentorship was often extended to male students only. Female students were not encouraged to be professional artists and designers.

Chicago sought to challenge sexism in the arts and to empower her female students. She began classes for the Feminist Art Program during the fall semester and held them off-campus. During the first six weeks, students held discussions at one another's houses. Consciousness-Raising (C-R), a technique employed by the women's liberation movement, was key to the learning environment. The class would sit in a circle and each participant would share personal thoughts about her experiences as a woman. This nonjudgmental atmosphere allowed each participant equal time to express herself. It also allowed her to realize that individual feelings and experiences were often shared experiences. Moreover, it allowed students to analyze how their lives had been conditioned and formed based on their gender.[1]

These C-R sessions produced art content in which students would return to class with poems, writings, drawings, and performance ideas based upon the discussions. Many of the women whom

Chicago selected for the program were new to feminism; some were new to art. Suzanne Lacy and Faith Wilding, for example, had little formal art training. Lacy came to art through sociology: she was a graduate student in psychology at Fresno when she decided to switch majors and study with Chicago. Both Lacy and Wilding had started Fresno's first women's C-R group and had written a proposal for the university's first women's studies class.[2]

During its second month, the Feminist Art Program moved into a 5,000-square-foot space—former barracks—that became its studio classroom for the next seven months. Each student contributed $25 a month for rent. Here, students could organize and create an alternative space—a safe space—without male interference.[3] The women constructed gallery walls, a darkroom, studio spaces, and a kitchen, directly challenging the notion that women could not learn or be skilled in the building trades. They also challenged the traditional education model. Instead of education being based upon the individual and the teacher as the primary instructor, their process became collective. Students helped develop the curriculum, which evolved organically. Wilding recalls, "Working off-campus in a building we controlled dissolved the normal academic time and space boundaries. We became part of the larger urban community."[4]

Feminist Art Program, Fresno State University, "Miss Chicago and the California Girls", ca. 1970–1971, image ID: wb 3165, (Woman's Building Image Archive, Otis College of Art and Design)

Many students began the program with three credit units and expanded to fifteen credits by the second semester, immersed in visual art, film, and performance art. Students staged a mock beauty pageant in their studio titled "Miss Chicago and the California Girls."

They also formed a mock cheerleading team where each of the four participants spelled out the word "cunt" on their uniforms, turning a derogatory phase into an empowering one. "Cunt art" created a new visual vocabulary for representing female sexuality and the female body.[5] In the words of Wilding, the images were meant to "analyze, confront, and articulate our common social experiences."[6]

Other collective projects included editing the May 7, 1971, special issue of the feminist publication *Everywoman*. This issue was produced solely by the Fresno students and helped expand their audience. The students further broadened their reach with an open-house event at their studio in the spring. That weekend, several hundred women artists traveled to Fresno from Los Angeles and San Francisco to witness a series of performances, art exhibitions, discussions, and a slideshow highlighting the work of women artists. "That weekend, in tears, laughter, and night-long discussions," says Wilding, launched, "the west coast women's art movement . . . It was also the end of the Program as it had been, hidden and private in Fresno, away from the stress and pressures and male standards of the art world."[7]

Feminist Art Program, Fresno State University, *CUNT Cheerleaders*, ca. 1970–1971; pictured: Cay Lang, Vanalyne Greene, Dori Atlantis, and Sue Boud (courtesy of Double X, Nancy Youdelman, Janice Lester, and Faith Wilding)

## Womanhouse

That fall, Chicago moved the Feminist Art Program to the California Institute of the Arts (CalArts) in Valencia, just north of Los Angeles. Chicago brought with her nine of the fifteen students from Fresno and launched the Feminist Art and Design Program that she co-directed with the New York painter Miriam Schapiro.

Their signature project, much like the Fresno experimental educational model, took place off-campus. Twenty-one students spent six weeks restoring a city-owned Hollywood home slated for demolition and turned it into a temporary exhibition and performance space called *Womanhouse*, which critiqued the pop-culture image of the 1950s suburban housewife.

Students began by fixing up the seventeen-room dilapidated house, after which they each chose spaces for their own individual or collaborative installations.

C-R techniques informed the process so that students and their instructors could tap into the gendered meanings of the conventional home—the kitchen, bedroom, bathroom, linen closet—and then turn these readings upside down. Camille Grey created *Lipstick Bathroom*, painting the entire room in gloss red. Judy Chicago also converted a bathroom to examine the taboo of female blood and fertility. Her *Menstruation Bathroom* was a clean and orderly environment, except for a trash can overflowing with used tampons. Other participants

*Womanhouse*, group photograph of some of the participants, ca. 1971–1972. Top row, left to right: Ann Mills, Mira Schor, Kathy Huberland, Christine Rush, Judy Chicago, Robbin Schiff, Miriam Schapiro, Sherry Brody. Bottom row: Faith Wilding, Robin Mitchell, Sandra Orgel, Judy Huddleston. Not shown: Jan Oxenburg, Paul Longendyde, Karen LeCocq, Camille Grey, Nancy Youdelman, Shawnee Wollenman, Janice Lester, Beth Bachenheimer, Robin Weltsch, and Marcia Salisbury (courtesy of Double X, Nancy Youdelman, Janice Lester, and Faith Wilding)

employed mannequins in their installations. Sandy Orgel segmented a female mannequin to fit inside the shelves of a linen closet, commenting on the housewife's gendered confinement to household roles.

Kathy Huberland installed a mannequin dressed in full bridal attire at the top of the stairs, absent her groom. Her installation expressed the essence of *Womanhouse*, shattering the veneer of the prototypical American suburban home and housewife by depicting a place where monotony, anger, despair, and loneliness replaced happiness.

Women who attended the opening of *Womanhouse* connected to this message. That night, the space was open to women only. Spectators watched a series of performances,

Sandy Orgel, *Linen Closet*, part of *Womanhouse*, 1972 (photograph by Lloyd Hamrol, courtesy of Faith Wilding)

including Chris Rush's *Scrubbing*, which had her methodically scrubbing the floor in an endless cycle of house chores, and Faith Wilding's *Waiting*, for which she sat in a chair and listed a not-so-glamorous life cycle aimed to please others besides herself: "Waiting for my breasts to develop, waiting to get married, waiting to hold my baby, waiting for the first grey hair, waiting for my body to break down, to get ugly, waiting for my breasts to shrivel up, waiting for a visit from my children, for letters, waiting to get sick, waiting for sleep."[8]

Reactions to all the work ranged from tears to laughter. The following weekend, the performances were repeated for a mixed-gender audience. Men in the audience did not react as favorably. They apparently could relate to the critique.

During the month it was open (January 30 to February 28), *Womanhouse* turned a private space into a public dialogue. More than nine thousand people attended *Womanhouse*, and unlike the Fresno project, it received extensive national media attention. *Time* magazine and *LIFE* magazine both covered *Womanhouse*, as did local radio and television. Gloria Steinem showcased it for an hour on public television. Johanna Demetrakas made a forty-minute film about the project. This media attention expanded the reach and influence of feminist art, enabling it to challenge the influential New York art world and the long shadow it cast over art institutions and art schools throughout the country.

The New York art world by and large championed formalist art, the commodification of art, and the notion of the lone individual artist. Feminist art countered all of these ideas about art and the artist's role in society: it was overtly political, collective, and collaborative. Traditional media—weaving, needlework, and other techniques associated with craft—were reclaimed as

Christine Rush, *Scrubbing*, part of *Womanhouse*, 1972 (photograph by Lloyd Hamrol, courtesy of Faith Wilding)

contemporary art. New media—performance art, video, and installation art—were harnessed to express feminist content. Moreover, feminist art was part of the Second Wave of Feminism, a larger national movement that confronted patriarchy by challenging economic

inequalities, cultural standards of beauty, and traditional views on gender roles, reproductive rights, and violence against women.

While the groundbreaking *Womanhouse* installation was an integral part of this movement, divisions existed among those who produced it. Some of the students resented the full-time nature of the project, which had them working from sunup to sundown. These pressures were exacerbated when Chicago and Schapiro would leave Los Angeles for stretches of time, traveling across the country to lecture about the Feminist Art Program and *Womanhouse*. When they would return, they would attempt to reassert control and authority over the project.[9] Wilding reflects that some students resisted this breach in the collective process and "what they saw as an increasingly ideological formulation and application of the 'feminist line' to their art and their lives by Chicago and Schapiro."[10]

Faith Wilding, *Waiting*, part of *Womanhouse*, 1972 (photograph by Lloyd Hamrol, courtesy of Faith Wilding)

Also present was the issue of recognition. *Womanhouse* was a collective project, yet the art world's tendency to celebrate individuals meant that the most attention went to those with the greatest name recognition—primarily Chicago.

Additionally, Chicago and Schapiro's Feminist Art Program was facing institutional resistance at CalArts. Other instructors and students were antagonistic toward the program, and feminism was not widely introduced across the curriculum. Students in the program thus learned one set of values from Chicago and Schapiro, and messages and values that countered feminism and feminist art in their other classes. Moreover, the two-to-one ratio of male students to female students hardly created a supportive environment. To complicate matters, tension existed between Chicago and Schapiro. Schapiro felt that being housed at CalArts was beneficial for the program, while Chicago came to view the Feminist Art Program's relationship to the larger institution as a mistake.

## The Woman's Building

In 1973, Chicago resigned from CalArts to form the first independent art school exclusively for women—the Feminist Studio Workshop (FSW)—in collaboration with the graphic designer Sheila de Bretteville and the art historian Arlene Raven.

Together, they chose the former Chouinard Art Institute—on 743 South Grand View Street, near MacArthur Park—which had fallen into disrepair and was ironically owned by CalArts, which rented it to them for $3,000 a year.

On November 28, 1973, after months of carpentry, painting, and repairs, a new epicenter for feminist art and activism—not to mention a model for alternative art spaces and art education—opened. Named the Woman's Building after the Woman's Building Pavilion at the 1893 World's Columbian Exposition in Chicago, it

Woman's Building founders; left: Judy Chicago; center: Sheila de Bretteville; right: Arlene Raven, ca. 1972 (image ID# wb3044, Woman's Building Image Archive, Otis College of Art and Design)

Woman's Building brochure designed by Sheila de Bretteville, ca. 1974 (image ID# wb74 1048, Woman's Building Image Archive, Otis College of Art and Design)

Women's Graphic Center, ca. 1980s (mage ID# wb 3019, Woman's Building Image Archive, Otis College of Art and Design)

housed the FSW and two other women's art education programs, the Extension Program and the Summer Art Program.

It also housed the Women's Graphic Center, run by Sheila de Bretteville and Helen Alm, which featured offset lithography presses, silkscreen, letterpress, and other printmaking techniques for creating broadsides, posters, newsletters, and artists' books; women-owned businesses (Sisterhood Bookstore and the Associated Women's Press, among others); seven galleries, including Grandview I and II, the Community Gallery, the Open Wall Show, the Upstairs Gallery, the Floating Gallery, and the Coffeehouse/Photo Gallery; performance-art spaces including Woman's Improvisation and the Performance Project; and activist groups, including the Los Angeles chapter of the National Organization for Women (NOW).

Group photo of the Feminist Studio Workshop (FSW), ca 1975–1976 (photo by Candace Compton, image ID# wb 30001 75, Woman's Building Image Archive, Otis College of Art and Design)

For two years, the Grand View location became a hub of activity. Exhibitions, performances, lectures, readings, and workshops took place nearly every day of the week. Women—primarily white, middle-class women—from across the country enrolled in the FSW and immersed themselves in the activities of the Woman's Building, training in new media, graphic arts, and feminist art (painting and sculpture classes were not offered).

Projects and groups that formed at the Woman's Building during the 1970s included Mother Art (a space that welcomed women artists and their children), the Waitresses (a performance group confronting sexism in the workplace), the Lesbian Art Project (whose groundbreaking work included the performance *An Oral Herstory of Lesbianism*), and Ariadne: A Social Art Network (that connected women artists, collectives, and activist groups across the country), among others.

This separatist space and separatist feminist movement was needed. Women artists and designers were not deemed equal in the art world and the workforce. In the early 1970s, the Los Angeles Council of Women Artists reported that out of 713 artists who exhibited in group shows at the Los Angeles County Museum only 29 of them were women. Out of 53 solo exhibitions, only one was a woman's.[11] The Woman's Building and the FSW supported women artists forging their own paths. It supported collectivity and collective action. All decisions at the Woman's Building were made by a council that included one member from each group and tenant in the building. Cheri Gaulke writes, "Collaboration

The Waitresses, *The Great Goddess Diana*, performance art vignette created as part of *Ready to Order?*, 1978; pictured: Anne Gauldin and Denise Yarfitz, photograph by Maria Karras (image ID# wb78.2009, Woman's Building Image Archive, Otis College of Art and Design)

The Cast of *Oral Herstory of Lesbianism*, directed by Terry Wolverton, 1979 (image ID# wb70 2284, Woman's Building Image Archive, Otis College of Art and Design)

was a means of production, but at its best, it was also the living, breathing embodiment of a culture transformed. In many ways it represented our utopian vision of the world, where people were truly equal and everyone's contribution was valued."[12]

Judy Chicago, whose vision helped create the Woman's Building, left after the first year to focus on her own individual art career. Nonetheless, others carried forth the organizing efforts; the Woman's

Building allowed the alternative art space to become larger than any of the individuals involved. People could come and go and bring forth new ideas and new energy. The pressures of maintaining the space, however, were notable. In 1975, CalArts sold the building and the new owner ended the lease. Undeterred, the Woman's Building, along with the FSW, moved to North Spring Street in an industrial corner of downtown Los Angeles.

Internal group pressures also took a toll. In 1976, Arlene Raven wrote to Sheila de Bretteville, "Somehow I feel the need to feel like a separate person instead of a cog in our group/organizational wheel, marching as I have been these last years to the sound of what I think is my duty . . . I love what we've built even though its maintenance is burdensome."[13] Raven's quote summarized the highs and lows of collective practices: the sacrifice of individual needs for the group's benefit, and the intense amount of work needed to keep these types of spaces running, often on little funds and donated labor.

Exterior of Woman's Building—Spring Street location with Kate Millett's *Naked Lady* sculpture on the roof, ca. 1980 (photograph by Mary McNally, image ID# wb 3051, Woman's Building Image Archive, Otis College of Art and Design)

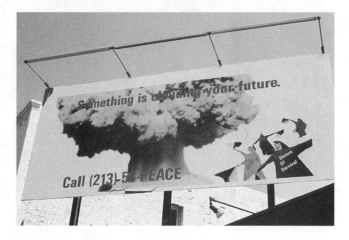

Sisters of Survival, *Something Is Clouding Your Future* billboard, 1985 (image ID# wb85 2195, Woman's Building Image Archive, Otis College of Art and Design)

In the early 1980s, low enrollment ended the FSW and forced the Woman's Building to alter its course once again. More space was carved out and leased to other groups to help pay the rent. Moreover, the focus of the Woman's Building shifted toward coalition-building and global solidarity movements. While the 1970s called for a much-needed separatist movement that nurtured and empowered women, the 1980s demanded new tactics. President Ronald Reagan's two terms in office ushered in a nuclear arms race between the United States and the Soviet Union, a covert war against leftist movements in Central America, the start of the mass incarceration of Americans—especially people of color (the War on Drugs)—a roll back on environmental protections, and an attack on

unions. In general, Reagan's policies represented a hyperprivatization of the public sphere that led to drastic defunding for public education and public services at the federal, state, and city levels. Cultural spaces were hit hard and had to scramble for funding. Furthermore, these policies embodied an affront to the gains made by the feminist and multicultural movements of the 1970s.

The Woman's Building responded in kind. The Sisters of Survival, a group that challenged the impending threat of nuclear war, formed in 1981. The Committee in Solidarity with the People of El Salvador also moved into the Woman's Building, bringing men and more minorities into the space, something that had been lacking during the 1970s.

In 1991, the Woman's Building project came to an end. Its influence, however, was felt by the tens of thousands of people who had passed through its doors as students, instructors, performers, artists, and visitors. It influenced an untold number of artists' groups and spaces that formed during and after its incredible run.[14] Cheri Gaulke reflects, "We were concerned with changing the lives of real women through our art, our activism, and our very organizational structures."[15] The Woman's Building, along with *Womanhouse* and the Feminist Art Programs, achieved this goal; they each served as a safe space where a separatist movement could be nurtured, as well as critiqued and expanded upon.

# 22

# Public Rituals, Media Performances, and Citywide Interventions

In June 1972, Suzanne Lacy, Judy Chicago, Sandy Orgel, Jan Lester, and Aviva Rahmani staged *Ablutions*, a one-night performance at a small art space in Venice, California. Audience members entered into an open studio room with a concrete floor that served as a temporary stage. Near the back wall was a single chair. In the middle of the room lay three metal tubs, each filed with a different substance—eggs, blood, and clay slip. Scattered across the floor were broken eggshells, rope, and animal kidneys. The stillness of the scene was ruptured when a naked woman was led to the chair in silence and slowly bound to it from head to foot with gauze bandages. Another woman walked unclothed toward the audience and the first tub. She began scrubbing herself in the bath of eggs and then proceeded to the second tub full of twenty gallons of beef blood, followed by the tub of slippery gray clay slip.

A third woman repeated her steps and entered the first tub. When the two women emerged from the final tub, the clay slip began to dry on their skin, revealing small rivulets of blood between the cracks on the surface. Simultaneously, other activities were taking place in the background. Lacy methodically pounded fifty beef kidneys into the wall with a hammer and nails, lining them up in a horizontal row. A tape recording played throughout the performance. The subject: women talking about their experience of being raped. The performance ended with Lacy and Jan Lester tying everything together with rope in a "spiderweb of entrapment" that connected the bound woman to the tubs, the two other women, and the beef kidneys. The tape recording repeated the single closing line, "I felt so helpless, all I could do was lie there and cry."

The audience's response was deafening silence. Cheri Gaulke reflected, "The powerful images shocked the art audience, who, like the general population, did not yet understand women's experience of violence."[1] Talking about rape was taboo. *Ablutions* ruptured the silence.

At the Feminist Art Program at Fresno, Suzanne Lacy and Judy Chicago had begun conceptualizing *Ablutions*. They spent a year seeking out seven women who were willing to talk candidly

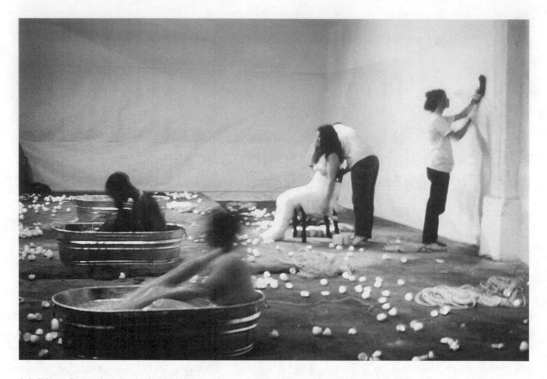

Judy Chicago, Suzanne Lacy, Sandra Orgel, Jan Lester, and Aviva Rahmani, *Ablutions*, June 1972 (Suzanne Lacy)

(and anonymously) on tape about their experience of being raped. These interviews served as the basis for the audio for *Ablutions*.

The performance space operated as a safe space to address painful subject matter. Lacy writes, "The strategy of *Ablutions* was to convince the audience of the reality of the problem, to create a cathartic experience for rape victims, and to stimulate a cultural context for women to begin the painful process of speaking out."[2] The next phase was to move this dialogue into the public sphere. Lacy moved performance art out of the gallery and into the city, where the potential stage became the city itself. She asked, "Why talk about rape exclusively in an art gallery when you could still be attacked on the way home?"[3]

## Citywide Interventions

Lacy's first citywide public performance, *Three Weeks in May*, was launched on May 8, 1977. The project involved a three-week series of actions that confronted the rape crisis in Los Angeles. More than thirty events were staged, including performances, actions, speak-outs, radio programs, self-defense clinics, exhibitions, and demonstrations. Central to *Three Weeks* were community organizing, creating a media strategy, working with politi-

cians, with artists taking on the role "as communicators, public spokeswomen for the cause of female safety."[4] Lacy explains that the goal of *Three Weeks in May* "was not only to raise public awareness, but to empower women to fight back and to transcend the sense of secrecy and shame associated with rape."

Lacy acted as a co-organizer, curator, and participant in the project.[5] She installed two twenty-five-foot-tall maps of Los Angeles at the City Hall Shopping Mall, an underground shopping arcade in downtown L.A., next to City Hall. As daily rapes were reported to the Los Angeles Police Department, Lacy would stamp the approximate area of the map with a red stamp that read RAPE.

By the end of three weeks, the map had more than ninety stamp marks—a *low* estimate, considering that many rapes are never reported to the police. The other map detailed the locations of clinics, shelters, organizations, and other services to help assist women who were victims of rape and violence. Both maps were printed on bright yellow paper with a caution-tape border design as an outline.

Lacy and her co-collaborators chalked sidewalks in the city that noted the approximate location and the date when a rape had taken place. Sharon Irish

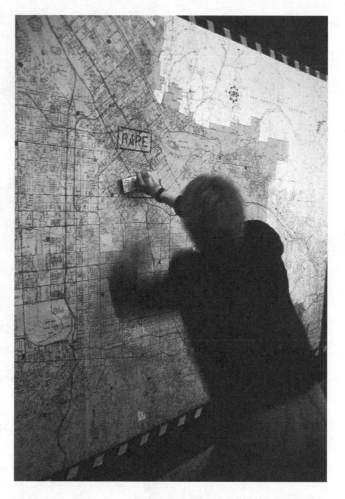

Suzanne Lacy stamping "rape" on map of Los Angeles in *Three Weeks in May*, May 1977, City Mall in City Hall, Los Angeles (Suzanne Lacy)

writes that these simple but poignant words served as a "marker of violence and activated new meanings in locations that may never before have been associated with violence in most people's minds."[6]

Lacy also activated the City Hall Shopping Mall location by focusing attention away from consumerism and toward civic engagement and activism. The City Hall Shopping Mall, although underground and seemingly removed from the public, reached a critical audience. City officials and government workers who frequented the mall began to pay attention and began to offer more support. Members of the city government started to join the demonstration and began speaking publicly about violence against women. And when *Three Weeks in May* concluded, the city government and the police department took concrete action by publicizing rape hotlines.[7]

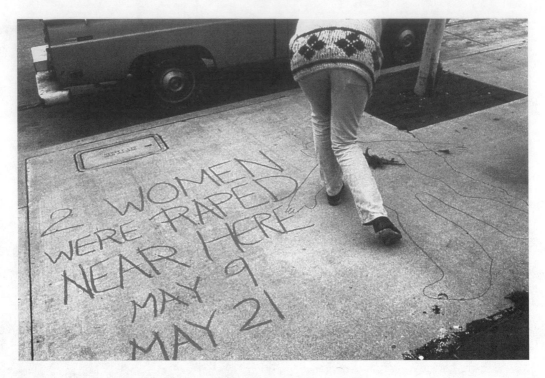

Chalking sidewalks near sites of rape, *Three Weeks in May*, May 1977, Los Angeles (Suzanne Lacy)

From the start of the project Lacy advocated that the government and the police play an important role in helping to reduce domestic violence, rape, and violence against women. On the other hand, she also communicated the role of artists in movements. During the planning stages for a subsequent performance, *In Mourning and in Rage*, Lacy had to explain to activist groups that artists were more than unpaid volunteers in a movement:

> We had a meeting with all the women's organizations in town that deal with violence, and we said we wanted to do this piece, and we wanted to support them. Immediately, one of the women from one of the centers jumped up and said we think the way you can support us is that you can help us do a self defense lecture-demonstration and then you can serve on the hot line and we need help doing that. And we said NO, we're artists, and we have skills in this area and we're going to talk with you about it. There was a struggle because they didn't understand what we were trying to do as artists; they don't trust art . . . so there was a struggle to educate them to what we can do, and about the power of this imagery and what it can do.[8]

In short, she helped bridge the gap between artists and activists.

## Made for Television

On December 13, 1977, Lacy collaborated with Leslie Labowitz on *In Mourning and in Rage,* a one-day action on the steps of City Hall that encouraged women to fight back against sexual violence. *In Mourning and in Rage* was concieved in response to the media coverage of the Hillside Strangler case. The murders of ten women by two male serial killers (assumed to be one at the time) had placed Los Angeles on edge. Mainstream media only heightened the sense of fear and helplessness by running sensationalized stories of the murders that dug into the victims' pasts and projected the storyline that women in Los Angeles were powerless to stop the violence. There was little public discussion or criticism of the culture of male violence against women, or information about women organizing and fighting back.

Lacy and Labowitz's response to the media coverage was to create a public performance that would place a feminist counternarrative into the media's coverage of the murder case. On the morning of December 13, Lacy and Labowitz (along with Bia Lowe) orchestrated a public action that was a "tableau enacted for the cameras" and "witnessed by the media audience."[9] Seventy women met at the Woman's Building, including ten women dressed in specially constructed black mourning garb that made each wearer stand seven feet tall. Next, the ten women climbed into a hearse and drove toward City Hall under a motorcycle escort. Twenty-two cars filled with women from the Woman's Building followed behind in the funeral procession. Each car had its

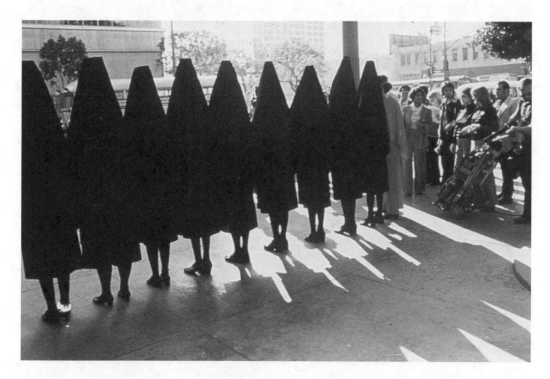

Suzanne Lacy and Leslie Labowitz–Starus, *In Mourning and in Rage,* performance at Los Angeles City Hall, 1977 (image ID# wb3044, photograph by Maria Karras, Woman's Building Image Archive, Otis College of Art and Design)

lights on and had stickers that read FUNERAL and STOP VIOLENCE AGAINST WOMEN. When the motorcade approached City Hall, it circled twice and then pulled up to a sidewalk location, where the media had been instructed to wait. The ten women dressed in black and one in red emerged from the hearse, formed a line on the sidewalk, and then walked to the City Hall steps.

On the steps of City Hall, a microphone was set up, and a banner was held behind the ten women that read IN MEMORY OF OUR SISTERS, WOMEN FIGHT BACK! The banner, much like the performance, was designed with the camera in mind. Lacy and Labowitz predetermined what the best spot would be for the media to set up so that the banner could be easily filmed and read through the medium of television.

The ten women each spoke. The first mourner walked up to the microphone and read, "I am here for the ten women who have been raped and strangled between October eighteenth and November twenty-ninth." The nine women behind her echoed in unison, "In Memory of Our Sisters, We Fight Back!" Each of the nine women read a short statement, followed by the repeated chorus. Next, the woman dressed in all red spoke: "I am here for the rage of all women. I am here for women fighting back!" Lacy read a short statement, followed by a statement by the director of the Los Angeles Commission on Assaults Against Women, who demanded, among other things, that free self-defense classes be offered to women in recreation centers in the city. The performance then ended with a song by Holly Near, written specifically for the occasion.

*In Mourning and in Rage* was specifically choreographed to fit within the three-to-five-minute duration of a television news story and was designed to leave the viewer with a

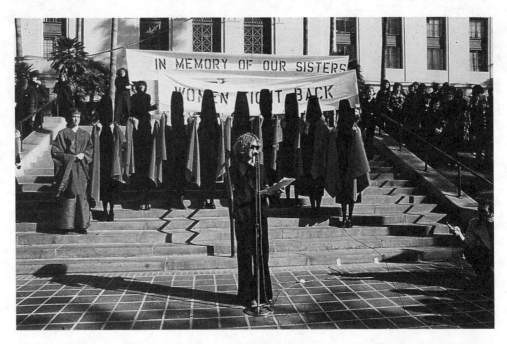

*In Mourning and in Rage*, performance by Suzanne Lacy and Leslie Labowitz–Starus, Los Angeles City Hall, 1977, photograph by Maria Karras (Suzanne Lacy)

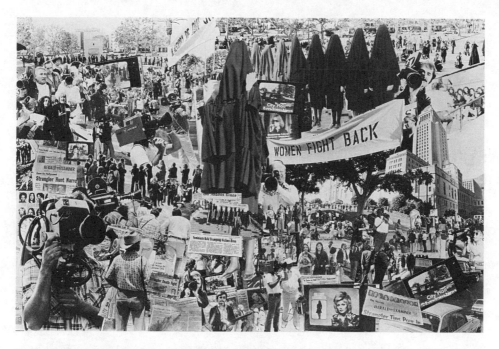

Suzanne Lacy and Leslie Labowitz-Starus, *A Woman's Image of Mass Media*, 1977, photomural of *In Mourning and in Rage*, performance by Leslie Labowitz-Starus and Suzanne Lacy, photomural by Labowitz-Starus (Suzanne Lacy)

concise and didactic message to remember: women organizing, mourning the loss of other women, and, most significantly, fighting back.

The performance also doubled as a press conference. Nearly every major television network in Los Angeles covered the event, and the action netted tangible results. The $100,000 reward for information about the Hillside Strangler was converted into a fund for free self-defense classes for Los Angeles residents, and two self-defense workshops were provided for city employees. Additionally, a reporter followed up on the event by asking the local telephone-book company why they had refused to list rape crisis hotlines in their books. This inquiry and the fear of negative press resulted in the phone-book company switching its policy and listing crisis numbers in the front of the book; unfortunately, the numbers were removed the following year.

Lacy and Labowitz's action entered the bloodstream of the media not by chance but by careful planning. Both artists understood how the media worked, and how artists and activists could use it to their advantage. Lacy and Labowitz designed the action so that it would speak to the short attention span of the media and the public. "News demands clarity and simplicity, a straightforward narrative composed of two to four images, a message that can be explained in thirty seconds by a reporter who may only invest a few minutes of her or his time at the event,"[10] Lacy said. Every detail was planned in advance. "We considered, for example, camera angles, reporters' use of voice-over, and the role of politicians in traditional reporting strategies."[11] The result was a succinct message that made it difficult for media outlets to distort the message. For artists, the message was also clear: consider your audience and consider the messenger.

# 23

# No Apologies: Asco, Performance Art, and the Chicano Civil Rights Movement

"It's not in your best interests to apologize publicly."

—Harry Gamboa Jr.[1]

WHOEVER SAID THAT POLITICALLY ACTIVE artists have to play by the rules and conform to the norms of a movement or a community? Not Asco, an East Los Angeles art collective that was founded by Harry Gamboa Jr., Willie Herrón, Gronk, and Patssi Valdez, and was active from 1971 to 1987. Asco (Spanish for "nausea") was infamous for agitating nearly everyone from residents of East L.A., Chicano artists, the guardians of the art world, and participants of the Chicano civil rights movement.

An early action by Asco, *Stations of the Cross*, epitomized their desire to rupture public space and public norms. On Christmas Eve, 1971, Gamboa, Gronk, and Herrón led a procession down Whittier Boulevard in East L.A. amid holiday shoppers and curious onlookers. Herrón carried a fifteen-foot-tall cross, was dressed up as a skeleton (a Christ/Death figure), and wore a white robe and face makeup. Gronk was dressed as Pontius Pilate (or Popcorn) with a green bowler hat, carrying an oversized fur purse and a bag of unbuttered popcorn. And Gamboa dressed up as zombie altar boy, accented with an animal-skull headpiece. The one-mile silent procession ended at a U.S. Marines recruitment station, where a five-minute silent vigil was held. Gronk blessed the site and spread popcorn over the ground, while Herrón leaned the cross against the door, symbolically blocking the recruitment center that had sent so many community members to their death. After the vigil, Asco split the scene and left behind the cardboard cross and popcorn for the Marines to ponder their meaning.

Remarkably, the police never spotted them, but community members on the busy street did. At times, onlookers verbally assaulted them but did not attack them. Regardless, Asco had placed themselves in a dangerous situation where there was the potential for violent community reaction. Gamboa reflected:

> Either the police were going to take care of you or someone in the neighbor-
> hood was going to take care of you. So you met a lot of resistance because it
> was so conservative. And to even to stray into the sensitive area of religious
> icons or even hinting that you might not believe in certain things or might
> even question what America is all about, again, you were setting yourself up
> to be someone that's punished.[2]

Gamboa adds:

> There were definite enforced roles bound up with growing up to be male or
> female . . . people would take it upon themselves to punish you for who you
> are. If you failed to comply with the rules or fulfill the requisite obligations,
> you could become the object of physical brutality at the will of the commu-
> nity by merely walking from one corner to another. There are countless ex-
> periences that I, personally, or other people I knew endured that involve
> such scenarios of admonishment and abuse as punishment for transgres-
> sions.[3]

To Asco, the risks were worth it. *Stations of the Cross* served as a litmus test for how far they
could push their audience. They dressed up in makeup, subverted gender roles, and altered
religious symbols. Ironically, *Stations of the Cross* focused on an issue that the community
overwhelmingly endorsed: opposition to the Vietnam War. Yet Asco's mode of communi-
cation defied conventions, asking the audience to dig deeper in search of the meaning of
its artistic expression. Moreover, the performance critiqued both the war *and* the commu-
nity. Both were violent, both were repressive, and Asco was not willing to give either one a
pass.

## Outside/Inside the Movement

Asco's abrasive methods placed them on the margins of their community, but their engage-
ment with community-based activist movements, especially Gamboa's, made them any-
thing but outsiders. Gamboa was one of a number of student leaders during the Chicano
Blowouts, a watershed moment in East L.A. when thousands of students walked out of five
high schools on March 5, 1968, demanding an overhaul of the education system.[4]

Students had good reason to walk out. East L.A. high schools had the highest dropout
rate in the nation, and violence was at an epidemic level. Students would attack other stu-
dents, teachers would attack students, and the police who patrolled the schools would re-
spond with even more violence. Learning was all but nonexistent in this setting. "The schools
were designed to create a product," reflects Gamboa, "and the product was either soldiers for
the war, cheap labor or prisoners. That was it."[5]

In the early 1970s, Chicanos represented less than 1 percent of students in the University
of California system, yet they filled the front lines of the military, representing the highest

death rates in Vietnam.[6] The Blowouts demanded changes in the schools: hiring more Chicano teachers and administrators, bilingual education, the end of rigid dress codes, and schools that were on par with those in the white districts of Los Angeles.

Gamboa's leadership role in the Blowouts at Garfield High School made him a target for police and FBI surveillance. He was listed as one of the top 100 most dangerous and violent subversives in the country. His crime: helping to organize students to demand better public schools in East L.A.

Regardless of police intimidation, Gamboa's activism continued after high school. He was one of 30,000 people who attended the National Chicano Moratorium March—a massive antiwar demonstration on August 29, 1970, at Laguna Park in East L.A. that turned into a riot when police stormed into the crowd and fired tear gas.[7] Chaos ensued throughout the night, and by dawn, three protesters were dead, sixty-one injured, and more than two hundred people were arrested.[8] One of those killed was Rubén Salazar, a Chicano journalist for the *Los Angeles Times* and news director for the Spanish-language television station KMEX. Salazar was killed when police fired a twelve-inch tear-gas canister at close range into his head as he sat inside the Silver Dollar Cafe. His death, and the acquittal of the officers responsible, sent shock waves through the Chicano community. Salazar was one of the prominent voices of the Chicano civil rights movement, and his murder at the hands of the police sent a clear message: Chicano people were deemed expandable, whether it was in the cities, rural America, or in Vietnam.

In the aftermath of the riot, Gamboa decided to turn to a new medium to voice his outrage: photography:

> I saw cops [at the Moratorium] acting like dogs, but the next day in the newspapers the cops were represented as the victims: all the photographs were images of the cops getting hit. That's when the idea hit me: they're manipulating these images. All of a sudden, the pieces of the puzzle fit together: If I don't capture these images and document the things I see, they're going to get lost, and ultimately other people will define them for me. It seemed to hit all at once, perhaps because it was so traumatic and life threatening, not only for my family, and me but also for the whole community. So I got a camera, bought some film, and started taking pictures.[9]

Gamboa also turned to writing. Community activist Francisca Flores invited him on the day of the Chicano Moratorium to become an editor of *Regeneración*, a Chicano political and literary journal that had been relaunched from its early 1900s origins, highlighted by Mexican anarchist Ricardo Flores Magón's involvement. Gamboa agreed and chose to expand the dialogue about Chicano culture and the Chicano movement itself. One of his first decisions was to invite Herrón, Gronk, and Valdez to contribute pen-and-ink drawings. The four soon began to collaborate, leading to the formation of Asco.

These four artists embraced dark humor and rejected the trends of Chicano art and mural art that looked to the past for inspiration. They had no desire to depict Mexican revolutionaries, Che Guevara, farmworkers, or images of Aztlán—the mythical homeland of the

Aztecs.[10] "A lot of Latino artists went back in history for imagery because they needed an identity, a starting place," explains Gronk. "We didn't want to go back, we wanted to stay in the present and find our imagery as urban artists and produce a body of work out of our sense of displacement."[11] Gronk added: "As an urban dweller . . . I couldn't paint farmworkers because I would be deceiving people. I'm not familiar with those things . . . I want to communicate an idea, not just a slogan."[12]

Willie Herrón and Gronk in 1979 in front of *Black and White Mural*, 1973 (photograph by Harry Gamboa Jr., copyright Harry Gamboa Jr., courtesy of the UCLA Chicano Studies Research Center)

This approach set the group at odds with the trends of Chicano activist art. During the First Chicano National Conference in 1969, a clear mandate was expressed through *El Plan Espiritual de Aztlán*: "We must ensure that our writers, poets, musicians, and artists produce literature and art that is appealing to our people and relates to our revolutionary culture."[13] Asco opposed this approach as one that disguised the reality of life in their community and one that would create a uniform artistic response. Instead, Asco chose to make art on their own terms: intensely political art that rose out of the barrio of East L.A. but shared more in common with the tactics and the humor of the 1920s avant-garde Dadaist movement. Gamboa and company named their collective Asco (nausea), a Dada-esqe

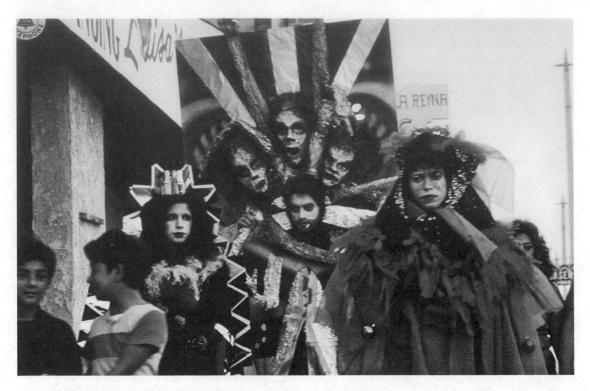

Asco, *Walking Mural*, 1972; left to right: Patssi Valdez, Willie Herrón, and Gronk (photograph by Harry Gamboa Jr., copyright Harry Gamboa Jr., courtesy of the UCLA Chicano Studies Research Center)

"anti-art" name that perfectly summarized their opinion on American society, the Vietnam War, Chicano art and movement politics, *and* the reaction that most people had to their work.[14]

## Instant Walking Murals

> "We were right in the middle of it; we wanted to change it. We wanted to reach inside and pull people's guts out."
>
> —Willie Herrón[15]

One year following the *Stations of the Cross* performance, Asco returned to Whittier Boulevard on Christmas Eve for another silent procession, *Walking Mural*. And once again, Asco held nothing back.

Gronk dressed as a Christmas tree, with a red-and-green dress and a five-pointed star painted on his face. Valdez dressed in black as the Virgin de Guadalupe, and Herrón dressed as a mural wall, one that had become so uninspired by the genre of mural painting and the

demands of cultural nationalism that it decided to walk off the wall and down the street.[16] Herrón's costume featured three zombielike heads that protruded from the background and formed an arch over his own face that gazed out with a blank expression.

Asco's intervention critiqued conventional murals, but it also addressed another key issue: restrictions on public space. In the aftermath of the Chicano Moratorium and a number of smaller riots, the city clamped down on Whittier Boulevard as

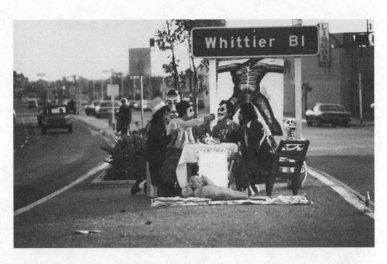

Asco, *First Supper (After a Major Riot)*, 1974 (photograph by Harry Gamboa Jr., copyright Harry Gamboa Jr., courtesy of the UCLA Chicano Studies Research Center)

an intimidation tactic to prevent further uprisings. Police routinely performed random stop-and-searches, and cars were prohibited from cruising down Whittier Boulevard after ten p.m. on weekends. The city also canceled the annual East Los Angeles Christmas parade. Asco's *Walking Mural* was thus as an act of defiance against the city's efforts to control the community. *Walking Mural* became an unsanctioned parade that reclaimed the streets and stood in solidarity with the community, albeit through avant-garde art that was garish and completely over-the-top. However, Asco won some converts with *Walking Mural*, and a number of onlookers and friends joined in with the procession.

On December 24, 1974, Asco performed another litmus test on the community and the police. They returned to Whittier Boulevard, this time on a traffic island during rush hour, to stage *First Supper (After a Major Riot)*. Each member dressed up in costume and wore masks that twisted Leonardo da Vinci's *Last Supper* and the traditional Day of the Dead celebrations into a new concoction. Props included a dinner table, chairs, food and drink, a painting of a tortured corpse, a skeleton, and a blow-up doll.

C. Ondine Chavoya described *First Supper* as an

> act of occupation in lieu of their previously mobile tactics.[17]
> The traffic island the artists occupied had been built over a particularly bloody site of the East L.A. riots as a part of an urban "redevelopment" project in 1973. Following the riots, the surrounding buildings, sidewalks, and streets were leveled and rebuilt to prevent further public demonstrations . . . an example of urban planning administered as a preventative obstacle and punitive consequence for mass social protest.[18]

Asco's response was to reclaim public space and to become more creative with their form of protest. Following *First Supper*, on the way walking home, Gronk took out a roll of masking

tape and taped Patssi Valdez and Humberto Sandoval (a frequent co-collaborator with Asco) to the exterior wall of a liquor store, creating *Instant Mural*.

Gronk described the concept behind the spontaneous performance:

> To me, the idea of oppression was that tape . . . It had a conceptual message—a thought-provoking one: how we are bound to our community and get bound to our environment. How we get caught up in the red tape.[19]

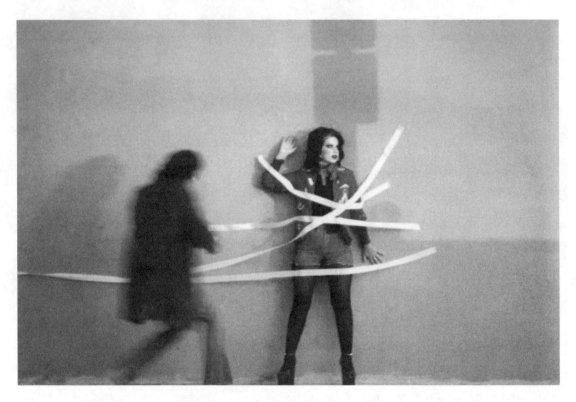

Asco, *Instant Mural*, 1974; left to right: Patssi Valdez and Gronk (photograph by Harry Gamboa Jr., copyright Harry Gamboa Jr., courtesy of the UCLA Chicano Studies Research Center)

Others could have read *Instant Mural* differently, and this was the point; the open-ended reading of *Instant Mural* defied the didactic modes of Chicano murals and kept the work raw, uninhibited, and cutting-edge—even with forty years of hindsight.

## Museums and Decoys

"To be revolutionary is to be experimental."

—Gronk[20]

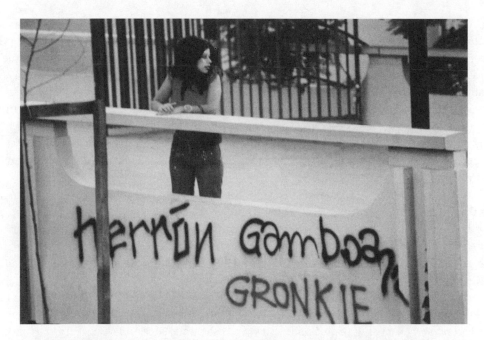

Asco, *Spraypaint LACMA*, 1972 (photograph by Harry Gamboa Jr., copyright Harry Gamboa Jr., courtesy of the UCLA Chicano Studies Research Center)

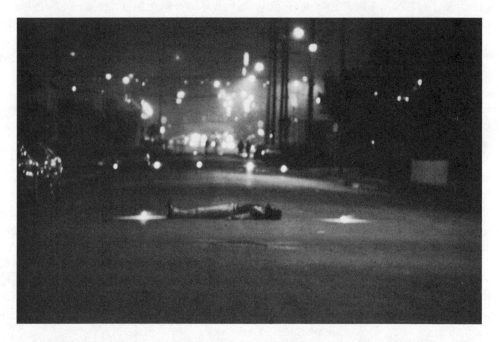

Asco, *Decoy Gang Victim*, 1975 (photograph by Harry Gamboa Jr., copyright Harry Gamboa Jr., courtesy of the UCLA Chicano Studies Research Center)

Gamboa's photograph of Valdez taped to a wall proved to be one of Asco's classic images, exemplifying the importance that photography played in their work. It was designed with the camera in mind.[21] Photographs and Super 8 films by Gamboa gave Asco's ephemeral works an extended life and allowed the images to travel far and wide, away from the constraints of East L.A. However, not all of Asco's work was situated in their own community. One of their most infamous works was performed at the Los Angeles County Museum of Art (LACMA). In 1972, Gamboa asked a museum curator, who likely did not know him, why contemporary Chicano art was absent from the museum's exhibitions. The curator's response was that Chicanos did not make "fine art," they made "folk art" or they were gang members.[22]

Gamboa's response was to give the curator a taste of his own medicine. He returned that night, after the museum was closed, and he, along with Herrón and Gronk, spray-painted their name "gang-style" on the side of the museum.[23] Gamboa latter described *Spraypaint LACMA* (or *Project Pie in Da/Face*) as an action that "momentarily transformed the museum itself into the first conceptual work of Chicano art to be exhibited at LACMA."[24]

As Chon A. Noriega writes, Asco's tags did not last long: "When LACMA whitewashed Asco's signatures, it simultaneously removed graffiti and destroyed the world's largest work of Chicano art, obscuring the inclusive notion of the public that underwrote its existence."[25]

While LACMA inadvertently tried to erase any notions of gang activity in Los Angeles, Asco created another performance to bring attention to the issue. *Decoy Gang Victim* (1974) addressed gang violence in their community, and used creative methods to try to stop it. The process involved showing up in the general region where a gang member had been killed or hurt, and setting off flares in the street. Next, Gronk would lie in the middle of the road, covered in ketchup, and pretend to be dead—the victim of a retaliatory killing, thus obviating the need for a revenge killing by a rival gang.

Asco took the action a step further by distributing photographs of the decoy to mainstream media outlets—a critique of the media's habit of sensationalizing violence in the inner city. KHJ-TV News fell for the decoy and ran a photograph of Gronk on a live broadcast as a "prime example of rampant gang violence in the City of Angels."[26]

*Decoy Gang Victim* resonates so powerfully, for it combined Asco's avant-garde performance work with community activism, suggesting that their antagonistic relationship toward the community was equally matched by their efforts to improve it. For if they were truly outsiders, why would they risk life and limb to try to stop gang violence? East Los Angeles served as Asco's subject matter, but it also was their home, and they employed art as a means to address the many problems that their community faced.

Asco's work was designed to agitate, but it was also meant to *inspire*. "We were after the kids that were looking for something different," reflects Herrón. "We wanted to find that little niche and create something . . . so if anyone wanted something alternative, they would turn to us for the alternative."[27] Herrón adds, "I felt we were doing it to expose them to art, to expose them to . . . looking at people that exist with them differently."[28]

Asco achieved this goal, but their largely unwelcomed internal critique put them at odds with their audience. Their name said it all. Disgust with society, disgust with conven-

tions, disgust with the way things were. Asco confronted the social and political problems of their time, and sadly ours—poverty, failing schools, high dropout rates, prisons, war, military recruiters, and racism. Their early work (1971–1975) was uninhibited and unstained by the art world.[29] No matter what their medium was, Asco critically challenged the inequalities and violence that plagued their community and greater Los Angeles. They also critiqued the tactics of the Chicano movement and the Chicano artists who were addressing the same issues. They created what Max Benavidez called a "parallel art movement," largely because other movements had rejected them.[30]

# 24

## Art Is Not Enough: ACT UP, Gran Fury, and the AIDS Crisis

THE MOST ICONIC GRAPHIC OF the AIDS movement was arguably the movement's most ambiguous—a pink triangle on a black background with text that read SILENCE = DEATH. To the viewer who encountered the image for the first time, the logical question became "Silence about what?"

By 1985, the number of reported AIDS cases nationally was more than 11,000. By mid-1986, this number was over 30,000, and nearly half of these individuals, primarily gay and bisexual men, had died.[1] San Francisco gay activist Cleve Jones recalled that at that time "everyone's address books were a mass of scratch-outs."[2] People were going to funerals every week. Entire social circles were being wiped out.

The government response to the AIDS crisis was shameful. Various government officials vilified gay and lesbian people instead of responding to a health emergency with compassion and expediency to find a cure. President Ronald Reagan was particularly callous. He pandered to the Religious Right and waited until the sixth year of his presidency before ever mentioning the word "AIDS" in a policy speech. And when he did, he proposed cutbacks in AIDS funding as well as mandatory-testing legislation that, if enacted, would only further demonize people with AIDS.

Other pundits went a step further. William Buckley wrote in a *New York Times* March 1986 op-ed piece that people with AIDS should be tattooed on their upper arm and buttocks to prevent the further spread of the disease. Not to be outdone, Lyndon LaRouche received the over 394,000 signatures required to place an initiative on the California ballot that called for people with AIDS to be placed in quarantine camps. This never came to fruition, but the climate of blame was deadly as funding for research and drugs that might slow down the virus, along with care for those already infected, remained substandard. Instead, the gay lifestyle and sexual "deviancy" was incorrectly deemed to be the cause of the AIDS virus that might harm "innocent" victims—children, hemophiliacs, and straight people.[3]

*Silence = Death* became an urgent response, not only to the deadly virus but also to the media hysteria and the political attacks that targeted the gay community. People with AIDS feared, justifiably, that the government might place them in quarantine camps. The *Silence = Death* graphic addressed this fear and the dangerous political and cultural climate. The pink triangle symbol referenced how gay prisoners in Nazi concentration camps were forced to wear pink triangles on their clothing before they were murdered, thus historically reinforcing that the failure to speak out was akin to death. The slogan and image became a call to action. To present an empowering message, the triangle pointed upward, as opposed to the Nazi image that pointed downward, and once the AIDS activist group ACT UP adopted the image, the message itself evolved. It was a call for direct action and creative resistance to force the government to adequately address the AIDS epidemic and help its citizens who were infected.

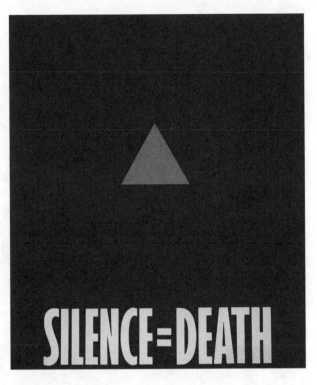

Silence = Death Project, *Silence = Death*, 1986, poster, offset lithography, placard, T-shirt, button, etc. (LGBT and HIV/AIDS Activist Collections, the New York Public Library, Astor, Lenox and Tilden Foundations)

ACT UP employed activist art with such success and at such at a high volume that they are almost without peers in terms of prioritizing *culture* as a form of resistance. Numerous art and video collectives were formed within ACT UP, including the Silence = Death Project (who created the iconic image in 1986), Gran Fury, Little Elvis, GANG, ACT UP Outreach Committee, DIVA TV, Testing the Limits, and House of Color. Their mediums included graphics, posters, T-shirts, installation, billboards, film and video, and performance art, among others. In ACT UP, artists were not simply asked to make banners or to design flyers—an insulting, and all-too-common role that artists are asked to fulfill in activist organizations. Instead, artists were active participants in ACT UP. They helped shape the organization's mandate, identity, and *tactics*—including art as a form of direct action.

## ACT UP

In early March 1987, more than three hundred gay and lesbian people gathered in New York City and founded ACT UP (AIDS Coalition to Unleash Power).[4] ACT UP's mandate was specific—"medication into bodies"—free access to antiviral drugs to help those who were

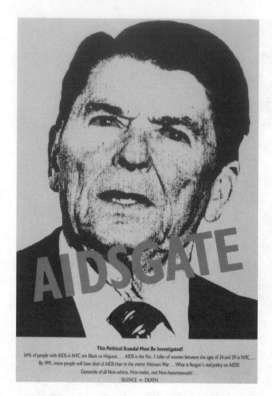

**This Political Scandal Must Be Investigated!**
54% of people with AIDS in NYC are Black or Hispanic. . . AIDS is the No. 1 killer of women between the ages of 24 and 29 in NYC . . .
By 1991, more people will have died of AIDS than in the *entire* Vietnam War . . . What is Reagan's *real* policy on AIDS?
*Genocide of all Non-whites, Non-males, and Non-heterosexuals?* . . .
SILENCE = DEATH

Silence = Death Project, *AIDSgate*, 1987, poster, offset lithography (LGBT and HIV/AIDS Activist Collections, the New York Public Library, Astor, Lenox and Tilden Foundations)

infected and more public awareness to stop the spread of AIDS. ACT UP embraced direct action as the primary way to respond to the AIDS crisis, to force the government, pharmaceutical companies, and the media to respond. Each meeting began with members stating in unison that they were "united in anger and committed to direct action to end the AIDS crisis."[5] These words were quickly backed up in practice.

The first ACT UP/NYC demonstration took place just two weeks after the founding meeting. On March 24, hundreds gathered at Wall Street to protest the FDA's slow approval process for drugs and the collusion of government and corporate interests that profited from the manufacture of AZT, the only FDA-approved AIDS drug, sold by the pharmaceutical company Burroughs Wellcome. AZT was a double negative; it was highly toxic and incredibly expensive. AZT cost patients more than $10,000 a year, despite the fact that the government had subsidized Burroughs Wellcome to develop it.[6]

During the protest, activists blocked traffic in the streets, an effigy of FDA commissioner Frank Young was hung, and seventeen people were arrested. In the aftermath, the demonstration made national news and CBS newsanchor Dan Rather credited ACT UP for bringing national attention to the issue. Several weeks later, the FDA announced plans to speed up its drug-approval process, and in December, Burroughs Wellcome announced plans to drop the price of AZT by 20 percent. The stunning success of the Wall Street action placed ACT UP at the forefront of the AIDS activist movement. In a short time, more than a hundred ACT UP branches were formed in cities across the United States and abroad, although the NYC branch would remain the most visible of the chapters.

Structurally, ACT UP was organized into a series of committees that allowed people to engage with the group depending upon their talents and interests. Gregg Bordowitz of ACT UP/NYC explains:

> ACT UP [NYC] was not one monolithic institution. It was a group of people who met every Monday night. Many of them were parts of smaller groups, or cells, or affinity groups within the larger group. And those affinity groups to some extent had, if not a separate life, a life outside the group.[7]

Committees included, among others, a steering committee, a coordinating committee, and a women's caucus. A majority caucus was formed in late 1987 because African Americans and

Latinos represented the highest percentage of AIDS cases in NYC. For many, ACT UP became their social circle, dating scene, extended family, and way of life. Members would often go to different committee meetings nearly every night of the week.

ACT UP was also home to numerous art collectives that marked the organization from the very beginning. Michael Nesline, who was a member of the art collective Gran Fury, recalls how members of the Silence = Death Project first introduced themselves to the group:

> Avram [Finkelstein] stood up and said, "I'm one of the people that made those posters [Silence = Death]. Most of us are in the room. We talked about it after last week's ACT UP meeting, and we decided that we want you all to know that we made those posters and we want ACT UP to be able to use that poster and that image for whatever purposes ACT UP deems appropriate. So, it's yours.[8]

The image would quickly be put into action, including during the New York City Gay Pride Parade on June 28, 1987. ACT UP blanketed the march with the logo on T-shirts and signs carried in the parade. Nesline explains:

> What the media was impressed by was the uniformity of our presentation. I mean, all of the posters are black posters with big pink triangles. It looked really organized. That was not a completely conscious strategy at that point. It quickly became a conscious strategy, because we realized that it worked, for the media.[9]

But the images and slogans were not aimed just at the media and spectators. Cultural critic and ACT UP/NYC member Douglas Crimp argues that the primary audience for the graphics was people within the movement:

> AIDS activist graphics enunciate AIDS politics to and for all of us in the movement. They suggest slogans (SILENCE = DEATH becomes "We'll never be silent again"), target opponents (the *New York Times*, President Reagan, Cardinal O'Connor), define positions ("All people with AIDS are innocent'), propose actions ("Boycott Burroughs Wellcome") . . . In the end when the final product is wheatpasted around the city, carried on protest placards, and worn on T-shirts, our politics, and our cohesion around those politics, become visible to us, and to those who will potentially join us.[10]

One of the most prolific of all the ACT UP art collectives, and the one responsible for much of the protest ephemera, was Gran Fury.

## This Is to Enrage You

"We wanted to point out that the idea of the isolated cultural producer, the lonely artist in the studio, was one that at a time of crisis for us did not quite work, did not reflect the necessities or the possibilities of what collective action could do."

—Gran Fury[11]

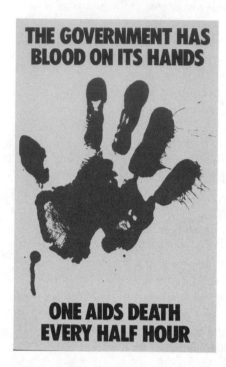

Gran Fury, *The Government Has Blood on Its Hands*, 1988, poster, offset lithography, placard, t-shirt, etc. (LGBT and HIV/AIDS Activist Collections, the New York Public Library, Astor, Lenox and Tilden Foundations)

Gran Fury, a ten-to-twelve-person activist art collective within ACT UP/NYC, was formed in January 1988 and created myriad projects, including posters, stickers, flyers, billboards, bus ads, art installations, fake newspapers, and other forms of creative resistance.[12] Gran Fury specialized in bold graphics and simple slogans—images were produced for actions, often the night before, and images were constantly repurposed.

*The Government Has Blood on Its Hands* followed this rubric.

The poster was initially created for an ACT UP demonstration on July 28, 1988, against the New York City Department of Health (DOC) and NYC health commissioner Stephen Joseph. Joseph had enraged activists by stating that only 50,000 NYC residents had AIDS (instead of the more accurate number of 200,000) to justify the city's minimal commitment to care services.[13] The original poster featured a blood-red handprint with text that read YOU'VE GOT BLOOD ON YOUR HANDS, STEPHEN JOSEPH. THE CUTS IN AIDS NUMBERS IS A LETHAL LIE. An alternate version of the poster was aimed at Mayor Ed Koch for his failure to seriously address the AIDS crisis. It read NYC AIDS CARE DOESN'T EXIST, which was a bitter reality. Mayor Koch had provided a measly $25,000 in funding for AIDS research and patient care in 1983, compared to the $1 million that Mayor Dianne Feinstein had committed in San Francisco, a figure that was still too low.[14] To address the failure of politicians in NYC, Gran Fury wheat-pasted the poster in the streets and "crews of ACT UP members went about with buckets of red paint, into which they dipped their latex-glove-covered hands to imprint bloody palm prints all over the city."[15]

Other actions were just as confrontational. During the second Wall Street action on March 24, 1988, Gran Fury photocopied thousands of $10, $20, $50, and $100 bills onto green paper and scattered them all over the streets, causing traffic to come to a standstill. There were 111 ACT UP activists arrested while passersby and Wall Street brokers were invited to collect the fake bills; messages on the back of the bills read, among other things, "White Heterosexual Men Can't Get AIDS . . . Don't Bank On It" and "Fuck Your Profiteer-

ing: People Are Dying While You Play Business." Gran Fury member Loring McAlpin reflected on the simplicity of the technique: "If you're angry enough and have a Xerox machine and five or six friends who feel the same way, you'd be surprised how far you can go with that."[16]

Some Gran Fury actions took more time and resources to create. ACT UP/NYC held the *New York Times* responsible for its abysmal reporting on the AIDS epidemic, consistently underestimating the scale of the crisis.[17] The June 29, 1989, editorial "Why Make AIDS Worse Than It Is?" became the last straw. It argued that the virus was leveling off and was confined to "special risk groups," saying in not-so-coded language that straight readers could relax while gay men and intravenous drug users died. In response, ACT UP demonstrated in front of *New York Times* editor Arthur "Punch" Sulzberger's Fifth Avenue home in late July. Body outlines were painted all over the streets, fact sheets were handed out throughout the neighborhood, and a large demonstration took place. The *Times* never felt compelled to cover it.

Gran Fury, *New York Crimes*, 1989, four-page newspaper (LGBT and HIV/AIDS Activist Collections, the New York Public Library, Astor, Lenox and Tilden Foundations)

To further address the lackluster reporting, Gran Fury printed thousands of copies of their own version of a fake newspaper called the *New York Crimes* that included stories by ACT UP members and graphics by Gran Fury. The four-page paper mimicked the look of the *Times* and was placed in newspaper boxes during a late-night action.

Activists fanned out throughout the city at four in the morning, opened *Times* newspaper boxes, and wrapped each paper with the new-and-improved front-page section. Included in the *Crimes* was a full-page graphic of a laboratory scene with a quote by Patrick Gage of the Hoffman-La Roche pharmaceutical company: "One million [people with AIDS] isn't a market that's exciting. Sure it's growing, but it's not asthma." Below the egregious quote, on the bottom of the image, Gran Fury simply added the commentary: "THIS IS TO ENRAGE YOU."

As a small collective, Gran Fury members would meet at the end of ACT UP meetings on Monday nights and discuss project ideas. Anyone in ACT UP/NYC was welcome to take part. By their second year, the group became closed. A good working nucleus had been formed and it became too difficult to work with noncommitted people who would come and go. By their second year, Gran Fury began meeting once a week at someone's apartment or studio. Here, they would debate ideas for images and actions, alter them, reject them, choose projects to take to the larger ACT UP meetings for discussions, and sometimes choose to do projects autonomously on their own terms. None of the artists in Gran Fury were paid, nothing was copyrighted, projects were credited to the collective's name, and nothing was sold on the art market. Everything that Gran Fury created was for the AIDS movement.

Gran Fury, *This is to Enrage You* from *New York Crimes*, 1989, four-page newspaper (LGBT and HIV/AIDS Activist Collections, the New York Public Library, Astor, Lenox and Tilden Foundations)

Gran Fury's drift toward more autonomous projects grew out of the frustration of seeing their finished ideas debated and overanalyzed by three-hundred–plus people at the Monday-night meetings. Michael Nesline reflects:

> [Gran Fury] didn't want to have to listen to ACT UP's—why is it blue? Why shouldn't it be green? We don't want to have to listen to a conversation for 45 minutes about which is better, blue or green. We've already had that discussion, and we've decided it's blue, and we're not going to have the discussion again. And, we don't really need to justify it, too. If you don't like it, you don't like it. So, tell you what—we'll just do what we're going to do, and if ACT UP is doing something, and we feel like piggy-backing onto that, we'll piggy back onto that. And, if we feel like doing something on our own, we'll do it on our own.[18]

The poster *With 42,000 Dead, Art Is Not Enough, Take Collective Direct Action to End the AIDS Crisis* represented work aimed at an art audience.

The text-based image served as an advertisement for the NYC performance art space The Kitchen and communicated the need for both art *and* direct action to confront the AIDS crisis.

Gran Fury, *Art Is Not Enough*, 1988, poster, offset lithography (LGBT and HIV/AIDS Activist Collections, the New York Public Library, Astor, Lenox and Tilden Foundations)

Gran Fury clearly understood the dire need for art and cultural activism, but they equally understood the limitations of the medium. Art was not enough if it was isolated within the art world and understood primarily as a commercial object to exhibit and sell. Gran Fury knew that they could benefit from the contemporary art world. As Gran Fury evolved, they began to tap into artist grants to fund their projects and museum shows to gain more exposure for the issue. Nesline viewed this as a win-win situation:

Here's this little Cinderella group [Gran Fury] that makes art that can't be sold, because it doesn't exist, and they'll give us money so that we can produce our art projects, which are actions, and the art world can feel really good about themselves, because they've now contributed to the AIDS crisis—to ending the AIDS crisis—and we can feel really good that we've taken their money. So, we've used them, and we're not going to give them anything in return, because there's not going to be any art product at the end of it that can be re-sold and could accumulate in value. So, our status as Cinderella was preserved.[19]

In short, Gran Fury navigated both the activist and the contemporary art world. Their message was aimed at all.

## Kissing Doesn't Kill

"We are trying to fight for attention as hard as Coca-Cola fights for attention."

—Loring McAlpin, Gran Fury[20]

Gran Fury's two paths had a common source. Both approaches sought to bring as much public attention to AIDS as possible, and both approaches utilized design styles that mirrored commercial advertisements and the aesthetic style of some of the most prominent artists in the New York art world, including Barbara Kruger, Jenny Holzer, and Andy Warhol.[21]

What mattered to Gran Fury was that their images communicated to a mass audience. Whether or not their work was labeled "art" became inconsequential. "We were never articulating that stuff as artwork," explains Gran Fury member Marlene McCarty. "It was other people who were doing that . . . we were only concerned about making a dent in the AIDS crisis . . . We were making propaganda."[22]

Gran Fury also never self-identified as a fringe movement or a countercultural movement positioned in opposition to the mainstream. Instead, they embraced popular culture and advertising in their graphics as a sign of belonging and demanded that gays, lesbians, and people with AIDS be accepted into American society. This demand was exemplified by their iconic image *Kissing Doesn't Kill*, a 1989 bus ad that mirrored the look of Benetton's clothing ad campaign "Colors of the World."

*Kissing Doesn't Kill* featured three couples kissing against a white background. Every detail of the design mimicked the Benetton ad. The people were young, of different races, and dressed in fashionable clothes. In the center, two gay men kissed, on the right two women kissed, and on the left, a cross-racial straight couple kissed. The Benetton ads had become a classic example of corporate branding—a slick campaign that pronounced that buying their sweatshop-made clothes would make you cool, a global citizen, and different from others who were not accepting of people of different races and nationalities.[23] The Gran Fury ad also represented a form of branding—activist branding. *Kissing Doesn't Kill* was designed to confuse the viewer on whether or not it was a Benetton ad.[24] At the same time, it attached itself to the

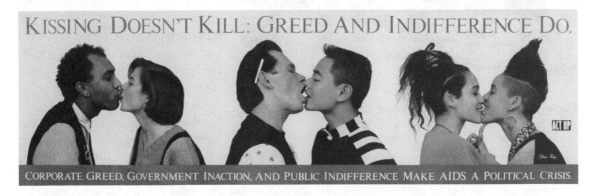

Gran Fury, *Kissing Doesn't Kill*, 1989, poster, offset lithography (LGBT and HIV/AIDS Activist Collections, the New York Public Library, Astor, Lenox and Tilden Foundations)

momentum, buzz, and hip appeal of the Benetton ad campaign and proudly projected the message "Our generation embraces all people and rejects racism *and* homophobia."

*Kissing Doesn't Kill*, however, differentiated itself from the Benetton ads by adding text. The top line, "Kissing Doesn't Kill: Greed and Indifference Do," countered the public misconception that AIDS could be spread through casual contact. The lower text, "Corporate Greed, Government Inaction, and Public Indifference Make AIDS a Political Crisis," framed the debate in ACT UP terms, targeting those responsible for not adequately addressing the AIDS crisis.

The first run of bus ads was funded by the NYC arts organization Creative Time, and ran on city buses in the Bronx with little controversy.[25] However, this changed when Gran Fury was invited to include *Kissing Doesn't Kill* on buses and subway platforms in San Francisco, Washington, DC, and Chicago as part of the traveling public art project *Art Against AIDS on the Road*, funded by the American Foundation for AIDS Research (AmFAR).

AmFAR had received significant amounts of funding from corporations and was uncomfortable with the sign's second line "Corporate Greed, Government Inaction, and Public Indifference . . ." that railed against their benefactors. Thus, Gran Fury was faced with an agonizing decision: reject AmFAR's request to remove the offending text and cancel the project, in full knowledge that Gran Fury could not fund it themselves; or go with the censored version of the design in the hope that reaching a large audience with a watered-down message might still bring much-needed attention to the issue of AIDS and homophobia.

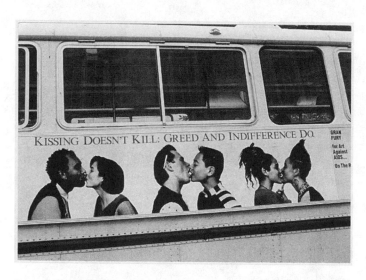

Gran Fury, *Kissing Doesn't Kill*, 1989, bus advertisement (LGBT and HIV/AIDS Activist Collections, the New York Public Library, Astor, Lenox and Tilden Foundations)

Gran Fury chose the latter—a decision that would become mired in controversy. The problem arose when Chicago city alderman Robert Shaw caught wind of the ad design that was scheduled to go up in advertising spaces in city bus shelters and subway train platforms. Shaw felt that images of gay couples kissing had nothing to do with AIDS, and instead, was meant to recruit children to be gay. With the second half of the message removed, the ad had become more ambiguous in its reading (even though some small text reading "Gran Fury, for Art Against AIDS, On the Road" had been added on the right side). Many viewers were equally confused by the ad's intended message and believed that it was simply advocating for the rights of gays and lesbians to kiss in public, never making the connection to AIDS activism.[26]

Shaw's homophobic reaction was to propose a citywide ban on the ad, a proposal that was voted down by the Chicago City Council. However, the Illinois State Senate took up the measure and enacted the ban on June 22, 1990. Worse, the State Senate went a step further

and prohibited the Chicago Transit Authority (CTA) "from displaying any poster showing or simulating physical contact or embrace within a homosexual or lesbian context where persons under 21 can view it."[27] The ruling, known as the "No Physical Embrace" Bill, became national news, prompting gay and lesbian activists and supporters in Chicago to march in protest and the ACLU to challenge the draconian bill as unconstitutional. Months later, the Illinois House of Representatives defeated the bill, and after much delay, forty-five *Kissing Doesn't Kill* billboards were installed in August. Their run, however, was short-lived when vandals, intent on ridding the city of the ads, destroyed them all within the first two days.

The ugly situation in Chicago over the billboards provided some bitter lessons. AmFAR's decision to self-censor *Kissing Doesn't Kill* had weakened its activist message and ultimately confused its reading.[28] Whether Shaw and others would have attacked the ads had the full text been included is open to debate. But it is clear that AmFAR failed to realize that ACT UP graphics and slogans worked best when they were didactic and easy to understand.

---

As the AIDS epidemic continued into the 1990s, ACT UP began to move away from single-focus issues and began addressing health care, housing, poverty, and prisoners with AIDS. This broader focus addressed systemic patterns of inequality in American life, issues of class, race, and gender. These battles proved much harder to win. More troublesome, the shift away from single-focus campaigns created divisions within ACT UP, divisions that led to members leaving and the steady decline of the organization.

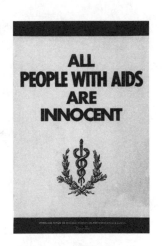

Dilemmas were also created for artists who had a more difficult time visualizing the shift in focus. "You have issues that can't be reduced to a billboard or a slogan," recalls Loring McAlpin. "I think we just increasingly felt like we didn't really know how to work in the same way."[29] Marlene McCarty adds

Gran Fury, *All People with AIDS Are Innocent*, 1988, poster, offset lithography (LGBT and HIV/AIDS Activist Collections, the New York Public Library, Astor, Lenox and Tilden Foundations)

> We were really great at just the over-generalization. After a number of years, the whole landscape of AIDS changed so much . . . we spent so many meetings towards the end, trying to decide how we were going to transform.[30]

During this time of transition, Gran Fury began to lose momentum as a collective in 1993, and by 1995 the few remaining members decided to call it quits. Regardless, the legacy of ACT UP continues to inspire others across the social justice spectrum. At a time when more moderate activists were still relying on petitions and marches, ACT UP turned to direct action and made AIDS front-page news. These tactics forced the media to cover the story, prevented the government from enacting repressive AIDS legislation, sped up the FDA drug approval process, and allowed people with life-threatening illnesses to get access to experimental drugs.

ACT UP also forced pharmaceutical companies to significantly lower drug prices and expanded the definition of AIDS to include infections that impacted HIV-infected women, among many other victories.

Equally significant, ACT UP demonstrated just how effective graphics and creative resistance are when a group prioritizes cultural agitation. Artists acted as equals within the movement; the very structure of ACT UP allowed creativity to flourish within various cells, committees, and affinity groups. Gran Fury represented one such group and helped communicate the concerns of the movement to the public and to those within ACT UP.

# 25

## Antinuclear Street Art

ON DECEMBER 14, 1988, A group of artists met at the PAD/D (Political Art Documentation and Distribution) office in NYC and drafted a flyer that announced *Groundwork: The Anti-Nuke Port Stencil Project*. Its text read, in part:

> The U.S. Navy is currently constructing a homeport for the Battleship IOWA and its support ships in the middle of New York harbor. An independent study has shown that that an accident involving the incineration of a single nuclear weapon containing plutonium-239 could release enough radioactivity into the atmosphere to cause up to 30,000 latent cancer deaths within 60 miles of the site. Our best hope for blocking the stationing of the Navy ships is to elect a city government opposed to the homeport. This stencil project is being organized to lay the groundwork for a broad effort to raise the issue in next year's municipal elections. Conceived as a citywide environmental artwork, the project involves covering the streets/sidewalks of the city with stenciled variable markers.
>
> E.g. 7.8 miles downwind of a nuclear Navy Base.[1]

A second flyer called out to artists: "*Groundwork* needs your stencils protesting the nuclear navy base being built in New York harbor—and you need *Groundwork* . . . With your images, we will blanket the city with thousands of stencils this spring and summer as municipal elections approach."[2]

The ambitious goal originated with Ed Eisenberg, who came up with the idea shortly after he was arrested and convicted for demonstrating at the Stapleton site in Staten Island. Eisenberg was a radical Marxist, a gay activist, an artist, and a musician, the type of person whose practice and activism could not be easily categorized. In the mid-1980s, he became active with the Coalition for a Nuclear-Free Harbor, an umbrella organization that included 125 environmental-justice groups in the New York area. Eisenberg's path as an artist led him to think outside the

boundaries of typical activist strategies, and to consider how creative resistance could aid the coalition's campaign. He teamed up with other like-minded artists. They envisioned *Groundwork* as an opportunity to cover the five boroughs of New York with 10,000 stencils during the spring and summer of 1989, a project that would employ street art as a means to get the public, and hopefully the media, talking about the dangers that the nuclear homeport posed. Media coverage, outside of the *Staten Island Advocate*, had been sparse and largely uncritical. More so, Mayor Edward Koch, along with Gov. Mario Cuomo, Sen. Alfonse D'Amato, and Sen. Daniel P. Moynihan supported the homeport. Opposition had to come from the grassroots level—from community members, the coalition, and from artists in the movement.

## Organizing Against the Military Industrial Media Complex

Traditional forms of protest and lobbying marked the early stages of the antinuclear campaign in New York. In May 1985, coalition members began gathering signatures to place a referendum on the New York City ballot that would prohibit the use of city revenue for facilities with nuclear capabilities. Members gathered more than the 100,000 signatures needed to qualify the referendum, and polls indicated that it would pass, but city officials overruled it. A state court removed it from the ballot, citing a 1909 state law that empowers cities to provide land for the military. Lawsuits were filed, but the Navy went ahead anyway and began construction.

In response, the coalition moved toward more urgent forms of protest and began using their bodies to block construction. Activists erected a Statue of Liberty replica and planted a sapling tree on the site. Four months later, a small group of activists paddled canoes out to the site and halted construction for a few hours. On November 1, 1987, Pete Seeger performed outside the gates of the Stapleton site in a concert that doubled as a protest rally. The most confrontational moment had occurred four months earlier, when protesters entered the site on July 14 and refused to leave. Thirty-eight people, including Eisenberg, were arrested and charged with criminal trespass. Shortly thereafter, a campaign was launched on behalf of the "Stapleton 38" to drop all the charges. At the trial, historian Howard Zinn testified that the international antinuclear movement had played a significant role in shaping public policy. It had, but in New York, the media largely ignored the story, an omission that marginalized the movement. The *New York Times*' reporting was particularly egregious. Leonard Marks, chairman of the New York Lawyers Alliance for Nuclear Control, surmised that "the [*New York*] *Times* has been totally co-opted in favor of the homeport from the very beginning. They have run almost nothing on any aspect of the protests, except an occasional photograph with no story when someone is arrested."[3] The *Times* even failed to adequately critique Mayor Koch's emergency-preparedness plan that trivialized the dangers of plutonium:

> In a hypothetical shipboard accident plutonium contamination will likely be confined to an area within 2000 feet and downwind from the accident

site . . . Plutonium dust suspended in the air can be kept out of the lungs by placing a hanker chief [*sic*] over the nose and mouth or remaining inside a building with ventilation secured and doors and windows closed. . . . Even if one thinks they have inhaled plutonium it is not a medical emergency. It can be significantly eliminated from the body by medical procedures.[4]

Koch's plan defied logic, as well as physics, and should have been front-page news. Instead it was not deemed newsworthy. Activists thus had to turn to other avenues of public outreach. *Groundwork* chose stencils.

## You Could Die Here

> "The paradox is that we have always been told that we have to have nuclear weapons to preserve democracy, yet now that we have them coming to New York City, democracy is being destroyed . . . In reality, no one in this country has been able to vote on nuclear weapons."
> —John Savagian, Coalition for a Nuclear-Free Harbor[5]

*Groundwork* required months of planning and fund-raising before stencils could first hit the streets. The call for artists had netted twenty-six original stencil designs and Eisenberg and other co-collaborators turned to well-known artists and art historians for financial support.[6] They sent letters to Hans Haacke, Tim Rollins + KOS, Leon Golub and Nancy Spero, Lucy R. Lippard, the Keith Haring estate, and other allies in the art world. Contributors who donated $50 or more received a portfolio of the images printed on paper. This call resulted in enough funds to purchase supplies—one hundred cans of spray paint, maps of NYC, materials for stencils, X-Acto knifes to cut the stencils, and film to document their handiwork. The call also fulfilled another function: outreach and a permanent archive of the project. The prints sent to various regions of the country informed those outside of New York about the campaign and served as an example to inspire other artists and activists to learn about the tactics that *Groundwork* had employed.

Stenciling of sidewalks began in the spring. Volunteers went out at night and targeted a specific area of the city. The plan called for each stencil design to be painted in either black or white spray paint, with a mile marker below it that informed viewers exactly how far they stood from the Staten Island homeport. Individual designs varied and included Mimi Smith's image that read "You Could Die Here"; John Fekner's design that featured a person running, with the text "The Daze of Toxic Water"; Gregory Sholette's image "Real Estate Futures" that featured two hands wearing gloves with the nuclear warning symbol sweeping the city into a dustpan; and Rachel Avenia's image that pictured a defiant Statue of Liberty pushing nuclear warheads away from her, metaphorically pushing the weapons away from the city.

On October 27, 1989, after months of painting, *Groundwork* held a press briefing in front of the Isaiah Wall on the west side of First Avenue, north of Forty-second Street in Manhattan. *Groundwork* took questions and invited the media to follow crews as they installed stencils at

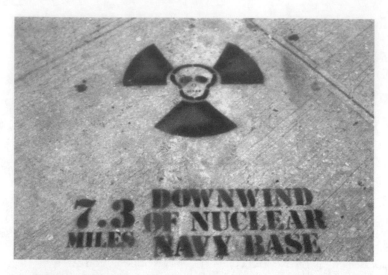

Stephanie Basch, *Groundwork: The Anti-Nuke Port Stencil Project*, 1989 (photographer unknown, Fales Library and Special Collections, Elmer Holmes Bobst Library, New York University)

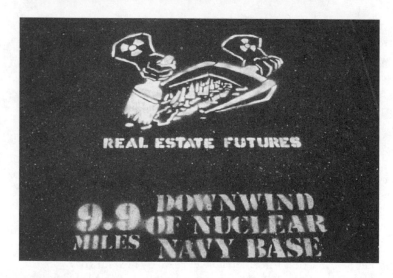

Gregory Sholette, *Groundwork: The Anti-Nuke Port Stencil Project*, 1989 (photographer unknown, Fales Library and Special Collections, Elmer Holmes Bobst Library, New York University)

nearby locations. The media solicitation did not generate as much press as hoped, yet the process had signified the importance that *Groundwork* had placed on street art as a form of tactical media. *Groundwork* had sought media coverage to amplify their message; but with or without media coverage, the stencils communicated directly to an unsuspecting public and informed people about the proposed nuclear Navy base. Viewers were left to ponder who was behind the warning signs. The unsigned work and anonymous nature of the project left people to question if the message came from a neighbor, an organization, or the city government.

The coalition's aim was to make the Stapleton homeport an election issue. A *Groundwork* flyer noted that "stenciling has coincided with municipal electoral races with the intention of making the Navy base a campaign issue. A similar proposed homeport was canceled in San Francisco earlier this year after the election of an antinuclear mayor made it clear that Navy ships carrying nuclear weapons were not welcome in the city."[7] The same scenario would take place in New York City. Koch lost the Democratic primary to David Dinkins, who opposed the homeport and went on to defeat the Republican candidate Rudolph Giuliani, who supported it.

However, Dinkins's election proved to be only a partial victory in the struggle to keep nuclear weapons out of New York's harbor; his power to stop the base was limited. Dinkins had called the homeport a "floating Chernobyl" and wanted the construction to stop even though it was 90 percent complete.[8] His concern was for public safety. The Coast

Guard had reported 609 accidents in New York Harbor from 1976 to 1980, and the Navy had even acknowledged 628 minor accidents on nuclear ships during the previous two decades. One reported accident was classified; another involved a missile falling off an aircraft carrier and into the sea. However, the federal government—specifically Dick Cheney, the secretary of the Department of Defense—had the final say, and he supported the Stapleton homeport. The nuclear ship USS *Normandy* was eventually docked in New York's waters. Public pressure, however, did have a significant effect. In 1994, the homeport was closed through the Base Realignment and Closure Process. The Stapleton homeport in the end proved to be too small for the Navy's needs, too costly, and too controversial.

*Groundwork*'s creative action was part of a sustained campaign and a wave of opposition that ultimately defeated the homeport. *Groundwork* became a form of independent media and a compelling example of how street art could have an influence. Moreover, the pri-

Rachel Avenia, *Groundwork: The Anti-Nuke Port Stencil Project*, 1989 (photographer unknown, Fales Library and Special Collections, Elmer Holmes Bobst Library, New York University)

John Fekner, *Groundwork: The Anti-Nuke Port Stencil Project*, 1989 (photographer unknown, Fales Library and Special Collections, Elmer Holmes Bobst Library, New York University)

mary focus on street stencils circumvented a reliance on the media, a relationship many activist groups and interventionist-type projects depend upon. If the media covered the action, and did not outright distort the story, it was a bonus. If they did not, 10,000 stencils placed throughout the city still had the power to communicate an antinuclear warning directly to the public.

The coalition's choice to employ art as a form of tactical media—actions designed to enter the bloodstream of the public—was no doubt influenced by other activist art projects including those by ACT UP; Suzanne Lacy and Leslie Labowitz; and Louis Hock, Elizabeth

Sisco, David Avalos, and Deborah Smalls, among others.[9] *Groundwork* realized that for their action to gain even a ripple of attention in New York City, a place where hundreds of issues compete for attention, they needed to compete on the scale of the city. Thus, they covered the five boroughs of New York with 10,000 stencils and invited the press to help amplify the message.

Today, the stencils have long since faded from the sidewalks, but the action has not been forgotten, and neither has Ed Eisenberg, who died of AIDS in 1997. Tom Klem, who co-organized *Artists for a Nuclear Free Harbor* following the *Groundwork* project recalls that after Ed passed, he, along with REPOhistory collective members, stenciled "ED" in bright-red letters on sidewalks on the Lower East Side in Manhattan in a guerrilla art action in his memory. "We did not tell the press. It was just for us."[10]

# 26

# Living Water: Sustainability Through Collaboration

"Where is your well, your source of water for your home? Who cares for and shares this source? What does your community need to know to protect and restore their water? Why is this information not common knowledge?"

—Betsy Damon[1]

SINCE 1985, BROOKLYN-BASED ARTIST BETSY DAMON has raised critical questions through her art and activism about water in the United States and abroad. In 1990, she founded Keepers of the Water, a nonprofit organization that mobilizes artists, scientists, and citizens to collaborate, raise awareness, and ultimately restore water sources throughout the world.

Damon's approach centers on the concept of "living water"—the purest form of a water molecule before it has been contaminated by the industrial landscape. To reverse the damage, a community has to go beyond simply cleaning up polluted waterways; it has to deindustrialize the areas around a water source so that water can function in its most natural state. A community has to allow *nature* to cleanse the water.

Cities rarely do this. Instead, problems caused by industrialization are treated with industrial responses. Dams are built, riverbanks are fortified with metal and cement, and wastewater treatment plants are introduced. All continue to harm water quality, human health, and the overall health of the environment.

Damon's vision differs. She collaborates with the community to create a *living water garden*—a public park that demonstrates how natural systems can restore a river's water quality. Her most famous reclamation project took place in China in 1995 on a six-acre site on the Fu-Nan (or Funan) River in Chengdu, a project where activist-based art played a vital role in mobilizing a city and a country to take action.

Why did she choose China for her project? And why did her previous efforts to do similar work in the United States run up against a brick wall? Damon explains, "We don't acknowledge the role [water] plays in our lives. Chinese do, like all people who have a deep history, like Native

Americans. People with a deep history understand on a profound level, not a gross level, the importance of water."[2]

## Process and the Underground Artist's Web

Damon first traveled to China in 1989 with her son, Jon Otto, as a guest artist at a United Nations conference. In 1993, she returned to visit sacred water sites in the remote mountains north of Chengdu. Her search took her on a series of adventures, and she discovered opportunities to learn.

On one journey, she and her son traveled nineteen hours by Jeep up dirt roads to visit a water spring that had belonged to the Tibetans for thousands of years but that was now fenced off with barbed wire and designated by the Chinese government as a future water-bottling company. Tibetans were prohibited from gaining open access to their water source, but they continuously defied the order and cut holes through the fence to drink the water that was so pure, it was believed to cure stomach problems and reduce tumors. The Chinese government wanted to put the water in plastic bottles and sell it, a process that would kill the living-water state of the molecules, further deny the Tibetans their rights to their water, and devastate the ecology of the region.

Damon returned to China in 1995, this time with the intent to create a public art project about the horrid river water quality found in Chengdu, the city where the Fu and Nan Rivers converge. In the 1960s, the Fu-Nan was clean enough to swim in. More than fifty-six species of fish flourished. But as the population of the city grew from two million to nine million people, the river became a dumping ground. Some 60,000 cubic meters of raw sewage was dumped into the river on a daily basis, and 100,000 people lived in shacks next to the riverbanks. Factories discharged paint, paper, and chemicals into the water. The Fu-Nan became so polluted, the locals nicknamed it "Fulan," meaning "rotten river."

In 1985, a natural-sciences teacher in an elementary school in Chengdu inspired his students to take action. The students studied the Fu-Nan and began writing letters to government officials, who responded by launching China's first large-scale environmental restoration project. Residents and factories were moved away from the banks of the river. The river was dredged; floodwalls were rebuilt; twenty thousand trees were planted; thirty-one miles of parks were established along the rivers, and plans for a future industrial wastewater treatment center were developed. Despite all these efforts, the Fu-Nan still remained polluted.

Damon's response was to catalyze the residents and the government to take another step. The medium she used to raise awareness was temporary public art projects and performances. In 1995, she arrived in China on a tourist visa with little funding and a single contact, who introduced her to the director of water quality in Chengdu. At the same time, Damon began talking to local artists. She hitchhiked illegally to Tibet to meet with Tibetan artists. Damon recalls:

> They [Tibetan artists] came down to Chengdu. By then word had spread in that wonderful way, quietly and through an underground web. Then artists came from Beijing and Shanghai and other cities. We all met twice a week. Everyone had to learn about the life of the river and the history of the river and the science.[3]

Simultaneously, the Chinese government closely monitored Damon's every move. Police from Beijing interviewed anyone who had spoken or met with her. Finally, the Chengdu city government asked to meet with her. The officials were intrigued by her actions and engaged her in a conversation about the river. They showed her their plans and asked for her opinion. Damon recalls:

> Their plan was impressive, but I knew they weren't going to get a clean river. You build flood control walls and you don't get a clean river. You dam it and you don't get a clean river. They were sure they would. I said, "Why don't you make a living water park to teach your citizens how nature cleans water?" They talked for thirty seconds and turned back to me and asked, "Can you do that?"[4]

Damon's response was to nod yes.

The city government officials wanted her to abandon the performances and temporary installations and to design a living-water system. They felt that the ephemeral artworks were a waste of time and money. Damon, however, insisted that the performances and temporary installations had to happen. She owed this to the other artists and, of equal importance she felt the performances were an essential part of the process. The government responded by saying that if they liked the performances, they would invite her back to the table and continue the dialogue.

Damon moved forward, brought together twenty artists from China, Tibet, and the United States, and staged twenty-five projects during a two-week series of public artworks and performances on the banks of the Fu-Nan.

Kristin Caskey, an artist from the United States, organized a performance with six women from the community called *Washing Silk*.

Thirty years earlier, the Fu-Nan was a place where people could wash their silk in the river and it would come out brighter. This was no longer the case. In the performance, the women came down to the banks of the river and washed red rugs and baskets of silk. In a short time, the silk turned gray, and if the women stayed too long in the water, boils would begin to appear on their legs.

Kristin Caskey, *Washing Silk*, performance series on the banks of the Fu-Nan River, 1995 (Betsy Damon)

Another artist did an installation where water was gathered from the river and frozen into large blocks of ice. Next, the blocks of ice were stacked into a rectangle, roughly six by four by six feet, and placed on a sidewalk that looked down toward the river. The public was invited to wash the ice with brushes—metaphorically cleaning the Fu-Nan through collective action. The blocks of frozen river water slowly melted over the course of the three days, resulting in three days of intense public dialogue.

A different sidewalk installation involved an artist who placed black-and-white photographs—portraits of people's faces—on white cafeteria trays that had a thin layer of river water on top. Over time, the water ate away at the paper, symbolizing the harm that filthy water has on human health. The artist also set up a stand to sell the river water in plastic bottles and invited the public to sign a petition. In this case, the artist directly merged public art with the call for political action.

Other installations took place on the river itself. One artist positioned a cable that ran across the river from one side of the bank to the other. Attached were brooms that hung just high enough as to touch the river's surface as it rushed past. Seen from a distance, the brooms looked as if they were sweeping the river clean, washing the pollution away.

Unknown artist, performance series on the banks of the Fu–Nan River, 1995 (Betsy Damon)

Another artist chose to hang signs with text about the water quality around the necks of ducks. The ducks were then set loose into the river, where they proceeded to die.

All of these performances and installations were broadcast on state-run television. This, in turn, increased the dialogue between the artists and the public, a dialogue that led to a larger project.

## A New Sculpture

Government officials in Chengdu responded favorably. They were impressed with the energy and the spirit of the performances and began to reconsider their approach to tackling polluted rivers with dams, floodwalls, and wastewater treatment centers. Zhang Ji Hai, the city's Funan River Comprehensive Revitalization Project director, listened to Damon's idea that the introduction of wetlands would educate the public on how to better care for the environment. Zhang agreed, and invited Damon to build her first living-water garden in their city.

Remarkably, Zhang risked his very freedom to move the project ahead. The Chinese premier opposed the park, and the mayor of Chengdu was not willing to go to jail if the project failed. Zhang was. He offered Damon a six-acre site on the banks of the river and a budget of $2.5 million to build the park.

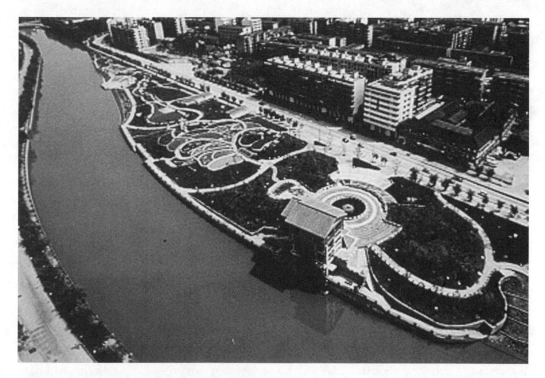

Aerial view of the Living Water Garden, Chengdu, China, 1998 (Betsy Damon)

Living Water Garden, Chengdu, China, 1998 (Betsy Damon)

Living Water Garden, Chengdu, China, 1998 (Betsy Damon)

Collaboration was the theme. Damon worked with a team of hydrologists, scientists, engineers, landscape architects, and government officials.

In 1996, she returned to Chengdu with Margie Ruddick, a landscape architect from Philadelphia, and began designing. The land was serendipitously shaped like a fish, and the river water was designed to pass metaphorically through the creature.

The concept was to divert water from the river, let it flow through and be filtered by a series of wetlands, and then return back to the river. Most significantly, the design allowed the residents of Chengdu to *visualize* the process in a public setting: a park that would serve as a place for education, enjoyment, nature—a place where plants, insects, fish, wildlife, and people would flourish.

Water guided the design. After being pumped uphill from the river, the water entered the park and into the first settling pond—the eye of the fish. In the middle of the pond, Damon designed a thirteen-foot-tall sculpture, a water droplet made out of green granite that served as a fountain. The water then passed through a series of "flow forms." These shapes, made of stones, encourage water to move laterally, to breathe, to move as water does in the mountains. Too often, people reconstruct nature and straighten rivers, dam rivers, prohibit the flow of water—all of which harms the integrity of the water molecule. After the flow-forms stage, the water enters into a series of wetlands—a dozen ponds where plants and fish further clean the water—and then into an amphitheater and splash ponds for children. Finally, it returns to the river, with a level of purity that meets the Chinese Category 3 environmental-quality standard for surface water.

Soon after the park opened in April 1998, the Living Water Garden became the most popular park destination in the city. Residents of the crowded city could find refuge in nature, engage with the river at a series of terraces that allowed people to walk down to the water's edge—a unique feature, considering that large concrete floodwalls make the rest of the river inaccessible. Children discovered new worlds at the park.

Mary Padua writes

> In almost every part of the park, children can be found kneeling or lying next to the stream and ponds trying to get a close look at water-borne insects and fish. This type of curiosity is a universal feature of childhood, but children in congested Chinese cities have few places like the Living Water Garden where they can satisfy a desire to learn about nature firsthand.[5]

Important to understanding the science of the living-water garden is that the diversion of river water through the six-acre park did not, and could not, clean the entire river. Padua notes

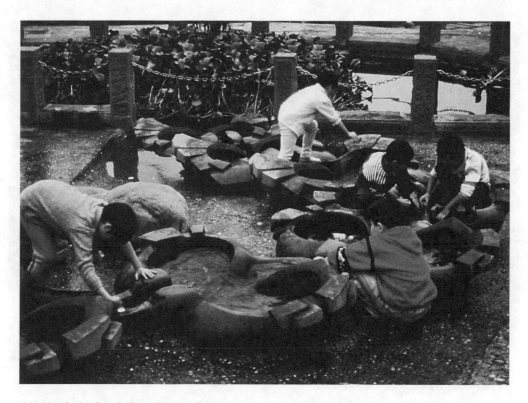

Living Water Garden, Chengdu, China, 1998 (Betsy Damon)

major improvements in a body of water the size of the Fu-Nan can be achieved only by reducing emissions of pollution. Instead, the impact of the Living Water Garden lies in its effects on the thinking of the people of Chengdu: their increased awareness of environmental issues and pride in the progress the city has made toward improvement of the river.[6]

Zhang echoes this sentiment. He noted that the Living Water Garden encourages "people to look at the world more carefully, to value each creek, river, and groundwater aquifer."[7]

This is the true essence of the project. The park provides a symbolic space, a public space that teaches the community how to care for nature. It directly challenges the notion that industrial systems can solve environmental problems and asks everyone to become a better steward of the environment.

Zhang had risked his own freedom when he approved the project. His fortitude was honored when the project was widely praised, including praise from the Chinese premier, who commended the park after visiting the site.

Damon received an honorary citizenship to the city of Chengdu, and the project won numerous international design awards. All the while, Damon is quick to point out that the Living Water Garden was a collaborative project, one that was born out of a long process

Living Water Garden, Chengdu, China, 1998 (Betsy Damon)

that included the performances and installations, and a diverse collaborative team who envisioned and built the park. She explains, "The park is not mine. That is a really important truth. We did it together."[8]

She adds:

> The Chengdu project is an extension of my philosophy of what it takes to live on the planet, the necessity of working together, bringing together unlikely partners, and forming new relationships. It is about building new kinds of connections and relationships while grappling with the consequences of a globalized class system and the economics of dominance, possession, exploitation, and greed.[9]

The project inspires future reclamation projects elsewhere, and future conversations about water. Damon asserts that water has to be the first consideration when building.

> How are you going to catch the water? Where is it going to go? How are you going to filter it? Everything should be designed like that. Water is the foundation of life. It should be the foundation of design.[10]

Damon asks artists to create change, not simply to make more objects. "We need a new sculpture—we need a new language that describes the physical universe that we've come to understand from ancient times to now and a future language about preservation."[11] In the process, she utilizes art to engage the public to work toward solutions. "What can artists do?" Damon asks. "We can generate hope, possibility, and conversation."[12] This in turn leads to collaboration.

Aerial view of the Living Water Garden, Chengdu, China, 2007 (Betsy Damon)

Artists must take a central role in helping people who do not traditionally work together find a common ground. Artists can help communicate scientific information to communities by finding a visual language. A public language does not mean that brilliance, excellence, and innovation are lost. Rather, the artist can help to create new patterns of thinking and infuse groups with the enthusiasm and common vision that are needed to break through the barriers.[13]

The Living Water Garden, along with the performances and the public installations, achieved a breakthrough and led to tangible results. Mary Padua writes:

This unusual collaboration may be what is most important about the Living Water Garden. Environmental problems no longer are bounded by nationality or place, and constructive responses demand collaborations across national and professional frontiers.[14]

Damon, through example, champions artists to take a *lead* role in solving environmental problems. She asserts that artists, with their creativity, talents, communication skills, and ability to collaborate, are ideally suited to help redesign communities around ecology, public participation, and sustainability. She inspires artists to become activists.

Judith F. Baca, *Danzas Indigenas*, Baldwin Park Metrolink Station, circa 2005 (Social and Public Art Resource Center)

# 27

# Art Defends Art

"The work is not a work of a lone artist working without relationship to the community, but rather a representation of community sensibilities and sentiment of the time."

—Judith F. Baca[1]

JUDITH F. BACA'S PUBLIC ART projects are always participatory, from her famous *Great Wall of Los Angeles* to her lesser-known works. Her murals and monuments belong to the community, for the community takes an active role in creating them. To Baca, public art is exactly as it sounds: art that is about, created by and belonging to the public. At the same time, her work is never designed to be safe or sanitized. Rather it addresses the complexities and multiplicities of voices in a community and their history. This was the case with *Danzas Indigenas*.

Baca's *Danzas Indigenas* is located at the Baldwin Park Metrolink station, twenty miles from downtown Los Angeles, and was installed in 1993. It stood without incident until 2005, when controversy was thrust upon it from outside the community. In 2005, Save Our State (SOS), an extreme anti-immigrant group (formed in 2004 and based out of Ventura County—eighty miles northwest of Baldwin Park), asserted that the monument was seditious. As "evidence," they relied upon two quotes out of many that were written on the side of Baca's monument.

Save Our State demanded that the city remove the text and, if they did not, SOS would take matters into their own hands, which they did. They staged two demonstrations in Baldwin Park, one in May 2005, the other in June 2005. Not willing to back down, Baca, the city government, and the community fought back. What unfolded was an incredible series of nonviolent resistance and creative protests, a struggle where a community defended their monument, an artist became a leader, and a community told a hate group that they were not welcome in their city.

## Danzas Indigenas

In the early 1990s, Baca received a $56,000 commission to produce a public artwork at the Baldwin Park Commuter Rail Station that reflected the history of the region, ranging from the effect that Spanish missions had on indigenous peoples to how the present-day city of Baldwin Park had grown to become a multiethnic community. The project contained two central elements: a train platform and a monument situated in a plaza. The four-hundred-foot train platform contained written phrases on the ground in indigenous languages that acted as voices coming up from the earth. In the plaza near the metro station, Baca constructed a twenty-foot-tall mission arch that referenced the site's proximity to the mission of San Gabriel. Baca writes, "Its intention was to become a site of public memory for the people of Baldwin Park; to make visible their invisible history."[2]

On the arch itself were quotes from the community, quotes that were far from controversial and ones that represented a multiplicity of voices: "The kind of community that people dream of—rich and poor, brown, yellow, red, white, all living together"; "Use your brain before you make up your mind"; and "a small town feeling."

Also included were two quotes that proved to be more contentious. One quote was from a fragment of a poem by the acclaimed Chicana feminist author Gloria Anzaldúa: "This land was Mexican once, was Indian always, and is, and will be again." Baca explains, "I chose this quote because . . . descendants of the Gabrielinos still live in the region, making Anzaldúa's text particularly relevant to the increasing indigenous population."[3] Also included was the quote, "It was better before they came," which Baca intended to be ambiguous:

> About which "they" is the anonymous voice speaking? The statement was made by an Anglo local resident who was speaking about Mexicans. The ambiguity of the statement was the point, and is designed to say more about the reader than the speaker—and so it has.[4]

The "reader" in this case was Save Our State; it highlighted these two quotes, decontextualized them from the rest of the public artwork, and claimed that the monument was seditious and "evidence" that a *reconquista* movement was attempting to return the land to Mexico. Joseph Turner, the twenty-eight-year-old spokesperson for the group, argued that

> the monument in Baldwin Park is not just a rock. It is a disgusting testament to how pathetically apathetic Americans have grown in response to the hostile takeover attempt by the Mechistas and the massive illegal alien invasion. It is a slap in the face to all Americans and an insult to us all. We have a patriotic obligation to ensure that the seditious language on that monument is removed. And one way or another, it will be removed. Together, we will drive a stake through the heart of the "reconquista" movement.[5]

Turner's violent and racist language was central to SOS and their tactics. The SOS website read:

Americans are tired of the unchecked third world invasion of illegal aliens . . . They are tired of watching their great American culture disappear, only to watch it be replaced by other cultures that are inferior and contradictory to everything this country was built upon . . . We are seething with anger and boiling with rage. And we are motivated and determined to fight back. This is our land. This is our fight. And we are willing to bleed to defend it.[6]

On May 14, 2005, SOS brought their rage to Baldwin Park. Approximately twenty members of the group picketed a busy street intersection, where they were met by nearly a thousand counterdemonstrators. A police line stood between the two sides to ensure that the tense situation did not descend into a full-scale riot. Police also guarded Baca's monument from the threats that SOS would tear it down if the quotes they objected to were not removed.

Video footage of the event demonstrates just how ugly the situation became.[7] A woman with SOS was caught on tape calling a Latino man a "mongrel". Another woman with SOS shouted at the counterdemonstrators, "You go back to Mexico! We're home! This is our land! This is not your land!" Counterdemonstrators mainly shouted "Racists, go home!" One person in the crowd hurled a water bottle that hit an SOS supporter in the head, sending her to the hospital for observation. No other injuries took place and no arrests were reported.

The heavy police presence was part of SOS's strategy to force the city government to meet its demands. The sin-

*Danzas Indigenas* protected by police, Baldwin Park Metrolink station, 2005 (Social and Public Art Resource Center)

gle demonstration cost the city of Baldwin Park $250,000 in police overtime and helicopters to protect SOS's right to protest. Turner bluntly stated, "Our aim is to make this painful. We want this to become expensive so that people will take notice."[8] He added, "I don't think the city can withstand that financial [burden], if we go back repeatedly."[9] In short, SOS was trying to bankrupt the city.

Following the demonstration, Baca and city council members received violent threats through websites, blogs, e-mails, and letters. All of the members of the Baldwin Park City Council received death threats, and Bill Van Cleave, the only white person on the city council, received a message that "they were going to bury me in brown soil."[10] Baca received numerous death threats, and was advised by the FBI to have a bodyguard and to temporarily leave the country. Baca rejected this advice; she refused to be intimidated and refused to back down to a hate group.

"Baldwin Park has never, ever in its history seen anything like this," stated Mayor Manuel Lozano. "The residents want these outsiders out of our city."[11] And councilman Bill Van Cleave added, "There is no race problem in Baldwin Park," but SOS "was bringing one."[12]

The city council pledged to stand behind Baca's work and made it clear that the artwork could not be legally changed without the artist's permission. Baca issued her own statements in defense of her work and the community that it represented.

> Our capacity as a democracy to disagree and to coexist is precisely the point of this work. No single statement can be seen without the whole, nor can it be removed without destroying the diversity of Baldwin Park's voices. Silencing every voice with which we disagree, especially while taking quotes out of context, either through ignorance or malice, is profoundly un-American.[13]

She added, "While this group [SOS] has cast the artwork as part of a 'Reconquista movement,' it is in fact neither advocating for the return of California to Mexico, nor wishing that Anglos had never come to this land."[14]

Others voiced strong support for Baca and her monument while rejecting the racism of SOS. Comments on the SPARC website (the Social and Public Art Resource Center, which Baca founded in 1976) included:

> Before the Mayflower was even built, my Spanish and Indian ancestors lived in what is now part of the U.S. Our land was conquered by force and our culture suppressed; these are historical FACTS. We need more monuments that stress our shared experienced [sic] of loss and oppression, as the only way in which true reconciliation can take place.[15]

César López wrote:

> Baca's public art work provides a model for the community-based reclaiming of sites of memory. *Danzas Indigenas* actively remembers not only the indigenous peoples of this land, but also the historical context of conquest that was ultimately about the erasure of histories. The power of Baca's public art production and community-based process is evident by the vision it inspires for social change. I am a witness to this power and it has shaped my reality.[16]

Following the first SOS demonstration and their plans for a second demonstration on June 25 in Baldwin Park, Baca worried that a tense situation would lead to violence during the second demonstration. "A concern that I had," reflected Baca, "was that I would have built something that was beautiful and it would become a place where people would be hurt."[17] To ensure that this would not happen, Baca became a leading voice in organizing a nonviolent movement against SOS.

## Good Art Confuses Racists

> "If a drop of blood is shed on this site, we have failed."
>
> —Judith F. Baca, June 12, 2005[18]

Baca's words on June 12 set the tone for the June 25 counterdemonstration. Hate would be countered with love. Racism would be met with multiculturalism, and art would be defended with art. Baca and her supporters declared June 25 as "La Reconquista de Justicia, Paz, Libertad y Amor" [The Reconquest of Justice, Peace, Liberty and Love]. During the lead-up, an "Arts Committee to Defend *Danzas Indigenas*" was formed and a plan of action was articulated. Goals included:

> The rejection of violence as an appropriate response to ignorance and fear.
> The support of ceremony, creativity and culture as points of resistance.
> The confrontation of political ideas and not people.
> The "reconquest" of spaces for dialogue and responsible action.
> The cooperation with appropriate authorities.[19]

The Art Committee's statement read, in part:

> We are neighbors to a work of art, DANZAS INDIGENAS, that reflects indigenous history, evolving sensibility about a multicultural world, and the power of human creation. We are simple people of diverse backgrounds who fear neither the fierce rhetoric of those who would insult us, nor the thoughtless actions of those so few who believe us to be a threat. If we are a threat, we are merely a threat to the idea that humans can be judged by race or region, and that the freedom to express is merely the obligation to agree. We are part of a larger movement of many people who, like us, face the growth of racist hysteria and must confront it.[20]

Other aspects of their statement addressed nonviolence and the power of art to combat hate:

> The resistance we envision does not look to violence as the response to the ignorance of their empty rhetoric, but looks instead to creativity. We believe that the groups who oppose us welcome confrontation so that they can broadcast their message of fear to others through the media. We will not succumb to these tactics, but will mount dignified and serious resistance to their ideas. We will protest, but we will challenge ideas and not people.[21]

The powerful statement closed with the following:

> They will offer cynicism and we will offer ceremony. They will raise criticism and we will offer culture. They will condemn art and we will simply make more of it. They will paint a picture of weakness and we will celebrate our strength, for in our eyes, the law protects us, our creativity dignifies us, and

we have already won. Ours is a defiance of spirit; our weapon is sound, color, word, and song.[22]

On June 25 this statement became a reality. More than a thousand community members and supporters told a handful of SOS supporters that they were not welcome in Baldwin Park. As the police guarded Baca's monument and formed a line between SOS and the counterdemonstrators, music filled the air and art was visible to all. Baca helped create a new work of art—a *Mural in Three Movements*, a portable mural including approximately twenty large digital images on both sides that were attached to wooden poles.

The front side had two themes. The first was "Reconciliation," and it highlighted Spanish and English translations of a Mayan concept-word, *"in lak ech,"* which translates to "You are my other me," and *"Tú eres mi otro yo."* Baca notes that this signifies "that whether we like it or not, we all share a common humanity, and that even the most vitriolic hatred doesn't change our connection to others who think differently."[23] Interspersed between the "Reconciliation" images was the second theme, "Speaking Back"—short quotes that supporters had uploaded on the SPARC mural website:

"We think you mean save our status, not save our state."
"The world is too big to fit into your narrow mind."
"Good art confuses racists."

Walking mural, Baldwin Park demonstrations, 2005 (Social and Public Art Resource Center)

Walking mural, Baldwin Park demonstrations, 2005 (Social and Public Art Resource Center)

The backside of the mural included the final theme, "Turn Our Back." Large text across the entire width of the mural read AMERICA TURNS ITS BACK ON HATE-GROUPS.

Behind the text were black silhouette images of people whom Baca had invited to her studio to become part of the portable mural. Listed on each person's silhouette was their ethnicity, a list that included Native American, Cuban American, Mexican American, Chinese American, Irish American, and numerous others.

The beauty of the mural stretched beyond the images and the words. For the mural to be read, each person had to hold up an individual sign and come together to form the completed message. The power of the mural could be seen in the content of the words and images, as well as the collective responsibility of people coming together and taking a unified stance against racism. This approach mirrored Baldwin Park itself, a diverse working-class community that came together and confronted a hate group.

On June 25, SOS left Baldwin Park and would not return again. No one was hurt and no one was arrested. Baca was presented with a proclamation by the city government that *Danzas Indigenas* would not be removed or altered.

The quote on her monument "It was better before they came" rang true, for it was indeed better before SOS came to Baldwin Park. Yet the community response and Baca's response were vital. They handled SOS in the correct manner and in doing so they inspired others to learn from their tactics. Baca wrote after the second protest, "My dream has always been that community participants would take ownership for our public art projects."[24] In Baldwin Park, this dream came true.

Iraq Veterans Against the War (IVAW), *Operation First Casualty*, ca. March 2007, Washington, DC, pictured: Ryan Lockwood (photograph by Lovella Calica, courtesy of Aaron Hughes)

# 28

## Bringing the War Home

ON MARCH 19, 2007, MORNING commuters in Washington, DC, witnessed a terrifying scene outside Union Station. More than a dozen U.S. military soldiers rushed upon a crowd and began apprehending civilians. Soldiers yelled:

> "Move!"
> "Get down on the ground!"
> "Get your hands behind your back!"

Eight people were detained. Their hands were tied behind their backs. Some detainees had sandbags put over their heads. Beside them, soldiers crouched, surveying the crowd for sniper fire, holding imaginary M16s in their hands and pointing them at the crowd. Some people in the crowd stood still, some screamed, others ignored them.

The soldiers were members of Iraq Veterans Against the War (IVAW), and they were reenacting their experiences of combat patrols in Iraq and reenacting what it was like to detain Iraqi civilians. They were bringing the war home, using street theatre to get the public to pay attention to what was taking place overseas and what the politicians, pundits, and media rarely discuss: the brutality of war and its effects on Iraqi citizens and U.S. soldiers alike.

Garett Reppenhagen, a former sniper with the 1st Infantry Division, explained why street theatre was needed:

> Talking and marching wasn't getting the point across. We wanted a demonstration that depicted what . . . we did. The average person could look at that . . . They can see what we are doing and see that the soldiers are going through a hell of a time and the occupation is really oppressive and violent and brutal on the Iraqi people."[1]

Reppenhagen helped conceive the action, along with Aaron Hughes and Geoff Millard. The three veterans were frustrated by the cautious approach of antiwar demonstrations, exemplified by the massive protest march that had taken place in Washington, DC, a few months prior. As Hughes said:

> All these people had come in from out of town and arrived on a Saturday—
> a time when representatives aren't even in Congress. President Bush isn't
> there. He's not in the White House. He's in Texas, in Crawford. And there's
> this huge march. But everyone goes home afterwards. Everyone goes and
> sleeps in their own beds. No one's willing to sacrifice to deal with the war. So
> we were pissed off. How do we make people deal with the war? Deal with it
> in a way where it's a part of their life.[2]

Reppenhagen and Millard named their action *Operation First Casualty* (OFC)—the first casualty of war being truth. IVAW sent out a press release but never informed the police of their intentions and never sought a permit or permission. They dressed in full military uniform—minus weapons, flak vests, and Kevlar vests. They walked in the same formations they used during combat patrols in Iraq. They held their invisible weapons the same way, employing their memory of months of training and battle experience.

Iraq Veterans Against the War (IVAW), *Operation First Casualty*, ca. 2008, Denver, CO (photographer unknown, courtesy of Aaron Hughes)

Iraq Veterans Against the War (IVAW), *Operation First Casualty*, ca. May 2007, New York City, pictured: Garett Reppenhagen (photo-graph by Lovella Calica, courtesy of Aaron Hughes)

The detainees were friends—peace activists who agreed to act as if they were regular civilians. During the course of the day, thirteen veterans performed mock patrols in numer-ous sections of the city.

They did a vehicle search on the National Mall, and patrolled in front of CNN and Fox News (who refused to interview them). They were briefly detained themselves by police offi-cers on the U.S. Capitol lawn. Hughes recalls:

> The cops actually surrounded us and a couple of SUVs pulled up. We were still on the Capitol grounds and as soon as we saw that the police were start-ing to surround us, we immediately got into formation, which is what we practiced the day before.[3]

Hughes continues:

> We had a police liaison stand in front of our formation. When the cops came up to us, they really did not know what to do. We were more organized than they were. We were more disciplined than they were. All of a sudden they

realized that we were not this mob that they could go up to and pull one person aside. They had to deal with us as a community, as a force together.[4]

Iraq Veterans Against the War (IVAW), *Operation First Casualty*, ca. March 2007, Washington, DC, pictured: Charles Anderson (photograph by Lovella Calica, courtesy of Aaron Hughes)

For IVAW, the action was a way to force the public to recognize the trauma that the soldiers had experienced and to make a political statement against the wars in Iraq and Afghanistan. It reinforced the primary goals of IVAW: an immediate withdrawal of occupying forces from Iraq and Afghanistan, adequate care for the physical and psychological health of veterans, and reparations for the human and structural damages that Iraq has suffered from the military occupation.

IVAW had formed in 2004 at the Veterans for Peace (VFP) convention in Boston. By the end of 2006, IVAW had transitioned from a speakers' bureau, where churches or organizations would call them requesting a veteran to speak at an event, to a membership-run organization where chapters would stage their own events and campaigns. By 2009, IVAW had sixty-one active chapters, including six on military bases, and a membership of over 1,700 veterans and active-duty service members across the United States, Canada, Europe, and Iraq.

Creative resistance is central to IVAW's tactics. Their actions are decentralized and arise from the creativity of individual members and chapters. Nothing is mandated from a central leadership. Hughes explains, "There is a real fear with being authoritative within a veteran community when you're coming from a completely authoritarian structure such as the military."[5] Their creativity derived from soldiers' need to heal and the need to speak out. The war had been pitched to the public as "Operation Iraqi Freedom"—a just war where U.S. soldiers would liberate the Iraqi people from a brutal dictator. IVAW argues that, in the process, the United States imposed a state of martial law, turned Iraq upside down, and opened it up to allow multinational corporations to come in and reap fortunes.

OFC articulates this critical perspective. It turns the stereotypical image of the soldier on its head. In OFC, the soldier is violent and authoritarian, but also critical, peaceful, and creative. Here, the soldier engages with the public on a direct level, and the soldier becomes the leading voice of dissent—reenacting war to end war.[6]

It presents the wars as ones that are fought by young Americans—enlistees in a military that former U.S. Marine Martin Smith describes as a "cross section of working class America . . . many of the country's poor and poorly educated."[7] Moreover, it allows these same soldiers to speak out and openly critique the military in public. Reppenhagen states:

> Being in the military, I felt oppressed and controlled by the government. I didn't feel like I had a voice. I didn't have the right to speak out, and now, I'm out here in the streets, doing something, taking control of my life, taking control of my country, taking control of my military and that is extremely empowering.[8]

Iraq Veterans Against the War (IVAW), DNC Demonstration, ca. 2008, Denver, pictured: Jeff Englehart (photographer unknown, courtesy of Aaron Hughes)

After Washington, DC, other mock patrols were staged by different chapters in other cities, including New York, Chicago, Seattle, Los Angeles, and Denver.

Hughes took part in a New York City patrol of Union Square, the subways, the former site of the World Trade Center, and Times Square. He described the Times Square action as a "real mess" because "we kind of got confused on who all the civilians were and we ended up pushing into some people that were real civilians. There was a moment of fear. Veterans are these young kids—eighteen and nineteen and we're patrolling New York. We were forcing the public to make a lot of jumps in their understanding"[9]

A YouTube video of the action attests to the chaos that was created. People in the streets scream as IVAW members rush into the crowd and begin detaining people. Some people try to help but are pushed to the side. Others in the crowd freeze and put up their hands so they won't be shot. Around them, the blinking lights, billboards, and television monitors of Times Square adds to the surreal nature of the scene.

For the veterans, the performance verged too close to reality, too close to an actual patrol. Hughes recalls:

> It would click in your head that there was this anger—you stop seeing Americans for a moment. You just see these people that you're angry with. It's just this idea of dehumanizing them to the point where there's anxiety.

Iraq Veterans Against the War (IVAW), *Operation First Casualty*, unknown date, San Francisco; pictured left: Steven Funk (photographer unknown, courtesy of Aaron Hughes)

> You want to knock them over. You want to pull the trigger. It's part of the whole mentality. That whole military training came back for a lot of us, and trying to process that back through was really hard.[10]

He adds:

> I think we were performing something that we didn't want to be anymore, and that's a lot of [the] reason why that action was so powerful, and why we couldn't keep doing it, why it wasn't sustainable. It was literally destroying our membership in some ways.[11]

OFC continued to force the public to deal with the wars in Iraq and Afghanistan, conflicts that were out of sight and out of mind for most Americans. Hughes asserts that OFC forces people to choose a position. "Depoliticalization is all about not having to choose," he says. "Not having to deal with conflict. Not having to have a position. Creative work changes that. It forces people to deal with war."[12]

## From Uniform to Pulp, Battlefield to Workshop, Warrior to Artist

> "We all have the ability to do something. We can push back."
>
> —Drew Cameron[13]

Creative resistance as personal and political action is also at the center of the *Combat Paper Project* by IVAW member Drew Cameron and artist Drew Matott. Cameron was deployed to Iraq in 2003 and served in the 75th artillery. In 2007, three years removed from active duty, Cameron put on his uniform outside his home in Burlington, Vermont, and asked a friend to take photographs of him cutting it off with a pair of scissors. He recalls, "My heart started beating fast. It felt both wrong and liberating. I started ripping it off. The purpose was to make a complete transformation."[14] His action provided the impetus for the *Combat Paper Project*. Cameron teamed up with Matott at the Green Door Studio in Burlington and learned the art of papermaking, and then they shared this process with the veteran community.

The *Combat Paper* workshops involve veterans shredding their uniforms into small pieces, mixing them with water, and pulping them. The pulp can then be made into sheets of paper for veterans to use for printmaking and personal journals. The process becomes a form of therapy, and the art a means to generate a larger conversation with the public about the reality of combat in Iraq and Afghanistan. Cameron explains:

> The story of the fiber, the blood, sweat, and tears, the months of hardship and brutal violence are held within those old uniforms. The uniforms often become inhabitants of closets or boxes in the attic. Reclaiming that association of subordination, of warfare and service into something collective and beautiful is our inspiration.[15]

To reach other veterans, Cameron and Matott held workshops in Burlington, and then took the workshops on the road and traveled extensively throughout the United States and abroad. They met with other veterans from the Iraq War, Afghanistan War, Gulf War, Bosnian War, Vietnam War, World War II, and the Korean War, who subsequently turned their uniforms into paper and personal expressions.

For participants, the act was one of release. Eli Wright, who served as an Army medic, explains, "This project saves lives, it gives us direction—to find we can build bridges and tear down those walls and remake sense of our lives."[16] Donna Perdue, a Marine Corps veteran, states, "Most of the therapy actually comes while shredding the uniform. During this time, participants are cutting small 1″ pieces that make it easier for the beater to turn it into pulp later, and honestly, memories are being triggered . . . People start talking quietly at first, and then the floodgates open."[17]

Combat Paper Project, workshop in Milwaukee, pictured: Drew Cameron, ca. March 2013 (author photograph)

Drew Cameron, *You Are Not My Enemy*, ca. 2012 (author photograph)

Jennifer Pacanowski, an Army medic who served in Iraq from 2004 to 2005 and was later diagnosed with PTSD, recalled, "I just started cutting my uniform up, and before I knew it, I was sweating and my hand was bleeding. It was so satisfying. I can't even describe it . . . like just destroying a really bad memory."[18] Leonard Shelton, a forty-four-year-old Marine Corps veteran who served for twenty years, adds:

> I was in the process of throwing the [uniforms] out when I learned about this [the *Combat Paper Project*] and thought, I want to make paper out of this so I can write on it. I remember standing in front of the mirror when I got out and saying, who are you? I didn't know. They [the military] told me where to go. They told me what to eat. They told me to cut my hair every two weeks.[19]

Shelton fought in the first Gulf War, and was diagnosed with PTSD just before he was to be shipped out to Iraq in 2003. He retired from the Marines in 2005 and now receives a check for $207 a month.[20]

Other veterans had similar reactions. Jason Hurd, a Tennessee National Guard veteran who served in Iraq in 2004 and 2005, stated:

When you hold these strips in your hand, you think about all the times you ironed it and spit polished your boots—all that was something the Army made you do. This is my uniform now. I'm not Army property anymore, and neither is it.[21]

The images that veterans put on paper are as intense as the reasons for making the work, and the paper itself.

Jon Michael Turner created a silhouette image from the dog tag of his friend who was killed in action in Iraq. Eli Wright created *Open Wound*—red ink splashed on paper with a hole torn in the center as if the paper were a body. Cameron's initial images were screen prints of photographs of him taking off his own uniform and included a poem entitled "You are not my enemy"—a message to the Iraqi people. Another print by Cameron shows a soldier and the U.S. Army logo. The text reads, "There's Wrong and Then There's Army Wrong: Resist Today"—a takeoff on the "Army Strong" campaign that helped recruit so many young men and women into the military. Cameron then littered the print with gunshots.

Other participants were less critical of the military. Zach Choate, a veteran who served as a gunner in the 10th Mountain Division, stated, "I'm hoping I come out of this a little more whole, a little more at peace. I'm not an anti-war, anti-military person. This is just me fixing me."[22] Choate adds that the project has provided him with a sense of community, helping him find other veterans to talk with and share experiences. "Each one of these guys I meet along the way, they're like family now. It's already helping. I'm starting to get the good feeling."[23] Aaron Hughes concludes, "War is such a destructive force. A part of the healing process, or a part of transforming out of that person who was part of that destructive process, is doing things that are creative—producing culture and finding a way to tell stories that are constructive instead of destructive."[24]

# 29

## Impersonating Utopia and Dystopia

ON DECEMBER 3, 2004, on the twentieth anniversary of the Bhopal disaster, a spokesperson for Dow Chemical, "Jude Finisterra," appeared on BBC World Television and made a stunning announcement. Dow Chemical, which had acquired Union Carbide in 2001, was going to take full responsibility for the 1984 chemical plant disaster in Bhopal, India—a disaster that had claimed approximately twenty thousand lives and made hundreds of thousands of people sick. Dow would immediately liquidate Union Carbide, worth $12 billion, and use the funds to compensate the victims and clean up the site because it was "the right thing to do." Finisterra also promised to push for the extradition of Warren Anderson, the former Union Carbide CEO who had fled India to the United States in 1984 after being charged on multiple counts of homicide.

The five-and-a-half-minute announcement to millions of listeners aired twice on the BBC, became the top story on Google News, and was further circulated by Reuters and other press agencies. The incredible news was met with jubilation in Bhopal and cheered around the world. In the

The Yes Men, BBC Bhopal announcement, December 3, 2004 (Yes Men)

financial sector, the announcement was met with condemnation. Dow's stock dropped by $2 billion on the Frankfurt Stock Exchange within a twenty-minute time span.

The only problem with the announcement was that "Jude Finisterra" was not a Dow spokesperson; he was a member of the Yes Men. The announcement was a hoax. Or, from the Yes Men's perspective, it was "an honest representation of what Dow should be doing."[1]

In one fell swoop the Yes Men, two activist artists—Igor Vamos (Mike Bonanno) and Jacques Servin (Andy Bichlbaum)—turned a major corporation, a leading media network, and the Frankfurt

Stock Exchange upside down by presenting the news that they wished to hear. They simultaneously caused a public-relations nightmare for Dow and brought renewed global attention to the Bhopal disaster, considered by many to be the worst industrial accident in history.

## Beyond Laughter

The Dow stunt followed the typical Yes Men blueprint for success. They created a fake website that closely resembled an official website of a corporation or government agency, including is a contact e-mail that media outlets or convention organizers inadvertently believed to be valid. They were then contacted with an invitation to speak. Next, the Yes Men arrived, pretending to be official company representatives, and then espoused positions and proposals that countered the official line—either being complete parodies of the corporation at its absolute worst or a move in a new direction toward social justice, which if real, would threaten the company's bottom line. Finally, the Yes Men broadcast the stunt far and wide through their own press releases and video, making a small private gathering a major public spectacle.[2]

In the case of the Dow stunt, the Yes Men presented their dream scenario. The BBC unwittingly contacted the Yes Men through the mock website that they had set up called Dowethics.com and invited them to make a statement at the BBC Paris studio. "Jude Finisterra" (Jude, the patron saint of lost causes; and Finisterra, "the end of the world") arrived and delivered the good news.

Union Carbide had in actuality made minimal payments to the victims of the disaster, and Dow had ignored the Bhopal issue after it had acquired Union Carbide. Mike Bonanno of the Yes Men explains, "The people of Bhopal have been trying for 20 years to get someone to listen. It was less about it being funny and more about being the only kind of action we could think of that would get into the media."[3] He adds, "Typically, we haven't been in the business of suggesting alternatives. In the case of the Dow statement, Andy [Bichlbaum] did suggest an alternative—paying out $12 billion in damages. That is exactly what Dow should do. Of course, everyone applauded and agreed with it—except Dow."[4]

Dow contacted the BBC once it caught wind of what had transpired and demanded a retraction of the story, which the BBC did, albeit two hours after the initial interview was given. Nonetheless, the damage was done. The hoax became the leading global news

Mike Bonanno and Andy Bichlbaum of the Yes Men (Yes Men)

story of the day and more than six hundred articles about it were published in the U.S. press alone.[5] The Bhopal catastrophe was placed into the public spotlight and, more important, Dow's unwillingness to come to the aid of the people of Bhopal was made clear by its comments following the discovery of the hoax. Dow stated that they were not responsible for the Bhopal accident, and would not commit financial resources to addressing the disaster. To reassert Dow's position, the Yes Men sent out another press release pretending once again to be Dow. The statement was picked up by some news organizations as fact, and read, in part:

> Dow shareholders will see NO losses, because Dow's policy towards Bhopal HAS NOT CHANGED. Much as we at Dow may care, as human beings, about the victims of the Bhopal catastrophe, we must reiterate that Dow's sole and unique responsibility is to its shareholders, and Dow CANNOT do anything that goes against its bottom line unless forced to by law.[6]

In the aftermath of the stunt, the corporate media blasted the Yes Men for playing a cruel hoax on the BBC and Dow, and for falsely raising the hopes of the people of Bhopal. The Yes Men countered:

> What's an hour of false hope to 20 years of unrealized ones? If it works, this could focus a great deal of media attention on the issue, especially in the US, where the Bhopal anniversary has often gone completely unnoticed. Who knows—it could even somehow force Dow's hand.[7]

The Yes Men also traveled to Bhopal and met with activists who appreciated how much they had raised awareness of the issue. The Yes Men add:

> After all, the real hoax here is Dow's claim that they can't do anything to help. They have conned the world into thinking they can't end the crisis, when in fact it would be quite simple. What would it cost to clean up the Bhopal plant site, which continues to poison the water people drink, causing an estimated one death per day? We decide to show how another world is possible, and to direct any questions about false hopes for justice in Bhopal directly to Dow.[8]

The Yes Men's action revealed not just the negligence of Union Carbide and Dow, but the fact that the market would punish Dow for being socially and environmentally responsible. David Darts and Kevin Tavin write:

> The Yes Men's performance clearly exposed the tenuous relationship between corporate responsibility and free-market capitalism. By appearing to be doing the right thing for the victims and people living in Bhopal, the Yes Men demonstrated that Dow would clearly be doing the wrong thing for its bottom line. The hoax thus illustrated the severe limitations of corporate social responsibility within an unregulated free-market system.[9]

After the BBC retracted the story, Dow's stock regained what it had lost. The stunt also addressed the shortcomings of the corporate media. If the Yes Men could get access to the BBC—one of the most respected news outlets in the world—one must assume that governments and corporations have had little trouble in consistently manipulating the media. This was exemplified by the George W. Bush administration's infamous claim that Iraq possessed "weapons of mass destruction"—a claim that many media outlets reported as fact.

In the Dow stunt, the Yes Men exposed just how easy it is to have fiction pass as fact. Bichlbaum explains, "It's an issue of time. There are so many stations with so few journalists that they cannot possibly verify all of their sources. That's how corporate press releases end up parading as news."[10] But the Yes Men's manipulation of the media did attract serious criticism. Kelly McBride, ethics group leader at the Poynter Institute, a nonprofit school for professional journalism contended that, "It makes the public dubious of real reporters. It makes it appear as if reporters are acting in collusion with various agencies."[11] McBride, however, misses the obvious. The corporate media *does* often act in collusion; they routinely line up in droves at White House and Pentagon press briefings and reiterate the viewpoints of those in power, often verbatim, and either ignore, or greatly marginalize, oppositional voices.

The Yes Men's decision to subvert the BBC was a tactical decision to reach the largest audience possible. Many activist artists are confined by their venue—often the gallery, museum, or the artist's own website. The Yes Men were not. They literally reached the same audience as the BBC. Moreover, the brilliance of the stunt was that the Yes Men employed the same tactics as corporations (public-relations campaigns and press releases), while working to undermine them. Naomi Klein writes that, "The most significant culture jams are not stand-alone ad parodies but interceptions—counter-messages that hack into a corporation's own method of communication to send a message starkly at odds with the one that was intended."[12] The Yes Men accomplished this with the Dow hoax, and in doing so, raised the bar for interventionist art and culture jamming.

———

Much of what passes for culture jamming is known as adbusting—where an individual artist or designer creates a fake advertisement or logo in order to subvert the original image and its message. The Vancouver-based magazine *Adbusters* epitomizes this practice, as does the practice of billboard alteration. But reworked images and the individualism that is often associated with contemporary culture jamming is often divorced from its political roots.

Culture jamming, adbusting, shop dropping, and interventionist art have all been influenced, directly or indirectly, by the Situationist International (SI), a loose international movement of artists and activists who employed creative resistance during the late 1950s and 1960s. Guy Debord, who wrote the seminal Situationist text *The Society of the Spectacle,* argued that capitalism had become so advanced, and so all-encompassing, that workers could not envision any other political or social reality. Worse, workers had become complicit in their own subjugation. Entertainment, advertisements, and consumer culture

presented a fake reality (a spectacle) in order to mask how capitalism degrades human life. The SI encouraged people to subvert the spectacle—to turn it on its head, and to alter its meaning.

However, many contemporary artists forget or choose to ignore SI's anticapitalist politics. Individual culture jamming and adbusting makes people think and often laugh, but rarely does it pose much of a threat to the corporation that it parodies. SI, in contrast, was part of the international socialist movement; during the May 1968 uprisings in Paris, SI supported the wildcat strikes and the workers' councils that were organized when people took over schools and factories. This approach differs from a lone artist who creates a mock ad and posts it on a website. The Yes Men's practice goes beyond adbusting. Their work, while still primarily rooted in the realm of the symbolic, uses parody and hoaxes to work in conjunction with the struggles of the movements that they are associated with—often the antiglobalization movement and various environmental-justice movements. Many of their actions take place during larger demonstrations, and have been in collaboration with the Rainforest Action Network and Greenpeace. Others have taken place in conjunction with international days of action designed to mobilize people around climate-change issues, including campaigns by 350.org and the Mobilization for Climate Justice.

## SurvivaBalls

The Yes Men have also turned their attention to the largest of all environmental disasters— global warming—targeting the corporate and governmental leaders who have undermined efforts to regulate greenhouse-gas emissions. In 2006, the Yes Men unleashed the "SurvivaBall" at the Catastrophic Loss conference for insurance companies at the Ritz-Carlton hotel in Amelia Island, Florida, pretending to be employees of the oil-services giant Halliburton.

And unlike the Dow announcement, the Yes Men this time presented themselves as Halliburton at their dystopian worst. Halliburton's "representative," whom they named Fred Wolf, presented a SurvivaBall informational video while three conference attendees modeled giant white orb outfits that Wolf describes as a "gated community for one."[13]

Wolf explained that with the outfits, corporate managers would be able to survive anything that "Mother nature throws his or her way."[14] Global warming? Floods? Hurricanes? Rising sea level? No problem, as long as one is inside a SurvivaBall. The outfits supposedly contained communication devices, weapons to fend off attacks, medical equipment, nutrient-gathering devices, and an appendage to stick into an unsuspecting animal to draw power from it. Wolf explained that:

> The SurvivaBall builds on Halliburton's reputation as a disaster and conflict industry innovator. Just as the Black Plague led to the Renaissance and the Great Deluge gave Noah a monopoly of the animals, so tomorrow's catastrophes could well lead to good—and industry must be ready to seize that good.[15]

The Yes Men, *SurvivaBall*, Catastrophic Loss Conference, Amelia Island, Florida, 2006 (Yes Men)

One would have hoped that the conference attendees would see through the prank (considering how bombastic it was), but the *opposite* occurred. People asked detailed questions (primarily about the SurvivaBall cost feasibility and defense abilities against terrorist threats) and requested business cards.

The audience response provided little confidence that individuals who subscribe to the logic of corporate capitalism will ever embrace meaningful solutions that will significantly curb climate change, especially if profit motives are at stake. If anything, the Yes Men helped draw connections to how the oil and gas industries have lobbied extensively against regulations that would curb greenhouse gas emissions.[16]

The Yes Men, *SurvivaBall*, diagram (Yes Men)

The Yes Men have unleashed SurvivaBalls in protest demonstrations throughout the country in their campaign, appropriately titled, *Balls Across America*. One action took the form of an attempted waterborne assault on the United Nations Building in New York. On September 22, 2009, twenty-one SurvivaBalls gathered on the banks of the East River to

**The Yes Men,** *SurvivaBall,* **diagram (Yes Men)**

"blockade the negotiations and refuse to let world leaders leave the room until they'd agreed on sweeping cuts in greenhouse gas emissions, as Secretary-General Ban Ki-Moon has demanded."[17] Yes Man Andy Bichlbaum described the event as a "scenic and mediagenic way to call attention to what our leaders need to do in the run-up to the U.N. Climate Change Conference in Copenhagen."[18]

Police swarmed in by land, boat, and helicopter as activists dressed in SurvivaBalls waded in the water. Seven people were charged with trespassing, and Bichlbaum was handcuffed and taken to jail. His arrest was given prime-time media coverage by CNN. Bichlbaum stated:

> That's the whole point of civil disobedience. Thanks to my momentary discomfort, our symbol of the stupidity of not taking action on climate change was seen by tens of millions of people. It all worked out great, and I remain grateful to the NYPD for having accidentally made our event successful beyond our wildest dreams.[19]

The media coverage resulting from the arrest conjures past activist tactics of the woman's suffrage movement, the civil rights movement, and various labor struggles, all of which used

The Yes Men, *SurvivaBalls* storming the U.N. Building, New York City (Yes Men)

representations of police arrests and abuse to their advantage. The Yes Men are part of this tradition of civil disobedience. Mike Bonanno states, "With 'Balls Across America,' our goal is to get arrested fair and square, all across this fair land of ours. It's a great way to get attention for a crucial issue."[20]

The Yes Men assert that their practice of impersonating and embarrassing corporations, administrations, and government agencies is not an end in itself. It is part of a broader movement, and part of a lineage of artists who agitate for change through creative and collaborative means.

# Notes

## Preface

1. Lucy R. Lippard writes, "There has long been a confusion between the notions of 'political' and 'activist' art, which is really a confusion between political and activist artists, exacerbated by the fact that they frequently cross over the unmarked boundaries. Loosely, very loosely, I'd say that the 'political artist' makes gallery/museum art with political subject matter and/or content, but may also be seen calling meetings, marching, signing petitions, or speaking eloquently and analytically on behalf of various causes . . . 'Activist artists,' on the other hand, face out of the art world, working primarily in a social and/or political context. They spend more of their time thinking publicly, are more likely to work in groups, and less likely to show in galleries, though many have ended up there. Activists may snipe at the power structures from the art world's margins, or simply bypass conventional venues to make art elsewhere." See "Too Political? Forget It" in *Art Matters: How the Culture Wars Changed America*, Brian Wallis, Marianne Weems, Philip Yenawine, eds. (New York: New York University Press, 1999), 49.

2. Richard W. Hill Sr., "Art of the Northeast Woodlands and Great Lakes" in *Uncommon Legacies: Native American Art from the Peabody Essex Museum*, John R. Grimes, Christian F. Feest, Mary Lou Curran, eds. (New York: American Federation of Arts, in association with the University of Washington Press, 2002), 189.

## Chapter 1: Parallel Paths on the Same River

1. Lynn Ceci, "The Value of Wampum Among the New York Iroquois: A Case Study in Artifact Analysis, *Journal of Anthropological Research* 38 (1982): 98.

2. Ibid., 102.

3. Daniel K. Richter, *Facing East from Indian Country: A Native History of Early America* (Cambridge: Harvard University Press, 2001), 46.

4. Ibid., 15.

5. Ibid., 44–45.

6. Ibid., 36.

7. Ibid., 39.

8. Also referred to as the Two Paths Belt, Two Rows Belt, Kaswentha, or the Covenant Chain.

9. William N. Fenton, "Return of the Eleven Wampum Belts to the Six Nations Iroquois Confederacy on Grand River, Canada," *Ethnohistory* (The American Society for Ethnohistory) 36:4, (Fall 1989): 398.

10. The approximate date of the formation of the Iroquois League is debated. All scholars agree that the formation of the League evolved over time. Janet Catherine Berlo and Ruth B. Phillips suggest that the League was set by the second half of fifteenth century. Dean R. Snow suggests that the completion of the League was set by 1525 and that Iroquois oral tradition and archeological evidence suggests that the League could not have formed before 1450. William F. Fenton states that the League came into existence around 1500, give or take twenty-five years, and Daniel K. Richter places the establishment sometime late in the fifteenth century.

11. Ceci, *"The Value of Wampum,"* 100.

12. Ibid., 100.

13. For instance, the Pequot controlled much of the wampum trade in the Massachusetts Bay Colony up until 1633. This changed when the Pequot were decimated during a series of skirmishes and attacks in 1637 and 1638 that pitted the Pequot tribe against English colonists and their Native allies—the Narragansett and Mohegan tribes. Hundreds were killed and hundreds more were captured and sold into slavery to the West Indies. Also, King Philip's War (1675–1678) exacerbated tensions throughout the region. Metacomet (or Matacom)—the Grand Sachem of the Wampanoag, called King Philip of Wampanoag by the colonial population—led the Wampanoag, Narragansett, Nashaway, Nipmuck, Podunk, and other tribes in a three-year war against the colonial population (and their Native allies—Mohegan, Pequot, Nauset, and Massachusetts) in present-day New England. Twelve colonial towns were destroyed and upward of six hundred colonists and three thousand Natives were killed. The colonial victory opened up much of present-day Massachusetts, Connecticut, and Rhode Island to colonial settlement.

14. John R. Grimes, Christian F. Feest, and Mary Lou Curran, eds., *Uncommon Legacies: Native American Art From the Peabody Essex Museum* (Seattle: University of Washington Press, in association with the American Federation of Arts, New York, 2002), 103.

15. Ceci, *"The Value of Wampum,"* 100.

16. Ibid., 101. Starting in 1627, Isaac Razier (Secretary of New Netherland) began championing wampum as currency while he was based in the Plymouth Colony. See William M. Beauchamp, "Wampum and Shell Articles Used by the New York Indians," *Bulletin of the New York State Museum* 41, vol. 8 (Albany, University of the State of New York, February 1901), 351.

17. Frances K. Pohl, *Framing America: A Social History of American Art* (New York: Thames and Hudson, 2002), 44.

18. Richter, *Facing East from Indian Country*, 45–46.

19. War was the normal state of affairs. The Iroquois were at constant war with the Huron, the Susquehannock, the Algonquians, the St. Lawrence Iroquois, and other Indian tribes long before the arrival of Europeans. Every death required an act of revenge—a cycle of violence that defined what became known as the mourning wars. To ease the grief and the pain of losing family members, warring parties would raid another tribe for captives to replace those who had been killed. Some captives would be absorbed as family members, taking on the names and positions of those they replaced. Others would be enslaved or killed. Diseases heightened the mourning wars. European diseases

(smallpox, measles, mumps, and the chicken pox) decimated Native populations throughout the Western Hemisphere. In the early 1630s, a smallpox epidemic reduced the Great Lakes Native population by half. The Iroquois were equally ravaged. The Mohawk population dropped from 7,740 to 2,830 in a matter of months and some Mohawk villages had to be completely vacated. Epidemics also reduced the population of the Oneida, Cayuga, and Onondaga by half. Only the Senecas held their pre-epidemic number of around 4,000, and this was only by absorbing 2,000 captives from other tribes. Wherever Europeans settled, diseases followed. The most dangerous carriers of these deadly microbes were children. The arrival of Spanish children in the Caribbean, Mexico, Central America, and South America had wiped out 75 to 95 percent of the population during the sixteenth century. The same scenario took place in North America a century later. The strongest age groups (ages fifteen to forty) had the most violent reactions to epidemics. Often secondary respiratory infections would be the cause of death. European populations had already adjusted to epidemics through repeated exposures; Native populations in the Western Hemisphere had no such immunity.

20. Daniel K. Richter, *The Ordeal of the Longhouse: The Peoples of the Iroquois League in the Era of European Colonization* (Chapel Hill: University of North Carolina Press, 1992, published for the Institute of Early American History and Culture, Williamsburg, Virginia), 6.

21. Mary A. Druke, "Iroquois Treaties: Common Forms, Varying Interpretations," in *The History and Culture of Iroquois Diplomacy: An Interdisciplinary Guide to the Treaties of the Six Nations and Their League*, Francis Jennings, ed. (Syracuse: Syracuse University Press, 1985), 89.

22. Ibid., 93. Colonists did not have a significant numerical advantage in the seventeenth century over Native populations despite the waves of epidemics. Colonial population numbers in 1700 were around 250,000, an estimated figure that increased dramatically by 1750 to around 1.25 million, which included the African slave population. The Iroquois numbered close to 22,000 people by the mid-seventeenth century. See Richter, *Facing East from Indian Country*, 7.

23. William N. Fenton, "Structure, Continuity, and Change the Process of Iroquois Treaty Making," in Jennings, ed., *The History and Culture of Iroquois Diplomacy*, 21.

24. Michael K. Foster, "Another Look at the Function of Wampum in Iroquois-White Councils" in Jennings, ed. *The History and Culture of Iroquois Diplomacy*, 108.

25. Druke, "Iroquois Treaties," 93.

26. *Bulletin of the New York State Museum*, 399.

27. William N. Fenton, "Structure, Continuity, and Change in the Process of Iroquois Treaty Making," 17.

28. Richter, *The Ordeal of the Longhouse*, 48–49.

29. Ibid., 48.

30. Ibid.

31. Dean R. Snow, *The Iroquois* (Cambridge: Blackwell Publishers, 1994), 132. Additionally, women were involved in the decision-making process at the village level. Senior women from the dominant clan segments of each nation selected a man to serve as League Chief, or Sachem. If they failed to serve the community well, senior women from the dominant clans could have the men de-horned—removed from power.

32. Ibid., 61.

33. Richter, *Facing East from Indian Country*, 171.

34. Richter, *The Ordeal of the Longhouse*, 44–45.

35. Druke, "Iroquois Treaties," 87.

36. Ibid., 89–90.

37. Realizing the dangers of colonists ignoring the agreements made in councils, the Iroquois sometimes insisted that signed documents and treaty notes be provided to them.

38. Chief Irving Powless Jr., "Treaty Making" in *Treaty of Canandaigua, 1794: 200 Years of Treaty Relations between the Iroquois Confederacy and the United States*, G. Peter Jemison and Anna M. Schein, editors (Santa Fe: Clear Light Publishers, 2000), 21.

39. Rick Hill, "Talking Points on History and Meaning of the Two Row Wampum Belt," Deyohaha:ge: Indigenous Knowledge Centre, Ohsweken, Ontario, March 2013, Two Row Wampum Renewal Campaign, April 22, 2013, http://honorthetworow.org/learnmore/history/.

40. In 2010, the federal government census recognized more than 565 Indian tribes and Alaska Native groups, tribes that speak more than 250 languages.

## Chapter 2: Visualizing a Partial Revolution

1. Alfred F. Young, *Liberty Tree: Ordinary People and the American Revolution* (New York: New York University Press, 2006), 339.

2. In colonial America, copyright protection did not exist. The standard operating procedure was for printers to reprint pamphlets and anything that found its way into their shops. Real copyright protection did not occur until the first U.S. Congress passed legislation in 1790.

3. Clarence S. Brigham, *Paul Revere's Engravings* (New York: Atheneum, 1969), 52–53.

4. Philip Davidson, *Propaganda and the American Revolution: 1763–1783* (Chapel Hill: University of North Carolina Press, 1941), 173.

5. Jonathan Mulliken, a clockmaker from Newburyport, Massachusetts, also published an engraving that differed little from Pelham and Revere's image.

6. Marcus Rediker, "The Revenge of Crispus Attucks; or, The Atlantic Challenge to American Labor History," *Labor, Studies in Working-Class History of the Americas* 1, issue 4 (2004), 37, 38.

7. Young, *Liberty Tree*, 42.

8. Ibid., 31.

9. Ray Raphael, *The First American Revolution: Before Lexington and Concord* (New York: The New Press, 2002), 149–50.

10. Young, *Liberty Tree*, 189.

11. Peter Linebaugh and Marcus Rediker, *The Many-Headed Hydra: Sailors, Slaves, Commoners, and the Hidden History of the Revolutionary Atlantic* (Boston: Beacon Press, 2000), 232, 237.

12. Ibid., 237.

13. Young, *Liberty Tree*, 331.

14. Ibid., 8.

15. Ibid., 9.

16. Ibid.

17. Ibid., 8.

18. Ibid., 335.

19. Revere sold copies of his engraving *A View of the Year 1765* at a number of locations, including under the Liberty Tree itself. More appropriately, the Liberty Tree itself served as an important location for celebrating the repeal of the Stamp Act a year after it had been passed. Due to the public outcry, Parliament was forced to repeal the act, and in May 1766 colonists in Boston celebrated by hanging forty-five lanterns from a tree that had come to symbolize organized resistance. By the second night more than 108 lanterns hung from its branches. See Young, *Liberty Tree*, 330.

20. Revere also included an image of the hanging effigy of John Huske (an American member of British Parliament who favored the Stamp Act), which was hung from the tree on November 1, 1765.

21. Broadsides were commonplace in urban centers and used for a host of reasons: communicating announcements, reprinting speeches, editorials, or opinions. During the war, broadsides communicated news as well as official addresses of Congress and state legislatures. Revolutionary songs were printed on broadsides. Even Massachusetts governor Thomas Gage widely employed broadsides. More often than not, broadsides often had no markers to identify the author or printer and were put up at night on doors, trees, posts, or left on doorsteps. It was common to list one's enemies on broadsides. For example, broadsides would list the names of those who violated an import boycott. Others listed the names of boats that allowed the boycotted British tea ashore. One broadside in Boston read, in part "This is to assume such public Enemies of this Country that they will be considered and treated as Wretches unworthy to live, and will be made the first Victims of our Just Resentment." It was signed "The People." See Davidson, *Propaganda and the American Revolution*, 219.

22. Young, *Liberty Tree*, 332.

23. Another example of intimidation tactics was an instance whereby the New York branch of the Sons of Liberty placed a letter in the window of the printer John Holt warning him that the content of his paper should *continue* to resist the Stamp Act. It read, in part, "Should you at this critical time shut up the press, and basely desert us, depend upon it, your house, person, and effects will be in imminent danger. We shall therefore expect your paper on Thursday as usual; if not on Thursday evening, Take CARE.—Signed in the name, and by the order, of a great number of the Free Sons of New York, On the Turf, the 2nd November, 1765, John Hampden." See Davidson, *Propaganda and the American Revolution*, 170–71.

24. Young, *Liberty Tree*, 351.

25. Davidson, *Propaganda and the American Revolution*, 188.

26. Ibid., 182–83.

27. Linebaugh and Rediker, *The Many-Headed Hydra*, 240.

28. Young, *Liberty Tree*, 235.

29. Ibid., 235.

30. Ibid., 370.

31. Ibid., 60.

32. Ibid., 230.

33. Ibid., 230–31.

34. Ibid., 231.

## Chapter 3: Liberation Graphics

1. These three points are made by Bernard F. Reilly Jr. in his essay "The Art of the Antislavery Movement," in *Courage and Conscience: Black and White Abolitionists in Boston*, ed, Donald M. Jacobs (Bloomington: Indiana University Press, 1993), 50–51.

2. The historian Herbert Aptheker cites the rise in the Southern slave population in conjunction with the growth of the cotton industry and cites figures from a number of Southern states. Aptheker notes, "Overall, in 1807 the number of slaves totaled 1 million and cotton production, about 50 million pounds; thirty years later, the number of slaves had doubled and the cotton production had multiplied ten times." See Herbert Aptheker, *Abolitionism: A Revolutionary Movement* (Boston: Twayne Publishers, 1989), 4.

3. To view a reprint of a cartoon depicting Garrison being beaten by a mob in Boston, *The Abolition Garrison in Danger and the Narrow Escape of the Scotch Ambassador, Boston, Boston, October, 21, 1835*, see James Brewer Stewart, "Boston, Abolition, and the Atlantic World, 1820–1861," in *Courage and Conscience: Black and White Abolitionists in Boston*, Donald M. Jacobs, ed. (Bloomington: Indiana University Press, 1993), 113.

4. A lithograph depicting the mob attack and murder of Elijah P. Lovejoy in 1837 was created by the African American artist Henry Tanner in 1881. The lithograph, *The Martyrdom of Lovejoy*, was printed by the Fergus Printing Company, Chicago.

5. Marcus Rediker, *The Slave Ship: A Human History* (New York: Viking, 2007), 311.

6. Ibid., 310.

7. J.R. Oldfield, *Popular Politics and British Anti-Slavery: The Mobilisation of Public Opinion Against the Slave Trade: 1787–1807* (Manchester: Manchester University Press, 1995), 165.

8. Rediker, *The Slave Ship*, 315.

9. Falconbridge, a physician, took part on four slave-ship voyages and later became an abolitionist. His text "Account of the Slave Trade on the Coast of Africa" (1788) was a damning first-person account.

10. Rediker, *The Slave Ship*, 338.

11. Ibid., 338.

12. Ibid., 324.

13. Oldfield, *Popular Politics and British Anti-Slavery*, 166.

14. Rediker, *The Slave Ship: A Human History*, 327.

15. Adam Hochschild, *Bury the Chains: Prophets and Rebels in the Fight to Free an Empire's Slaves* (Boston: Houghton Mifflin Company, 2005), 7.

16. Ibid., 354.

17. A rare illustrated pamphlet entitled *The History of the Amistad Captives*, compiled by John W. Barber in 1840, is reprinted in Sidney Kaplan, "Black Mutiny on the Amistad," in *Black and White in American Culture: An Anthology from the Massachusetts Review*, Jules Chametzky and Sidney Kaplan, eds. (Boston: The University of Massachusetts Press, 1971), 291–330. The fascinating pamphlet contains biographical sketches and illustrations of the Africans whom John W. Barber, a Connecticut historian, interviewed while the *Amistad* captives awaited trial in New Haven.

18. Reilly, Jr. "The Art of the Antislavery Movement," 57–58.

19. Ibid., 59.

20. Ibid., 60.

21. Reilly Jr., "The Art of the Antislavery Movement," 63.

22. James Oliver Horton and Lois E. Horton, *Slavery and the Making of America* (New York: Oxford University Press, 2005), 143–144.

23. Bernard F. Reilly Jr. suggests that both prints may be the work of J. H. Bufford due to the stylistic similarities of lithographs published in Boston at the time, as opposed to those produced in New York and Philadelphia. An expert on American prints, Reilly Jr. was formerly the head of the curatorial section of the Library of Congress's Prints and Photographs Division. See Bernard F. Reilly Jr. *American Political Prints 1766–1876: A Catalog of the Collections in the Library of Congress* (Boston: G.K. Hall & Co., 1991), 73–74.

24. Horton, and Horton *Slavery and the Making of America*, 157.

25. For an in-depth essay that covers the visual outpouring of graphics and prints in reaction to the caning of Sumner, see David Tatham, "Pictorial Responses to the Caning of Senator Sumner," in *American Printmaking Before 1876: Fact, Fiction, and Fantasy: Papers presented at a symposium held at the Library of Congress, June 12 and 13, 1972* (Washington, DC: Library of Congress, 1975), 11–19.

### Chapter 4: Abolitionism as Autonomy, Activism, and Entertainment

1. William Still was an African American abolitionist who helped organize the Underground Railroad in Philadelphia. Along with assisting fugitive slaves escaping north, he interviewed hundreds of fugitives and published these interviews in 1872 in the book *The Underground Railroad*. Although William Still was omitted from the lithograph *The Resurrection of Henry Box Brown at Philadelphia*, a second "Resurrection" print (with the same title) was completed in 1851 by Peter Kramer that more accurately portrays the people who were in the room, including Still, at the time of Brown's arrival. See Jeffrey Ruggles, *The Unboxing of Henry Brown* (Richmond: The Library of Virginia, 2003), 114.

2. Frederick S. Voss, *Majestic in His Wrath: A Pictorial Life of Frederick Douglass* (Washington, DC, Smithsonian Institution Press, 1995), 46.

3. Ruggles, *The Unboxing of Henry Brown*, 88, 89.

4. Ibid., 89.

5. Ibid., 117.

6. Negative reviews of *Mirror of Slavery* had the potential to derail their tour. This was the case when a *Staffordshire Herald* review in March 1852 blasted the performance as being a "gross and palpable exaggeration" of slavery. The negative review caused attendance for local shows to decrease from several hundred to forty. Brown sued the paper for libel, stating that his profits had been adversely affected and won the case, receiving £100 in damages. See Ruggles, *The Unboxing of Henry Brown*, 143–45.

7. Ibid., 117.

8. Ibid., 123.

9. Ibid.

10. Ruggles discusses possible scenarios. See *The Unboxing of Henry Brown*, 134–37.

11. Brown quoted in Ruggles, *The Unboxing of Henry Brown*, 145.

12. Daphne A. Brooks, ed., *Bodies in Dissent: Spectacular Performances of Race and Freedom, 1850–1910* (Durham: Duke University Press, 2006), 77.

13. Audrey A. Fisch argues that the UK public responded favorably to any work that presented the United States in a negative light, for it increased the UK's own sense of nationalism and superiority. Abolitionists were especially embraced for exposing the hypocrisy in America's claim as being a beacon of democracy. See Audrey A. Fisch, *American Slaves in Victorian England: Abolitionist Politics in Popular Literature and Culture*, 74–75.

14. Ruggles, *The Unboxing of Henry Brown*, 174.

## Chapter 5: The Battleground over Public Memory

1. In 1998, artist Ed Hamilton completed and installed The African American Civil War Memorial (The Spirit of Freedom) in the Shaw neighborhood in Washington, DC. The monument honored the 180,000 black soldiers in the Union Army and Navy and featured three black infantry soldiers and a sailor set against the exterior of a nine-foot semicircular column. The interior of the circle depicted a soldier departing from his wife and child, and an adjacent wall to the sculpture listed the names of all of the African American soldiers who served during the Civil War, including the white officers who led black regiments.

2. Frederick Douglas, "MEN OF COLOR, TO ARMS!" Broadside (Rochester, March 2, 1863), reprinted in *Frederick Douglass: Selected Speeches and Writings*, Philip S. Foner, ed. (Chicago: Lawrence Hill Books, 1999), 526.

3. In 1859, Massachusetts governor Nathaniel P. Banks had vetoed a bill that would have allowed black soldiers to join the Massachusetts militia, viewing it as unconstitutional. See James Oliver Horton, "Defending the Manhood of the Race: The Crisis of Citizenship in Black Boston at Midcentury," in *Hope and Glory*, Martin H. Blatt, Thomas J. Brown, and Donald Yacovone, eds. (Amherst: University of Massachusetts Press, 2001), 19. President Lincoln had also initially obstructed the path of black soldiers. In July 1862, Congress lifted the legal ban on allowing black soldiers to join the military, but Lincoln was reluctant and did not endorse the large-scale recruitment of black soldiers until the following year. Lincoln did not want to lose the support of loyal slave states, nor did he want to lose the support of white voters who did not support black equality. Lincoln abhorred slavery, but his actions often charted a middle path. His preliminary announcement for the Emancipation Proclamation on September 22, 1862, declared that on January 1, 1863, slaves controlled by people in rebellion against the United States would be declared free, while those slaves held by masters still loyal to the United States would not be affected by the proclamation. African Americans and abolitionists abhorred the qualification measure, but in fairness Lincoln lacked authority to outright ban slavery, for the Constitution protected slavery in slave states, so he employed a different option: freeing slaves under the powers granted during war to seize enemy property. Thus the Emancipation Proclamation shifted the Union cause from reunification to that of ending slavery. See Ira Berlin, "Who Freed the Slaves?" in *Civil Rights Since 1787: A Reader on the Black Struggle*, Jonathan Birnbaum and Clarence Taylor, eds. (New York: New York University Press, 2000), 90–97.

4. In 1863, Massachusetts became the first state to form a black volunteer regiment under a federal mandate, but it was not the first time black soldiers served in the Union armies. In 1861, close to 30,000 of the 120,000 enlistees in the Navy were black soldiers, although most served in obscurity, working as cooks and laborers, and rarely saw combat. See Robert B. Edgerton, *Hidden Heroism: Black Soldiers in America's Wars* (Boulder, CO: Westview Press, 2002), 25. The following year, some Union military leaders enlisted black soldiers in in South Carolina, Louisiana, and Kansas regardless of federal law. The first black regiment to see combat action was the 1st South Carolina Volunteers, which was later commanded by the white abolitionist Thomas Wentworth Higginson.

5. Douglass, *Frederick Douglass: Selected Speeches and Writings*, 526.

6. Edwin S. Redkey, "Brave Black Volunteers: A Profile of the Fifty-fourth Massachusetts Regiment," in Blatt, Brown and Yacovone, eds., *Hope and Glory*, 22, 26.

7. David W. Blight, *Race and Reunion: The Civil War in American Memory* (Cambridge, MA: The Belknap Press of Harvard University Press), 132.

8. David W. Blight, *Beyond the Battlefield: Race, Memory, and the American Civil War* (Amherst: University of Massachusetts Press, 2002), 163.

9. Blight, *Race and Reunion*, 106.

10. Ibid., 93.

11. Historian W. Fitzhugh Brundage writes, "Even in the North the typical common soldier monument advanced the primacy of the white male citizen by depicting the face of the nation as white. In the South, of course, the black soldier could not be represented without acknowledging the Union cause or the abolition of slavery." See W.F. Brundage, *The Southern Past: A Clash of Race and Memory* (Cambridge: The Belknap Press of Harvard University, 2001), 72.

12. Additionally, the 55th Massachusetts Regiment and African Americans throughout the Sea Island communities contributed funds in the hopes of creating a stone monument on Morris Island. A monument on the sandy coastal island, the site of Fort Wagner, never came to be, but the effort was not in vain. The money instead was diverted to a project that many of the black donors felt was equal, if not more important: the building of the first free school of its kind for black children in Charleston. The school was named in honor of Shaw.

13. Thomas J. Brown, *The Public Art of Civil War Commemoration: A Brief History with Documents* (Boston: Bedford/St. Martins, 2004), 117.

14. Kirk Savage, "Uncommon Soldiers: Race, Art, and the Shaw Memorial," in Blatt, Brown, and Yacovone, eds., *Hope and Glory*, 163–64.

15. Ibid., 166.

16. Blight, *Race and Reunion*, 341.

17. Booker T. Washington, "Address at Dedication of the Shaw Memorial," May 31, 1897, *The Monument to Robert Gould Shaw: Its Inception, Completion and Unveiling, 1865–1897* (Boston: Houghton Mifflin and Company, 1897), 73–87, reprinted in Brown, *The Public Art of Civil War Commemoration*, 128.

18. Booker T. Washington, *Up from Slavery: An Autobiography* (Williamstown: Corner House Publishers, 1971, orig. pub. 1900, 1901), 253.

19. Homer Saint-Gaudens, ed., *The Reminiscences of Augustus Saint-Gaudens*, 2 vols. (New York: The Century Co., 1913), 1:332, reprinted in Brown, *The Public Art of Civil War Commemoration*, 122.

## Chapter 6: Photographing the Past During the Present

1. Gerald McMaster, "Colonial Alchemy: Reading the Boarding School Experience," in *Partial Recall: Photographs of Native North Americans*, Lucy R. Lippard, ed. (New York: The New Press, 1992), 79.

2. James C. Faris, "Navaho and Photography," in *Photography's Other Histories*, Christopher Pinney and Nicolas Peterson, eds. (Durham: Duke University Press, 2003), 93

3. Alan Trachtenberg, *Shades of Hiawatha: Staging Indians, Making Americans, 1880–1930* (New York: Hill and Wang, 2004), 177.

4. Ibid., 187.

5. Vine Deloria Jr., "Introduction," in *The Vanishing Race and Other Illusions: Photographs of Indians by Edward S. Curtis*, Christopher M. Lyman, ed. (New York: Pantheon Books, 1982), 11.

6. Ibid.

7. Lucy Lippard, "Introduction," Lippard, ed., *Partial Recall*, 25.

8. Deloria Jr., "Introduction," 13.

9. George P. Horse Capture, *Print the Legend: Photography and the American West*, Martha A. Sandweiss, ed. (New Haven: Yale University Press, 2002), 270–71.

10. Lippard, "Introduction," 25.

11. Faris, "Navaho and Photography," 95–96.

12. Lippard, "Introduction," 29.

13. Ibid., 30.

14. Ibid. 22.

15. Hulleah J. Tsinhnahjinnie, "When Is a Photograph Worth a Thousand Words?" in Pinney and Peterson, eds., *Photography's Other Histories*, 45.

16. Ibid., 41.

17. Peggy Albright, *Crow Indian Photographer: The Work of Richard Throssel* (Albuquerque, University of New Mexico Press, 1997), 7–8.

18. Ibid., 9.

19. Ibid.

20. Ibid., 30.

21. Ibid., 71.

22. Ibid., 29–30.

23. Ibid., 34–35.

24. Ibid., 35–36.

25. Ibid., 37.

26. Ibid.

27. Ibid., 38.

28. Around this time, Throssel had also "assimilated." In 1916, at age thirty-four, he was selected to become a U.S. citizen, one out of twenty-three Crow who were also given U.S. citizenship. This was part of a government initiative to move Native people away from being wards of the state. However, Throssel did not ask to become a U.S. citizen. Albright notes, "It was issued to him without his authorization and, in fact, against his wishes." Ibid., 51.

29. Ibid., 41–42.

30. Ibid., 41.

31. Ibid., 29.

32. Ibid., 46.

33. Ibid., 62.

### Chapter 7: Jacob A. Riis's Image Problem

1. Jacob A. Riis, *The Making of an American* (New York: The MacMillan Company, 1901), 266–67.

2. Daniel Czitrom, "Jacob Riis's New York," in *Rediscovering Jacob Riis*, Bonnie Yochelson and Daniel Czitrom, eds. (New York: The New Press, 2007), 32.

3. Riis, *The Making of an American*, 272–73.

4. Ibid., 268.

5. Ibid., 423.

6. Peter Bacon Hales, *Silver Cities: Photographing American Urbanization, 1839–1939: Revised and Expanded* (Albuquerque: University of New Mexico Press, 2005), 320.

7. Czitrom, "Jacob Riis's New York," 116.

8. Jacob A. Riis, *How the Other Half Lives: Studies Among the Tenements of New York* (New York: Dover Publications, Inc., 1971, orig. pub. 1890), 22.

9. Ibid., 109.

10. Ibid., 43.

11. Ibid., 78.

12. Ibid., 77.

13. Ibid., 118.

14. Edward T. O'Donnell, "Pictures vs. Words? Public History, Tolerance, and the Challenge of Jacob Riis," *The Public Historian* 26, no. 3 (Summer 2004): 19.

15. Riis, *How the Other Half Lives*, 83.

16. Cindy Weinstein, "How Many Others Are There in the Other Half? Jacob Riis and the Tenement Population," *Nineteenth-Century Contexts* 24, no. 2 (2002): 211.

17. Bill Hug, "Walking the Ethnic Tightwire: Ethnicity and Dialectic in Jacob Riis' *How the Other Half Lives*," *Journal of American Culture* 20 (1997): 49.

18. Ibid.

19. O'Donnell, "Pictures vs. Words?," 16.

20. Tom Buk-Swienty, *The Other Half: The Life of Jacob Riis and the World of Immigrant America* (New York: W. W. Norton & Company, 2008), 254.

### Chapter 8: Haymarket: An Embattled History of Static Monuments and Public Interventions

1. William J. Adelman, "The True Story Behind the Haymarket Police Statue" in *Haymarket Scrapbook*, Dave Roediger and Franklin Rosemont, eds. (Chicago: Charles H. Kerr Publishing Company, 1986), 168.

2. Paul Avrich speculates that the bomb thrower could have been a lone militant anarchist. See Paul Avrich, *The Haymarket Tragedy* (Princeton, NJ: Princeton University Press, 1984), 437–45. For more historical analysis on Haymarket, see Dave Roediger and Franklin Rosemont, eds., *Haymarket Scrapbook* (Chicago: Charles H. Kerr Publishing Company, 1986); James Green, *Death in the*

*Haymarket: A Story of Chicago, the First Labor Movement and the Bombing that Divided Gilded Age America* (New York: Pantheon Books, 2006); and Bruce C. Nelson, *Beyond the Martyrs: A Social History of Chicago's Anarchists, 1870–1900* (New Brunswick, NJ: Rutgers University Press, 1988).

3. James Green, *Taking History to Heart: The Power of the Past in Building Social Movements* (Amherst: University of Massachusetts Press, 2000), 129.

4. The Union League Club of Chicago, an exclusive club whose membership was limited to only European American men through the midpoint of the twentieth century was first established in 1879 and played a key role in establishing many of the city's elite cultural organizations and events, including helping to fund the Art Institute of Chicago, Orchestra Hall, the Field Museum, and the World's Columbian Exposition to Chicago in 1893. See James D. Nowlan, *Glory, Darkness, Light: A History of the Union League Club of Chicago* (Evanston, IL: Northwestern University Press, 2004).

5. Adelman, "The Time Story Behind the Haymarket Police Statue," 168.

6. "Police Groups Angered over Haymarket Statue Bombing," *Chicago Tribune*, October 8, 1969.

7. "Daley Asks for Law, Order at Haymarket," *Chicago Tribune*, May 5, 1970.

8. Harry Golden Jr., "We'll Rebuild Statue: Daley," *Chicago Sun-Times*, October 6, 1970.

9. Adelman, "The True Story Behind the Haymarket Police Statue," 168.

10. Nicolas Lampert, "Public Memories of Haymarket in Chicago: Michael Piazza Interviewed by Nicolas Lampert," *AREA #2* (2006), 9.

11. Maya Lin's Vietnam Veterans Memorial (Washington, DC) and Civil Rights Memorial (Montgomery, Alabama) counter this notion by encouraging the public to interact with the monument, often by touching the surface. As well, Jochen Gerz and Esther Shalev-Gerz's Monument Against Fascism, War and Violence-and for Peace and Human Rights (Harburg, Germany) invites the viewer to take an active role by carving words and marks into the surface of the monument.

12. It remains unclear who initiated and installed the tile mosaic. The *Chicago Tribune* article featured quotes from Evan Glassman, who asserts that he was the one who created and installed the mosaic, with Grifter as an "accomplice" who helped him with his project. However, in conversations that I have had with Grifter, she notes that the information that Glassman provided to the newspaper reporter is misleading. Instead, it was she who initiated the project, created the mosaic, and set it in the concrete. See Blair Kamin, "Mystery Solved: Mosaic Artist Raises a Flag in Protest," *Chicago Tribune*, August 13, 1996. Glassman later commented on the Justseeds Artists' Cooperative blog on January 17, 2012: "Kim [Kehben] Grifter was indeed my assistant on a project I was contracted on in that neighborhood at Red Light Restaurant, the mosaic was indeed a collaboration between the two of us . . . Also I was the lone installer who hoodwinked a city sub contractor into helping me install it as Kim [Kehben] was not there that day and is only using my story as hers." See http://www.justseeds.org/blog/2012/01/art_thoughtz_takes_down_damien.html.

13. Lampert, "Public Memories of Haymarket in Chicago," 7.

14. Stephen Kinzer, "In Chicago, a Deliberately Ambiguous Memorial to an Attack's Complex Legacy," *New York Times*, September 15, 2004, A14.

15. The ILHS control of the martyrs' monument was contentious for a number of reasons. To many anarchists, the monument at Waldheim was embraced because it was initiated by

anarchists—the martyrs' families, including Lucy Parsons (widow of the slain Albert Parsons), under the direction of the Pioneer Aid and Support Association. In this regard, the monument was disconnected from direct government funding and control. After the ILHS took over its deed, they decided in 1997 to register the monument under as a National Historic Landmark. Connecting the martyrs' monument to the federal government was the last straw for many anarchists, and the National Historic Landmark plaque has been routinely vandalized with anarchist symbols and the commemorative events have been picketed.

16. Lara Kelland, "Putting Haymarket to Rest?," *Labor Studies in Working-Class History of the Americas* 2, no. 2 (2005): 35.

17. In 1986, Mayor Harold Washington, the first African American mayor in Chicago's history, declared the month of May as "Labor History Month in Chicago" to commemorate the hundred-year anniversary of the Haymarket Tragedy. Within his proclamation, Washington stated, "On this day we commemorate the movement towards the eight-hour day, union rights, civil rights, human rights, and by remembering the tragic miscarriage of justice which claimed the lives of four labor activists." Washington in his speech also highlighted the program organized by the ILHS, the Chicago Federation of Labor and the Haymarket Centennial Committee and urged "all citizens to be cognizant of the events planned during this month and of the historical significance of the Haymarket Centennial." For a reprint of this statement, see http://www.chicagohistory.org/dramas.

18. Jeff Huebner, "A Monumental Effort Pays Off: After Years of Struggle and Disagreement, a Sculptural Tribute to Haymarket Is Finally in the Works—With Almost Everybody on Board," *Chicago Reader*, January 16, 2004.

19. Tom McNamee, "After 138 Years, Haymarket Memorial to Be Unveiled May Day, At Last, for a Cause," *Chicago Sun-Times*, September 7, 2004.

20. Huebner, "A Monumental Effort."

21. Kinzer, "In Chicago, a Deliberately Ambiguous Memorial."

22. McNamee, "After 138 years."

23. Michael Piazza interviewed by the author, in person, December 9, 2005.

24. Huebner, "A Monumental Effort."

25. To the new monument's credit, an element of participation, if extremely limited, was built in. The pedestal of the monument has room for additional plaques to be installed connecting recent labor struggles to Haymarket. During the May Day 2005 ceremony at the monument, a delegation of union trade leaders from Colombia presented the first plaque to be added to the pedestal, honoring the 1,300 trade unionists murdered in Colombia between 1991 and 2001. Johnny Meneses, a union activist from Colombia, told the crowd, "You have one monument. But in Colombia, we would need many more than that." In this case, the new monument served as an important location for solidarity campaigns, helping inform viewers of the troubling situation in Colombia, and making an otherwise static monument more flexible. However, one should note that the pedestal is relatively small, and only a small number of plaques will be able to be installed. Who will select the plaques and which struggles will be deemed important and which ones will be deemed unimportant? See James Green, "The Globalization of a Memory: The Enduring Remembrance of the Haymarket Martyrs around the World," *Labor Studies in Working-Class History of the Americas* 2, no. 4 (2005): 22, 23.

26. McNamee, "After 138 Years."

27. Kinzer, "In Chicago, a Deliberately Ambiguous Memorial."

28. Huebner, "A Monumental Effort."

29. Donahue has voiced resistance to the proposed renaming of a city park to Lucy Parsons, wife of Haymarket martyr Albert Parsons. He also voiced objection to a street in Chicago being re-named after the late Fred Hampton, a Black Panther Party leader who was murdered in 1969 by the police during a raid. Donahue said, "It's a 'dark day' when city officials honor a man who called for harming police officers." See "Union head blasts plan to name street after Black Panther," The Associated Press, February 28, 2006.

30. Diana Berek, interviewed by the author, by e-mail, February 20, 2006.

31. Ibid.

## Chapter 9: Blurring the Boundaries Between Art and Life

1. Joyce L. Kornbluh, ed., *Rebel Voices: An I.W.W. Anthology: New and Expanded Edition* (Chi-cago: Charles H. Kerr Publishing Company, 1998), 201.

2. Ibid., 197.

3. Irving Abrams, transcript of interview by Frank Ninkovich, 1970, Labor Oral History Proj-ect, Roosevelt University, Chicago; Book 17, p. 14. Quoted in Salvatore Salerno, *Red November, Black November: Culture and Community in the Industrial Workers of the World* (Albany: State University of the New York Press, 1989), 26.

4. "Revolution," *Industrial Worker*, June 26, 1913 quoted in Salerno, *Red November, Black November* 41–42.

5. Elizabeth Gurley Flynn stressed this point in a speech to the workers where she stated, "I have nothing to lose so I can say whatever I please about the manufacturers as long as I express your sentiments." See Steve Golin, *The Fragile Bridge: Paterson Silk Strike, 1913* (Philadelphia: Temple University Press, 1988), 56.

6. Golin, *The Fragile Bridge*, 41.

7. Carlo Tresca, Patrick Quinlan, and Adolf Lessig (a Paterson IWW silk worker) were also key organizers during the strike.

8. Golin, *The Fragile Bridge*, 71.

9. Ibid., 136.

10. Ibid., 162.

11. Ibid.

12. *New York Call*, May 21, 1913, page 2, quoted in Golin *The Fragile Bridge*, 163.

13. Anne Huber Tripp, *The I.W.W. and the Paterson Silk Strike of 1913* (Urbana: University of Illinois Press, 1987), 142.

14. Ibid., 145.

15. *New York Times*, quoted in *Current Opinion* 55 (July 1913): 32 and Golin, *The Fragile Bridge*, 168.

16. Kornbluh, *Rebel Voices*, 212.

17. Ibid., 213.

18. Text of Flynn's speech is reprinted in Kornbluh, *Rebel Voices*, 214–26.

19. Ibid., 221.

20. Ibid. Golin challenges the idea that jealousy played a significant role. He writes, "There is no evidence to confirm her charge that the Pageant caused jealousy and dissention; all other ac-

counts agreed that immediately after the performance the Paterson strikers seemed more enthusiastic than ever." See *The Fragile Bridge*, 173.

21. Kornbluh, *Rebel Voices*, 221.

22. Golin's critique of Flynn ignoring so many positive aspects of the pageant (and how Flynn's critique has influenced how historians frame this event) is detailed in *The Fragile Bridge*, 170–78. Art historian Linda Nochlin is one of the rare scholars who have argued that the pageant had a positive effect on both strikers and artists alike who were involved in the production. See Linda Nochlin, "The Paterson Strike Pageant of 1913," *Art in America* 52 (May–June 1974), 67.

23. Golin argues that the main goal of the pageant was to create publicity, and that the production was staged even though organizers were warned beforehand that it might lose money. He writes, "The working committees finally decided to go ahead, not because they believed money could be made from a single performance—especially not one aimed primarily at working people—but because New York silk strikers who were present at the meeting insisted that the Pageant simply had to be put on and themselves lent money to offset production costs. The New York ribbon weavers knew what most historians have forgotten, that the real purpose of the Pageant was to publicize the dramatic class struggle then taking place in Paterson, in the hope of influencing the outcome." See *The Fragile Bridge*, 161.

24. This point is contentious, for the IWW did carry on throughout the decade (surviving the harsh governmental repression during WWI), and the Wobblies continue to this day. However, Paterson (following the success at Lawrence) represented a major defeat in the IWW's ability to organize and win large-scale strikes against manufacturers, a loss that harmed its overall reputation. Paterson also took a tremendous toll on the main IWW organizers. Elizabeth Gurley Flynn never led a major strike again, and Haywood (whose health fell apart during the strike) was sentenced to prison under the Espionage Act. However, while he waited for an appeal, he skipped bail and fled to Russia, where he remained until his death in 1928.

25. Richard Fitzgerald argues that Greenwich Village artists "never regarded themselves as workers or identified their own interests with those of the working class. They saw industrial working-class struggles as real, but they did not consider them their own. They never regarded themselves simultaneously as both artists as workers. Thus, they saw their career options as open in a way no industrial worker could, and they responded in different ways to the situation which they confronted." See Richard Fitzgerald, *Art and Politics: Cartoonists of the* Masses *and* Liberator (Westport, CT: Greenwood Press, 1973), 5.

26. Golin, *The Fragile Bridge*, 110. Golin's book, particularly chapters four through seven, focuses on a critical and historical analysis of the interaction between Greenwich Village artists and intellectuals, IWW organizers, and silk workers during the Paterson strike.

27. Ibid., 110.

### Chapter 10: *The Masses* on Trial

1. Katherine H. Adams and Michael L. Keene, *Alice Paul and the American Suffrage Campaign* (Urbana: University of Illinois Press, 2008), 180.

2. Franklin Rosemont, *Joe Hill: The IWW and the Making of a Revolutionary Workingclass Counterculture* (Chicago: Charles H. Kerr Publishing Company, 2003) 353.

3. Eugene E. Leach, *1915, The Cultural Movement: The New Politics, the New Woman, the New Psychology, the New Art, and the New Theatre in America*, 28.

4. Leslie Fishbein, *Rebels in Bohemia: The Radicals of* The Masses, *1911–1917* (Chapel Hill: The University of North Carolina Press, 1982), 16.

5. "Editorial Notice," *The Masses* 4 (December 1912), 3, reprinted in Fishbein, in *Rebels in Bohemia*, 18.

6. [Editorial: "The magazine is a success . . ."], *The Masses* 4 (January 1913), 2, reprinted in Fishbein, in *Rebels in Bohemia*, 18.

7. Ibid., 18.

8. *The Masses* 4 (December 1912), 3, reprinted in Richard Fitzgerald, *Art and Politics: Cartoonists of the* Masses *and* Liberator (Westport, Greenwood Press, 1973), 27.

9. Leach, *1915, The Cultural Movement*, 36.

10. Paul H. Douglas, "Horrible Example," *The Masses* 9 (November 1916), 22, reprinted in Leach, *1915, The Cultural Movement*, 36.

11. *The Masses*' support for women's issues and workers issues was commendable, but they failed miserably at race issues. The editors, artists, and writers were overwhelmingly European-American men, and their inability to see and understand racism and form a deeper analysis of sexism is baffling. Eugene L. Leach writes, "At its worst *The Masses* purveyed racist stereotypes in cartoons and poetry; at its best it sporadically protested the same stereotypes. For the most part the magazine hewed to the myopic line that racism was a by-product of capitalism, so that no special emphasis had to be given to the peculiar oppressions borne by blacks. Like the white leaders of the Socialist party, *The Masses* shrank back in fear and confusion from confronting this deepest divide in American Society." See Leach, *1915, The Cultural Movement*, 42.

12. For more on the Ludlow Massacre, see, Howard Zinn, "The Colorado Coal Strike, 1913–1914," in Howard Zinn, Dana Frank, Robin D. G. Kelley, *Three Strikes: Miners, Musicians, Salesgirls, and the Fighting Spirit of Labor's Last Century* (Boston: Beacon Press, 2001), 7–55.

13. Fishbein, *Rebels in Bohemia*, 21.

14. Ibid., 20.

15. Fitzgerald, *Art and Politics: Cartoonists of the* Masses *and* Liberator, 50.

16. Thomas A. Maik, *The Masses Magazine (1917–1917): Odyssey of an Era* (New York: Garland Publishing, Inc., 1994), 204–05.

17. This countered other information that they had received. *The Masses* had sought out the opinion of George Creel, chairman of the Committee on Public Information, who gave his assurance that the August issue had not violated any laws.

18. Rebecca Zurier, *Art for the Masses: A Radical Magazine and its Graphics, 1911–1917* (Philadelphia: Temple University Press, 1988), 60.

19. Maik, *The Masses Magazine (1917–1917)*, 207.

20. Fishbein, *Rebels in Bohemia*, 24–25.

21. Ibid., 25.

22. Maik, *The Masses Magazine (1917–1917)*, 217.

23. Ibid., 212.

24. Allan Antliff, *Anarchist Modernism: Art, Politics, and the First American Avant-Garde* (Chicago: University of Chicago Press, 2001), 205–06.

25. Eugene E. Leach writes about Eastman, "When party loyalists abused him for saying kind things about Woodrow Wilson in 1916, Eastman gave them a scolding for their sectarian stiffness: 'Let us try to use our brains freely, love progress more than a party, allow ourselves the natural emotions of our species, and see if we can get ready to play a human part in the actual complex flow of events.'" See Leach, *1915, The Cultural Movement*, 38, originally printed in "Sect or Class?," *The Masses* 9 (December 1916), 16.

26. Maik, *The Masses Magazine (1917–1917)*, 217–18.

27. Ibid., 221.

## Chapter 11: Banners Designed to Break a President

1. Katherine H. Adams and Michael L. Keene, *Alice Paul and the American Suffrage Campaign* (Urbana: University of Illinois Press, 2008), 164.

2. Doris Stevens, *Jailed for Freedom* (New York: Boni and Liveright Publishers, 1920), 21.

3. Marjorie Spruill Wheeler, ed. *One Woman, One Vote: Rediscovering the Woman Suffrage Movement* (Troutdale, OR: NewSage Press, 1995), 11.

4. States to ratify in the 1910s included Washington (1910), California (1911), Oregon (1912), Kansas (1912), and Arizona (1912).

5. NAWSA President Anna Howard Shaw stated, "Do not touch the Negro problem. It will offend the South." Quoted in David Levering Lewis, *W.E.B. Du Bois: Biography of a Race: 1868–1919* (New York: Henry Holt and Company, 1993), 417. Carrie Chapman Catt, who would also serve as NAWSA president argued that democratic rights had been given to "the Negro [men] . . . with possible ill advised haste" and that "perilous conditions in society were the result of introducing into the body politics vast numbers of irresponsible citizens." Quoted in Manning Marable, *W.E.B. Du Bois: Black Radical Democrat, New Updated Edition* (Boulder, CO: Paradigm Publishers, 1986), 85.

6. Adams and Keene, *Alice Paul and the American Suffrage Campaign*, 82.

7. Linda J. Lumsden, *Rampant Women: Suffragists and the Right of Assembly* (Knoxville: University of Tennessee Press, 1997), 84.

8. Linda G. Ford, "Alice Paul and the Triumph of Militancy," in Wheeler, ed., *One Woman, One Vote*, 283.

9. Adams and Keene, *Alice Paul and the American Suffrage Campaign*, 124.

10. Ibid., 59.

11. Stevens, *Jailed for Freedom*, 92.

12. Ibid, 95.

13. Adams and Keene, *Alice Paul and the American Suffrage Campaign*, 167.

14. Ibid., 171.

15. Robert Booth Fowler, "Carrie Chapman Catt, Strategist," in Wheeler, ed. *One Woman, One Vote*, 310.

16. Ibid.

17. Ibid, 286.

18. Adams and Keene, *Alice Paul and the American Suffrage Campaign*, 216.

19. Ibid., 222.

20. Connecticut would also ratify in September.

21. Stevens, *Jailed for Freedom*, 339.
22. Ibid., 251.

## Chapter 12: The Lynching Crisis

1. W.E.B. Du Bois, *The Crisis*, September 2, 1911, 195, reprinted in *Writing in Periodicals: Edited by W.E.B. Du Bois: Selections from The Crisis: Volume 1: 1911–1925*, Herbert Aptheker, comp. and ed. (Milwood, NY: Kraus-Thomson Organization Limited, 1983), 16.

2. *The Star of Ethiopia* celebrated contributions of Africans and African Americans to society and was performed to large crowds in New York City in 1913 and again in 1921, in Washington, DC, in 1915, in Philadelphia in 1916, and in Los Angeles in 1925.

3. Jim Crow laws existed between 1876 and 1965 and erased the gains that African Americans had made during the Reconstruction period following the Civil War. These gains were thwarted when Republican politicians sold out the civil and political rights of African Americans when they agreed to remove federal troops from the South in return for electoral commission votes for the Republican Rutherford B. Hayes in the disputed Tilden-Hayes election. This became known as the Compromise of 1877, and the equal protection guaranteed by Fourteenth Amendment all but disappeared, ushering in disenfranchisement and Jim Crow laws. The 1896 Supreme Court decision in *Plessy v. Ferguson* cemented this disenfranchisement and established the "separate but equal" doctrine that legalized racial segregation. This allowed racism and race terror to flourish, especially in the Deep South.

4. Interracial working-class organizing sought to change this. In the late 1880s the Southern Farmers' Alliance led a grassroots campaign to end the economic exploitation of black sharecroppers and impoverished white farmers alike. The Farmers' Alliance (allied with the Populist Party) developed farmers' co-ops to challenge the crop lien system in which small-scale farmers mortgaged their crops in return for supplies and household goods from merchants (usually the plantation owners), who charged exorbitant sums.

5. The Tuskegee Institute statistics were generally lower than those of the NAACP.

6. Many others were active leaders in the anti-lynching movement. Most notable was Ida B. Wells-Barnett, who led a one-woman crusade to combat lynching after the murder of her three friends (Thomas Moss, Calvin McDowell, and Henry Stewart) who owned a grocery store in Memphis that competed with a white-owned store. Wells-Barnett—an African American investigative journalist—exposed that only one in every six individuals who was lynched was accused of rape, and that many of those accusations were false, resulting from either consensual sex between white women and black men, or black men simply being in the company of white women. Wells-Barnett's own safety in Memphis was compromised when it became known that she was the author of the anti-lynching reports from the black-owned Memphis *Free Speech*. She fled Memphis and relocated to Philadelphia and then Chicago, where she continued to organize on behalf of the anti-lynching movement and the feminist movement. See Paula J. Giddings, *Ida: A Sword Among Lions: Ida B. Wells and the Campaign Against Lynching* (New York: Amistad: An Imprint of Harper Collins Publishers, 2008).

7. Amy Helene Kirschke, *Art in Crisis: W.E.B. Du Bois and the Struggle for African American Identity and Memory* (Bloomington: Indiana University Press, 2007), 50.

8. Ibid., 49.

9. Abby Arthur Johnson and Ronald Maberry Johnson, *Propaganda and Aesthetics: The Literary Politics of African-American Magazines in the Twentieth Century* (Amherst: University of Massachusetts Press, 1979), 34.

10. Manning Marable, *W.E.B. Du Bois: Black Radical Democrat, New Updated Edition* (Boulder, CO: Paradigm Publishers, 1986), 78.

11. Ibid., 97.

12. Kirschke, *Art in Crisis*, 12.

13. David Levering Lewis, *W.E.B. Du Bois: Biography of a Race* (New York: Henry Holt and Company, 1993), 411–12.

14. Kirschke, *Art in Crisis*, 5.

15. Anne Elizabeth Carroll, *Word, Image, and the New Negro: Representation and Identity in the Harlem Renaissance* (Bloomington: Indiana University Press, 2005), 34.

16. Kirschke, *Art in Crisis*, 51.

17. Ibid., 76.

18. Dora Apel, *Imagery of Lynching: Black Men, white women, and the Mob* (New Brunswick: Rutgers University Press, 2004), 32.

19. Elisabeth Freeman, "The Waco Horror," *Supplement to The Crisis* 12, no. 3 (July 1916): 6.

20. Subsequent bills that were introduced included the Costigan-Wagner Bill that was defeated during the 1930s. The Wagner-Van Nuys Bill, drafted by NAACP lawyers and introduced to the Senate in 1934, was also defeated. President Roosevelt failed to throw much support behind the bill, but he did create the civil rights section of the Justice Department, which won its first conviction of a lyncher in 1946 and helped to reduce the proliferation of lynchings in the decades that followed.

21. Kirschke, *Art in Crisis*, 74.

22. Ibid., 8.

23. Ibid., 135.

24. Oswald Villard reportedly first proposed the idea of a Silent Parade to Du Bois and Johnson. See Lewis, *W.E.B. Du Bois: Biography of a Race*, 539.

25. The Ku Klux Klan was re-founded in 1915 after being dormant from the early 1870s. It experienced a rapid growth from two thousand members in 1920 to two million in 1926. Close to two-thirds of the members lived outside the South, including 50,000 in Chicago, 38,000 in Indianapolis, 35,000 in Philadelphia, and 16,000 in NYC. See Marable, *W.E.B. Du Bois: Black Radical Democrat*, 118.

26. Lewis *W.E.B. Du Bois: Biography of a Race*, 506.

27. Ibid., 507.

28. Kirschke, *Art in Crisis*, 26.

29. See Shawn Michelle Smith, *Photography on the Color Line: W.E.B. Du Bois, Race, and Visual Culture* (Durham: Duke University Press, 2004); The Library of Congress, with essays by David Levering Lewis and Deborah Lewis, *A Small Nation of People: W.E.B. Du Bois and African American Portraits of Progress* (New York: Amistad, an Imprint of Harper Collins Publishers, 2003).

30. Johnson and Johnson, *Propaganda and Aesthetics*, 46.

31. David Levering Lewis, ed. *W.E.B. Du Bois: A Reader* (New York: Henry Holt and Company, 1995), 514.

32. Amy Helene Kirschke, *Aaron Douglas: Art, Race, and the Harlem Renaissance* (Jackson: University Press of Mississippi, 1995), 42.

33. Johnson and Johnson, *Propaganda and Aesthetics*, 47.

34. Du Bois wrote, "The men who will fight in these ranks must be educated and *The Crisis* can train them: not simply in its words but in its manner, its pictures, its conception of life, its subsidiary enterprises." Quoted in Lewis *W.E.B. Du Bois: Biography of a Race*, 494.

35. Johnson and Johnson, *Propaganda and Aesthetics*, 45.

36. "Opinion," *The Crisis* 18, no. 5 (September 1919), 231.

## Chapter 13: Become the Media, Circa 1930

1. Russell Campbell, "Radical Cinema in the 30s: Introduction," *Jump Cut* 14 (March 1977), 24.

2. Russell Campbell, *Cinema Strikes Back: Radical Filmmaking in the United States 1930–1942* (Ann Arbor: UMI Research Press, 1982), 29. David Platt, the national secretary for the F&PL and editor of its short-lived publication, *Film Front*, later downplayed the connections between Moscow and F&PL chapters in the United States. In 1977 he stated, "It is true that the CP USA played an important role, but the League of which I was a part was rooted in the conditions existing in the country in the early 1930s. It wasn't necessary for anyone on the outside to press buttons to tell us our task was to cover the breadlines, flophouses, picket lines, hunger marches, etc. People interested in films and photos as weapons in the social struggle came over to the League as I did, partly out of admiration for the films of Eisenstein, Pudovkin, Dovjenko, and Vertov, but mostly in response to the failure of the older independent documentarians, as well as the commercial film industry, seriously to concern themselves with what was going on in the streets, factories and farms in the years following the stock market crash." See David Platt and Russell Campbell, "Dialog on Film and Photo League," *Jump Cut* 16, 1977, 37.

3. Ibid., 29.

4. Campbell, "Radical Cinema in the 30s," 23.

5. Ibid.

6. Campbell, *Cinema Strikes Back*, 38.

7. Ibid., 39. By 1931, the F&PL began meeting at 7 East Fourteenth Street.

8. Russell Campbell, "Interview with Leo Seltzer: 'A Total and Realistic Experience,'" *Jump Cut* 14 (March 1977), 26.

9. Helen Langa, *Radical Art: Printmaking and the Left in 1930s New York* (Berkeley: University of California Press, 2004), 103.

10. Campbell, "Radical Cinema in the 30s," 23.

11. William Alexander, *Film on the Left: American Documentary Film from 1931 to 1942* (Princeton: Princeton University Press, 1981), 28.

12. Campbell, *Cinema Strikes Back*, 101.

13. Alexander, *Film on the Left*, 17.

14. Ibid.

15. Ibid., 26.

16. Ibid.

17. Ibid., 27.

18. Ibid., 43. Samuel Brody argues that the Soviet films had an influence on working-class U.S. audiences: "It must be said, that intellectuals and artists in the 1930s who saw all of these great films couldn't possibly totally escape the content. They saw that here was a different technique, a different aesthetic, and at the same time, a revolutionary content. And that helped push them towards a more Marxist and revolutionary outlook on life in general. How can you separate the Russian Revolution from *October*?" See Tony Safford, "Interview with Samuel Brody: 'The Camera as a Weapon in the Class Struggle,'" *Jump Cut* 14 (March 1977), 29.

19. Alexander, *Film on the Left*, 39.

20. Ibid., 40.

21. Ibid., 29.

22. Carla Leshne, "The Film and Photo League of San Francisco," *Film History* 18, no. 4 (2006), 363.

23. Ibid., 364–65.

24. Ibid., 366.

25. Ibid., 368.

26. Ibid., 369.

27. Samuel Brody, reflecting on the demise of the F&PL, stated in 1977, "The split in the old Workers Film and Photo league in the thirties was the result of a principled disagreement as to whether we ought to continue doing short documentaries born in the heat of the class upheavals of the time or concentrate on enacted, recreated 'features' produced over considerably longer spans of time—blockbuster productions, so to speak. The result was a split away from the Workers Film and Photo League and others who looked upon us as the great unwashed who could not be initiated into the more lofty realms of cinema art." See Safford, "Interview with Samuel Brody," 30.

28. Alexander, *Film on the Left*, 47.

29. Ibid., 46.

30. Campbell, *Cinema Strikes Back*, 65.

31. Ibid., 66–67.

32. Ibid., 68.

33. Leshne, "The Film and Photo League of San Francisco," 371.

34. Ibid., 367.

35. Safford, "Interview with Samuel Brody," 30.

36. Ibid. In the same 1977 interview, Brody added, "I am not a disinterested art-for-art's-saker. The most 'escapist' art is, by that very fact, sterile at best and reactionary at worst. This art abdicates the artist's responsibility to society and social progress." Ibid., 29.

## Chapter 14: Government-Funded Art

1. Chet La More, "The Artists' Union of America," in *Art for the Millions: Essays from the 1930s by Artists and Administrators of the WPA Federal Art Project*, Francis V. O'Connor, ed. (Boston: New York Graphic Society, 1973), 237.

2. Biddle is often given central credit for proposing the idea. See Olin Dows, "The New Deal's Treasury Art Program: A Memoir," in *The New Deal Art Projects: An Anthology of Memoirs*, Francis V. O'Connor, ed. (Washington, DC: Smithsonian Institution Press, 1972), 14; Richard D. McKinzie,

*The New Deal for Artists* (Princeton: Princeton University Press, 1973), 5; and Helen Langa, *Radical Art: Printmaking and the Left in 1930s New York* (Berkeley: University of California Press, 2004), 226. However, it is likely that other artists were involved in this process. Lincoln Rothschild argues that the Unemployed Artists Group played a key role in urging advisers to FDR to form the PWAP. See Lincoln Rothschild, "Artists' Organizations of the Depression Decade," in O'Connor, ed., *The New Deal Art Projects*, 200.

3. Beniamino Benvenuto Bufano, "For the Present Are Busy," in O'Connor, ed., *Art for the Millions*, 107.

4. Langa, *Radical Art,* 34.

5. Louis Guglielmi, "After the Locusts," in O'Connor, ed., *Art for the Millions*, 114–15.

6. Holger Cahill, "American Resources in the Arts," in O'Connor, ed., *Art for the Millions*, 36.

7. Ibid., 38.

8. Ibid., 43.

9. Throughout the essay, Holger Cahill cites the work of philosopher John Dewey as an influence in helping him to arrive at a more egalitarian view of art.

10. The book *Art for the Millions* details many of the various WPA-FAP projects and contains a wide array of short essays by artists, designers, and administrators. The book itself was written in 1936 as a national report by the Washington Office of the WPA-FAP. The essays are fascinating but tend to be overly optimistic. This is unsurprising, as they served the purpose of championing the WPA-FAP to help sway a reluctant Congress to continue to fund the arts. The original publisher, the Government Printing Office, failed to publish the text in 1937, and a private publisher fell through in 1938 and again in 1939. By this time, the WPA-FAP was in crisis mode and the book was never published. Holger Cahill held on to the manuscript and was unable to publish it before his death in 1960. In 1973, the art historian Francis V. O'Connor obtained the manuscript from Mrs. Holger Cahill. O'Connor published *Art for the Millions* (adding his introduction and photographs) and also deposited the original documents in the Library of the National Collection of Fine Arts of the Smithsonian Institution. See Francis V. O'Connor, "Introduction," in *Art for the Millions: Essays from the 1930s by Artists and Administrators of the WPA Federal Art Project*, Francis V. O'Connor, ed. (Boston: New York Graphic Society, 1973), 13–31.

11. For a more in-depth look at the WPA-FAP art centers in the U.S., see: John Franklin White, ed. *Art in Action: American Art Centers and the New Deal* (Metuchen, NJ: The Scarecrow Press, Inc.), 1987 and Francis V. O'Connor, ed. *Art for the Millions: Essays from the 1930s by Artists and Administrators of the WPA Federal Art Project* (Boston: New York Graphic Society, 1973).

12. C. Adolph Glassgold, "Recording American Design," in O'Connor, ed., *Art for the Millions*, 167.

13. Ibid., 168–169.

14. Eugene Ludins, "Art Comes to the People," in O'Connor, ed. *Art for the Millions*, 232–33.

15. Ibid., 233.

16. Ibid.

17. Ibid.

18. Langa, *Radical Art*, 43–45.

19. Cahill, "American Resources in the Arts," 43.

20. Robert Cronbach, "The New Deal Sculpture Projects" in O'Connor, ed., *The New Deal Art Projects*, 140.

21. For a more extensive treatment of the right-wing governmental attacks against the WPA-FAP, see Richard D. McKinzie, *The New Deal for Artists* (Princeton: Princeton University Press, 1973), 149–71.

22. Langa, *Radical Art*, 205.

23. McKinzie *The New Deal for Artists*, 154.

24. Ibid., 155.

25. Langa, *Radical Art*, 206.

26. During the build-up to World War II and the war itself, the U.S. economy began to recover, aided by selling steel and materials to the Allies.

27. Vachon, quoted in James Guimond, *American Photography and the American Dream*, (Chapel Hill: University of North Carolina Press, 1991), 139.

28. Roosevelt, quoted in McKinzie, *The New Deal for Artists*, 169.

29. Jacob Kainer, "The Graphic Arts Division of the WPA Federal Art Project," in O'Connor, ed., *The New Deal Art Projects*, 166.

### Chapter 15: Artists Organize

1. Boris Gorelick, "Artists' Union Report," in Matthew Baigell and Julia Williams, eds., *Artists Against War and Fascism: Papers of the First American Artists' Congress* (New Brunswick, NJ: Rutgers University Press, 1986), 183.

2. Gerald M. Monroe, "Artists As Militant Trade Union Workers During the Great Depression," *Archives of American Art Journal*, 14, no. 1 (1974): 7.

3. Gerald M. Monroe, "Artists on the Barricades: The Militant Artists Union Treats with the New Deal," *Archives of American Art Journal* 18, no. 3 (1978): 22.

4. Helen Langa, *Radical Art: Printmaking and the Left in 1930s New York* (Berkeley: University of California Press, 2004), 10.

5. Monroe, "Artists As Militant Trade Union Workers," 8.

6. Ibid.

7. Stuart Davis, "Why An Artists' Congress?," in Baigell and Williams, eds., *Artists Against War and Fascism*, 66.

8. Olin Dows, "The New Deal's Treasury Art Program: A Memoir," in *The New Deal Art Projects: An Anthology of Memoirs*, Francis V. O'Connor, ed., (Washington, DC: Smithsonian Institution Press, 1972), 28.

9. Politically, McMahon took the middle road with the hopes that this path would ensure that the WPA-FAP would not be completely cut. She noted, "The conservatives were certain I was a 'Red'; the liberals thought I was conservative. Both were wrong. Emotionally and practically I was dedicated to helping artists in distress and to furthering the WPA/FAP. Politically I was totally committed to the Roosevelt doctrine." See Audrey McMahon, "A General View of the WPA Federal Art Project in New York City and State", in O'Connor, ed., *The New Deal Art Projects*, 74.

10. "Our Municipal Art Gallery and Center," *Art Front*, February 1936. pg. 4.

11. "Self-Government and the Municipal Art Center," *Art Front*, February 1936. pg. 5–6.

12. Ibid.

13. Einar Heiberg, "The Minnesota Artists' Union," in *Art for the Millions: Essays from the 1930s by Artists and Administrators of the WPA Federal Art Project*, Francis V. O'Connor, ed. (Boston: New York Graphic Society, 1973), 244.

14. Chet La More, "Crisis in the Rental Issue," *Art Front*, January 1937. p. 16–17.

15. Joseph Solman, "The Easel Division of the WPA Federal Art Project," in O'Connor, ed., *The New Deal Art Projects*, 120.

16. "The Artists' Unions and Spain," *Art Front*, December 1936, 3.

17. Langa, *Radical Art*, 185.

18. "On to Spain," *Art Front*, March 1937, 3.

19. Monroe, "Artists As Militant Trade Union Workers," 8.

20. Langa, *Radical Art*, 185.

21. Meyer Schapiro, "Public Use of Art," *Art Front*, November 1936, 4.

22. Clarence Weinstock, "Public Art in Practice," *Art Front*, December 1936, 8–10.

23. "Full Report of the Eastern District Convention of the Artists' Union," *Art Front*, June 1936, 5–7.

24. Monroe, "Artists As Militant Trade Union Workers,"10.

## Chapter 16: Artists Against War and Fascism

1. Gerald M. Monroe, "The American Artists Congress and the Invasion of Finland," *Archives of American Art Journal*, 15, no. 1 (1975): 16.

2. Matthew Baigell and Julia Williams, eds., *Artists Against War and Fascism: Papers of the First American Artists' Congress* (New Brunswick: Rutgers University Press, 1986), 11–12.

3. "A Call for an American Artists Congress," Louis Lozowick papers, *Archives of American Art*, Smithsonian Institution, Printed Matter, 1936–1942, n.d., Box 4, Reel 5898, Frame 314, http://www.aaa.si.edu/collections/container/viewer/Printed-Matter–305715.

4. Gerald M. Monroe writes that Stuart Davis "secured the assurances of [Alexander] Trachtenberg [CP USA representative for cultural affairs] that the Congress would be free of any interference by the party." He adds, "Although the Communist Party had an interest in the formation of the Congress, it could not have taken place without the support of noncommunist artists, who surely constituted the vast majority." See Monroe "The American Artists Congress," 14–15. Matthew Baigell and Julia Williams present a slightly different argument: "Stuart Davis was assured that the Party would not interfere in congress activities, but it is possible that, as with the Artists' Union, a small, perhaps shifting, group of Party members actually ran the daily affairs of the organization." See Baigell and Williams, *Artists Against War and Fascism*, 10–11.

5. Stuart Davis, "Why An Artists' Congress?," in Baigell and Williams, eds., *Artists Against War and Fascism*, 69.

6. Ibid., 69–70.

7. Aaron Douglas, "The Negro in American Culture," in Baigell and Williams, eds., *Artists Against War and Fascism*, 84.

8. Ibid.

9. Congress papers were subsequently turned into a book and sold for fifty cents. The print run was 3,000. Reprints of the papers are found in Baigell and Williams, eds., *Artists Against War and Fascism*.

10. José Clemente Orozco, "General Report of the Mexican Delegation to the American Artists' Congress," in Baigell and Williams, eds., *Artists Against War and Fascism*, 203–07.

11. Louis Lozowick papers, *Archives of American Art*, Printed Matter, 1936–1942, n.d., Box 4, Reel 5898, Frame 331, http://www.aaa.si.edu/collections/container/viewer/Printed-Matter–305715.

12. Ibid.

13. Other important exhibitions (not organized by the congress) included the 1938 exhibition *Housing: Roofs for Forty Million,* sponsored by the WPA-FAP and organized by the art cooperative An American Group. They also co-organized the 1937 exhibition *Waterfront Art Show,* with the Marine Workers Committee, which was held at the New School of Social Research and visualized the concerns of the dockworkers' strike. See Helen Langa, *Radical Art*, 35.

14. Alex R. Stavenitz, "American Today Exhibition," in Baigell and Williams, eds., *Artists Against War and Fascism*, 282. A catalogue for the show was also published during the same year: *America Today: A Book of 100 Prints Chosen and Exhibited by the American Artists' Congress* (New York: Equinox Cooperative Press, 1936).

15. Harry Sternberg, "Graphic Art," in Baigell and Williams, eds., *Artists Against War and Fascism*, 137.

16. Ibid.

17. Francis V. O'Connor, "Introduction," in *Art for the Millions: Essays from the 1930s by Artists and Administrators of the WPA Federal Art Project*, Francis V. O'Connor, ed. (Boston: New York Graphic Society, 1973), 19.

18. Baron's gallery also hosted the 1935 print show *The Struggle for Negro Rights* that was sponsored by five groups: the Artists' Union, the Artists' Committee of Action, the International Labor Defense, the John Reed Club, and the African American art group the Vanguard. *The Struggle for Negro Rights* was staged as a counterpoint to the NAACP anti-lynching exhibition *An Art Commentary on Lynching* that was organized by the acting secretary of the NAACP Walter Francis White and held at the Arthur U. Newton Galleries a month prior to the ACA exhibition.

19. After showing at the Valentine Gallery, *Guernica* was moved to MoMA. Picasso had refused to allow *Guernica* to return to Spain as long as the country was under fascist rule. After Franco's death in 1975 (and Picasso's in 1973), Spain became a democratic constitutional monarchy and ratified a new constitution in 1978. The Museum of Modern Art, reluctant to part with arguably its most famous painting, finally ceded in 1981 when the painting was shipped to the Museo del Prado in Madrid. It has subsequently been moved to the Museo Nacional Centro de Arte Reina Sofía. *Guernica* has taken on such a level of fame that even the crate that was utilized to ship the painting from MoMA back to Spain has been placed on exhibit.

20. Langa, *Radical Art*, 210–211.

21. Baigell and Williams, *Artists Against War and Fascism*, 30.

22. Ibid, 32.

## Chapter 17: Resistance or Loyalty: The Visual Politics of Miné Okubo

1. Following Pearl Harbor, martial law was declared in Hawaii. On December 9, two days following the attack, 1,291 Japanese, 865 Germans, and 147 Italians were in custody in Hawaii and the mainland. See Gary Y. Okihiro, "An American Story," in *Impounded: Dorothea Lange and the Censored Images of Japanese American Internment*, Linda Gordon and Gary Y. Okihiro, eds. (New York: W.W. Norton and Company, 2006), 52.

2. Ronald Takaki, *Strangers from a Different Shore: A History of Asian Americans: Updated and Revised Edition* (Boston: Back Bay Books, 1998), 391.

3. Ibid., 388.

4. Okihiro, "An American Story," 62.

5. Takaki, *Strangers from a Different Shore*, 391.

6. Japanese Americans and Japanese immigrants in California, Oregon, and Washington were sent to one of ten concentration camps: Amache, Colorado; Gila River, Arizona; Heart Mountain, Wyoming; Jerome, Arkansas; Manzanar, California; Minidoka, Idaho; Poston, Arizona; Rohwer, Arizona; Topaz, Utah; or Tule Lake, California. Temporary camps/assembly centers included Arizona (Mayer); Oregon (Portland); Washington (Puyallup); California (Fresno, Marysville, Merced, Pinedale, Pomona, Sacramento, Salinas, Santa Anita, Stockton, Tanforan, Tulare, and Manzanar). The U.S. Department of Justice also operated camps in Texas (Crystal City and Seagoville), Montana (Fort Missoula), Idaho (Kooskia), and New Mexico (Santa Fe) for "dangerous" suspects—that is, community leaders, fishermen, newspaper editors, and activists. See Stella Oh, "Paradoxes of Citizenship: Re-viewing the Japanese American Internment in Miné Okubo's *Citizen 13660*," in *Miné Okubo: Following Her Own Road*, Greg Robinson and Elena Tajoma Creef, eds. (Seattle: University of Washington Press, 2008), 155.

7. Miné Okubo, "Statement Before the Commission on Wartime Relocation and Internment of Civilians," in Robinson and Tajoma, *Miné Okubo*, 47.

8. The U.S. government promoted this notion through the propaganda film *The Japanese Relocation* and by tightly controlling media access to the camps. The press had been allowed to film the evacuation process, yet access to the camps was limited and those who were allowed to photograph the camps faced restrictions. Images that showed armed guards, crowded camp scenes, prison towers, or barbed wire were discouraged. Ansel Adams (hired by the WRA) presented this rubric in his MoMA exhibition and book *Born Free and Equal: The Story of Loyal Japanese Americans*. Other photographic images of the camps can be found in pictorial summaries that accompanied the "Final Report of the Western Defense Command," and two high school yearbooks from the Manzanar camp that included photographs by internee Toyo Miyataki.

9. Elena Tajima Creef, *Imaging Japanese America: The Visual Construction of Citizenship, Nation, and the Body* (New York: New York University Press, 2004), 80. Creef adds that throughout *Citizen 13660*, Okubo "constructs herself as a marginal figure, often standing at a distance on the very edge and border of the frame looking at the crowds of internees as through she herself were an outsider among the exiled," 80.

10. Deborah Gesensway and Mindy Roseman, *Beyond Words: Images from America's Concentration Camps* (Ithaca: Cornell University Press, 1987), 71.

11. Creef, *Imaging Japanese America*, 88.

12. Miné Okubo, *Citizen 13660* (Seattle: University of Washington Press, 1983, orig. pub. 1946), 177.

13. Laura Card, "Miné Okubo's Illustrations for *Trek* Magazine," in Robinson and Tajoma, eds., *Miné Okubo*, 132–33.

14. In fairness, Okubo also critiqued the questionnaire process within *Citizen 13660*. She writes, "Many of the Nisei also resented the question because of the assumption that their loyalty might be divided; it was confusing that their loyalty to the U.S. should be questioned at the moment when the army was asking them to volunteer." Yet she sided with the internees who were "patriotic" and joined the military, which included her brother. Okubo, *Citizen 13660*, 176. Around 4,600 (22 percent) of the 21,000 Nisei males who were eligible for draft said "no" on the questionnaire as a protest against their internment. Takaki, *Strangers from a Different Shore*, 397.

15. Another Supreme Court case, *Ex Parte Endo v. United States*, had a different verdict. Mitsuye Endo's lawyer successfully argued that the U.S. government had no right to detain U.S. citizens whom the WRA had deemed loyal to the United States. On December 18, 1944, the court ruled that she should be released, since her loyalty had been established. This ruling opened up a legal precedent against the camps, resulting in their eventual end.

16. Takaki, *Strangers from a Different Shore*, 397.

17. Heather Fryer, "Miné Okubo's War: Citizen 13660's Attack on Government Propaganda," in Robinson and Tajoma, eds., *Miné Okubo*, 97.

18. Okubo, *Citizen 13660*, 176.

19. Takaki, *Strangers from a Different Shore*, 398.

20. Ibid., 398–99.

21. Ibid, 399.

22. Okubo, *Citizen 13660*, 177.

23. Ibid., 199.

24. Ibid., 201. Okubo's opinion on the loyal versus disloyal question shifted over time. In her 1983 introduction to the reprinted edition of *Citizen 13660*, she writes, "One camp, in Tule Lake, California was for supposedly 'disloyal' persons . . . Incidentally, no cases of disloyalty were found in the camps," *Citizen 13660*, viii.

25. Greg Robinson, "Birth of a Citizen: Miné Okubo and the Politics of Symbolism," in Robinson and Tajoma, eds., *Miné Okubo*, 160. Greg Robinson also writes that in 1943 the WRA and the OWI teamed up to "produce an enormous pile of propaganda for public consumption, focusing jointly on the achievements of the WRA and on the loyalty and American character of the inmates. WRA efforts included informational pamphlets, documentary films, and speaking tours . . . The WRA and OWI also exerted pressure on publishers and film producers to promote responsible media images of Japanese Americans and avoid hostile depictions," 163.

26. Okubo, *Citizen 13660*, x.

27. Gesensway and Roseman, *Beyond Words*, 72–73.

28. Okubo, *Citizen 13660*, xii, xi.

29. Gesensway and Roseman, *Beyond Words*, 73. Okubo had good reason to fear that civil liberties would be threatened again. In 1950, the Internal Security Act enabled the attorney general to apprehend and place people in detention camps without a trial by jury. The ambiguous language noted that any person suspected of "probably" engaging in espionage or sabotage could be apprehended. It was aimed primarily at communist activists in the United States during the Cold War era. See Okihiro, *Impounded*, 78.

## Chapter 18: Come Let Us Build a New World Together

1. Danny Lyon, *Memories of the Southern Civil Rights Movement* (Chapel Hill: University of North Carolina Press, 1992), 26.

2. James Forman noted that by June 1962, the SNCC was $13,000 in debt. See James Forman, *The Making of Black Revolutionaries* (New York: The Macmillan Company, 1972), 246.

3. SNCC formed in April of 1960 when Ella Jo Baker, the executive secretary of the Southern Christian Leadership Conference (SCLC), gathered student leaders of the sit-in movement to meet in Raleigh, North Carolina, to discuss ideas for a more formal umbrella organization. Baker argued that the students should determine their own structure in contrast to the ideas of Martin Luther King Jr., Ralph Abernathy, and Wyatt Tee Walker, who wanted students to be part of a youth wing of SCLC.

4. This approach differed from SCLC and the other two main organizations—the Congress of Racial Equality (CORE) and the National Association for the Advancement of Colored People (NAACP). The SCLC primarily organized shorter actions—marches, boycotts, and confrontation actions meant to incite violent police reactions and mass media coverage that would spur a national outrage and prompt the federal government to intervene. This work was critical and highly successful, but it did not carry the same risks that SNCC workers did when they embedded themselves in the rural communities of the South.

5. Steven Kasher, *The Civil Rights Movement: A Photographic History: 1954–68* (New York: Abbeville Press, 1996), 16.

6. Julian Cox, *Road to Freedom: Photographs of the Civil Rights Movement: 1956–1968* (Atlanta: High Museum of Art, 2008), 29.

7. Ibid.

8. Lyon, *Memories of the Southern Civil Rights Movement*, 30.

9. Ibid.

10. Kasher, *The Civil Rights Movement*, 16.

11. Forman, *The Making of Black Revolutionaries*, 299.

12. Lyon, *Memories of the Southern Civil Rights Movement*, 30.

13. Ibid., 80.

14. Ibid.

15. Vanessa Murphree, *The Selling of Civil Rights: The Student Nonviolent Coordinating Committee and the Use of Public Relations* (New York, Routledge, 2006), 29.

16. Some 86 percent of African Americans in Mississippi lived below the national poverty level. Their annual income was $1,444—the lowest in the country. Only 7 percent of African Americans finished high school, and only 5 percent were eligible to vote. Those who attempted to register to vote risked losing their jobs and being evicted from their homes. Those who organized risked their lives. See Kasher, *The Civil Rights Movement*, 132.

17. Ibid., 135.

18. Ibid.

19. Lyon, *Memories of the Southern Civil Rights Movement*, 146.

20. Ibid., 42.

21. Ibid.

22. SNCC was not the only group involved in the Summer Project. SNCC, CORE, the SCLC, and the NAACP had come together to form COFO (Council of Federated Organizations), which

all took on different tasks. Part of the reason for the alliance was to equally divvy up the money gained from national fund-raising efforts. That said, Bob Moses of SNCC was a principal organizer of the project, and SNCC committed a vast amount of energy and people to the project, setting up numerous offices across Mississippi.

23. Forman, *The Making of Black Revolutionaries*, 373.

24. Ibid., 372.

25. Murphree, *The Selling of Civil Rights*, 63.

26. Leigh Raiford, "'Come Let Us Build a New World Together': SNCC and Photography of the Civil Rights Movement," *American Quarterly* 59, no. 4 (December 2007): 1139.

27. The Southern Documentary Project included Herron, George Ballis, Fred de Van, Nick Lawrence, Danny Lyon, Norris McNamara, Dave Prince, and Maria Varela. Many of the images taken were distributed through the Black Star Photo Agency in New York and were featured in publications including *LIFE* magazine. See Kasher, *The Civil Rights Movement*, 150.

28. Ibid., 144.

29. Raiford, "Come Let Us Build a New World Together," 1139.

30. Kasher, *The Civil Rights Movement*, 141.

31. Murphree, *The Selling of Civil Rights*, 58.

32. Ibid. 67.

33. The decision to exclude whites from SNCC was mired in controversy and remains contentious to this day. The debate took place during the December 1966 SNCC retreat at the Peg Leg Bates resort in upstate New York. Lyon writes, "Approximately one hundred staff members were present at the conference. At two o'clock one morning, when many of the staff had gone off to go to sleep, SNCC passed a resolution to exclude whites. Nineteen voted for the resolution, eighteen voted against it, and twenty-four abstained, including all the white people present . . . To this day, many SNCC veterans think that the whites were not thrown out but instead were directed to work in the white community." See Lyon, *Memories of the Southern Civil Rights Movement*, 175.

34. The shift to self-defense and militancy was cemented by Hubert "Rap" Brown—the SNCC chairman who replaced Carmichael—who, during a forty-five-minute speech in Cambridge, Maryland, on July 25, 1967, stated in response to the KKK attacks against the black community, "If America don't come around, we are going to burn it down, brother." Soon thereafter, gunfire was exchanged between the police and demonstrators, and seventeen buildings were damaged or completely destroyed by fire. Brown was later charged with arson due to his speech and served jail time. See Murphree, *The Selling of Civil Rights*, 146.

35. Lyon, *Memories of the Southern Civil Rights Movement*, 135.

## Chapter 19: Party Artist: Emory Douglas and the Black Panther Party

1. Bobby Seale, *Seize the Time: The Story of the Black Panther Party and Huey P. Newton* (Baltimore, MD: Black Classics Press, 1991, orig. pub. 1970), 62.

2. October 1966 Black Panther Party Platform and Program, "What We Want, What We Believe," in *The Black Panthers Speak*, Philip S. Foner, ed. (Cambridge, MA: De Capo Press, 1995), 3.

3. Jane Rhodes, *Framing the Black Panthers: The Spectacular Rise of a Black Power Icon* (New York: The New Press, 2007), 58.

4. Elton C. Fax, *Black Artists of the New Generation* (New York: Dodd, Mead, and Company, 1977), 273.

5. Rhodes, *Framing the Black Panthers*, 100.

6. St. Clair Bourne, "An Artist for the People: An Interview with Emory Douglas," in *Black Panther: The Revolutionary Art of Emory Douglas*, Sam Durant, ed. (New York: Rizzoli, 2007), 200.

7. Douglas would eventually be part of the BPP Central Committee, along with Newton, Seale, Cleaver, David Hilliard, and Kathleen Cleaver.

8. Rhodes, *Framing the Black Panthers*, 101.

9. Bourne, "An Artist for the People," 200.

10. Seale, *Seize the Time*, 404.

11. Davarian L. Baldwin, "Culture Is a Weapon in Our Struggle for Liberation: The Black Panther Party and the Cultural Politics of Decolonization," in *In Search of the Black Panther Party: New Perspectives on a Revolutionary Movement*, Jama Lazerow and Yohuru Williams, eds. (Durham: Duke University Press, 2006), 296.

12. Seale, *Seize the Time*, 62–63.

13. Rhodes, *Framing the Black Panthers*, 236.

14. Ibid., 96.

15. Seale, *Seize the Time*, 181.

16. Rhodes, *Framing the Black Panthers*, 105.

17. Ibid., 296.

18. Seale, *Seize the Time*, 180.

19. Emory Douglas, "Position Paper No. 1 on Revolutionary Art," *The Black Panther*, January 24, 1970; republished in *Art and Social Change: A Critical Reader*, William Bradley and Charles Esche, eds. (London: Tate Publishing, in association with Afterall, 2007), 166.

20. Malcolm X speech on the founding of the OAAU, June 28, 1964. See Malcolm X. *By Any Means Necessary: Speeches, Interviews, and a Letter by Malcolm X.* (New York: Pathfinder Press, 1970), 35–67.

21. Huey P. Newton, "The Correct Handling of a Revolution," *The Black Panther*, May 18, 1968; republished in Foner, ed., *The Black Panthers Speak*, 43.

22. "Douglas, Position Paper No. 1 on Revolutionary Art," 166.

23. Greg Jung Morozumi, "Emory Douglas and the Third World Cultural Revolution," in Durant, ed., *Black Panther: The Revolutionary Art of Emory Douglas*, 130.

24. Jama Lazerow and Yohuru Williams write, "Most estimates in the late sixties and early seventies hovered around 1,500 to 2,000; since those estimates, other sources have suggested figures as high as 5,000. In a recent essay on the Illinois chapter of the Black Panther Party, Jon Rice maintains (based on an interview with one Panther) that in spring 1969 there were 1,000 members of the Party in Chicago alone." See "The Black Panthers and Historical Scholarship: Why Now?" in Lazerow and Williams, eds., *In Search of the Black Panther Party*, 4.

25. Erika Doss, "Revolutionary Art Is a Tool for Liberation: Emory Douglas and Protest Aesthetics at *The Black Panther*," in *Liberation, Imagination, and the Black Panther Party: A New Look at the Panthers and Their Legacy*, Kathleen Cleaver and George Katsiaficas, eds. (New York: Routledge, 2001), 186.

26. Chisholm was a progressive Democrat who was elected to the New York state legislature in 1964, and in 1968 she became the first black woman elected to Congress. In 1972, she was the first Democratic black candidate for president. She lost in the Democratic primary and survived three

attempted assassination attempts during the campaign. Chisholm held her seat in Congress from 1969 to 1983 and advocated on behalf of inner-city residents; promoted bills for social spending for education, health care, minimum wage, and day care; and opposed military funding and the draft.

27. Fax, *Black Artists of the New Generation*, 278.

28. Edward P. Morgan, "Media Culture and the Public Memory of the Black Panther Party," in Lazerow and Williams *In Search of the Black Panther Party*, 335.

29. *The Black Panther*, May, 18, 1968; republished in Foner, ed., *The Black Panthers Speak*, 43.

30. Bourne, "An Artist for the People," 203.

## Chapter 20: Protesting the Museum Industrial Complex

1. Malevich's painting was not chosen arbitrarily. He was a modernist abstract artist who joined the Russian Revolution, and his paintings became part of the visual language of revolutionary art. GAAG, thus, aligned themselves in solidarity with Malevich and suggested that his work had lost its radical meaning hanging on the walls of MoMA as an art object.

2. The Guerrilla Art Action Group, *The Guerrilla Art Action Group: 1969–1976: A Selection* (New York, Printed Matter, 2011, orig. pub. in 1978), Number 2.

3. Ibid.

4. Ibid., Number 3.

5. Ibid., Number 3.

6. "Guerrilla Art Action—Toche and Hendricks talk to Gregory Battcock," interview, October 18, 1971, in ibid., Number 25.

7. The Guerrilla Art Action Group, *The Guerrilla Art Action Group*, Number 49.

8. Ibid.

9. Ibid., Number 10.

10. Ibid.

11. Bradford D. Martin, *The Theater Is in the Street: Politics and Performance in Sixties America* (Amherst: University of Massachusetts Press, 2004), 154.

12. Ibid., 126.

13. Lucy R. Lippard, "Biting the Hand: Artists and Museums in New York Since 1969," in *Alternative Art New York, 1965–1985*, Julie Ault, ed. (Minneapolis: University of Minnesota Press/The Drawing Center, 2002), 79.

14. Julia Bryan-Wilson, *Art Workers: Radical Practice in the Vietnam Era* (Berkeley: University of California Press, 2009), 120.

15. Ibid., 117.

16. Roman Petruniak, *Art Workers on the Left: The Art Workers Coalition and the Emergence of a New Collectivism* (A Thesis Submitted in Partial Fulfillment of the Requirements for the Degree of Master of Arts, Department of Art History, Theory & Criticism, the School of the Art Institute of Chicago, 2009), 58.

17. Ibid., 74.

18. Equal gender representation in exhibitions was not included in the first list of demands, but it was later added—a sign of the frustration that many women artists had with the men in AWC who tried to control leadership.

19. Bryan-Wilson, *Art Workers*, 113.

20. Petruniak, *Art Workers on the Left*, 74.

21. Bryan-Wilson, *Art Workers*, 117.

22. Lucy R. Lippard, *Get the Message? A Decade of Art for Social Change* (New York: E.P. Dutton, Inc., 1984), 30.

23. Ibid., 30–31.

24. The AWC influenced others to organize as well. The Artists' Reserved Rights Transfer and Sale Agreement was drafted in 1971 by artist Seth Sigelaub and lawyer Bob Projansky. Their other influence can be felt in the passing of the Visual Artists Rights Act of 1990. For more recent discussions on artists' rights and artists' economic issues, see, Temporary Services, *Art Work: A National Conversation About Art, Labor, and Economics*, 2009, http://www.artandwork.us/.

Additionally, the AWC helped influence artists to start spaces. Their meeting space was a rented loft called "MUSEUM" at 729 Broadway. Petruniak argues that this space "set a precedent for the later development of the 'Alternative Spaces Movement' throughout the seventies and eighties"—most notably Artists' Meeting for Cultural Change (1975), Collab (1978), Group Material (1979), ABC No Rio (1980), PAD/D, and REPOhistory (1989). See Petruniak, *Art Workers on the Left*, 101.

24. Francis Frascina, *Art, Politics and Dissent: Aspects of the Art Left in Sixties America* (Manchester; Manchester University Press, 1990), 175.

26. Frazer Dougherty is often listed as Frazier Dougherty or Fraser Dougherty.

27. Frascina, *Art, Politics and Dissent*, 182.

28. Martin, *The Theater Is in the Street*, 149.

29. Frascina, *Art, Politics and Dissent*, 184.

30. The AWC had previously tried unsuccessfully to lobby Picasso to remove *Guernica* from MoMA as a protest against U.S. intervention in Vietnam.

31. Temporary Services, *Jean Toche / Guerilla Art Action Group* (self-published zine, part of the Temporary Conversations series, 2008), 25.

## Chapter 21: The Living, Breathing Embodiment of a Culture Transformed

1. Faith Wilding, "The Feminist Art Programs at Fresno and CalArts, 1970–75," in *The Power of Feminist Art: The American Movement of the 1970s, History and Impact*, Norma Broude and Mary D. Garrard, eds. (New York: Harry N. Abrams, Inc., 1994), 35.

2. Faith Wilding, *By Our Own Hands: The Women Artist's Movement, Southern California 1970–1976* (Santa Monica: Double X, 1977), 10.

3. Wilding, *By Our Own Hands*, 11.

4. Wilding, "The Feminist Art Programs," 34.

5. Ibid., 35.

6. Ibid.

7. Wilding, *By Our Own Hands*, 14.

8. Arlene Raven, "Womanhouse," in Broude and Garrard, eds., *The Power of Feminist Art*, 58.

9. Faith Wilding, "The Feminist Art Programs," 41.

10. Ibid.

11. Cheri Gaulke, "1+1=3: Art and Collaboration at the WB," in *Doin' It in Public: Feminism and Art at the Woman's Building*, Meg Linton and Sue Maberry, curators (exhibition catalog, Ben Maltz Gallery, Otis College of Art and Design, 2011), 23.

12. Ibid., 27.

13. Jenni Sorkin, "Learning from Los Angeles: Pedagogical Predecessors at the Woman's Building" in Linton and Maberry, *Doin' It in Public*, 60.

14. An incomplete list of some of the radical artists' groups and radical alternative spaces that were established during the same period as the Woman's Building, or after, include: Artists' Meeting for Cultural Change (1975), Collab (1978), Group Material (1979), ABC No Rio (1980), PAD/D (1981), Guerrilla Girls (1985), Critical Art Ensemble (1987), REPOhistory (1989), Temporary Services (1998), 16 Beaver Group (1999), the Dirt Palace (2000), the Beehive Collective (2000), Mess Hall (2003), Justseeds Artists' Cooperative (2007), and InCUBATE (2007).

15. Gaulke, "1+1=3," 29.

## Chapter 22: Public Rituals, Media Performances, and Citywide Interventions

1. Cheri Gaulke, "Acting Like Women: Performance Art of the Woman's Building," in *The Citizen Artist: 20 Years of Art in the Public Arena: An Anthology from High Performance Magazine 1978–1998*, Linda Frye Burnham and Steven Durland, eds. (Gardiner, NY: Critical Press, 1998), 14.

2. Suzanne Lacy, *Leaving Art: Writings on Performance, Politics, and Publics: 1974–2007* (Durham: Duke University Press, 2010), 96.

3. Suzanne Lacy, "Affinities: Thoughts on an Incomplete History," in *The Power of Feminist Art: The American Movement of the 1970s, History and Impact*, Norma Broude and Mary D. Garrard, eds. (New York: Harry N. Abrams, Inc., 1994), 269.

4. Sharon Irish, *Suzanne Lacy: Spaces Between* (Minneapolis: University of Minnesota Press, 2010), 65.

5. Groups and organizations that help co-organize *Three Weeks in May* included the Studio Watts Workshop, the City Attorney's Office, the Commission on Public Works, the Los Angeles Commission on the Status of Women, Women Against Violence Against Women, the East Los Angeles Hotline, the American Civil Liberties Union, the Los Angeles Police Department, the Sheriff's Department, and the Ocean Park Community Center Women's Shelter. See Irish, *Spaces* Suzanne Lacy, 64.

6. Ibid.

7. Laura Meyer, "Constructing a New Paradigm: European American Women Artists in California 1950–2000," in *Art, Women, California 1950–2000: Parallels and Intersections*, Diana Burgess Fuller and Daniela Salvioni, eds. (Berkeley: University of California Press, 2002), 107.

8. Richard Newton, "She Who Would Fly: An Interview with Suzanne Lacy," in Burnham and Durland, eds., *The Citizen Artist*, 11.

9. Irish, *Suzanne Lacy*, 71.

10. Lacy, *Leaving Art*, 122.

11. Lacy, "Affinities," 267.

## Chapter 23: No Apologies: Asco, Performance Art, and the Chicano Civil Rights Movement

1. "Oral History Interview with Harry Gamboa Jr., 1999, Apr. 1–16," Archives of American Art, Smithsonian Institution.

2. Ibid.

3. C. Ondine Chavoya, "Social UnWest: An Interview with Harry Gamboa Jr.," *Wide Angle*, 20, no 3 (July 1998): 54–78.

4. See Mario T. García and Sal Castro: *Blowout! Sal Castro and the Chicano Struggle for Educational Justice* (Chapel Hill, University of North Carolina Press, 2011).

5. Nora Bebavidez, "Harry Gamboa, Jr: L.A. Urban Exile," interview, August, 23, 2010, http://www.harrygamboajr.com.

6. C. Ondine Chavoya, "Internal Exiles: The Interventionist Public and Performance Art of Asco," in *Space, Site, Intervention: Situating Installation Art*, Erika Suderburg, ed. (Minneapolis: University of Minnesota Press, 2000), 203.

7. An Asco work that responded directly to the events of the National Chicano Moratorium March and the death of Salazar was their 1977 mural *Black and White Mural*, painted by Herrón and Gronk. The mural was painted at the Estrada Courts Housing Projects in East L.A., and Herrón and Gronk painted it to look like a series of black-and-white film reels or television screen shots. Images of the riot and Salazar's death were interwoven with snapshots of Asco performances, abstract images, graffiti tags, and other images. See Max Benavidez, *Gronk* (Los Angeles: UCLA Chicano Studies Research Center Press, 2007), 22–33.

8. Yolanda Alaniz and Megan Cornish, *Viva La Raza: A History of Chicano Identity and Resistance* (Seattle: Red Letter Press, 2008), 187.

9. Chavoya, "Social UnWest," 54–78.

10. Sandra de la Loza argues that other factors also influenced Chicana/o murals at the time in Los Angeles: "Although dominant discourse on Chicana/o art of the 1970s tends to focus on overt examples of Chicana/o iconography and political imagery, there is no denying the aesthetic and ideological impact of psychedelia and the countercultural impulse of the time . . . Third World liberation movements, student strikes, antiwar demonstrations, and experimentation with music, drugs, sexuality, and lifestyles all contributed to a visual language that became popular in the larger culture and surfaced in Chicana/o murals." See Sandra de la Loza, "La Raza Cosmica: An Investigation into the Space of Chicana/o Muralism," in *L.A. Xicano*, Chon A. Noriega, Terezita Romo, and Pilar Tompkins Rivas, eds. (Los Angeles: UCLA Chicano Studies Research Center Press, 2011), 57.

11. Steven Durland and Linda Burnham, "Interview with Gronk," *High Performance* 35, vol. 9, no. 3 (1986): 57.

12. George Vargas, *Contemporary Chicano Art: Color and Culture for a New America* (Austin: University of Texas Press, 2010), 206.

13. Chavoya, "Internal Exiles," 205.

14. Asco's name came about after the group had already been collaborating for three years. In September 1974 Gronk, Herrón, and Valdez staged an art show at Self Help Graphics titled *Asco: An Exhibition of Our Worst Work*. Shortly thereafter, Asco became the official name of the collective.

15. Chavoya, "Internal Exiles," 197.

16. Description of the work inspired by Noriega's analysis, which reads, "Herrón's tortured mural faces—perhaps a veiled reference to the tripartite 'mestizo head' symbolizing the racial mixture of Spanish and Indigenous peoples in the Americas—become so bored with their place within the racial mythology of Chicano nationalism that they walk off the wall and into the streets," Ibid., 10.

17. Ibid., 196.

18. Ibid.

19. Vargas, *Contemporary Chicano Art*, 203.

20. Ibid., 206.

21. Photographic stills and media manipulation were the driving concept behind Asco's project *No Movies*. Gamboa would photograph Asco members dressed up as film stars, playing pretend roles in pretend movies. Gronk describes *No Movies* as "making a movie without the use of celluloid. It's projecting that real without the reel." The stills would then be mailed off as representations of real movies. Conceptually, *No Movies* critiqued the lack of access that Chicanos had to the film and media industry. See Harry Gamboa Jr., in *Urban Exile: Collected Writings of Harry Gamboa Jr.*, (Chon A. Noriega, ed. Minneapolis: University of Minnesota Press, 1998), 12.

22. Chavoya, "Internal Exiles," 194–195.

23. Valdez was not invited to take part in the spray-paint action, for the three men in Asco felt it was too dangerous and anticipated having to run from the police or getting arrested. Instead, she was photographed the following morning by Gamboa Jr. standing on a walkway above the tags. Valdez's diminished role in this action left Asco open for criticism for reinforcing patriarchal attitudes.

24. Harry Gamboa Jr., "In the City of Angels, Chameleons, and Phantoms: Asco, a Case Study of Chicano Art in Urban Tones (or, Asco Was a Four-Member Word) (1991)," in *Urban Exile*, 79.

25. Chon A. Noriega, "Asco: Your Art Disgusts Me," *Afterall* 19, no. 19, (Autumn/Winter, 2008): 109.

26. Gamboa Jr. "In the City of Angels," 82.

27. "Oral History Interview with Willie Herrón, 2000 Feb. 5–March 17," Archives of American Art, Smithsonian Institution.

28. Ibid.

29. By the late '70s/ early '80s, the four original members of Asco began to collaborate less with one another. They transitioned into individually based projects and other forms of expression, including music and running alternative art spaces. During this time, Asco took on more members, expanding to more than twenty artists. Past projects even became absorbed into museum shows, including LACMA, the same institution that they had so poignantly critiqued. That said, Asco members have not softened their critique of institutions. Gamboa Jr. stated in a 2004 interview, "Museums are basically display cases for the wealthy and for a particular audience. The museums here in L.A. are particularly anti-Chicano and so are their audiences. And I'm not about to waste another breath on them. The way that capitalism causes cultural amnesia it will be amazing if anyone remembers that our ancestors were from Mexico to begin with!" See Jennifer Flores Sternad, "Harry Gamboa Jr.: Ephemerality in an Urban Desert: an Interview," *The Journal of American Drama and Theatre* 16, no. 3 (Fall 2004): 52–62.

30. Benavidez, *Gronk*, 40.

## Chapter 24: Art Is Not Enough

1. Deborah B. Gould, *Moving Politics: Emotion and ACT UP's Fight Against AIDS* (Chicago: University of Chicago Press, 2009), 104, 137.

2. Ibid., 60.

3. Ibid., 236.

4. ACT UP was not the first group, and certainly not the only group, to address the AIDS crisis, but the organization gained the most media attention for their confrontational tactics.

5. Gould, *Moving Politics*, 188.

6. Major insurance companies would not cover people with AIDS or people at risk for AIDS. Medicaid would, but would not cover the costs of experimental drugs. See Douglas Crimp with Adam Rolston, *AIDS Demo Graphics* (Seattle: Bay Press, 1990), 28.

7. Gould, *Moving Politics*, 190.

8. Sarah Schulman, "Interview with Michael Nesline," March 24, 2003, *ACT UP Oral History Project,* interview number 014, 14.

9. Ibid., 15.

10. Rolston, *AIDS Demo Graphics*, 20.

11. Gran Fury (Tom Kalin, Michael Nesline, and John Lindell), "A Presentation," in *Art and Social Change: A Critical Reader*, William Bradley and Charles Esche, eds. (London: Tate Publishing in Association with Afterall, 2007), 280.

12. Gran Fury's members included Richard Elovich, Avram Finkelstein, Amy Heard, Tom Kalin, John Lindell, Loring McAlpin, Marlene McCarty, Donald Moffett, Michael Nesline, Mark Simpson, and Robert Vazquez-Pacheco. McAlpin and McCarty also notes that Anthony Viti, Todd Haynes, and Ana Held were involved in the collective for a short duration. See Sarah Schulman, "Interview with Loring McAlpin," August 18, 2008, *ACT UP Oral History Project,* interview number 098, 30; Sarah Schulman, "Interview with Marlene McCarty, February 21, 2004, *ACT UP Oral History Project,* interview number 044, 17.

13. Rolston, *AIDS Demo Graphics*, 72.

14. Gould, *Moving Politics*, 96.

15. Rolston, *AIDS Demo Graphics*, 73.

16. Karrie Jacobs and Steven Heller, *Angry Graphics: Protest Posters of the Reagan/Bush Era* (Layton: Utah: Peregrine Smith Books, 1992), 14.

17. The AIDS crisis was severely underreported by the *New York Times* during the early stages of the epidemic. Seven articles were run over a nineteen-month period, compared to fifty-four articles on the Tylenol scare in 1982.

18. Schulman, "Interview with Michael Nesline," 32.

19. Ibid., 30.

20. Jacobs and Heller, *Angry Graphics*, 12.

21. A 1989 image, *I Am Out, Therefore I Am* by Adam Rolston (part of the GANG collective, not Gran Fury), illustrates this point, as it is nearly identical to Barbara Kruger's 1987 image *I Shop, Therefore I Am*. The only difference is the slogan. Even the style of font is copied. Marlene McCarty recalled meeting Barbara Kruger in person and saying to her, "You know, we owed you a lot." Kruger's response was, "I know, but I'm glad you did it." Kruger understood that the graphics produced by ACT UP operated in a different realm. They were not designed for art fame or to make a profit,

they were designed to serve the needs of a movement where issues of artistic originality became irrelevant. See Sarah Schulman, "Interview with Marlene McCarthy," February 21, 2004, *Act Up Oral History Project*, interview number 044, 33–34.

22. Ibid., 34.

23. For a critique of the Benetton ad campaign, see Henry A. Giroux, "Benetton's 'World Without Borders': Buying Social Change," in *The Subversive Imagination: Artists, Society, and Social Responsibility*, Carol Becker, ed. (New York: Routledge, 1994), 187–207.

24. The photo for the Gran Fury ad, according to Gran Fury member Robert Vazquez-Pacheco, was shot at a friend's loft, where friends and people in ACT UP/NYC dressed up, posed in front of the camera and started kissing. The set was shot as still images and also as a video. Vazquez-Pacheco was paired with a woman and recalls, "A cousin of mine was one day crossing the street and this bus went by and she saw my face. She saw my face kissing a girl. She called me and she was like, 'Robert, were you in a poster? Were you in a Benetton's [sic] ad?' Which I loved, because everyone thought it was a Benetton's ad. She was hesitant, like, 'You were kissing a girl.' I was like, 'Yeah, what you do for art.'" Sarah Schulman, "Interview with Robert Vazquez-Pacheco," December 14, 2002, *ACT UP Oral History Project*, interview number 002, 59–60.

25. Ibid., 59.

26. Richard Meyer, *Outlaw Representation: Censorship and Homosexuality in Twentieth-Century American Art* (Boston: Beacon Press, 2002), 237.

27. Ibid., 238.

28. Ibid., 241.

29. Sarah Schulman, "Interview with Loring McAlpin," August 18, 2008, *ACT UP Oral History Project*, interview number 098, 39–40.

30. Sarah Schulman, "Interview with Marlene McCarty," February 21, 2004, *ACT UP Oral History Project*, interview number 044, 20–21.

## Chapter 25: Antinuclear Street Art

1. *Groundwork* flyer, Fales Library and Special Collections, New York University, REPOhistory Archive, 1911–1999 (Bulk 1989–1999), MSS 113, Series 5: Members Files, Box 13, Folder 11.

2. Ibid.

3. Josh Daniel, "New York City's Big Secret: The Nuclear Homeport," *EXTRA*, May/June, 1988, 6–7.

4. Ibid.

5. Ibid.

6. Artists who participated in *Groundwork,* to the best of my research, include Rachel Avenia, Stephanie Basch, Terry Berkowitz, Mariella Bisson, Roger Boyce, Keith Christensen, Ed Eisenberg, Harry Eriksen, John Fekner, Shelly Haven, Carin Kuoni, John LoCicero, Robert Morris, Mike Murphy, Paul Nagle, Susan Rapalee, Kristin Reed, Robert Reed, Janet Restino, Gregory Sholette, Jody Wright, Eva Cockcroft, Olivia Beens, Janet Koenig, Mimi Smith, and Tess Tomoney.

7. *Groundwork* press release, October 27, 1989, Fales Library and Special Collections, New York University, REPOhistory Archive, 1911–1999 (Bulk 1989–1999), MSS 113, Series 5: Members Files, Box 13, Folder 11.

8. Terence J. Kivlan, "The Fighting Continues on Stapleton Homeport," *Staten Island Advance*, April 25, 1990.

9. Thank you to Gregory Sholette, who discussed by phone some of the overarching goals of *Groundwork* and the community of artists that influenced its practice.

10. E-mail correspondence between Tom Klem and the author, December 6, 2010.

## Chapter 26: Living Water: Sustainability Through Collaboration

1. Sue Spaid, *Ecovention: Current Art to Transform Ecologies* (Cincinnati, OH: co-published by Greenmuseum.org, the Contemporary Arts Center, ecoartspace, 2002), 139.

2. Linda Weintraub, *In the Making: Creative Options for Contemporary Art* (New York: D.A.P./ Distributed Art Publishers, Inc., 2003), 360.

3. Richard Whittaker, "An Interview with Betsy Damon, Living Water," conversations.org, December 25, 2009; 25 April 25, 2010, http://www.conversations.org/story.php?sid=222.

4. Ibid.

5. Mary Padua, "Teaching the River," in *Waterfront World Spotlight* 17, no. 1 (Winter 1999): 105.

6. Ibid., 102.

7. Weintraub, *In the Making*, 360.

8. Ibid.

9. Ibid., 356.

10. Whittaker, "An Interview with Betsy Damon."

11. Terri Cohn, "Betsy Damon: Living Water Garden," *Sculpture* 19, no. 2 (March 2000): 55.

12. Whittaker, "An Interview with Betsy Damon."

13. "Living Water: Combining Art and Science to Rejuvenate Communities and Restore Waterways," *Bush Fellows News*, Autumn 2000, 3.

14. Padua, "Teaching the River," 107.

## Chapter 27: Art Defends Art

1. Judith F. Baca, "Artist Statement: May 12, 2005," Sparcmurals.org, April 25, 2010, http://www.sparcmurals.org/sparcone/index.php?option=com_content&task=view&id=209&Itemid=124&limit=1&limitstart=8.

2. Ibid.

3. Ibid.

4. Ibid.

5. Save Our State Declaration, reposted on Sparcmurals comment page. 13 June 13, 2005; April 25, 2010, http://www.sparcmurals.org/sparcone/index.php?option=com_content&task=view&id=209&Itemid=124&limit=1&limitstart=2.

6. Ibid.

7. Video footage of the May 14, 2005, demonstration and counterdemonstration can be seen at http://www.youtube.com/watch?v=f-GEj58Rb80.

8. Wendy Thermos, "Immigration Protest in Baldwin Park Is Peaceful," *Los Angeles Times*, June 26, 2005.

9. David Pierson and Wendy Lee, "A Monumental War of Words," *Los Angeles Times*, June 25, 2005.

10. "Protest Report from the Social and Public Art Resource Center: Baldwin Park, CA," May 16, 2005, Sparcmurals.org, http://www.sparcmurals.org/sparcone/index.php?option=com_content &task=view&id=209&Itemid=124&limit=1&limitstart=7.

11. Pierson and Lee, "A Monumental War of Words."

12. "Protest Report from the Social and Public Art Resource Center."

13. Baca, "Artist Statement: May 12, 2005."

14. Ibid.

15. Guest post, "Truth, Reconciliation and Consequences," Sparcmurals.org comment page, Sparcmurals.org, May 16, 2005, http://www.sparcmurals.org/sparcone/index.php?option=com_ content&task=view&id=209&Itemid=124&limit=1&limitstart=2.

16. Cesar Lopez, "A Different Mirror," Sparcmurals.org comment page, May 16, 2005, http:// www.sparcmurals.org/sparcone/index.php?option=com_content&task=view&id=209&Itemid =124&limit=1&limitstart=2.

17. Judith F. Baca, public lecture, University of Wisconsin–Milwaukee, March 29, 2007.

18. Judith F. Baca, "Documenting Our Presence: History, Cultura, y Arte," Sparcmurals.org, June 12, 2005, http://www.sparcmurals.org/sparcone/index.php?option=com_content&task=view &id=209&Itemid=124&limit=1&limitstart=5.

19. "Statement of the Committee to Defend *Danzas Indigenas*," Sparcmurals.org, n.d., http:// www.sparcmurals.org/sparcone/index.php?option=com_content&task=view&id=209 &Itemid=124&limit=1&limitstart=4.

20. Ibid.

21. Ibid.

22. Ibid.

23. Judith F. Baca, letter to supporters following the second demonstration, Sparcmurals.org, http://www.sparcmurals.org/sparcone/index.php?option=com_content&task=view&id=209 &Itemid=169&limit=1&limitstart=1.

24. Judith F. Baca, letter to supporters before June 25, 2005, counterdemonstration, Sparc- murals.org, n.d., http://www.sparcmurals.org/sparcone/index.php?option=com_content&task =view&id=209&Itemid=169&limit=1&limitstart=3.

### Chapter 28: Bringing the War Home

1. "Operation First Casualty," YouTube, June 5, 2007, http://www.youtube.com/watch ?v=GdXY3Y4q_Ds.

2. Nicolas Lampert, "Aaron Hughes," interview, *Temporary Services* (self-published zine), part of the Temporary Conversations Series, 2010), 17.

3. Ibid., 20.

4. Ibid., 20.

5. Ibid., 17.

6. OFC was not without precedent. Vietnam Veterans Against the War (VVAW) had per- formed "Operation Raw" in the 1970s—a sixty-mile road march, where veterans marched through

small towns in the Northeast with fake weapons as if they were patrolling villages in Vietnam. Soldiers wore white face makeup to draw attention to the racism found within the military and the process of dehumanizing the Vietnamese.

7. Martin Smith, "Structured Cruelty: Learning to Be a Lean, Mean, Killing Machine," in *Warrior Writers: Re-Making Sense: A Collection of Artwork by Members of Iraq Veterans Against the War*, Lovella Calica, ed. (Iraq Veterans Against the War, 2008) 32–33.

8. "Operation First Casualty."

9. Lampert, "Aaron Hughes," 21.

10. Ibid. 21–22.

11. Ibid., 22.

12. Ibid., 28.

13. Robin Caudell, "War, What Is It Good For? Combat Paper," Press Republican.com, May 9, 2009, http://www.pressrepublican.com/0705_people/local_story_129223929.html.

14. Nan Levinson, "The Power in Their Pain: Iraq War Veterans Create Art to Protest," *Boston Globe*, April 22, 2008, http://www.boston.com/ae/theater_arts/articles/2008/04/22/the_power _in_their_pain/?page=1.

15. *Combat Paper Project*, http://www.combatpaper.org/about.html.

16. Jan Barry, "Culture Warriors," *Earth Air Water*, December 15, 2008, http://earthairwater .blogspot.com/2008/12/culture-warriors.html.

17. Elise Hennigan, "Art as Catharsis—The Combat Paper Project," *Juxtapoz*, November 11, 2009, http://www.juxtapoz.com/Features/art-as-catharsisthe-combat-paper-project.

18. Stacy Teicher Khadaroo, "Shredding War's Dark Memories: Iraq War Veterans Release Their Angst by Turning Their Uniforms Into Paper," *Christian Science Monitor*, October 5, 2009.

19. Julia Rappaport, "War in Pieces: Combat Paper Project Sees Veterans Use Uniforms to Heal," *Vineyard Gazette Online*, July 25, 2008, http://www.mvgazette.com/article.php?17547.

20. Ibid.

21. Russ Bynum, "Veterans Shred Uniforms to Heal Themselves Through Art," *Stars and Stripes online edition*, August 6, 2009 http://www.stripes.com/article.asp?section=104&article=64052.

22. Ibid.

23. Ibid.

24. Lampert, "Aaron Hughes," 17.

## Chapter 29: Impersonating Utopia and Dystopia

1. *The Yes Men Fix the World*, Dir. Andy Bichlbaum, Mike Bonanno, Kurt Engfehr, 2009, Film.

2. The Yes Men developed out of an earlier project, RTMark, which was an Internet-based infrastructure developed to fund and help facilitate activist art projects. The premise was that artists and activists would list projects that they wanted to create and visitors to the site could select which ones they wanted to fund. In essence, it was a tool kit for creative disruption and anticorporate activism that reached a zenith during the 1999 protests against the World Trade Organization meetings in Seattle. The Yes Men would go on to impersonate the WTO, falsely representing them at conferences, and going as far as to announce their dissolution at a meeting in Sydney, Australia. During the hijinks, the Yes Men announced the formation of a new Trade Regulation Organization

that would abide by the United Nations Universal Declaration of Human Rights, instead of a system based upon maximizing corporations' profit margins. See http://www.rtmark.com.

3. Dave Gilson, "Trust Us, We're Experts," *Mother Jones,* March/April 2005, 82–83.

4. Ibid.

5. *The Yes Men,* http://theyesmen.org/faq.

6. "Dow 'Help' Announcement Is Elaborate Hoax," DowEthics.com, December 3, 2004, http://www.dowethics.com/r/about/corp/bbc.htm.

7. *The Yes Men,* http://theyesmen.org/hijinks/bbcbhopal.

8. Ibid.

9. David Darts and Kevin Tavin, "Global Capitalism and Strategic Visual Pedagogy," in *Critical Pedagogies of Consumption: Living and Learning in the Shadow of the "Shopocalypse,"* Jennifer A. Sandlin and Peter McLaren, eds. (New York: Routledge, 2010), 238.

10. Gilson, "Trust Us, We're Experts, 82–83.

11. Anne C. Mulkern and Alex Kaplun, "Fake Reporters Part of Climate Pranksters' 'Theater,'" NYTimes.com, October 20, 2009 http://www.nytimes.com/gwire/2009/10/20/20greenwire-fake-reporters-part-of-climate-pranksters-thea-39576.html.

12. Naomi Klein, *No Logo* (New York: Picador, 2000), 281.

13. Brooke Shelby Biggs, "Yes-Men Taunt Halliburton," CorpWatch.org, May 10, 2006, http://www.corpwatch.org/article.php?id=13568.

14. Ibid.

15. Ibid.

16. One of the most notorious offenders is Exxon Mobil. See Greenpeace's research project *Exxon Secrets*—"highlighting the more than a decade-long campaign by Exxon-funded front groups—and the scientists they work with—to deny the urgency of the scientific consensus on global warming and delay action to fix the problem," Greenpeace.org, http://www.greenpeace.org/usa/campaigns/global-warming-and-energy/exxon-secrets/faq.

17. The Yes Men, "Yes Man Sprung, Police Misconduct; Direct-Action Campaign Launch," press release, September 23, 2009.

18. Ibid. Copenhagen was the site for the December 2009 UN Climate Change Conference, where political leaders failed to establish an agreement on reducing greenhouse gases. Activists demanded that nations reduce greenhouses gases to 350 parts per million—the maximum level of $CO_2$ that the atmosphere can safely bear. In 2009, greenhouse gases were at 387.

19. Ibid.

20. Ibid.

# Index

Page numbers in *italic* refer to illustrations.

FEB 1 9 2014